VIVIAN MAIER DEVELOPED

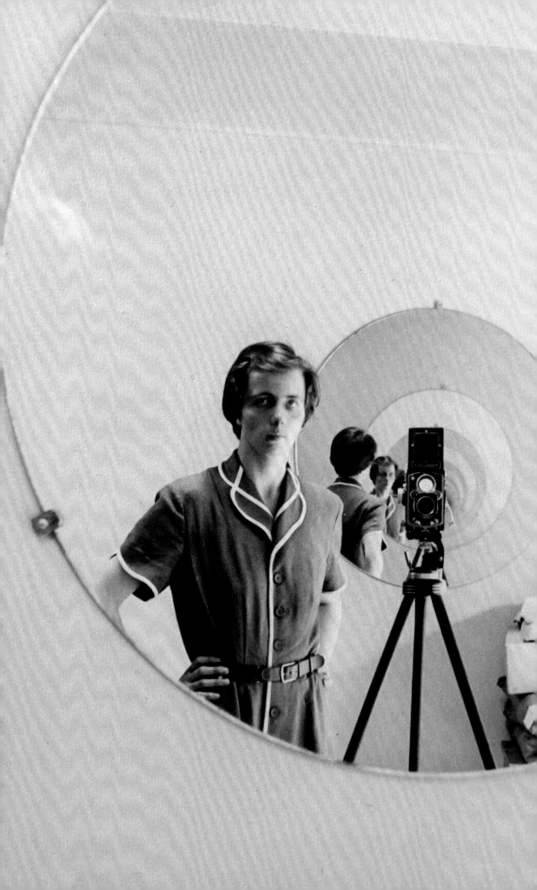

VIVIAN MAIER
DEVELOPED

The Untold Story of the Photographer Nanny

ANN MARKS

ATRIA BOOKS

NEW YORK ■ LONDON ■ TORONTO ■ SYDNEY ■ NEW DELHI

An Imprint of Simon & Schuster, Inc.
1230 Avenue of the Americas
New York, NY 10020

Page ii: Circle self-portrait, New York, 1955 *(Vivian Maier)*

To my mother, Harriet Marks,

public television's first publicist and the pioneer

promoter of Mister Rogers,

who passed away at the age of ninety-five

during the final preparation of this book.

To photograph is to appropriate the thing photographed.

It means putting oneself into a certain relation to the world.

—Susan Sontag, *On Photography*

CONTENTS

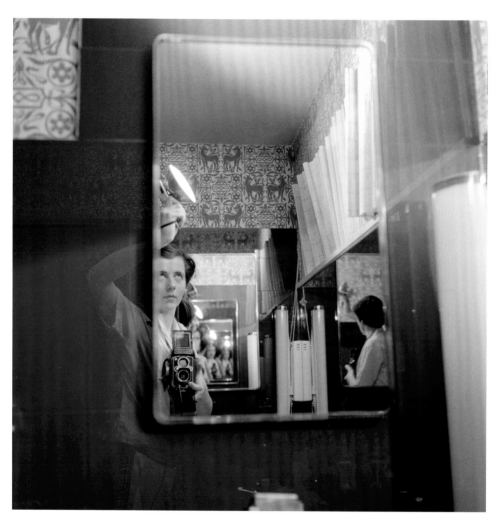

Self-portrait, Chicago, 1956 *(Vivian Maier)*

INTRODUCTION

*American/French • Authoritative/Reserved • Caring/Cold
Feminine/Masculine • Fun/Strict • Generous/Unyielding
Jovial/Cynical • Neat/Packrat • Nice/Mean • Passionate/Frigid
Personable/Stern • Polite/Brusque • Responsible/Inattentive
Social/Solitary • Feminist/Traditional • Visible/Reclusive
Mary Poppins/Wicked Witch*

—Descriptions of Vivian Maier by those who knew her best

The story begins in 2007, at a foreclosure auction in Chicago. When one of the buyers, John Maloof, closely examined his purchase—abandoned boxes stuffed with photographs he hoped to use for a book project—he uncovered a treasure trove: thousands of negatives shot by an unknown photographer. Maloof was only twenty-six years old, but his instincts told him that the pictures were special. He hunted down other buyers who had attended the sale and bought their boxes of prints and negatives. In fits and starts, he scooped up the majority of the photographer's work.

The original buyers were able to identify the photographer as Vivian Maier because the name appeared on processing envelopes in their boxes. In an effort to find her, they repeatedly searched the internet but, time and again, they came up empty-handed. That is, until April 2009, when an obituary popped up revealing that a recently deceased Chicago nanny was the one who had taken all the pictures. She was called a "photographer extraordinaire" and "second mother to John, Lane, and Matthew." Excited and intrigued, Maloof tracked down the family that had placed the death notice to learn more.

At the same time, after devoting the bulk of his savings to the purchase of Vivian's photographs, Maloof contemplated the best way to share and market

the work. Seeking feedback from those more expert than himself, he prepared a blog containing some of his favorite Vivian Maier photographs to link to the Hardcore Street Photography group on Flickr. When he clicked "Share," everything changed. Vivian's images were met with such enthusiasm that they began to go viral, with admirers sharing and resharing the photographs all over the globe. While relatively small in number, the original two dozen Flickr images were full of character and emotion, featuring a diverse array of topics and people: there was literally something for everyone.

Eventually, Maloof partnered with another buyer, Jeffrey Goldstein, to prepare and archive their combined portfolios. Few of the more than 140,000 images they had purchased were prints; most existed only as negatives or undeveloped film. Examination of Vivian's materials as a whole brought the stunning realization that she had only seen seven thousand of her photographs, the number that existed in hard copy. In fact, 45,000 exposures had never even been developed. Master photographer Mary Ellen Mark considered this highly unusual circumstance and articulated what everyone else was thinking: "Something is wrong. A piece of the puzzle is missing."

As Maloof and Goldstein rolled out their portfolios, evidence of Vivian's achievement and talent mounted. A nonstop cycle of shows, lectures, books, and accolades ensued, fueled by media that couldn't stop talking about the new nanny wonder. Newspapers, magazines, websites, and television networks the world over breathlessly told her story. The *New York Times' Lens* blog exclaimed, "The release of every new image on the web causes a sensation."

Vivian Maier Archive Components

65% negatives 30% undeveloped film 5% prints

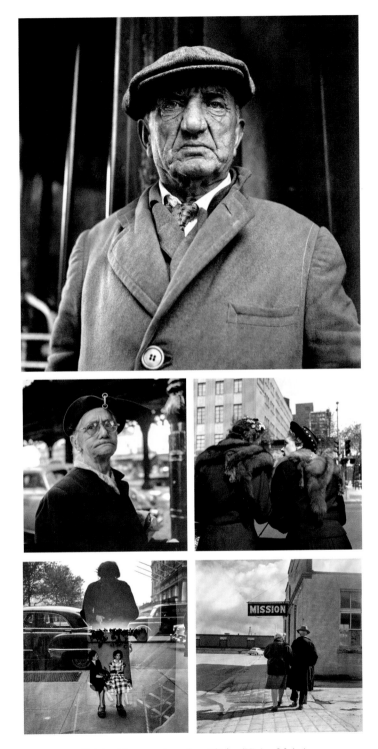

Original images shared on Flickr *(Vivian Maier)*

The *Los Angeles Times* wrote that Vivian's work was "characterized by a crisp formal intelligence, a vivid sense of humor, and a keen grasp of the serendipitous choreography of daily life." She was called a "genius" by the Associated Press and "one of the most remarkable stories in American photography" by *Smithsonian* magazine. The *New York Times*' venerable art critic Roberta Smith claimed that Vivian's initial exhibits "nominate a new candidate for the pantheon of great 20th-century street photographers."

Vivian Maier debut, Chicago Cultural Center, 2011 *(John Maloof)*

Concluding that the story of hidden talent and its improbable discovery would make a compelling documentary, Maloof began to research Vivian's background. He was proven right when interviews with a dozen of her Chicago employers revealed that they knew almost nothing about the woman who had lived in their homes and cared for their children. While many were aware she had taken pictures, they never imagined the extent of her photography. Some offered completely contradictory descriptions of their nanny's personality and behavior. The more Maloof discovered, the more mysterious Vivian became.

The resulting 2014 film, *Finding Vivian Maier*, received an Academy Award nomination and launched the photographer nanny into a rarefied stratosphere of fame. The documentary's global audience was just as enthralled by her baffling background as by her pictures. The filmmakers found genealogical records revealing that Vivian had spent six years with relatives in France as a child and had lived in Manhattan until she was thirty, but were unable to locate anyone in New York who remembered her or her family. She spent the remainder of her life in Chicago, yet none of Vivian's employers could accurately relay where she was born, where she had been raised, if she had family or friends, why she started

taking pictures, why she hadn't become a professional photographer, why she didn't process much of her work, or why she didn't share it with others. These questions were posed in the documentary but many remained unanswered, leaving millions of fans hoping that someone might unlock the nanny's secrets.

This was precisely when I entered the orbit circling Vivian Maier, and my involvement was as unlikely as that of all others associated with the photographer. I am a former corporate executive, and for three decades my purview included research and analysis geared toward understanding the desires, motivations, and behavior of everyday people. For me, no detail is inconsequential, and no question is left unanswered. My greatest passion is solving quotidian mysteries—the more convoluted, the better. One wintry afternoon in late 2014, I wrapped myself in a blanket and watched Maloof's documentary in advance of the upcoming Academy Awards. Like many, I was captivated by the photographs but puzzled by the opposing descriptions of Vivian's personality, the lack of understanding surrounding her photographic behavior and goals, and the absence of information about her family and personal life. But where most saw an impenetrable mystery, I saw gaps that needed filling, and felt compelled to unravel the story that had confounded so many.

Within weeks I had contacted John Maloof and Jeffrey Goldstein with an offer to collaborate. They told me of a pressing need to find out what happened to Vivian's brother, Charles, who became untraceable after the 1940s. As the direct heir to her valuable estate, it was imperative that he and his descendants be found. A few months later, I discovered a baptism record for a Karl Maier that had rested for almost a century in the cavernous archives of Manhattan's Saint Peter's Lutheran Church. This finding led to confirmation that Vivian's brother never married or had legitimate children—and that he had passed away in New Jersey in 1977. His death affirmed what most had suspected: there was no clear heir to Vivian's estate. The *Chicago Tribune* featured me on their front page and the Cook County estate administrators reached out to exchange information. Suddenly and unexpectedly, I became part of the Vivian Maier phenomenon.

As my research continued, Maloof and Goldstein independently requested that I write a comprehensive and authoritative biography of Vivian Maier and offered me access to all of their photographs. Thus, I became the only person in the world to examine their combined archive of 140,000 images, which served as the cornerstone of this biography. They graciously furnished the technical expertise that I lacked by connecting me to industry experts, and the administrators of Vivian's estate generously granted me permission to use her photographs to help tell her story. I was further armed with other materials from Maloof's

collection: tape recordings, films, records, and personal artifacts. All this ultimately amounted to the tip of the Maier family iceberg; buried deep under the surface was a hidden history of illegitimacy, bigamy, parental rejection, violence, alcohol, drugs, and mental illness.

My first task was to construct a family tree to create a framework for the world into which Vivian Maier was born. The companion burial map that I prepared revealed an uncommon story: Vivian's ten New York family members were all buried in the metropolitan area, but in nine different places! Most people, logically, share cemetery plots with close relatives, often with a broader collection of kin. This family's final places of rest signaled a clan at such odds in life that they had intentionally separated for eternity.

My hunch was that Vivian's brother—who had left no education, employment, or relationship trail—was the key to unlocking the family's history. I hypothesized that he had been incapacitated through either illness or incarceration, which would explain his lack of records. It was an unsubstantiated guess, but I nonetheless spent months sifting through asylum, hospital, and inmate files on instinct alone. And indeed, after peeling back layers of data from the New York

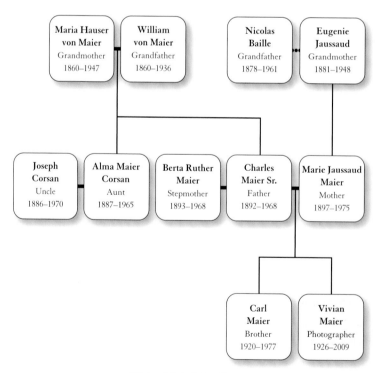

Vivian Maier's family tree

State Archives, I came upon a 1936 reference to a "Karl Maier" at the New York State Vocational Institution, a reformatory in the town of Coxsackie. It was not at all obvious that this was the right person—there were hundreds of Karl, Carl, and Charles Maiers in the tristate area—but when I was apprised of the inmate's birth date, a chill traveled down my spine. It matched the baptism record from Saint Peter's. To access Carl's folder, I acquired written permission from family members in France, although the material was subsequently certified for public availability. The New York State archivist informed me that the records were in a nearby storage locker and could be retrieved quickly, so off to Albany I went.

A volunteer at the archives greeted me with a knowing smile, and handed over a three-inch-thick folder. Crammed with letters and records, it contained the complete family story, told from six different perspectives—that of Carl, his two grandmothers, both parents, and the reformatory. Tucked among the reports were Carl's mugshots, the only pictures ever found of Vivian's brother.

At the time, I was also working to secure Carl's military file, having identified online records associated with his enlistment and post-service death. I was informed that the material had been lost in a 1973 fire at the National Personnel Records Center in St. Louis. It quickly dawned on me that this couldn't be true—Carl's death had been posted to his public-service record in 1977, *after the fire*. With some pushback, the military archive was searched again, and a large Karl Maier folder surfaced, revealing critical information not only relating to his service, but to the remainder of his life. When I received copies of both the military and reformatory files in the same week, I felt like I had won the Vivian Maier genealogical lottery.

But that was only the beginning. To prepare a proper biography, I judged it necessary to trace and interview individuals who had known Vivian during each stage of her life. The fact that photographs had few annotations made this an almost impossible task, and for years I painstakingly overlaid clues from the pictures with other information in an attempt to identify their subjects. Stories of my most important quests can be found in appendix C, including the convoluted, sometimes preposterous lengths I would go to track down my quarry.

Ultimately, I interviewed thirty people who had known Vivian as a child or young adult or had spent time with her immediate family members. Identifying and locating these individuals posed the project's greatest challenge, but offered the most exhilarating rewards. In addition to garnering new and important details, I had the unparalleled pleasure of sharing Vivian's photos from long ago with their surprised subjects. After six years of examining countless genealogical records; studying the entire archive of images; conducting firsthand interviews in New York, California,

and Chicago; visiting the French Alps; and reviewing the extensive materials John Maloof had collected for his film, a full picture of Vivian Maier finally emerged.

The first art books featuring the photographer's images offered limited corresponding information, but by ordering them chronologically, I have been able to place and date many and prepare a timeline of where Vivian lived, worked, and traveled. The result is essentially a daily diary of her life, interests, and view of the world—an incomparable resource in constructing a biography and understanding its subject's actions and motivations. The chronology simultaneously documents Vivian's artistic development, including the revealing progression of her self-portraits. Most of all, a marriage of images with all other forms of information—artifacts, records, and interviews—provides the first-ever opportunity to place Vivian's photographs within the context of her life.

After Vivian's pictures were discovered and money and fame came up for grabs, guesswork and accusations quickly clouded what was initially an unadulterated celebration. The debate that played out in the media questioned if the two men who purchased the bulk of her photographic material had the rights, qualifications, and experience to manage her archive and whether she would have wanted to share her work with the public. Numerous historians, journalists, and critics egregiously maligned Maloof and Goldstein in the press, and accused them of exploiting Vivian for financial gain. These controversies are examined in appendix A, with the conclusion that almost all the aspersions were misleading or unsubstantiated. In fact, that two amateurs who frequent storage-locker sales purchased and prepared Vivian's archive gives the story a satisfying symmetry.

With intelligence, creativity, passion, and a great eye, Vivian developed a massive and broadly relatable portfolio reflecting the universality of the human condition. Today, exhibits and lectures continue around the globe, and museums have begun to acquire her work. Some have mentioned her name in the same breath as masters of street photography—Berenice Abbott, Lisette Model, and Robert Frank—and we can look forward to how experts will ultimately place Vivian Maier in the canons of photographic history.

The odds that Vivian's exceptional body of work would ever surface were infinitesimal, given the chain of improbable events that led to its rescue and dissemination. If even one of those steps had failed to occur, the photographs could have disappeared forever via their almost certain dumpster destiny. The photographer had to be a singular talent who saved all her work. Due to financial or other constraints, she had to default on payment for storage lockers that housed her archive. An auctioneer had to buy the unorganized containers, believing they held items worth

selling. John Maloof had to be untethered from school and employment, preparing to write his first book, which required visuals from the period in which Vivian worked. Living but a stone's throw from the auction house, he had to walk into the establishment exactly when her negatives were on sale and join others in purchasing the lots. These buyers had to save their materials and sell them to Maloof and Goldstein when they came to call. The two men, entrepreneurial risk-takers, had to be willing and able to invest in and prepare the archive of an unknown photographer. They had to have the artistic know-how to bring in professionals and adopt proper methodologies to organize, develop, exhibit, and promote Vivian's work. Perhaps most important, they had to have the insight to introduce the images online.

This narrative focuses on Vivian Maier the person, covering her entire lifespan. I use her first name throughout because this is how most people know and speak about her. My priority has been accuracy and objectivity, secured through an emphasis on primary research, firsthand and transcribed interviews, expert opinions, and photographic evidence. I believe the disclosure of Vivian's past is justified because negative perceptions of her can now be debunked and her remarkable personal story can be shared. It is clear that a family history of mental illness is a crucial chapter of her story, an element that so far has been largely ignored or dismissed as irrelevant, as if acknowledgment would stigmatize or devalue her accomplishments. Vivian's talent stands alone, but it is only through the prism of her childhood experiences and psychological makeup that we can understand her motivations and actions as they relate to her work.

From the beginning, others projected their own values and expectations onto Vivian. Perhaps the greatest myth associated with her is that she felt marginalized, unhappy, and unfulfilled—that her life story is sad. In fact, the opposite is true; Vivian was a survivor and had the fortitude and capabilities to break away from family dysfunction and exponentially improve her lot in life. She bulldozed through every obstacle that stood in her way with limitless resilience. Her concern was for the fair treatment of the disadvantaged, never for herself. Until late in life, she was mostly upbeat, action-oriented, engaged, and well-informed, perpetually living life on her own terms. Her creative and intellectual brilliance, progressive outlook, and independent thinking resulted in an unusually rich—even extraordinary— existence, one that was inextricably entwined with her photography.

Vivian Maier lived the life she wanted to live. This biography is written with the hope that readers will find relevance, even inspiration, in her story and body of work. By book's end, key questions will be answered, including the one everyone asks: "Who was Vivian Maier, and why didn't she share her photographs?" Mystery solved.

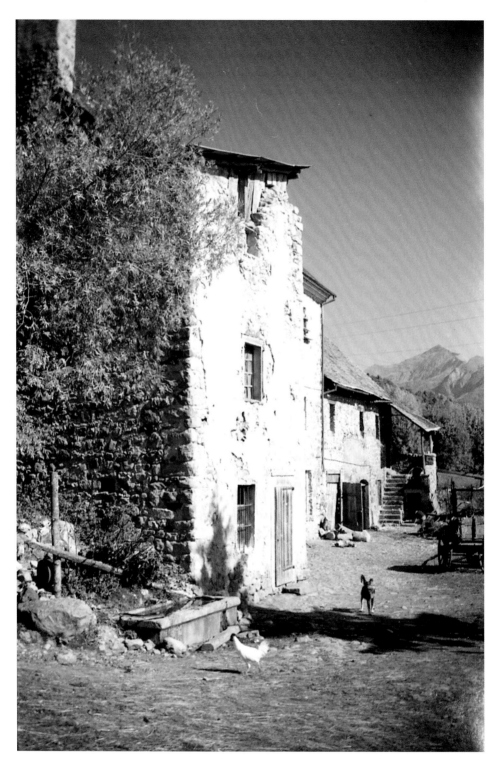

Beauregard, Saint-Julien, 1950 *(Vivian Maier vintage print)*

1

FAMILY: THE BEGINNING

I'm the mystery woman.

—Vivian, describing herself

Considering its improbable ending, Vivian Maier's story begins conventionally enough: it's a tale of two European families who left everything behind at the turn of the twentieth century, seeking a better life in New York. The path toward the American Dream was far more treacherous than most immigrants imagined, and the pressures of its pursuit left many fractured families in its wake, including the one into which Vivian was born.

Her father's ancestors, the von Maiers, were culturally German, and came from the small town of Modor, now called Modra, in present-day Slovakia. They were of distant noble ancestry, as evidenced by their inherited German prefix "von." William, Vivian's grandfather, was one of ten children from a large Lutheran family, and had owned a butcher shop. His wife, Maria Hauser, was from nearby Sopron. Their home, a former evangelical prayer house, was one of the most beautiful and valuable in town. The family that purchased it from the Maiers more than a century ago still occupies it today.

In 1905, William and Maria immigrated to New York with their daughter, Alma, age eighteen, and son, Charles, thirteen. They took a step down in stature from the life they had previously enjoyed and settled into a typical tenement rental on Manhattan's Upper East Side, a neighborhood flooded with new arrivals wedged into tight quarters. Charles, Vivian's father, had it better than most, receiving two years of tutoring to qualify as a licensed engineer. From all appearances, they were a highly functional and hardworking family, although no longer business owners. They joined Saint Peter's Lutheran Church, which conducted services in German.

New owners in the von Maier home, Modra, Slovakia, 2015 *(Michal Babincak)*

Alma left the family quickly, marrying a Russian Jewish immigrant from Chicago in 1911. By 1915, she had divorced, moved back to New York, and gotten remarried, to successful clothing manufacturer Joseph Corsan, also a Russian Jew. They had no children but happily spent the rest of their lives together while helping to support the elderly Maiers. If affluence was the goal of the immigration, Alma was the only one to grab the brass ring: she would go on to accumulate a large stock portfolio and live with Joseph on posh Park Avenue.

Vivian grew up having minimal contact with her Maier relatives, but her maternal French family, the Pellegrins and Jaussauds, would influence her in almost every way. Originally farmers and shepherds, the Jaussaud clan settled in the Hautes-Alpes of southeastern France during the fourteenth century. The region's villages, collectively called the Champsaur Valley, are removed from major transportation routes and comprise a patchwork of impossibly picturesque farms encircled by zigzagging alpine peaks. While rural, the area's residents possess a refined aesthetic sensibility and cultural appreciation. A scholar of the region, Robert Faure, describes that a Champsauran is "someone who is, above all, in love with freedom, who wants to be his master and has difficulty accepting constraints." Today, the cobblestoned streets of the main town, Saint-Bonnet-en-Champsaur, are still lined with pristine stone homes adorned with pastel shutters and patterned lace curtains. Visual details abound: woven straw nests cradle

warm eggs at breakfast, heavy cream is poured from thick glass pitchers, and tilted berets signal the joviality of the villagers. Authenticity and thrift trump quantity; wool is hand-spun, shoes are crafted from real leather, and food is homegrown. This valley would capture a piece of Vivian's heart.

At the beginning of the twentieth century, many residents of the Champsaur were poverty stricken. Long, harsh winters limited farming and families invariably had many mouths to feed. Typically, a baby was born every two years and was raised in a multigenerational home. The valley's society was patriarchal, and male children were most desired due to their usefulness as laborers. Day-to-day life was dominated by strict adherence to Catholic mores, and women dressed modestly in long-sleeved white blouses and black skirts that skimmed the ground. Even though the Jaussauds owned farmland throughout the region, they struggled like everyone else.

In 1896, Vivian's great-grandfather Germaine Jaussaud purchased Beaure-gard, an important estate in the commune of Saint-Julien-en-Champsaur that was built by a nobleman three hundred years before. Germaine and his wife, Emilie Pellegrin, who was twenty-four years his junior, had three children: Joseph, Maria Florentine, and Eugenie, Vivian's grandmother. With marriage and procreation of primary importance, it was highly unusual that the siblings would produce just one child, setting the stage for Vivian's lack of heirs. Eugenie and her parents moved to their new residence ahead of the others to prepare the homestead, hiring young field-worker Nicolas Baille to help. Up until then, fifteen-year-old Eugenie had led a chaste and bucolic life, but invariably, setting two teenagers loose on a far-flung property was asking for trouble. The

Grandmother Eugenie Jaussaud, Naturalization, 1932 (*USCIS*)

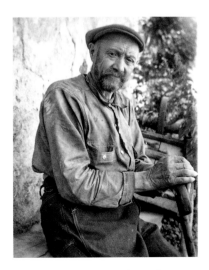

Grandfather Nicolas Baille, France, 1951 *(Vivian Maier)*

inevitable pregnancy came quickly and was treated as a family catastrophe, made far worse when the farmhand refused to wed Eugenie or admit paternity. This decision, made by a frightened seventeen-year-old boy more than a century ago, would set into motion three generations of family dysfunction, the nature of which provides the key to unlocking the story of Vivian Maier.

On May 11, 1897, Vivian's mother, Marie Jaussaud, was born. Because she was illegitimate, she carried no rights or status in France; thus, the baby girl was welcomed into a world where she officially didn't exist. In the deeply religious community, the entire family bore the stigma of the "bastard" child. Germaine passed away two years later, leaving his wife, son, and daughters to manage Beauregard's thirty-five acres. While holding on to the land was a priority, his survivors periodically sold off plots to fund their livelihood.

On Marie's fourth birthday, the ostracized Eugenie temporarily abandoned her daughter and fled to America to start a new life. This was likely planned in conjunction with her family and was not necessarily a selfish act. In the United States, she would have the opportunity to earn money to support Marie while relieving her family of the source of their shame. By then, many residents of the Hautes-Alpes had already immigrated to California and other parts of the American West to take advantage of the Homestead Act, which offered them free land if they agreed to develop and farm it for five years. Men of the Champsaur possessed the ideal experience and endurance to thrive in the rugged territory, and viewed the opportunity as a road to riches. Typically, they would immigrate alone, and after accumulating substantial savings would either return to the Haute-Alpes or send for their families to join them. At the time, virtually every household in the valley had relatives in America. In fact, just a few months after Eugenie left France, Nicolas Baille immigrated to Walla Walla, Washington, an enclave of French farmers. No one appears to have had more of an influence on Vivian than Eugenie, whose life took an improbable course. Her experiences and their implications help inform a deeper understanding of Vivian.

Unlike almost all others leaving the Champsaur, Eugenie's destination was the East Coast of the United States, where she would live with relatives of her family's Saint-Julien neighbors. In May 1901, she arrived at Cyprien Lagier's farm in Litchfield County, Connecticut. The only other Champsauran family that had settled in the county were the Bertrands, whose daughter Jeanne was the same age as Eugenie. When Jeanne Bertrand first immigrated in 1893, she worked in a needle factory, but within a few years she had finagled employment at a local

photo studio to escape the grind and became a highly skilled photographer. By the time Eugenie arrived, Jeanne's father had died and her mother had resettled the family in Oregon, leaving her and a brother behind. In 1902, the beautiful and talented young Frenchwoman was featured on the front page of the *Boston Globe*, and was well on her way to becoming a society photographer. While Jeanne enjoyed an upward career trajectory, Eugenie landed more conventional employment as a housekeeper. But once she ascertained that French cooks were in great demand among the elite, she grabbed an apron and never looked back. Within a few years, Eugenie had become a cook for the rich and famous.

HIGH-LOW LIFE

While establishing herself in the kitchens of the well-to-do, Eugenie met Frenchman François Jouglard who was fifteen years her senior. François had also immigrated to the East Coast in 1901, along with his wife, Prexede, and two children. After a visit with relatives, his family returned to France while François stayed on to make money, securing work in the burgeoning mill town of Cleghorn, Massachusetts. His ten-year-old daughter died while he was abroad, a sadly common occurrence at a time when 20 percent of French children failed to reach the age of five. Eugenie's parents themselves had lost a child, Albert, at age four.

Whether they met through French connections or by chance, twenty-five-year-old Eugenie and forty-year-old François formed a relationship that was not limited to friendship or even an illicit affair. Eugenie and François *married* each other in Manhattan's city hall on March 9, 1907. It makes sense that Eugenie would want a husband: she desperately sought a facade of legitimacy for Marie, and her own mother, Emilie, had found comfort and security from an older man. The marriage certificate states that they were single and it was a first marriage for both. Before the wedding, the pair had been living apart in Manhattan where François was working as a butler and Eugenie was likely a cook, although the marriage certificate did not capture the bride's employment. It can only be assumed that the religious Eugenie would find bigamy unacceptable, and was unaware of her husband's marital status. If she did know, François must have convinced her that he had split from his spouse and changed plans to remain in the United States. Court documents would later reveal that he was neither separated nor divorced, and that his wife and son were eagerly awaiting his return, oblivious to his hijinks in America.

Busted: François Jouglard's bigamous marriage, New York, 1907 *(NYCA)*

The newlyweds set out to find employment together just as another French couple from Litchfield resigned their positions as cook and butler for the Witherbees, a fabulously wealthy clan in upstate New York. François and Eugenie were the perfect replacements, and once hired, they moved into the family's mammoth home overlooking Lake Champlain in Port Henry. The Witherbees were owners of iron mines and benevolently ruled the town. Walter Witherbee was knee-deep in planning the tercentennial of the discovery of Lake Champlain, a once-in-a-lifetime commemoration which was to take place in the summer of 1909. Over five days in July of that year, a raft of notables—governors, senators, congressmen, prime ministers, cardinals, bishops, ambassadors, generals, and the vice president and president of the United States—descended on Port Henry and the surrounding towns.

The festivities kicked off with a small luncheon for the governors of New York and Vermont at the Witherbee residence, most likely prepared by Eugenie. It is impossible to overstate the magnitude of the celebration that followed: there were Native American pageants, battle reenactments, big band parades, a water carnival, and fireworks. The US Secretary of War brought troops to march in formation, as did the Canadian premiers. Discoverer Simon de Champlain was honored with original poems and songs, a bronze bust, and a life-size replica of his ship. A Rodin sculpture was

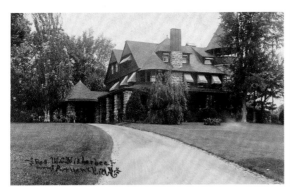

Starter job: Walter Witherbee and his mansion, Port Henry, New York, 1909 *(LOC)*

commissioned for future delivery. As a nod to Champlain's heritage, events had a decidedly French flavor and as a subsequent thank-you, Walter Witherbee would be crowned a knight of the Legion of Honour by France. It can only be assumed that the outsize festivities left the relatively impoverished butler and cook with a serious case of culture shock.

The 1910 census indicates that the couple had remained with the Witherbees and falsely states they had been married for thirteen years, timing that perfectly corresponds with Marie's birth. By positioning François as Marie's father, Eugenie could optically right her wrongs and invent a new personal profile. But given the underlying duplicity, it is no surprise that the relationship was too good to be true, and François would be revealed as a dishonorable and violent man. Early in 1910, for unknown reasons, Eugenie's brother, Joseph, traveled from Saint-Bonnet to Port Henry to visit his sister, but did not bring thirteen-year-old Marie along. He remained in America for two years and by early 1912, both he and François traveled back to France, possibly together. Eugenie would never see either man again.

Joseph returned to managing the Saint-Julien farm and was exempted from military service due to his role in supporting his family. Just five years later he would die at home at age twenty-nine, followed a month later by his mother, Emilie. With their passings, Eugenie and her sister, Maria Florentine, became the sole owners of Beauregard.

After being away from his family for almost eight years, François Jouglard rejoined them in Saint-Bonnet. His wife, Prexede, sensed a change in her husband and in 1913 she filed for separation, citing his abusive behavior. Court transcripts include allegations that François hit her with a pickax, punched

her face so hard that he broke her tooth, and threw an open knife at her head, which miraculously missed. Due to the dire circumstances and in anticipation of a permanent split, the court ordered the conjugal home sealed and an inventory taken. It was completed just days later, down to the soupspoons. Records from the proceedings portray Prexede as strong and resourceful, noting that she had launched a mattress business to support herself and her son during her husband's absence. But as is the case with all too many battered women, her options were limited and she remained in the marriage. Prexede appeared to be none the wiser regarding François's "American wife."

Retrospectively, it can only be hoped that Eugenie was not also abused—however, at the very least, her "husband" had almost certainly misled and abandoned her. It is possible there was a pregnancy during the more than five years they spent together. Eugenie had demonstrated herself to be fertile and was an unlikely candidate for birth control, but there is no evidence of a birth one way or another. She understandably tried to keep the marriage secret; there is no reference to it in family letters or records.

After her estrangement from François, thirty-year-old Eugenie set about carving out a life as a domestic and appears to have been finished with men for good. She became friendly with other Europeans, self-described as servants, some of whom would later offer lifelines for Vivian. Eugenie in fact led a progressively remarkable life by establishing herself as a family cook for a "Who's Who" of New York society, in households where staff outnumbered family. Hardworking, likable, and undoubtedly an exceptional cook, over the next forty years she would attract a steady stream of upper-crust employers. Residing in their lavish penthouses and sprawling country estates, she fed many of the most famous people in the country. Through Eugenie, Marie and her children would experience a kind of high-low existence, exposed to the riches of the city's elite but knowing that they didn't belong.

Eugenie joined the congregation of Saint Jean de Baptiste, a stunning Catholic church in Manhattan founded in 1882 to cater to French Canadian immigrants. Going forward she doctored all records to portray herself as a widow, making just one disguised mention of her husband. In her 1931 naturalization petition, she depicted herself as the widow of a man named François whom she had married in "Saint Barnard," France, on March 9 (her real wedding day), 1896—just in time for him to have fathered Marie. This fictional François was born in 1871 and had sadly passed away in 1900 at twenty-nine, the same age her brother, Joseph, had been when he died.

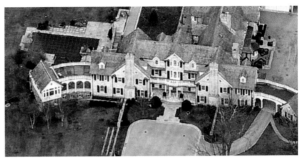

Gibson girl, 1890s Ensign Farm, Bedford, New York *(Google Earth)*

Toward the end of her career, Eugenie worked in the tony horse town of Bedford, New York, for the family of a little boy named Charles Gibson, the only person ever found to remember the cook. He lived with his mother, stepfather, brother, and six servants on an estate called Ensign Farm. His grandfather was Charles Dana Gibson, the artist whose iconic "Gibson Girl" was an embodiment of beauty, wealth, education, and independence, a sort of fictional Jackie O of her time. Charles fondly recalls Eugenie as a warm, wise, and private woman who expressed herself in charming broken English. He found her sweet and amenable, although wizened beyond her years from hard work. As a boy, he once proudly shot and dragged home a woodchuck. In her element, Eugenie skinned, cleaned, and roasted the animal, serving it on a fancy platter for the family dinner and winning the boy's heart. In fact, in all the letters and records associated with Eugenie, no one has a negative word to say. She would emerge as the only stable and loving force in Vivian Maier's life.

By 1913, Eugenie had moved back to Manhattan to cook for Fred Lavanburg, a noted philanthropist who owned an upmarket dress business, which was run by his close friend Louise Heckler. Historical transcripts describe lunches held at the Lavanburg residence when Eugenie was his cook. At the end of the year, when the company's gown designer quit under contentious circumstances, Heckler quickly hired a replacement and booked a buying trip to France. With World War I on the horizon, Lavanburg arranged for Eugenie's daughter, Marie, to accompany his colleague on her return voyage to the United States, serving as Heckler's maid. They left Europe in June 1914, in the nick of time—within weeks the war would begin and Germany would invade France.

Marie had been raised by her grandmother at Beauregard, but later gave others the impression that she had been sent to a convent. (It is possible that she attended a convent school.) Predictably, rejection by both parents and the stigma of illegitimacy as a child would have a negative impact on her mental health, with serious consequences for her children. Marie was seventeen when she was finally reunited with the mother she barely knew, joining Eugenie in the Lavanburg apartment. The country girl, who grew up without electricity or plumbing, now lived in a luxurious tower adjacent to Central Park, where she endeavored to learn English and adapt to the clamor of the city. Such a change would intimidate anyone, and in possession of a fragile ego and with only her mother for support, she undoubtedly struggled to make the adjustment. From the moment Marie set foot in New York, Eugenie wholly devoted herself to her daughter.

Toward the end of the decade, Lavanburg suffered a nervous breakdown and temporarily left Manhattan. Eugenie moved on to work for Henry Gayley, a steel fortune beneficiary who lived on Park Avenue with his wife, two children, and three servants. By Christmas of 1920, Gayley was dead, but Eugenie stayed on for several more years. While her mother lived on Manhattan's east side, Marie briefly resided on the west side, serving as a governess for the children of stockbroker George Seligman.

THE PARENTS

Vivian's father, Charles Maier, was also firmly ensconced in Manhattan. He had lived with his parents in a tenement apartment at 220 East Seventy-Sixth Street for almost ten years, working as a licensed steam and electrical engineer. The first floor of his building was leased to commercial outlets, one of which placed classified advertisements. As was the norm, the Jaussauds and the Maiers occasionally purchased such ads to sell belongings and seek employment, and it is possible that Marie and Charles met at the Seventy-Sixth Street office.

Whether there or elsewhere, Lutheran Charles Maier and Catholic Marie Jaussaud came together, and the unlikely pair were married in Saint Peter's Lutheran Church on May 11, 1919, Marie's twenty-second birthday. Nuptials were conducted by Reverend Moldenke, with only his wife and the church custodian as witnesses. Consistent with family convention, Marie fabricated her lineage for the marriage certificate. She noted that her mother

Star-crossed union: Marie Jaussaud and Charles Maier,
Saint Peter's Lutheran Church, May 11, 1919 *(NYCA)*

was named Eugenie Pellegrin and her father was Nicolas Jaussaud, justifying her surname and camouflaging her out-of-wedlock birth. Just to be sure, she also entered an incorrect birth date and place, obstacles to tracing her real identity. These pervasive record falsifications would send future researchers into genealogical tailspins.

The newlywed Maiers had little in common except difficult personalities. In New York, Charles held a steady job at the National Biscuit Company, but lost money through gambling and complained that his wife refused to work, cook, or clean. Marie was lazy and argumentative, and presented herself as being more refined than her husband, asserting that he was a cheap drunk and a poor provider. According to their families, the bickering never stopped, effectively ending the marriage before it ever really began.

On March 3, 1920, just nine and a half months after their nuptials, Charles Maurice Maier Jr. was born, adding pressure to a situation that was already on the verge of exploding. The baby's Catholic baptism took place at Saint Jean de Baptiste, on May 11, 1920, Marie's birthday and the couple's first anniversary, with devout Eugenie as witness. To level the playing field, Charles requested a Protestant ceremony, resulting in an unusual double dip. Two months later, at Saint Peter's, the baby was christened Karl William Maier Jr. in honor of his paternal grandfather,

Certificate of Baptism

Saint Jean Baptiste Church
184 East 76th Street
New York, NY 10021

* This is to Certify *

That _Charles Maurice Maier_

child of _Charles Maier_

and _Maria Jaussaud_

Born in _New York, NY_

on the _3_ day of _March_ _1920_

* Was Baptized *

On the _11_ day of _May_ _1920_

According to the Rite of the Roman Catholic Church

By the Rev. _L. Shaeu, SSS_

Sponsors being _Eugene Jaussaud_

And _____

Dated _September 16, 2015_

Rev. John L. Kamas, SSS Pastor.

Baptism 1: Saint Jean de Baptiste Catholic Church, New York,
Charles Maurice Maier Jr., May 11, 1920

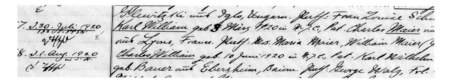

Baptism 2: Saint Peter's Lutheran Church, New York,
Karl William Maier Jr., July 30, 1920

the official name he would use for the rest of his life. He called himself Carl, as did the Maiers, but the Jaussauds referred to him as Charles, or Charlie. (This narrative refers to his father, Charles Sr., as "Charles" and his son as "Carl," which was written as "Karl" in most official documents.) The child's identity issues had only just begun.

When they first wed, the couple lived with Charles's parents and their two boarders, but once Carl arrived they moved to their own apartment, which was furnished by Eugenie. Marie struggled after the birth of her son, becoming so thin and weak her mother feared she might die. Unexpectedly, word came that Marie's father, Nicolas Baille, was returning to France after working in Washington State for twenty years and planned to stop in New York to visit his

daughter. Marie was desperate for his recognition and financial support, but was left anxiously awaiting an arrival that never came. Eugenie complained to her sister in France that the selfish man had first abandoned her and now had done the same to his daughter.

In early 1921, desperate for cash to support Marie and her baby, Eugenie sold the inheritance rights for her half of the Beauregard estate to her sister, Maria Florentine. Marie's relationship with her husband had become intolerable. As the marriage crumbled, Charles turned heavily to drink and lost all his money at the racetrack, while Marie's sense of superiority and prickly temperament only escalated their differences. Their son, Carl, was raised amid constant turmoil and conflict. Again and again, his parents separated and got back together, and in between Marie sought support from the courts and local charities.

The state-of-the-art Heckscher children's home had recently opened on upper Fifth Avenue in partnership with the New York Society for the Prevention of Cruelty to Children. The project was funded by enlightened German philanthropist August Heckscher, who had provocatively pronounced that "there are no bad children" and blamed parents for poorly behaved offspring. Marie met with the New York State Charities Aid Association, who placed jeopardized children into such temporary facilities after which the vast majority were adopted.

In 1925, Carl entered the Heckscher home, where he spent most of the fifth year of his life. He ultimately escaped adoption when his paternal grandmother sought and was granted legal custody of him. While Carl was in the institution, his parents were living together on East Eighty-Sixth Street. Even though she wasn't working, Marie couldn't or wouldn't take care of her son. The rancor between the couple continued, prompting their own mothers, Eugenie and Maria, to bond over their mutual disdain for their children, with the unlikely outcome that they became very close friends.

Everyone expected the unsuited pair to permanently separate, but they came together at least one more time, resulting in another unwanted pregnancy. Already deemed unfit to be parents, Charles and Marie reunited for the upcoming birth.

Sylvain, Marie, and Vivian, Saint-Bonnet, 1933 *(Courtesy of Sylvain and Rosette Jaussaud)*

2

EARLY CHILDHOOD

My mother didn't take care of me.

—Vivian, confiding to an employer

Vivian Dorothy Maier joined her dysfunctional family on February 1, 1926. Her birth certificate listed Charles Maier as father and as mother, perplexingly, Marie Jaussaud Justin—a new surname that came out of nowhere and then disappeared. Marie was doctoring records again so that her maiden name was not the same as her mother's. Unlike her brother, Vivian was baptized only once, in Saint Jean de Baptiste, on March 3, 1926, Carl's sixth birthday. He served as a "witness," but Eugenie was unavailable and sent Victorine Benneti, a French governess from Oyster Bay, in her stead.

The following year, Charles and Marie separated for good, and Marie sued her husband for being an abusive parent. Vivian and Carl were raised apart from their father and from each other. Grandmother Maria Maier stayed at home to raise Carl, and Vivian was all but prohibited from mingling with the Maiers. Like Eugenie, Maria was described by everyone in very positive terms; grandfather William Maier remained in the background and worked until he was seventy-five to support his family. Eugenie fully supported Marie and Vivian and helped out with Carl.

For the first years of her life, Vivian was raised solely by her mother, who perpetually turned to others for help. She took Charles to court for lack of support and tapped into the resources of Catholic, Protestant, and Jewish charities. Although she worked on and off, Marie was never known to hold a steady job. When she was employed, or was otherwise indisposed, it is likely that she placed Vivian into temporary care. The Heckscher facility had opened an

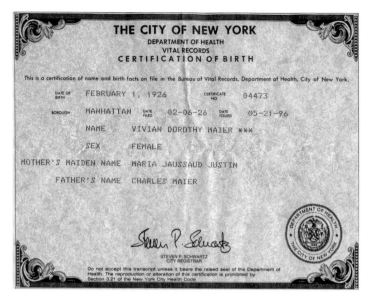

Vivian Maier birth certificate; New York, February 1, 1926 *(John Maloof Collection)*

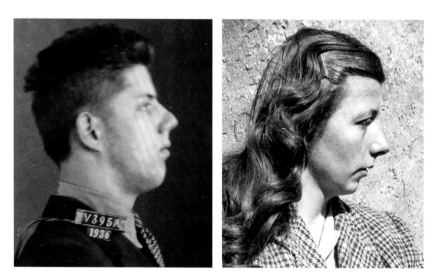

Sibling resemblance: Carl Maier, 1936; Vivian Maier, 1950

infantorium for healthy babies, which would have served as an expedient solution as would have the Swiss Benevolent Society of New York. In a 1932 classified ad that Marie placed seeking employment, it was this institution's telephone number that she provided for contact. Much later, Vivian took a

picture of the society's building, which suggests a prior connection. Marie's aggregate actions paint a picture of a woman unwilling or unable to take responsibility for her children or even herself. Later, in a rare moment of candor, Vivian would tell an employer she didn't like her mother, who had never taken care of her.

CHAMBERMAID-MAID. French; references. Call SUsquehanna 7-7540. Mlle. Jaussaud.

New York Times classified ad, 1932

The end of the decade marked the beginning of the Depression and the families moved to the Bronx. Charles continued to absolve himself of all responsibility for his children and lived on his own. Carl and his grandparents secured an apartment on one side of Saint Mary's Park, and Vivian and her mother on the other, moving in with Eugenie's old friend Jeanne Bertrand. It is not surprising that the Frenchwomen had stayed in touch—both had moved in the incestuous circles of high society, Jeanne as their artist and Eugenie as their cook.

JEANNE'S AND EUGENIE'S REMARKABLE CAREERS

In the years after leaving Litchfield County, Jeanne's and Eugenie's lives strayed far from their humble beginnings. While Eugenie enjoyed burgeoning success, Jeanne's denouement evoked a tragedy worthy of Shakespeare. She had fallen passionately in love with "sculptor of society" C. S. Pietro and eschewed photography to devote herself to sculpting and promoting her paramour. Pietro was associated with the most famous people in America, including Gertrude Vanderbilt Whitney, who rested at the coveted intersection of the Vanderbilt and Whitney dynasties. During the summer of 1915, he was commissioned to create a marble likeness of Alfred Gwynne Vanderbilt, who had just perished on the *Lusitania*, and to sculpt his widow, Margaret Emerson, heiress to the Bromo-Seltzer fortune. She agreed to pay five thousand dollars if satisfied with her bust, an arrangement that would later thrust Jeanne into a conflict with the richest family in America.

In 1916, a raging fire destroyed the contents of the artists' Fifth Avenue studio. Among the lost artwork was the bust of Margaret Emerson, requiring Pietro to sculpt a replacement. In 1917, Jeanne bore Pietro's love child, characterized as such because he had a wife and children. Prone to "nervous breakdowns," Jeanne had already spent time in hospitals and sanitariums, and shortly after the birth of her son endured an episode so severe that the press reported "Miss Bertrand had gone violently insane." In the face of recovery came unbearable tragedy when, in the fall of 1918, thirty-three-year-old Pietro died, a victim of the Spanish flu. In a predicament similar to Eugenie's, Jeanne permitted his family to adopt their son to protect him from the stigma of illegitimacy.

As Pietro's wife and lover struggled to get back on their feet, Margaret Emerson refused to pay for her bust, claiming the work was incompetent. The insensitivity of one of the wealthiest women in the world was so mind-boggling that Pietro's widow sued to defend her husband's legacy and secure money to support her fatherless children. During three years of litigation, Emerson fervently dug in her heels as she house-hopped in her private railcar between her Adirondack camp, Berkshires estate, Maryland horse farm, Palm Beach villa, and Fifth Avenue penthouse, residences referenced in news articles by their charming monikers. In 1924, the case finally reached the New York Supreme Court and Jeanne Bertrand joined forces with Pietro's widow to defend him. Nevertheless, the now Margaret Emerson McKim Vanderbilt Baker prevailed, paid not a cent, and returned to naming her houses.

Eugenie's story picks up where Jeanne's leaves off as she progressively secured positions via the silken connections that wove together high society. In 1925, she joined six other servants on the Lord estate in Tarrytown. The family was in the midst of celebrating the upcoming nuptials of their son, whose fiancée was related to Cornelius Vanderbilt Whitney, son of Pietro's colleague Gertrude. Their social set summered on Long Island's Gold Coast, an enclave of the city's most well-to-do, where Eugenie landed in 1930, hired by the Dickinsons. Hunt Tilford Dickinson became famous when he was just nine years old after a great-uncle left him $4 million. While he was surely the richest kid in his boarding school class, he would not even be Eugenie's wealthiest employer; the crème de la crème were still to come.

In contrast, Marie, Vivian, and Jeanne Bertrand were mired in the Bronx and by 1930 the light that had shone on the artist was all but extinguished. She had returned to photography, reduced to taking studio pictures for others. Still, there is no arguing, that against all odds, the Hautes-Alpes had produced a pair of photographers worthy of the front page, and its residents perpetually seek connections between the two. Vivian was only four years old when she lived with Jeanne and would not have been directly influenced by her. However, the photographer's legacy was channeled through Marie, who at the time came into possession of a camera, a novelty typically reserved only for the wealthy.

Unlike Eugenie, Marie had been unable to establish an independent life for herself and never resolved her childhood issues. She continued to crave paternal recognition until Nicolas Baille was finally coaxed into admitting paternity. A Saint-Bonnet notary was paid to travel to Baille's farm to obtain his signature certifying that he was Marie's father, a type of decree that proved to be exceptionally rare. Baille signed the document on August 12, 1932, and ten days later Marie and Vivian were on a boat to France.

"It was me," Nicolas Baille, Les Ricous, France, 1932 *(ADHA)*

FRANCE, 1932-1938

Marie had spent limited time with her son during his early childhood, and by moving to France fully abandoned him when he was twelve, solidifying her children's divergent life paths. Carl later reported that his mother left for France in 1927, five years earlier than was true, suggesting they may have seen little of each other during the intervening years. After Marie departed New York in 1932, she never again met with her estranged husband, Charles.

Upon arriving in the Champsaur, mother and daughter moved into Beauregard with Maria Florentine. With the dubious right to carry her father's surname, Marie Maier now became Marie Baille, temporarily disconnecting herself from her daughter's surname.

In Saint-Julien, six-year-old Vivian was released from the turmoil, loneliness, and constraints of her earlier childhood and for the first time was surrounded by a large network of relatives and young people similar in age. Despite speaking mostly English, she became the leader among the village children, who found her authoritative, energetic, and brimming with ideas. Vivian enthusiastically accompanied boys on outdoor adventures, always ready to plop down on the ground in her pretty dresses. There were visits to the Pellegrins in Bénévent-et-Charbillac and the Blanchard relatives in nearby Domaine. Josepha Pellegrin Blanchard was Marie's cousin and seemingly only close friend. Her son Auguste was a few years younger than Vivian, and remembers that his cousin was bold and bossy and insisted on directing the other children in their games.

Auguste recalls Marie as more of a background figure, somewhat possessive of her daughter and never seen without her. Vivian was a bit "wild" and was a handful for her mother. Like most, he doesn't remember many specifics, but concludes Marie was likely an adequate mother since Vivian was enrolled in school and confirmed in the Convent du J'Cours

Cousin Josepha Pellegrin Blanchard, Bénévent, 1959 *(Vivian Maier)*

Marie's Lumière Lumibox camera, Saint-Laurent-de-Cros (*Daniel Arnaud*)

de Marie in the town of Gap. After World War II, Marie briefly remained in touch with Josepha, and sent her clothing and gifts from America, including a collapsible cup from the war, which made the villagers laugh, as they failed to comprehend its purpose. Vivian herself would return to France several decades later and compose Josepha's portrait.

In 1932, excitement spread across the region when the Route Napoléon, which marked the path Napoleon took from the French Riviera to Grenoble on his 1815 return to Paris from exile, was inaugurated as a tourist attraction. Signs and promotional material encouraged travelers to trace his journey along a route that crossed right through the Champsauran capital of Saint-Bonnet. The trail remains popular today.

During the summer of 1933, Vivian's cousin Sylvain Jaussaud was born, prompting Marie to bring out her Lumière Lumibox camera, a model introduced in 1930. As the only person in the valley with a camera, Marie was afforded a sense of prestige. The images are the earliest-known photographs of Vivian, who posed in a handful of pictures with baby Sylvain; his mother, Louise; and Marie. Everyone dressed for the occasion, although in the photos, the women's attire is the reverse of what one would expect: New Yorker Marie wears old-fashioned garb combining a lace blouse with a long linen skirt and straw hat (see page 24), while local Louise poses in a sleek flapperesque suit and high-heeled white shoes. Seven-year-old Vivian appears in a sweet cotton

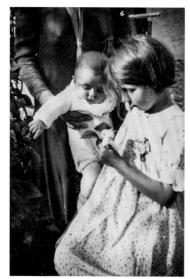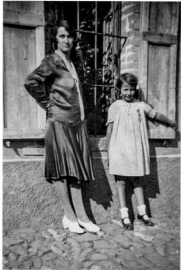

Sylvain, Vivian, and Louise, Saint-Laurent-de-Cros, 1933
(Courtesy of Sylvain and Rosette Jaussaud)

frock, but no one had bothered to comb or even part her hair. Marie left her camera behind with Josepha when she returned to the United States, and many years later, after word of Vivian's fame crossed the Atlantic, Auguste found it stowed in a drawer.

Behind the scenes, life was not as carefree as it seemed. Middle-aged spinster Maria Florentine was engaged in an affair with her Beauregard farmhand Jean Roussel, following in Eugenie's unfortunate footsteps. A recent widower, Roussel had been married to a woman sixteen years his senior who owned property in the village of Poligny. He had experienced difficulty adapting to military service during World War I; on two occasions he was arrested for desertion, and he was twice hospitalized for mental disability. Known as a heavy drinker, he became violent when intoxicated. According to Auguste Blanchard, Roussel once beat Maria Florentine so badly, she spent two months living with his family in order to heal. Despite this, she remained in an on-again, off-again relationship with her paramour for the rest of her life. The norm among the Catholic villagers was to look the other way, and no one ever overtly acknowledged the abuse that went on inside the farmhouse.

In early fall 1933, Eugenie sold her last piece of property so that Marie and Vivian could move out of Beauregard and rent their own apartment in Saint-Bonnet. Curiously, shortly afterward, Maria Florentine drew up a will leaving her entire

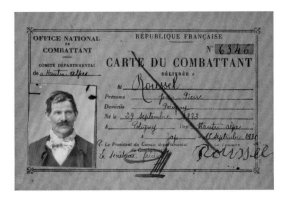

The villain: Jean Pierre Roussel, 1930 military card *(ADHA)*

estate to eight-year-old Vivian rather than to Marie, who would have been the logical successor. The inheritance would later serve a pivotal role in Vivian's foray into photography.

It was the very depths of the Depression but Eugenie was still attractively employed in New York, now by Jack Straus, the co-owner of Macy's whose grandparents had famously gone down on the *Titanic*. With Jews barred from the city's finest residences, his father, Jesse Straus, built the luxurious 720 Park Avenue apartments, reserving a massive duplex penthouse for himself. When he was appointed ambassador to France in 1933, his son Jack became head of the household, which was composed of eight bedrooms, three maids' quarters, sweeping terraces and galleries, plus valet, sewing, and wine rooms. Its cavernous kitchen would be commanded by Eugenie for the next three years. It had been thirty years since she had seen her sister and some have wondered why Eugenie hadn't traveled to France with the others; but not only did she leave the Champsaur under less-than-ideal circumstances and shoulder financial responsibility for the family, it is understandable that she would want to avoid former lovers Nicolas and François. As fate would have it, the Jouglard home was just blocks away from Marie's rental in Saint-Bonnet and François's grandchildren were in school with Vivian. He would die at the end of 1935, but this would not be the end of the family's relationship with the Jouglards.

During this period, Charles Maier divorced Marie and married Berta Ruther, a German immigrant. Berta was raised in a large Catholic family in Lake Constance, Germany. One of nine children, she had tragically lost three brothers during the war. She immigrated to New York alone, and, in 1934, returned to Germany sporting a new name, Berta Maier.

In early 1936, word arrived that Vivian's grandfather William Maier had succumbed to pneumonia at age seventy-six. Carl was at William's deathbed, and subsequently claimed his grandfather had been worked to death because his father, Charles, had "no conscience" and refused to provide financial support. The funeral ledger stated that William had one grandchild, omitting any reference to Vivian. Similarly, the *New York Times* obituary failed to include her, although she was added when it ran again the following day, citing her name as Dorothea Vivian von Maier.

von MAIER—Wilhelm, on Jan. 29, 1936, at Lenox Hill Hospital, dearly beloved husband of Marie von Maier, devoted father of Mrs. Alma C. Corsan and Charles von Maier, and grandfather of Charles von Maier Jr. Funeral private.

von MAIER—Wilhelm, on Jan. 29, 1936, at Lenox Hill Hospital, dearly beloved husband of Marie von Maier, devoted father of Mrs. Alma C. Corsan and Charles von Maier, and grandfather of Charles von Maier Jr. and Dorothea Vivian von Maier. Funeral private.

Take 1: Grandfather Maier's obituary, *NYT*, January 30, 1936, without Vivian

Take 2: Grandfather Maier's obituary, *NYT*, January 31, 1936, with Vivian

THE TROUBLE WITH CARL

News that Carl was in serious trouble reached France in August 1936—not an unexpected turn of events, since he had long been a juvenile delinquent. At age thirteen, he had begun to skip class to hang out on the streets, and in eighth grade, he had been placed in a probationary school because of his "disorderly and disobedient behavior." He managed to graduate, but after running away from home to roam the country on several occasions, he was assigned an attendance escort when he matriculated at the Bronx Vocational High School.

All along, Charles Maier had undermined his own parents' efforts to set Carl straight. Now he encouraged his son to drop out of school and tried to regain custody to take advantage of Carl's breadwinning potential. Inconceivably, Charles went to the authorities and successfully obtained a summons that required Carl to appear in family court on the grounds that the boy had refused to obey his father. With conflicting forces in play, Carl did leave school shortly after his grandfather's death and moved into a local YMCA. He was an aspiring guitarist and hoped to join a band. Just two weeks later, his life began to unravel when he and a buddy were caught tampering with mail and forging a $60 check. With his preexisting history of delinquency, Carl was sentenced to three years in the New York State Vocational Institution, a reformatory in Coxsackie.

Name *Karl Maier* 395

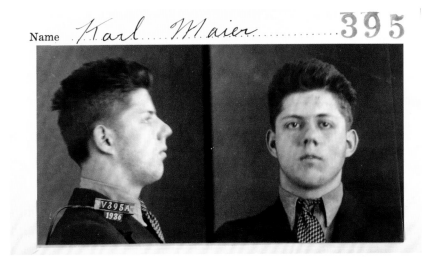

Mug shot: Carl (Karl) Maier, Coxsackie Reformatory, 1936 *(NYSA)*

Imprisoned in April 1936 at age sixteen, Carl's full story is told through an exchange of letters and reports between administrators, his family, and himself during what would be a four-year period of incarceration and parole. These records simultaneously paint a vivid portrait of Vivian's early childhood environment and family dynamics. When first arrested, Carl was able to cite both of his grandmothers' addresses, but was so removed from his parents that he did not know where they lived. The address log in his inmate file reveals that the family was constantly on the move, changing residences almost every year.

As part of the reformatory's admittance procedures, each family member was interviewed, which unmasked the continued disgust the two grandmothers felt for their own children, Carl and Vivian's parents. In Maria Maier's interview, she blamed her son for the family's troubles, citing his refusal to pay support and alleging that he tried to steal the life insurance policy she'd bought to protect her grandson. She considered Charles a "worthless individual" and a "harsh man" who sought to find fault around every corner. Her desire was "to not ever see him again." In Charles's own interview with the officers, he complained that his mother had spoiled Carl, who was "lazy, had no respect for authority, and wouldn't work." Their only point of agreement was that the teenager needed discipline.

During his imprisonment, Carl was permitted to send one letter a month and receive family visits. The first to arrive at the institution's gates was tiny, frail, seventy-six-year-old Maria, accompanied by her wealthy daughter, Alma. They

sent a steady stream of letters and gifts, and Carl typically wrote his monthly letter to them. His father visited that fall, but afterward his contact was erratic. Eugenie regularly wrote to Carl and by 1937 was working at Consuelo Vanderbilt's new mansion in Palm Beach, which was being featured in newspapers across the country. Here, as in other posh residences, Eugenie seemed comfortable, unintimidated, and happy in her surroundings. She sent Carl press photos with notations explaining that a pump was used to fill the pool with seawater and the palm trees that had come from Africa would take fifty years to produce a coconut. She added notations that "is very nice here [sic]," "here very varm [sic] all time," and "I wish you she [sic] beautiful Florida." Eugenie would have almost certainly maintained a similar correspondence with Vivian, which would have furthered her exposure to how the other half lived. Once, in a poignant malapropism, Eugenie sent a letter to Carl at the institution, addressing the envelope to the "Vacation School."

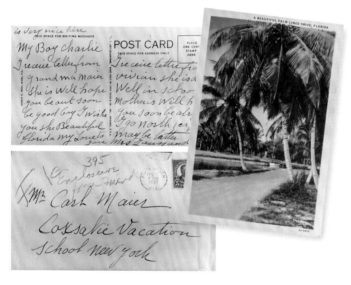

Postcards: Palm Beach to prison block, 1937 *(NYSA)*

The Coxsackie reformatory had opened the year before Carl was arrested and he was among its youngest inmates. Naively assuming he would serve just six months of his sentence, he assured his grandmother Maria he would be home by Christmas. In fact, it would be an entire year before he even qualified for parole and when that time came it was denied because of his poor grades, bad attitude, and propensity to get into fights. Letters to and from friends reveal that Carl was a bit of an operator, planning and manipulating events, but that

he also had a good heart and was often torn between right and wrong. His subversive attempts to secure release were charmingly transparent—a letter signed by his "dad" was obviously written by a teenager. To expedite his discharge, Carl worked all angles by claiming his father had been suddenly hospitalized, in need of surgery, and that his grandmother was on death's door.

When he was finally released to his father in August 1937, Carl violated the terms of his parole by meeting with a former inmate. He was thrown into the notorious Tombs, a municipal prison in Lower Manhattan. He accused his father of framing him and awaited a decision on his fate, while appealing to his grandmothers for his release; but no amount of blame, pleading, or intervention helped. Eventually his family and the administrators came to the joint conclusion that Carl needed more discipline, and six weeks after he'd left the reformatory, he was returned, having scrawled a telegram to his grandmother Maria: "I'm going back." She wrote to Carl with advice: "Take good care of yourself and be obedient, polite, friendly show respect to everybody especially to your superiors." Eugenie encouraged him to take responsibility for his actions: "Don't blame anyone for you now didn't obey Parole Board in your record is not good [sic]." She added, "Vivian prays God every day in your name." In a disparity of epic proportions, while Carl summered in the Tombs, Eugenie resided in a Gatsby-like 1,000-acre estate on Long Island.

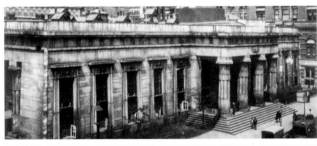

Summer houses, New York, 1896 and 1937

When news of Carl's incarceration reached Marie in France, she atypically sprang into action and insinuated herself into matters. Her documented behavior reveals that something was seriously amiss, beyond the forty-year-old woman's inability to hold a job or raise her son. She wrote a letter to the reformatory to ascertain details of Carl's circumstances and addressed the envelope to the president of the United States. Six months afterward, she traveled to the American consulate in Marseilles to inquire about Carl, and was advised to simply write to the reformatory. She did once, but then hired the Saint-Bonnet notary to write another letter of inquiry, which he composed in French, creating translation burdens for the institution. When administrators at Coxsackie responded, they suggested that Marie correspond directly with her son and offer him encouragement. When she finally did write to Carl, Marie created even more confusion by assuring him that Eugenie's old friends, the Lindenbergers, promised him employment. Eugenie cleared up the misunderstanding with an apology to the reformatory, explaining her family was "wild" and that her daughter "is very nervous person, always full trouble [sic]," language that was typically code for the existence of mental instability or illness.

Carl finally came to his senses and tried to help himself. He wrote to officials, divulging the story of his miserable family, and requested to switch to a unit away from his friends' bad influence. He admitted his prior indiscretions, adding, "Don't judge harshly. When one hears of nothing but money shortage and not enough to eat when a father who makes 40 dollars a week refuses to pay for his own flesh & blood will drive anyone to desperation." He made the legitimate argument that he had made one mistake and was paying for it with three years of his life. His parole was granted in August 1938, with the recommendation that "the inmate would probably have a better chance for a successful adjustment if placed outside the immediate family circle."

```
the members of inmate's family, and they have been unable
offer a feasible plan.

DISPOSITION:  His parole is recommended.  He can be relea
when a satisfactory plan for residence and employment has
worked out.  Committee agrees that inmate would probably
a better chance for a successful adjustment if placed ou
the immediate family circle.

PAROLE RECOMMENDED
```

Paroled with nowhere to go, Coxsackie, 1938 *(NYSA)*

During his upcoming year on parole, Carl was required to be supervised by an adult. Eugenie was unable to fulfill that role, as she was committed to supporting the family and was now uncannily cooking for the infamous Margaret Emerson, who had joined the rest of the Vanderbilts on Long Island's Gold Coast after purchasing a twenty-four-room waterfront "cottage" called Cedar Knoll. Grandmother Maria was feeble and afraid of defying Charles by taking her grandson back in. Carl refused to live with his father and campaigned desperately to a friend's mother to help him, writing, "I don't want to have anything more to do with my people. The more I've listened to them, the more trouble I've gotten into." While he waited, family discussions went round and round with no agreement on where to send Carl.

In Saint-Bonnet Vivian had just finished primary school, and was happily living on the same narrow lane as another young girl named Marie Armande. The inseparable duo had been spending a great deal of time in Vivian's stairwell, which was wallpapered in an exotic Asian pattern, pretending they lived in a castle. As Armande describes it, her friend always had a runny nose and wore old clothes, exactly like all the other children in the village. Vivian would later laugh that in France "we only changed socks once a week and we thanked God for that!" When the family asked Marie to return to New York to supervise her son, World War II was looming, and so she agreed. Sylvain's grandfather Jean was persuaded to lend money for Marie and Vivian's passage, and in August 1938, mother and daughter sailed home on the SS *Normandie*. At twelve years of age, Vivian returned to a city and a brother she barely knew, and a language she no longer remembered.

Hautes-Alpes to Upper East Side, 1951 *(Vivian Maier)*

3

NEW YORK TEENAGER

I was shuffled around a lot.

—Vivian to an employer

Vivian's two childhood environments were opposites: the Champsaur, a far-reaching valley of farmhouses and family; and Manhattan, a concrete jungle jam-packed with tenements and strangers. Eugenie secured a highly coveted apartment on East Sixty-Fourth Street in the First Avenue Estates, a city project designed to supply middle-class workers with decent housing. Carefully planned to fill a city block and maximize natural light, the complex is now a registered historical landmark. Once settled in New York, Marie did little to acclimate her daughter to her new surroundings. Further, by continuing to isolate her from the Maiers, she eliminated an opportunity for Vivian to secure love and support from her paternal grandmother and wealthy aunt Alma. There are no signs that she was enrolled in school or encouraged to make friends, establishing Vivian's lifelong tendency to seek companionship with elderly women. She would later characterize her return to America as the end of her childhood, suggesting that at age twelve, she was treated as an adult and left to her own devices.

MOMMY DEAREST

In New York, Marie again caused turmoil by writing to the Department of Corrections in Albany asking if Carl would ever be eligible for parole even though she was well aware that his release was imminent. The institution's internal communications indicate that even they were becoming increasingly annoyed with Marie. In advance of her son's discharge, parole officer Joseph Pinto paid a visit to the Sixty-Fourth Street apartment. After the meeting,

Empress of maladies: Marie Jaussaud to Carl, New York, 1938 *(NYSA)*

Marie wrote to Carl, who was then still an inmate, complaining that after the offi-cer's visit she "took violently sick" and "vomited all over." She prophesied her "end would surely come soon." (She lived for almost forty more years.) This was just the beginning of Marie's long list of grievances and illnesses. Letters and reports from the year she watched over Carl feature an irresponsible, self-centered hypochondriac. She called herself Marie Baille, and prepared fancy stationery with her new initials as if to reaffirm her legitimacy. Her fountain pen spewed accusations and criticism, alternately griping about reformatory administrators and her son.

Carl moved into the Manhattan housing complex when jobs were in short sup-ply. The apartment had two small bedrooms and a kitchen, which meant that

Vivian had to sleep with her mother. Eugenie purchased her grandson a guitar and accompanying lessons, and after diligent practice, he secured gigs at local bars. Like Vivian, Carl enjoyed reading, and as an inmate had pointedly begun to plow through Hervey Allen's lengthy novel *Anthony Adverse*, the odyssey of a boy who was left in a convent after losing his mother, destined to live a life of adversity. Now Carl spent most of his free time with his paternal grandmother and fellow musicians. Records reveal a tense atmosphere; Marie rudely missed virtually every scheduled meeting with the parole officer due to obviously fabricated ailments, and Carl quickly came to believe his mother was "crazy." He told Officer Pinto that she was lazy, echoing his father's complaints, and said he was treated as "a boarder not a family member."

By the end of 1938, Marie's rationality began to dissolve. She complained about Carl to Officer Pinto while simultaneously defending him in a letter to the administrators at the Coxsackie reformatory, claiming he had been brutalized and beaten bloody by prison guards. Her primary concern seemed to be his future ability to make money. She threatened that "if Carl is unable to earn his own living through mental deficiency" after the alleged beatings, she would hold the institution responsible. Pinto informed the chief of parole and reformatory superintendent of Marie's behavior and made the unusual suggestion that Carl be allowed to live at the YMCA. Remarkably, no supervision was deemed a better solution than supervision by Marie. They requested that Carl give his mother one more chance, so he put a lock on his door (a tactic his sister would religiously adopt) and returned to fraternizing with unsavory characters. Officer Pinto, who was born in Italy, soon received a letter from Marie criticizing Carl because he "is always going up to these Italians who I do not think help him in anything."

By the spring of 1939, Marie was exhibiting signs of serious mental illness. In a paranoid missive to the officer, she inexplicably claimed that her ex-husband had new children (he didn't; his new wife was forty-six) and that everyone had "plotted against me." She was "terribly rundown" and had "heart beats," and her "health won't stand for it." She wanted her son out, insisting that he was better suited to live with the likes of his father. A meeting was set up to discuss matters, but Marie failed to show up. This was the state of affairs when the supervision term expired a month later in April 1939 and Carl was finally set free.

It took years for modern-day researchers to grasp that Marie's entry in the 1940 census was a colossal fabrication. It depicted the original family of four reunited and living on Sixty-Fourth Street. Carl was listed as younger than his sister, a layer of deceit that would greatly impede the ability of the administrators

```
        Received this date the following communication from
the parolee's mother:-
            "I have been wanting to see you for a long time to tell
you that Charles or Carl as you call him is making us dis-
turbances in the house all the time.  I had complaints from
the office to move in account of him.  I have heard that
his father has other children and that my son sees him and
they have all this plotted against me - no one else would
put him up to things like that but his father.  You sould
see to have him changed, with me it will never do  this day.
I became terribly rundown he aggravated me to the limit.
```

Paranoid complaint: Marie's letter to parole officer, New York, 1939 *(NYSA)*

of Vivian's estate to trace his birth date and whereabouts. In truth, the members of this nuclear family had never resided together, and at the time of the census, Vivian and Marie lived alone in the Sixty-Fourth Street apartment. Carl had moved out, swearing never to return, and Charles was long remarried and situated in Queens. On the form, Marie indicated that she had completed one year of high school and was not looking for work. Curiously, she depicted Vivian as currently in the first grade and having no prior education.

Fictional family, 1940 Census *(USNA)*

In all the documentation from the 1930s, there is no mention of Vivian, except by her grandmother Eugenie. The impression is that the other family members treated her as if she were wallpaper, including her mother. She wasn't referenced in their letters, was left off her grandfather William's death record, and was not entered as a stepdaughter in Berta Maier's Alien Enemy Record alongside step-son Carl. Perhaps Vivian was the one delegated to do the cooking, cleaning, and laundry, given her mother's aversion to housework. How did Carl treat his sister, and what would she have thought of him? It would be natural for a teenage girl to take an interest in an older sibling, but if she did, there was no sign of reciprocation. When he was first arrested, Carl pretended to not even know his sister's name. It seems almost impossible that Vivian could live among the others and never be noted. It would take just a few more years for her mother to abandon her for good.

The collective records from these years not only chronicle events, but also provide a rare window into the personalities, interplay, and foibles of an entire family. Marie stands out as disturbed and mentally unstable, even among a group of troubled individuals. She was an indisputably self-absorbed and unfit mother who would ultimately abandon both of her children, but her actions and letters reveal a deeper pathology. Dr. Donna Mahoney, an expert on the diagnosis and treatment of personality disorders and the effects of parental mental illness on children, examined the Jaussaud and Maier family records for clues to Marie's condition. She is of the opinion that Marie may have suffered from identity issues associated with childhood abandonment and rejection, a situation that was complicated by a genetic predisposition toward mental illness. (Familial mental illness is definitive: Carl Maier's later medical records reveal a diagnosis of schizophrenia, a biologically based disorder.) Mahoney believes that these factors may have combined to form the underpinnings of a personality disorder.

It is of course impossible to know the specifics or extent of Marie's affliction, but Mahoney observes that her actions are most strongly correlated with assignations of narcissistic personality disorder (NPD): self-absorption, attention-seeking, entitlement, lack of empathy, arrogance, and exploitation. This is a serious condition spurred by such a diminished sense of self that narcissistic behaviors develop as a form of protection. In her lectures on the subject, Mahoney explains that "hypochondria is common among narcissists, who employ external means of attention-getting related to physical health to seek internal validation." The crucial implication of Marie's demonstrated behavior, regardless of diagnosis, is that her children were bound to suffer significant emotional consequences.

THE FINAL DISSOLUTION

Left to herself in New York, the intelligent, inquisitive, and resourceful Vivian embarked on a program of self-education. To relearn English, she frequented movies and devoured newspapers, magazines, and books across a broad range of subjects, becoming as cultured and knowledgeable as those with more formal schooling. French governess Emilie Haugmard, a friend of Eugenie's, moved into the Sixty-Fourth Street building when Vivian was fourteen years old, and appeared to have a role in looking after her. Tellingly, Eugenie would name Haugmard, not mother Marie, as Vivian's contact in her will. Years later, during the summer of 1953, Vivian and Haugmard took the ferry to Staten Island and

shot a series of lively pictures on the beach. If there was ever a study in contrast, the pair were perfect models: Vivian tall, lean, and angular; the caretaker squat, soft, and rotund. Counter to the vast majority of her self-portraits, Vivian makes no attempt to hide her body around her trusted friend.

On January 18, 1943, Maria Florentine died at the Blanchard home in Saint-Bonnet. If Marie hadn't previously known she was excluded from her aunt's will, she was about to find out. This is when the last vestiges of Vivian's family life evaporated. That year Marie moved to a furnished room on West 102nd Street, and applied for a Social Security number so she could work at the Hotel Dorset. For the first time in her life, the forty-six-year-old woman entered her parents' correct names and her accurate birth date on a document. No longer illegitimate, her real identity could be exposed. Vivian moved in with Eugenie's longtime friend Berthe Lindenberger, who owned a home in Queens and was recently widowed. The pair appeared to live together for the next eight years.

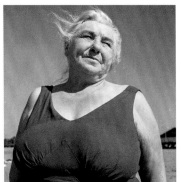 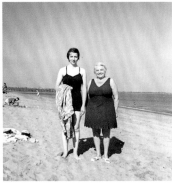

Emilie Haugmard and Vivian, Staten Island, 1953 *(Vivian Maier)*

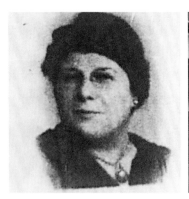

Berthe Lindenberger, 1944 *(USCIS)*; Queens home, 1954 *(Vivian Maier)*

Berthe purchased an insurance policy for her young companion and opened a joint savings account with $1,200. Vivian rented a Queens post office box, which she would use until moving away from New York. At age seventeen, she was old enough to work and secured a position at the Madame Alexander doll factory on East Twenty-Fourth Street in Manhattan. The toy company's owner, Beatrice Alexander Behrman, was born into a family of poor Jewish immigrants. Determined to further her station in life, she became valedictorian of her high school class and went on to create one of the largest doll businesses in the world. The establishment was admired for its product quality and innovations and was the first to license characters like Alice in Wonderland and Eloise for re-creation in doll form. Behrman was a strong taskmaster, but she was also said to have been fair and philanthropic, helping other women follow in her footsteps.

Madame Alexander, as Behrman was known, styled herself and the company with a French sensibility, and it had a lasting impact on Vivian. At the factory, Vivian learned to sew and smock and was exposed to style trends from around the world that were implemented for the top-flight dolls. Her boss had previously worked in millinery, and the dolls' hats were as important and detailed as their dresses. For much of her life, Vivian sewed her own clothes or hired expert tailors, and demonstrated a passion for fine fabrics and hats. Later, in her address book, fabric stores were the most prevalent type of listing.

Doll factory, 1948
(Courtesy of the Madame Alexander Doll Company)

Wendy Ann doll
(Bruce A. deArmond)

Inspired by Eugenie, Madame Alexander, and possibly Marie, Vivian was a stickler for quality, often associating herself with prestige brands and opining loudly on shoddy workmanship. Her early pictures would reveal a fixation with dolls. While the experience at the toy company clearly influenced Vivian in a positive way, she was wired to keep moving, and it isn't surprising that she ultimately found a factory setting confining.

On his own, Carl supported himself by playing in live bands and performing on the radio. Marijuana was prevalent on the music scene, and he quickly developed a dependency, later describing how drugs made him feel "wonderful" and able to "analyze each instrument in an orchestra." Finally, unemployed and in a downward spiral, Carl attempted to join the army in 1941 to straighten himself out, only to be rejected because of the criminal record from his youth. From there, he supplemented his thirty-joint-a-day habit with morphine injections, and by the time he was officially drafted in 1942, the twenty-two-year-old was using a cocktail of eight different drugs. For unknown reasons, his teenage record went unnoticed and he made it through the enlistment process, passing the physical in extremely good health, his excellent posture and flat feet noted. First posted to Camp Upton in Yaphank, New York, he failed to make the army band and was sent to Langley Field in Virginia. It was here that the life of Private Karl W. Maier, 416 Ordnance Company, Aviation (Bomb), went off the rails.

His superiors noticed that Carl was quiet and moody, but never suspected he had a large cache of hidden drugs, replenished during furloughs. To get high, he would simply walk away as if to smoke a cigarette. After his supply was drained, he tried to use another soldier's pass to leave base. Desperate and exhibiting signs of withdrawal, he was quickly caught and the entire story poured out. While he was receiving detox treatment in the station hospital, a friend sent him a letter containing a joint, and the dispatch was intercepted by the authorities. A formal proceeding to consider discharge was scheduled.

At the hearing, the captain of the Medical Corps was asked if the military could make use of Private Maier. The response was negative: "It is not just the drug alone that has to be contended with, but also the break-down in the moral character of the individual as well." Given the chance to explain himself, Carl was polite and articulate, but defenseless. Asked if he could work or fight, he said he could not. Asked if he cared who won the war, he replied, "I have no control over myself, sir." Asked if the enemy "promised you dope, would you go over on their side?" he candidly admitted that he couldn't answer the question.

Discharge Hearing: Captain of Medical Corps

Question: At the present time, can use be made of the services of
Private Maier?

Answer: I do not believe so because I believe from his history that
as soon as he is out, he will return to the drug habit and the
great probability is that he will land back in the hospital in a
week or two.

Question: Is it true that if he does not have drugs, he is absolutely
useless? Can he be given useful jobs to do?

Answer: I do not believe he can. Without drugs he is restless and
uneasy and naturally such a person as he could not be given
useful tasks. A cure for such a man is doubtful for he will
continue to get drugs when he is out.

Question: You say a cure is doubtful. Why?

Answer: Experience with drug cases shows that it is not just the
drug alone that has to be contended with, but also the
break-down in the moral character of the individual as well.

Discharge Hearing: Carl Maier

Question: If we gave you a gun, could you fight?

Answer: No, sir.

Question: If we gave you a pick and ax, could you work?

Answer: No, sir.

Question: Does it make any difference to you who wins this war?

Answer: I have no control over myself, sir.

Question: Can you answer that question?

Answer: I have no control over myself, sir.

Question: If the Japs came and promised you dope, would you go over
on their side?

Answer: I can't answer that.

Military discharge hearing transcription, Langley Field, Virginia, 1942 *(NPRC)*

Carl was dishonorably discharged in August 1942 and barred from receiving any future veteran benefits, a punishment that would ultimately have serious consequences. The drug-addicted twenty-two-year-old returned to Manhattan and moved into a small Thirty-Fourth Street apartment rented by Eugenie. He would never work again, numbed by drugs and his poor life prospects. Vivian and Carl likely had contact during this period, due to their proximity and a shared love for their grandmother Eugenie. A decade later, Carl would be officially diagnosed with schizophrenia; use of psychotropic drugs is known to trigger its onset.

Carl Maier Dishonorable Discharge

It is hereby certified by the undersigned that on the evidence of record the veteran's discharge from service was under dishonorable conditions within the meaning and intendment of Sections 300 and 1503, Public 346, 78th Congress and that the veteran is, therefore, barred from all benefits based upon the period of service set forth in the accompanying memorandum which outlines the basis for said determination.

Dishonorable discharge, Langley Field, Virginia, 1942 *(NPRC)*

The years following World War II marked a period of hardship and loss for the family. In 1947, Carl's grandmother Maria Maier, his lifelong advocate, died at age eighty-seven. Alma placed her mother's ashes in a double niche at Ferncliff Cemetery and Mausoleum in Hartsdale, New York, but her husband William's urn was elsewhere, lost or perhaps taken by Charles. Eugenie had moved back to Manhattan during the war when her Bedford employers pared back their staff, and she secured a final position at 960 Park Avenue. In May 1948, she signed a will naming Carl as executor. In August, Marie once again placed classified ads to secure work. That same month, Berthe Lindenberger filed for her first Social Security number at age fifty-eight, indicating she planned to work at the Upper East Side town house of General David Sarnoff, a pioneer of radio and television and the founder of RCA and NBC. Inexplicably, her application was falsified with an incorrect birthplace, maiden name, and age, claiming she was twenty years younger than she actually was.

All the activity was to prepare for the biggest blow of all—the loss of beloved Eugenie Jaussaud in October, who passed away from heart failure at her employer's residence at age sixty-seven. Her funeral mass was held at Saint Jean de Baptiste but was conducted by a priest from Saint Ignatius Loyola, a church just one

Grandmother Marie von Maier's niche, Grandmother Eugenie Jaussaud's grave,
Hartsdale, New York *(Ann Marks)* Hawthorne, New York, 1956 *(Vivian Maier)*

block away from where she had died. Her employer may have had a relationship with this priest, or due to proximity he may have been called to give Eugenie last rites. She reposed at Frank E. Campbell's funeral home and was laid to rest in a plot purchased by Marie in the sweeping Gate of Heaven Cemetery in Hawthorne, New York.

Eugenie's last will and testament revealed that Marie was living on her own in the same Upper West Side boarding house where Lillian Duke, who had married into a wealthy tobacco family, famously died in poverty. Eugenie's estate was worth upward of $10,000, with the assets to be split equally among Marie, Carl, and Vivian. It was stipulated that the grandchildren receive payment outright, but that Marie receive an annuity, officially acknowledging her irresponsible nature. As noted earlier, Vivian's contact was listed as Emilie Haugmard instead of her mother. Required to ratify the will as executor, Carl Maier did so by oddly signing "William Jaussaud, a/k/a Charles Maier." It would be a prelude to upcoming events.

Name of Legatee or Devisee.	Post Office Address.	Value of Legacy or Devise.
MARIE JAUSSAUD MAIER	125 West 88th Street New York, N.Y.	A life annuity in the value of 1/3 of the residuary estate.
WILLIAM JAUSSAUD a/k/a CHARLES MAIER	316 East 34th Street New York, N.Y.	1/3 of residuary estate.
VIVIAN MAIER	c/o Miss Emilie Haugmard 419 East 64th Street New York, N.Y.	1/3 of residuary estate

Eugenie Jaussaud's will, 1948 *(NYCA)*

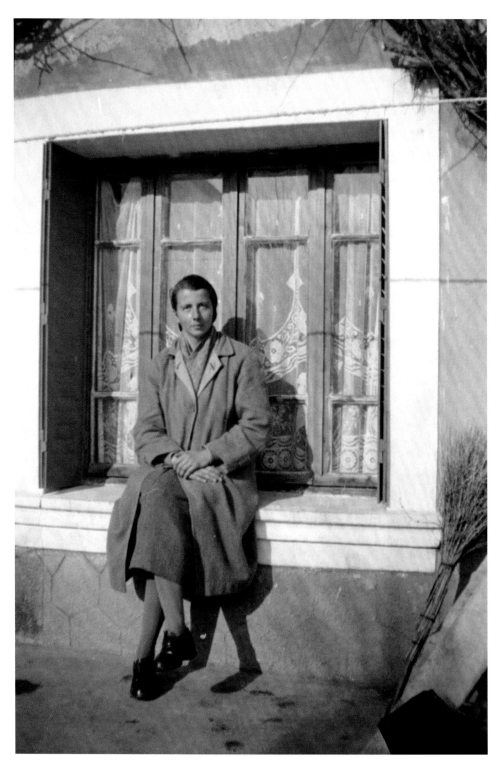

Vivian Maier, Hautes-Alpes, 1951

4

FIRST PHOTOGRAPHS: FRANCE

I often look at my masterpieces of the Champsaur.

—Vivian, writing to mentor Amédée Simon

After the death of Eugenie, twenty-four-year-old Vivian decided it was time to claim her French inheritance. In April 1950, she booked a berth and sailed to France to sell Beauregard. Shortly after her arrival in the Champsaur, she began to take pictures with a simple box camera, embarking on a forty-year career in photography. When she had lived in the valley as a child, her mother garnered status as the only camera owner. Whether this or something else sparked Vivian's initial interest, she began to shoot obsessively. As Susan Sontag once observed, "People robbed of their past seem to make the most fervent picture takers."

From the start, Vivian worked diligently to learn her craft and developed a respectful friendship with Amédée Simon, who owned the photo shop in town. He taught her to develop film and make prints from her 2¼ × 3¼ negatives, and performed some of the processing himself. The first adult portraits of Vivian, made during the chill of early spring, show that her dress and demeanor conform to the conservative local aesthetic. She wears wool coats, Mary Jane shoes, high-buttoned blouses, below-the-knee skirts, and rolled-down hose. With her tightly pulled-back hair, she gives the impression of a prim schoolgirl. Summer brings a switch to short sleeves, shift dresses, loafers, and the occasional release of her long, wavy hair.

Vivian's outsize energy and curiosity are immediately apparent. During her year abroad, she visited virtually every village in the Champsaur and also traveled to Spain, Italy, and French cities farther afield. She seemed to be in a different location each day and even made her way to medieval Saorge, the

native French town of Victorine Benneti, who had filled in for Eugenie at her baptism, and to Neuchâtel, Switzerland, hometown of Berthe Lindenberger. Traveling alone with her camera, Vivian walked, rode bicycles and buses, and boarded the occasional train and plane. In between her excursions, she always returned to her home base of Saint-Bonnet. With her earliest photos, taken with her box camera, Vivian began to develop themes that she would explore for the remainder of her life.

PANORAMAS

The blooming photographer turned her lens to the angled peaks, deep valleys, and meandering streams of the rugged countryside, tenaciously experimenting with natural light, shadow, and reflection. She shot the same scenes repeatedly to document changes from the movement of the sun and the seasons. In the biting alpine winter, Vivian trekked into the mountains to catch snowflakes gently blanketing slopes and thick icicles forming in jagged tunnels of trees. She used focus and perspective to vary foregrounds and backgrounds, altering the visual emphasis of her images.

Her early French photographs may have been the ones Vivian cherished the most. They represent half the images she ever printed, and she held on to them for the rest of her life. In Chicago, she framed enlargements of her favorite versions, and for many years they were the only portfolio pictures that she displayed in her room.

MILESTONES

While Vivian would go on to experiment with a broad array of genres and subjects, her photographic choices were often grounded in her own experiences. It is apparent from her pictures and notes that she felt it important to commemorate life's milestones and rituals. Her mother clearly cared about her own celebrations—she scheduled her wedding on her May 11 birthday, and then later had her son baptized on that same date. Throughout her adult life, Vivian would dutifully record the important events and accomplishments of those she met, from children she cared for to strangers she randomly interviewed on the street. She approached such occasions as a photojournalist, matter-of-factly covering happenings from beginning to end.

Hautes-Alpes perspectives, 1950–51 *(Vivian Maier)*

In the heavily Catholic Hautes-Alpes, all occasions were dominated by religion. While Vivian later labeled herself an atheist, the influence of Catholicism was abundantly reflected throughout her portfolio, with photographs of churches, ceremonies, clergy, and cemeteries. Death-related activities were of particular interest to her. She followed funeral processions, capturing the reactions of mourners as much as their rituals, and approached grave preparation with shovel-to-shovel coverage. The newly widowed who made regular appearances in her portfolio demonstrate her willingness to invade their space to capture expressions of raw grief. When she traveled, she invariably visited cemeteries at every stop.

Vivian enjoyed carte blanche to participate in community proceedings, which afforded her the opportunity to create a large and varied portfolio. The

Milestones, France, 1950–51 *(Vivian Maier)*

shot of a baptism is so visceral that it is easy to imagine the echo of the infant's wails bouncing off the surrounding stone walls. A picture of two girls in white confirmation dresses is complemented by a backdrop of snowy mountain peaks and a vehicle ready to whisk the young pair on to the rest of their lives. The weight and solemnity of the funeral of a child not yet three is chronicled by a procession of bowed-head villagers trudging uphill to the cemetery where he would soon be laid to rest.

PORTRAITS OF THE WORKING CLASS

The Champsaur was rich in portrait material, as if every colorful character in France had convened in this single valley. Here, Vivian was able to enjoy a comfortable venue for developing an up-close shooting style—everyone was "family," after all, honorary or real. She primarily focused on photographs of individuals that evoked an authenticity and feeling of being rooted in place. She posed her subjects in their typical clothing and environments, often with a personalized accessory. In a region where sheep outnumbered people and every household had a pig and a goat, her pictures frequently included animals as legitimate family members.

The large Jaussaud clan was a regular source for subjects, with patriarch Jean shot from below to fully capture his erect posture, calm confidence, and family status. In scenes typical of the region, Vivian captures young shepherds proudly showing off their wards. In one scene a trio of kids sweetly nuzzle, and in another, a singular goat raises his ears to perfectly complete the distant horizon. One day she encounters a caped creature who presents more as wizard than workman, his silhouette all angles, his peaked hood mimicking the craggy landscape behind him. Prior to Vivian's arrival, no one had taken pictures of the area's working class except on special occasions—and the majority of her subjects had never seen everyday pictures of themselves.

It is clear from her early negatives and prints that Vivian possessed a great deal of confidence. She typically covered her subjects with just one shot, an approach that would become a trademark. She would go on to create many more pictures reflecting the day-to-day lives of the lower and middle classes. The subtext of her alpine portraits—pride of place, belief in hard work, and affection for the innocent—are universal values that translate across subjects and geographies and contribute to a portfolio that feels relevant even today.

Working-class portraits, 1950–51 *(Vivian Maier)*

CHILDREN

Vivian is believed to have had minimal caretaking experience prior to this trip, but her pictures reveal an immediate and deep connection with children of all backgrounds and ages. She took pleasure in photographing them just as they were, keeping all their charm and spontaneity intact. A captivating image of four French youngsters displays their mismatched clothing, miniature berets, and liquid emotions. Unlike most photographers of the time, Vivian would just as soon take pictures of them angry or sobbing than posed with uniform smiles.

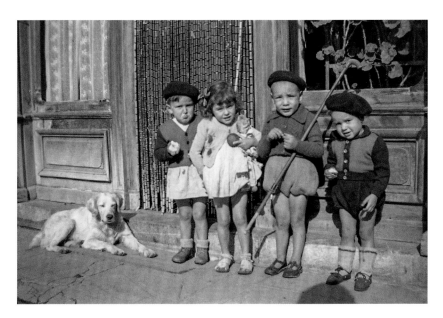

Children of the Champsaur, 1950 *(Vivian Maier)*

In France, Vivian paid some attention to subject matter she would fully explore in her later work. She was an early advocate of equality for all, regardless of gender, race, or class, and pictures of a communist rally, impoverished and destitute people, and interracial families foreshadow a deep devotion to social causes. Likewise, coverage of a movie shoot in Nice presages a keen interest in film, celebrity, and paparazzi-like photography.

Vivian's near obsession with self-portraiture began in Saint-Bonnet, where she lent her camera to others while almost certainly directing them on how to take

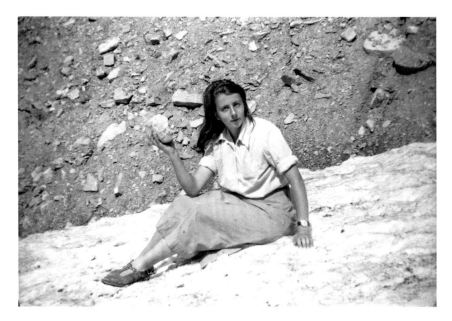

Vivian Maier, Hautes-Alpes, 1950

her picture. Indeed, a lovely, self-possessed woman emerges. One mermaid-like pose on an icy beach, her tresses freed from their bobby-pin bondage, features her beauty and youth. This type of relaxed presentation would all but disappear over the years, giving way to images of the "uptight" or "quirky" nanny that so many of the families for whom she worked described. Before she left France in 1951, she chopped off her hair and brought out her tailored suits to firmly establish herself as a serious and independent woman.

FRIENDS AND FAMILY

Shortly after she arrived in France in April 1950, Vivian took and labeled her first photograph. Its subject is a rotund widow wrapped in a white apron posing in the aftermath of a surprise springtime snowstorm that blanketed the Alps. While this image has the feel of a snapshot, the woman would regularly appear in formal portraits that Vivian made during her year in France. Logically, as her first and frequent subject, this woman must have been important to Vivian, which makes sense, because she turns out to be Prexede, the widow of François Jouglard.

It is impossible to trace how Vivian came to know her or if either was aware of Eugenie and François's secret. However it happened, Prexede improbably

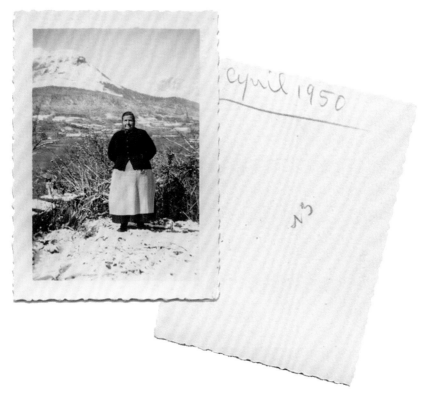

First photograph, Prexede, April 1950 *(Vivian Maier)*

was Vivian's very first muse. She frequently posed with her sister, Maria Pascal, also a widow, and the old-fashioned pair in head-to-toe black made for eye-catching, even dramatic, subject matter.

In a poignant farm tableau, the sisters pose with laborers, spread out to emphasize the incline of the land and their isolation within the Alps. At the Shrine in La Salette-Fallavaux, where an apparition of the Virgin Mary was once said to appear, Prexede is photographed off-center, shadowed and diminished by the ramrod-straight statue that points up the mountain toward heaven. Hands on her hips, locking eyes with the camera, tiny Prexede looks as formidable as she does in a close-up portrait that Vivian made into a postcard. Here, unflappably clutching her walking stick with a visible wedding ring, she appears as the grieving widow that she may or may not have been. By the end of her time in France, Vivian was living with Prexede.

During the summer of 1950, Vivian made her way to the outskirts of Les Ricous to spend time with a girlfriend named Nellie, who lived next to her

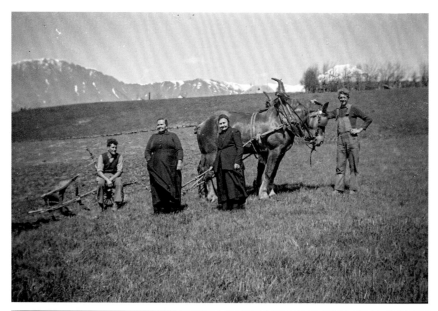

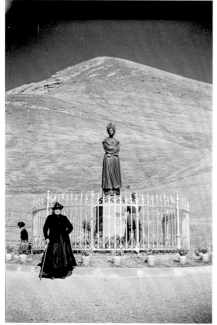
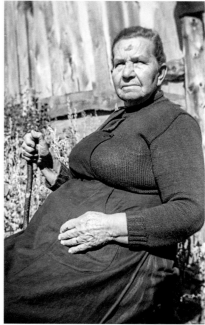

Widows of Champsaur, 1950–51 *(Vivian Maier)*

Grandfather Baille and Vivian, Les Ricous, 1950

grandfather Nicolas Baille, the man who had abandoned her grandmother and mother half a century before. She had first met him while living in the valley as a child, and now she stopped by his farm for a visit. In an out-of-focus picture of the pair leaning on a fence, their awkward body language and nervous expressions reflect the discomfort they must have felt with one another. She was yet twenty-five, but this is the last known picture of Vivian Maier with an immediate family member.

The nascent photographer spent a great deal of time with Amédée Simon and captured him at his shop in the center of Saint-Bonnet, which he and his descendants would continue to run for seventy more years. With her rudimentary darkroom skills, she relied heavily on her mentor for quality workmanship. They discussed Vivian's plan to develop a postcard business once she returned to New York, and Simon made samples for her to carry home.

Altogether, the thousands of early images—including underexposures, blurry prints, and the trial and error seen in repetitive series—confirm how intensely Vivian worked to master the basics of photography during her time in the Champsaur. The aggregate number of exposures from the visit is staggering, almost as if she'd spent a decade instead of a year in the valley. The familiar villages provided a crucial opportunity for her to practice before turning her

Amédée Simon and his photo shop, Saint-Bonnet, 1951 *(Vivian Maier)*

lens toward the rest of the world. It was here that Vivian demonstrated the beginnings of a dispassionate photographic style that sought to capture the reality of the human condition with an absolute absence of judgment.

Before leaving her adopted homeland, Vivian successfully completed the complex sale of Beauregard. The thirty-five-acre property, along with its farmhouse and outbuildings, was auctioned off in thirteen lots. Her combined inheritance from her grandmother and great aunt equaled about $70,000 in today's dollars. While not enough to last a lifetime, it was more than enough to get her started. After the sale was consummated, the Escallier family, who had rented the property for years, claimed they had a lease and refused to vacate the premises for the new owners. Vivian left France without resolving the matter; the dispute was litigated in her absence, and the new owners prevailed.

Vivian returned to New York in the spring of 1951, taking pictures throughout her homeward journey. Street photographer Vivian Cherry was aboard at the same time, and it is easy to imagine the two Vivians strolling the decks and clicking away. Just as she had with more familiar subjects in the Alps, Vivian covered her fellow passengers at point-blank range, sometimes

breaching their personal space. She had already become an aggressive and fearless practitioner.

With her nest egg, Vivian was returning to the United States with the freedom to start anew. Until then, she had led a strikingly bifurcated life: urban and rural, important and invisible, deeply loved and tragically abandoned. She mingled among the rich but was raised by the poor. She belonged everywhere and nowhere. Now, she was on her own.

Homeward bound, 1951 *(Vivian Maier)*

Third Avenue, New York, 1953 *(Vivian Maier)*

5

FIRST PHOTOGRAPHS: NEW YORK

New York is Europe, Asia, America. It's everything.

—Vivian, to a neighbor

Vivian eagerly returned to New York to begin to photograph what would remain her favorite place on earth. While she held deep affection for the Hautes-Alpes, she found French life too structured. Her plan was to support herself through caregiving, a profession that offered the opportunity to spend time with children and the flexibility to develop her photographic skills. Before securing a full-time position, she had time to capture her native city with a studied intensity.

With her original box camera, Vivian swapped mountain peaks for rooftops and rural landscapes for urban panoramas. She shot from above and below, in shadow and light, building on her earlier experiments. As she traversed the city, repeating elements particularly caught Vivian's eye: the cantilevers holding up bridges, the grids supporting elevated trains, and the uniform windows that climbed up skyscrapers. She found beauty in both the pristine and the twisted, and focused on items ignored by most. There were shots of overflowing garbage receptacles as well as cascading flower boxes. Gleaming postwar towers were shown rising to the sky, while shabby tenements imploded in a tangle of debris. Symmetry, pattern, and texture became fundamental to Vivian's work, and were elements that she would emphasize throughout her career.

Her first position as a governess was in old money Long Island, where her grandmother Eugenie had worked long before. Vivian spent August 1951 in Southampton, with its shingled mansions, high-trimmed hedges, and restricted

Southampton summer, New York, 1951 *(Vivian Maier)*

beach clubs. Her images from those long summer days feature the Walker children, descendants of society banker Grenville Kane. They pose on crisp lawns with fresh-cut flowers from the property's garden, while sunning on their private beach, and joining other members at the elite Southampton beach club. A half century later, Laura Walker perused these childhood pictures and noted that she had never before seen photographs of the exclusive club that included family household help. She also commented that in the 1950s, no one took everyday shots of children.

Vivian's Southampton pictures are notable for illustrating the stunning contrast between the haves and have-nots. Propelled by her keen interest in Native Americans, one day she chose to forgo the beach to cross over the tracks and meet members of the indigenous Shinnecock population who had long resided in town. She enthusiastically photographed them in pairs and clusters. Their sparse, tattered garb is markedly different from the Walkers' fastidious frocks and bows, but the Shinnecock children are just as charming.

Many have observed that Vivian possessed an underdog's perspective, and regardless of her circumstances, she identified primarily with the working class. While the beginnings of such an affiliation is apparent in her French photographs, this point of view would permeate her New York work. Possessing a progressive perspective, she was drawn toward capturing the intersections of race and class.

One day, fifty-five-year-old Marie Jaussaud visited Vivian's seaside workplace, most likely looking for a share of her daughter's inheritance. Vivian took three portraits of her mother on the beach. Prints of one image, featuring Marie facing forward in a cap, were found both among Vivian's possessions and at her cousin Sylvain Jaussaud's residence in France. These are the only pictures of Marie discovered in Vivian's entire archive. There is no record of mother and daughter ever meeting again.

Mother, Southampton, 1951 *(Vivian Maier)*

While babysitting for the Southampton set, Vivian made connections for future employment, networking just as Eugenie had done. In November 1951, she traveled to Cuba, accompanying a family associated with the Fanjul and Rionda sugar dynasties. She must have been thrilled to make the trip, traveling to a place steeped in history on her employer's dime and with the opportunity to tour as an insider. The journey included stops at beaches, sugar refineries, and "bateyes," the communities set up for workers. Unused to photographing on the fly, Vivian mostly made exposures from a distance or in conditions of poor light. She posed families in front of their bungalows and children at school. Among the most engaging subjects from the excursion to Cuba were Carlos Fanjul's playful rabbits.

Three wise rabbits, Cuba, 1951 *(Vivian Maier)*

A stint at the John Akin estate in Oyster Bay followed, where Vivian cared for sweet little Gwen, who grew up to be a photographer herself. Here she practiced techniques for shooting children that she would call on frequently in the future. She distracted the toddler with games, posed her in cardboard boxes, and stooped down to her level to chat and snap. On January 24, 1952, Vivian left their snowy lane to take in the Museum of Modern Art's celebrated *Five French Photographers* exhibit. Here she scored the first of her celebrity conquests,

Cuban worker, Cuba, 1951 *(Vivian Maier)* Salvador Dalí, NY, 1952 *(Vivian Maier)*

shooting Salvador Dalí from below, just as she had a Cuban worker two months earlier, a technique that heightened each man's presence. They face the camera appropriately outfitted for their disparate milieus, Dalí adding a bit of flourish via his trademark mustache. Vintage prints show that Vivian prepared a version that was cropped to cut off Dalí at the waist, but the resulting image lost much of its impact.

As Vivian's employment opportunities moved to Manhattan, New York's public parks became her picture-taking venues of choice, offering her interesting subject matter while watching the children in her care. Central Park served as a microcosm of the city where she could shoot the young and the old, the rich and the poor, the fashionable and the fringe. Attracted to difference and diversity, everyone mattered to Vivian. Her lens caught distinguished men in top hats and fedoras as they strolled briskly to appointments, as well as the downtrodden they passed on their way. Sleeping on park benches and in doorways, the destitute were dirty, ragged, and strung out, mostly oblivious to Vivian's voyeurism. She didn't hesitate to photograph them in such vulnerable states, ignoring their privacy in favor of her own artistry. Vivian made

The ins and outs, New York, 1951–52 *(Vivian Maier)*

prints of the dichotomous men with somewhat crooked results, reflective of her learning curve.

Vivian frequently returned to the Upper East Side she had known as a teenager, and lived in the apartments on Sixty-Fourth Street between nanny stints. Emilie Haugmard still resided in the building, although after a handful of early pictures, she failed to reappear in the archive. For Vivian, this was home, a sentiment reflected by hundreds of exposures of the compound's buildings, courtyards, and residents. She even photographed the exact apartment in which she had lived, inside and out.

Sixty-Fourth Street apartments, New York, early 1950s *(Vivian Maier)*

While today these Upper East Side neighborhoods still encompass a range of household income levels, in the 1950s the differences were more extreme. The wealthy resided and shopped on the fancy avenues closer to Central Park, while the cooks, plumbers, maids, and seamstresses who served them were housed in tenements and public complexes to the east. Vivian had a foot in each world. She valued quality and style, and was the type of person who preferred one well-made item over ten cheap ones. Many errands took her to upscale Madison Avenue to bargain hunt for prestige brands and process film at Lugene Optical. Conversely, the laundromats, fruit stands, and liquor stores on First and Second Avenues appear in her portfolio by the scores.

Residing in a railroad flat around the corner from Vivian was a family with three sisters. Sophie Randazzo, the eldest, met Vivian in the neighborhood one day in 1951. They developed a fast friendship, but on Vivian's terms: they only spent time together when she stopped by the Randazzo home

for unannounced visits. The youngest sibling, Anna Randazzo, now in her eighties and living in Queens, is the only New York peer of Vivian's who has ever been found. Sixty years later, answering an out-of-the-blue phone call, Anna offered a detailed description of her old friend, remembering she was masculine and cold, and wore flat men's shoes and no jewelry or makeup. Her standard uniform was "a conservative brown tweed suit" and Vivian would "tug at her skirt to make sure her knees were covered." In summer, her light cotton dresses were more flattering although she almost always wore a hat, even indoors. Anna never knew the last name of her big-boned and self-assured acquaintance.

Anna recalled that once her mother tried to welcome Vivian with a hug, but she pulled away with a curt "We don't hug and kiss," and then offered Mama Randazzo a handshake. The family found the young woman's use of the royal "we" and distaste for physical contact quite striking. While Vivian was chatty and liked to gossip with the girls, she revealed little of her past, giving the impression that she had been born in France and was alone in the world. According to Anna, "She was a bit strange, but pleasant and polite—unless you said the wrong thing, and then she would jump down your throat." When asked about her parents, Vivian's retort was, "We don't talk about that." At first she carried a large camera, but later arrived with a smaller instrument slung around her neck. She never discussed her photographic aspirations, simply stating that she liked to take pictures. Nor did she ever mention that she worked as a nanny. As with most people whose lives intersected with Vivian's, the Randazzos knew almost nothing about her.

On two fall Sundays in 1951, Vivian photographed the family in the natural light on their rooftop. While this was likely her first formal portraiture session, she was directive, confident, and in full command of events, conducting herself as a professional photographer. Anna described how Vivian instructed each of them, including her parents, where to sit or stand and how to pose. Requesting to shoot them individually, she sought to capture their unique personalities, which Anna feels she did effectively; Sophie was a dramatic jokester, Anna appeared shy and demure, and the middle Randazzo sister, Beatrice, posed like a would-be model. Vivian also fired off a single shot of the rooftop's edge, the first of a photo collection of classic New York City tenements.

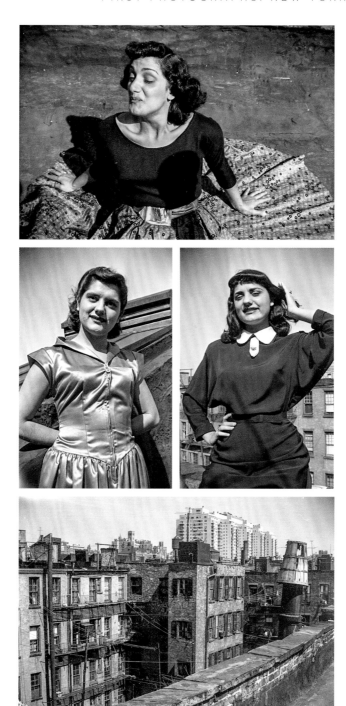

Up on the roof: Sophie, Anna, and Beatrice Randazzo, New York, 1951 *(Vivian Maier)*

Vivian made two sets of prints from the sessions and gave copies to the family. While Anna was familiar with all the rooftop images, she had never viewed Vivian's other work, but was not surprised to see grimy shots of vagrants taken at the same time as her family's portraits. From the beginning, she had the distinct impression that their friend was fearless. Anna's account corroborates that Vivian's personality and behavior were firmly established by the time she took up photography: she was private, deftly diverting attention from herself and displaying an overt aversion to physical contact. She had already acquired the protective shell that would remain in place for the rest of her life. The Randazzo sisters were the only sustained girlfriends Vivian was ever known to have. Even so, after about twenty visits to their home, she never returned, the first of many sudden relationship exits.

In 1952, after the end of the school year, Vivian shifted from a long series of seasonal jobs to year-round employment caring for a self-possessed young girl named Joan on Manhattan's Riverside Drive. Joan was an adventurous tomboy

New York muse, 1952 *(Vivian Maier)*

and thus an ideal subject, willing to pose with family, friends, and assorted strangers rounded up by her nanny. Much of the time she was hilariously attired as an Upper West Side cowgirl, despite a closet crammed with party dresses, which she wore with obvious disdain. The vivacious little girl served as a new

muse for Vivian, who photographed her hundreds of times, using the results for printing and cropping experiments.

That summer, as the weather turned warm, Vivian's pictures turned square: she had purchased an expensive, top-of-the-line camera. With unique features that were compatible with her aspirations and talents, the Rolleiflex changed everything.

Vivian Maier, Camera Center at the School of Modern Photography, New York, 1953

6

PROFESSIONAL AMBITIONS

The photographer is very particular.

—Vivian, about herself

THE ROLLEIFLEX

When Vivian Maier's images first became public, most of her Chicago friends and employers claimed that she had had no professional ambitions, and that she almost always declined to share her pictures with those who asked to see them. This was not always the case. Vivian's actions in New York reveal that she did want to launch a commercial career and frequently shared her work. Her business pursuits began with the development of postcards in France, but accelerated in New York with the purchase of her German Rolleiflex TLR camera, a favorite of professionals.

The new instrument was difficult to master, but twenty-six-year-old Vivian quickly worked through its complexities to take full advantage of its unique capabilities. It was designed to be held at the waist, facilitating inconspicuous picture taking. At the same time, without a device blocking her face, Vivian could establish eye contact with her subjects when she desired. With its square format, there was no need to shift from horizontal to vertical positioning, and with a waist-level lens, most subjects were shot from below, imparting a heroic quality. These features were game changers, making the quiet, sturdy Rolleiflex the perfect choice for Vivian. Soon she began to compose self-portraits while cradling her camera, presenting herself as a serious photographer.

While Vivian was never known to take a photography class or seek formal training, she made concerted efforts to connect with the photographic community

during her years in New York. There is no remaining evidence of materials that may have contributed to her self-education, but she primarily learned through observation of working practitioners and incessant practice. With her enviable new instrument, Vivian pursued a path typical of aspiring professionals by exploring a wide range of genres, and she relentlessly took to the streets to gain shooting fluidity and master new techniques. After World War II, camera clubs and photo studios offering round-the-clock darkroom rentals had sprung up throughout the city. Two such facilities existed on the block adjacent to Vivian's old elevated train, or "el," station at Fifty-Ninth Street and Third Avenue, where two seasoned female photographers—Carola Hemes and Geneva McKenzie— had studios.

Hemes had long worked from the location, specializing in bridal and celebrity portraiture, and Vivian came to know her. She posed the elderly photographer in her studio and office, which was full of mementos from her native Karlsruhe, Germany.

Likewise, Vivian photographed McKenzie, who worked two doors down at an establishment run by well-known photojournalist Robert Cottrol that was heavily promoted as the premier place to learn photography. In the portrait, McKenzie is shown examining negatives of exposures Vivian had made a few weeks before. When the Cottrol facility became embroiled in a scandal, McKenzie moved closer to the celebrity and advertising action of Times Square. Her new studio on West Forty-Sixth

Carola Hemes, New York, 1953 *(Vivian Maier)*

Geneva McKenzie, New York, 1954 *(Vivian Maier)*

Street housed a bevy of talent, including Elliott Clarke, whose cover launched *Seventeen* magazine; noted photojournalist Marvin Koner; Albert Staehle, creator of Smokey Bear; and emerging photographers Ronnie Ramos and John Wrinn. The latter would eventually commit suicide in the studio by drinking photographic chemicals. Hemes and McKenzie are the only photographers Vivian was ever known to photograph in their studios, and they almost certainly served as sources of training, introductions, and assignments.

In her zeal Vivian seemed to be everywhere at once, seeking out colleagues to learn from, collaborate with, and engage in shoptalk. She observed photo sessions with models and stars, and covered shoots depicting everything from architecture to petty crime to tabletop displays. On occasion, she stood outside churches along with hired photographers to take pictures of brides, and attended funerals to again capture widows, impervious to the scorn thrown her way.

The postwar years also saw a rise in the number of institutions designed to train professional photographers. Many of their newly minted graduates worked freelance, eager to capture images that could be sold to their subjects, agencies, and publications. Since Midtown Manhattan was known to be a fruitful location, Vivian shifted her shooting base to Fifty-Seventh Street. This was the location of the School of Modern Photography, where in 1953 she processed

The pros, New York, early 1950s *(Vivian Maier)*

her first color film. She often lingered in front of the institution, and on several occasions passed her camera to others to take her picture in its doorway.

While Vivian's archive shows her in pursuit of other photographers and in commercial settings, there is scant evidence of her specific goals or accomplishments. Several records confirm singular sales, as in the case of a 1953 image of an attractive couple nuzzling in a carriage on the southern perimeter of Central Park. In reality, this was a scene from a March advertising shoot, and the two models were dressed in lightweight clothing while everyone else wore heavy wool coats. Vivian covered the setup with five frames, and on the negative sleeve marked one exposure sold for "$1.00," which seemed to be her standard charge. In this case, her paying customer is a mystery; it could have been the advertiser, one of the models, the carriage owner, or even a bystander.

Toward the end of 1953, as her proficiency grew, Vivian experimented with lights and color film, moving indoors to take studio-style portraits. Sometimes she would find customers by prowling familiar neighborhoods, and while most

First sale, Central Park, 1953 *(Vivian Maier)*

of her subjects were female, she occasionally found men watching the world go by from their stoops. When she passed eighty-three-year-old Rose Hamilton on Seventieth Street and Third Avenue, Vivian took a picture with her old camera, jotting down a brief bio. A few months later, she circled back and worked her way into the formidable subject's home for a session using her Rolleiflex. The not-so-merry widow poses in her tidy kitchen while Vivian follows the protocol she established for such portrait taking: three setups with one shot of each. In the beginning, her poses were contrived and lighting suboptimal.

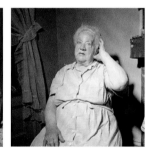

The not-so-merry-widow, New York, 1954 *(Vivian Maier)*

Vivian incorporated color into her portraiture by fashioning a salon using patterned draperies, throws, and scarves to obscure shabby doorways and furniture. While a series of pictures appear to be taken in different places, they were actually staged in a single apartment. As in France, she carefully chose props—books, dolls, and household items—to underscore her subjects' personalities and interests. The results demonstrate her eye for color and a passion for bright hues, fine fabrics, and expert tailoring as she transforms the room into an elegant boudoir of deep crimson, brilliant turquoise, and rich gold, adding a handcrafted doll with workmanship rivaling that of a Madame Alexander.

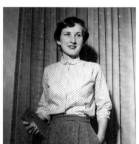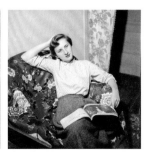

Portrait salon, New York, 1954 *(Vivian Maier)*

PHOTOJOURNALISM

Like famed street photographer Weegee, Vivian eagerly followed cops on their beats, occasionally detailing crimes, accidents, and altercations in her notes. She loitered near precincts and trawled marginal neighborhoods looking for action. Shots taken on Christmas Eve 1953 could have been stills from a film noir of the era, as Vivian chronicled the drunken misadventures of a man she identified as Kruger. Most young women would have been repelled or frightened by such subject matter, but as confirmed by her friend Anna Randazzo, Vivian was fearless. In fact, for a portion of street photographers, such exploits were considered a rite of passage.

To get her shot, Vivian employed a Weegee-like flash photography effect requiring a Rolleiflash with a built-in reflector, battery, sync cord, and disposable flashbulbs. Her archive is full of criminal subject matter, including pictures of at least one dead body. Images made in the bowels of the Bowery were particularly voyeuristic and predatory, exposing subjects who were passed out or otherwise unaware. Again, her pictures represented a clear invasion of privacy, but Vivian did not hesitate to document people at their worst in her quest for authenticity. It is possible she hoped to file her captures of arrests with news organizations like the Associated Press and the *New York Times*—but it is most likely that this type of photography ended up being for practice and enjoyment.

CELEBRITY

Vivian's photojournalism included paparazzi-style work, and she obsessively hunted for filming locations and movie premieres. She would elbow her way through throngs of fans for ideal positions on stairways and balconies to shoot the biggest stars of the day. On contact sheets, a few of Vivian's celebrity pictures are adjacent to those of her mentors, suggesting they offered leads or provided work, as does her appearance in press pools, dressing rooms, and backstage venues.

During the summer of 1952, the film *Taxi* was shot right in front of Hemes's studio. Vivian's coverage provides a behind-the-scenes look into moviemaking under the girders of the el train. The next summer, when George Cukor was filming *It Should Happen to You* in Columbus Circle, Vivian grabbed candids of Judy Holliday's stand-in and then ventured across town to meet with Hemes. At the premiere of *The Barefoot Contessa*, she maneuvered past police and autograph seekers to secure a close-up of Ava Gardner. Out on the street, she snapped the equally stunning Lena Horne.

Christmas Eve crime, New York, 1953 *(Vivian Maier)*

Ava Gardner, Judy Holliday stand-in, and Lena Horne, New York, 1954 *(Vivian Maier)*

FAMILY PHOTOGRAPHY

On a day-to-day basis, Vivian photographed her young charges as authentically and artistically as she would other subjects. Occasionally, her employers commissioned pictures of special events that called for more traditional compositions. Vivian often performed such work on her standard days off, but there are no records of compensation arrangements. In addition to the required formal shots, she typically threw in a few candids.

While taking care of Joan on Riverside Drive, Vivian came to know many of the building's families and frequently was called on to take pictures of their unending stream of birthday and holiday parties. In February 1953, she and Joan darted up two flights of stairs to attend a Valentine's Day celebration at the apartment of Sydney and Lucia Charlat. Their children have distinct memories of the nanny, who required them to address her as Mademoiselle. One sister, Joan Charlat, remembers Vivian as old-fashioned, well-mannered, and refined, but with an awkward and cold countenance. During the party, the nanny took a portrait of two of the Charlat sisters; upon seeing it for the first time sixty-five years later, Joan Charlat exclaimed that it precisely reflects their different personalities—echoing Anna Randazzo's sentiment. Joan stands with an erect posture and a bold stare, posed behind the chair where her sweet and ladylike sister Carol is seated, evoking their distinct temperaments and demeanors.

There were a number of circumstances where Vivian covered events that would typically be shot by a hired professional. Joan's family owned a famous New York steak house, and they commissioned Vivian to shoot two full rolls of its interior. For decades, one of these photographs has been passed down to family members as the quintessential representation of the restaurant; no one was aware it had been taken by the nanny.

In May 1953, Joan's parents requested that Vivian photograph their daughter's First Communion, with the internationally renowned Bishop Fulton Sheen in attendance. Sheen had been featured on the cover of *Time* magazine the prior spring and was the star of his own highly rated television show. At the breakfast celebration, Vivian followed standard event protocol by shooting multiple rolls of film, but when Joan and a friend were given the unique privilege of posing on the lap of the revered religious figure, Vivian covered the once-in-a-lifetime moment with just a single frame. Many have assumed that her lifelong practice of taking only one shot was driven by

First Communion, New York, 1953 *(Vivian Maier)*

thrift, but while that may have been a factor in other situations, there were no cost constraints here. She was simply confident. While the children look directly at the camera, Sheen's eyes shift elsewhere, an imperfection Vivian likely appreciated. Afterward she prepared proofs of the communion pictures and ordered 8 × 10 enlargements printed on upgraded paper. The family was left with two final sets. If this wasn't a professional arrangement, everyone treated it like one.

PICTURE POSTCARDS

Some practice pictures hint that Vivian had an interest in fashion and advertising photography, but her most serious commercial pursuit was the launch of a postcard business. In France, she had worked on the idea with Amédée Simon, and the sample postcards he made from her landscapes were printed on high-quality paper with address markings on the reverse side. Her disproportionate emphasis on landscape images is a testament to the fact that she

initially approached photography, at least in part, as a business opportunity. Back in New York, she created cityscapes to add to her inventory, and prepared a business plan. Her dissatisfaction with her local printer, who was most likely Geneva McKenzie, proved to be a stumbling block. Planning to change course, she drafted a letter to Simon in Saint-Bonnet proposing a wholesale arrangement:

> *I wonder if we could not do business, despite the great distance between us. I have a friend (girl) who develops my rollers very well but its tests are not great. Frankly, I like to see nice work such as yours and I am difficult as no doubt you remember. I had the idea that perhaps I send you my photographs to enlarge. I'm set. They tell me there is no duty to pay. . . . I have stacks of good shots I could get to you by registered mail and that I took with my German machine Roller-Flex and also struggling with my dear old box who gave me so much pleasure.*

—English translation of excerpt from Vivian Maier's letter to Amédée Simon

Vivian's conviction that an adequate supplier did not exist in all of New York, necessitating a transatlantic partnership, reveals the underlying difficulty she faced in establishing a commercial career. She was unable to suppress her own need for perfection in favor of practicality, as she struggled to achieve a cost-benefit balance. There is no indication that she ever considered an alternative career in the fine arts, despite deep confidence in her own talent. In her letter to Simon, she wrote with tongue firmly in cheek, "I often look at my masterpieces of the Champsaur" and "I have a stack, by that I mean a big stack of shots, and if I say so myself, they are not bad." While Vivian sought mastery in regard to shooting, she did not focus on achieving proficiency in the darkroom, which would have further hindered her professional ambitions.

DARKROOM

In New York, Vivian developed and printed much of her black-and-white work herself, but supplemented with commercial processors. Her habit was to file negatives in dated glassine envelopes, with few notes, almost never

recording her subjects' names. Markings on the sleeves indicated which pictures she intended to have printed, confirming that the vast majority were to stay in the negative stage. As was common, she cropped her square exposures vertically to increase focus on their primary subjects and conform with the rectangular dimensions of standard photographic paper. She frequently tried different approaches to printing the same negative, as in a 1954 image featuring a petite elderly lady shadowed by another, who addresses an imposing park employee. The woman turns her gaze toward Vivian just as she fires the shot. Originally a square negative, Vivian cropped it vertically and then experimented by closing in to different degrees. Ultimately, she chose the least-cropped version on the left to mount and hang on her wall.

Size matters, New York, 1954 *(Vivian Maier)*

As Vivian became increasingly comfortable with her Rolleiflex, she made more decisions in the camera. Her contact sheets confirm a consistent ability to create well-composed exposures that didn't need to be cropped. Some photographers speculate that the Rolleiflex's large, 2.25-inch focusing screen, which was almost like viewing a wallet-size print, helped her produce such successful negatives. The square format seemed to elicit her best work, and her ceaseless practice contributed to her advancement. According to New York photographer and Rolleiflex user Dan Wagner, shooting with this camera requires practitioners to overcome the challenge of photographing subject matter that is reversed

horizontally in the viewfinder. He explains that "the camera's complexity helps photographers improve their ability to maintain a state of high concentration, manage many technical variables, and capture the fleeting moments that define greatness. The effort itself rewards them with a sense of accomplishment and the desire to persevere."

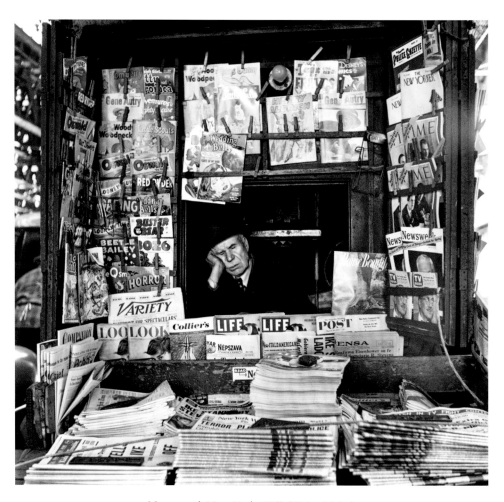

Newsstand, New York, 1953 *(Vivian Maier)*

7

STREET PHOTOGRAPHY

*Some people think life is a tragedy. No, life is
a comedy. You just have to laugh.*

—Vivian, to an employer

During the period Vivian pursued commercial photography, she was equally drawn to the streets. Master photographer Joel Meyerowitz observed that "street photographers, women or men, tend to be gregarious in the sense that they can go out on the street and that they are comfortable being among people, but they are also a funny mixture of solitaries. You observe and you embrace, and you take in, but you stay back, and you try to stay invisible. It's a dichotomy that comes into alignment with photography." This is an apt description of Vivian, who inconspicuously tracked her subjects in order to capture spontaneous actions and reactions. By shooting from behind archways, trees, and windows, she used found elements for framing. With her Rolleiflex and young Joan in tow, she canvassed the city, developing the themes that had first interested her in France.

Vivian had an uncanny ability to coax children into cooperating with her photographic endeavors. Her pictures feature those of every age, race, and background, as if by a mandate to represent all the young people in the world. Through eye contact and lightning-speed reactions, she created images that emanated pure authenticity. Typically, children of the time were photographed scrubbed, dressed, and happy—packaged like little presents. Vivian covered the full spectrum of their lives and feelings, tears and tantrums included. Her subjects would look straight at her, too innocent or inquisitive to divert their gazes, enabling her to capture their raw emotions.

One toddler is photographed as he fiercely presses his nose against the glass

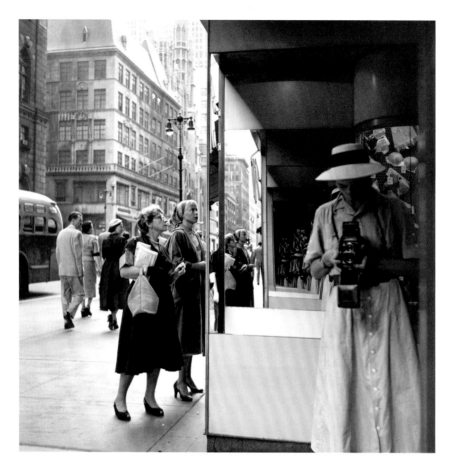

The Rolleiflex, New York, 1953 *(Vivian Maier)*

door that separates him from the rest of the world, his sweet eyes beckoning the photographer to let him out. In Central Park, a row of crisply dressed African American children form a human skyline mirroring the west side buildings behind them. A fearful, apple-faced boy rides his trike as streaks of tears dry on his cheeks. On the verge of melting into full-fledged sobs, he bravely proffers a defiant stare.

In New York, Vivian regularly took pictures of infants in strollers and dolls, although the former were not particularly engaging. She depicted dolls in the same contrasting manner as children. Periodically she shot them at their pristine best, as if straight from the box, but more often they appeared discarded or in a state of disrepair. Their limbs might be attached backward or missing entirely, their hair filthy and their clothes askew, no better or worse than how

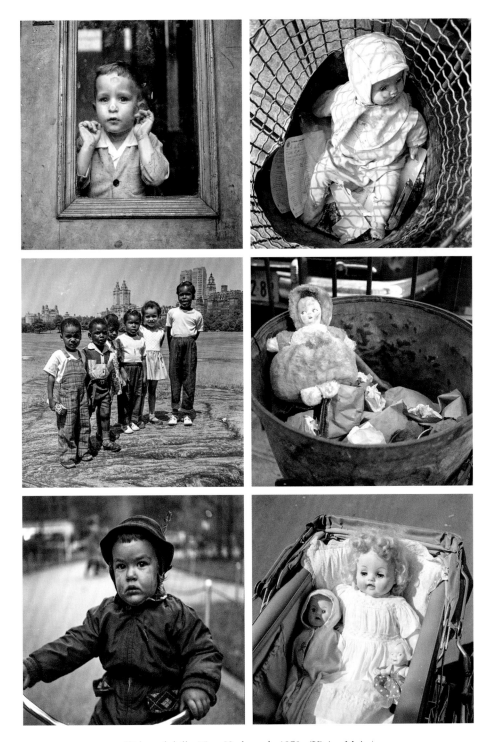

Kids and dolls, New York, early 1950s *(Vivian Maier)*

she found them. In some compositions the toys eerily resemble their flesh-and-blood counterparts, lifelike enough to provoke a double take. Photographs of babies and dolls largely disappeared in her Chicago portfolio.

As she patrolled Manhattan, Vivian generated a broad range of pictures featuring the city's women. In Midtown, her lens found meticulous matrons shielded by stoles, headpieces, and helmets of exquisitely coiffed hair. Joel Meyerowitz describes Vivian's treatment of well-heeled women: "She gives them dignity and also a little tweak, and there is a kind of elasticity, in that the pictures have a double reading, and that's where her sensitivity comes to play." In one example, the lines of a dowager's furrowed brow mimic the pelt of her luxurious mink. In another, an attractive lady in black registers as a mysteriously

High-low women, New York, early 1950s *(Vivian Maier)*

smiling widow, framed from behind so that her hat forms a diamond, echoing its patterned veil. Working-class women are discovered on stoops, benches, and ferries, their eyes reflecting suspicion as they meet the photographer's. Vivian effectively captured the beauty, depth, and wisdom in their timeworn faces.

In France, Vivian had taken pictures of mixed-race families, and her street work frequently featured individuals of different races sharing their everyday lives. These photographs are composed like all others, capturing joy and frustration, togetherness and separateness. One displays a Black shoeshine boy serving a white peer, pigeonholed in a position typified by the racial norms of the time. Vivian was a fervent advocate for civil rights, and her pictures related to race would become more prevalent and poignant in the turbulent decades ahead.

Race relations, New York, early 1950s *(Vivian Maier)*

Vivian's work also discloses a keen appreciation of human affection, despite a childhood of deprivation that constrained her own ability to connect with others physically and emotionally. She took a broad view of the topic, covering not only the romance of young couples, but the closeness of children, friends, and the oft-ignored elderly. Sometimes she homed in on small gestures to evoke more intimacy than overt sexuality ever could. For a woman with a reportedly frigid demeanor, she appreciated the passion of an entwined pair on a steamy, man-made beach in New Jersey, oblivious to the surrounding chaos.

Beach lovers, New Jersey, 1953 *(Vivian Maier)*

Admirers of Vivian's photography often describe her remarkable ability to convey the universality of the human condition. No matter where she photographed, at least a portion of her exposures can be viewed as location agnostic—for example, those of working men. While still a beginner in the Champsaur, Vivian composed pictures of laborers that demonstrate she already possessed a strong understanding of the core principles of photography. The images are loaded with geometry, symmetry, and comaraderie, featuring workmen who have come together to examine a metal rim. Long leading lines in the form of a road draw focus through the composition to the distant Alps. In New York, she instinctively finds the scene's urban equivalent, closing in on two men as they scrutinize a coiled hose. Here it is Fifth Avenue that travels through the action to the buildings farther downtown.

Road work, France, 1951, and New York, 1954 *(Vivian Maier)*

The naked city, New York, 1953 *(Vivian Maier)*

As she did in France, Vivian scouted for offbeat characters and compelling juxtapositions. A newsstand vendor (see page 92) literally surrounded by the most exciting events of the day can't be bothered to stay awake. Seedy, pre-gentrification Times Square offered great possibilities when megastores like M&M's World were distant dreams. A comical scene features a man standing on his head, blocking the "good parts" of a stripper on a poster behind him. In a place where looking is the point, he is wholly ignored by a young woman standing less than two feet away, incongruously wearing a ball gown, a workman's shirt, and one shoe. Another subject is even more inappropriately dressed, or rather *undressed*, seeming to have lost his pants. A fully clad passerby affords him but a brief sideways glance. Sleepers abound, like a pair who lay head-to-head on a public bench forming mirror images of one another. The expression of the man facing outward affirms that he is enjoying his dream. Another sleeper is splayed in the

entrance to the Third Avenue studios. Vivian took one picture of his lower torso and another of his face, making no attempt to piece him together.

After Vivian watched Joan for a year, they were given the chance to fulfill their cowgirl dreams on a monthlong cross-country road trip out west, accompanied by Joan's mother and two young cousins. The journey began in Niagara Falls, continued to Yellowstone National Park, and then turned northward to visit Joan's grandparents in Vancouver, Canada. The group passed through the redwoods and made serendipitous stops on their way down the California coast toward Hollywood. Vivian chronicled the vacation start to finish, carefully choosing her shots and numbering her rolls. She was obviously excited by the novelty and diversity of the subjects she encountered.

The family checked into roadside motels with blinking welcome signs and squeaky-clean amenities. Poolside, bikini-clad golden girls basked in the sun, one striking enough to earn her own portrait. They hiked canyons, rode mechanical bulls, and swam in crystal-clear lakes. They tilted their heads back in unison to watch the country's tallest trees grow to the sky, examined totem poles and gorges, and stared into the eyes of too-close grizzly bears. Native American reservations were of keen interest to all, and Vivian awarded them extra coverage. Though typically reticent to pose with others, she readily submitted to a picture with a tribal chief.

Western attractions, 1953 *(Vivian Maier)*

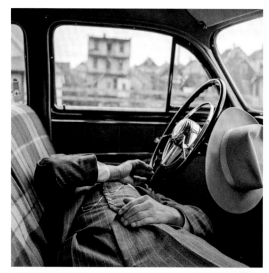

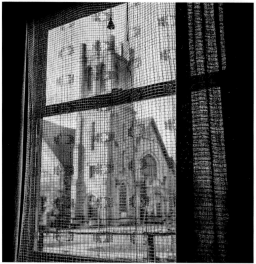

Vestiges of Vancouver, 1953 *(Vivian Maier)*

In Vancouver, Vivian was given the opportunity to explore the city on her own, and she used film sparingly while roving for worthy subjects. Among the limited exposures are several that have received admiration for their sense of intimacy and charm. In one, a seemingly headless but impeccably groomed gentleman sleeps comfortably stretched out in his front seat. Making himself at home, he employs the turn signal to fastidiously hang his hat while his car window functions as a frame, such that a picture hangs over his "bed." Equally unexpected is the welcoming presentation of a towering old church, its full facade fitted into a single window so

that it is veiled in a curtain of lace. No other photographs have been found that portray Vancouver's esteemed stone churches in such an approachable manner.

Joan and her cousins remember the nanny as a strict rule follower who could, on occasion, be a difficult traveling companion. Vivian would ask to pull over for a photo and take her time while everyone else impatiently waited in the car. The children all agree that she was aloof, and one cousin summed up their feelings with "It's not that we disliked Mademoiselle. We just didn't like her." In almost all situations, Vivian seemed unaware of her perceived lack of warmth. Here, stories about the nanny became family legend, and even the children born after the fact can repeat the tales. While generally considered a very good country cook, Vivian stubbornly chose to prepare dishes unfamiliar to Americans. Once, she encouraged the girls to eat raw beef in the form of steak tartare and they flatly refused, unable to understand the appeal. This was a precedent for a raft of food "horror stories" to come, told by every one of her subsequent employers.

The manner in which the nanny left Joan's family still has them shaking their heads. The cousins were sharing a Los Angeles hotel room with Vivian and one morning during the early hours, they were awakened by a noise. The girls opened their eyes to discover their caregiver sneaking away with her suitcase. Vivian shushed them back to sleep and left without another word. The original plan was for the group to travel to Arizona, on to the Texas Panhandle, and then return to New York, where the nanny would resume her employment. Joan recalls that when her mother woke up, she was of course stunned to find that Vivian had gone AWOL. They all strained to figure out the reason, but to this day, no one knows what went wrong.

Judging from her subsequent actions, Vivian had made plans to visit friends from the Champsaur in Southern California and then fly back to New York. She seemed oblivious to the inconvenience and hurt feelings she left behind. Despite taking daily photographs of their adventures, Vivian never returned to share them with the family. Sixty-five years later, Joan was finally given the opportunity to enjoy visual memories of her vacation. Over fifteen months of employment, Vivian took more than 500 frames of the family and their friends, and almost always gave them copies. Most she printed herself, practicing with a variety of treatments; thus, their vintage prints appear on matte and glossy paper, in square and rectangular shapes, and in full and cropped formats. After never-ending portraits of Joan, the little girl disappeared from Vivian's portfolio forever, and she never sought to meet her young muse again.

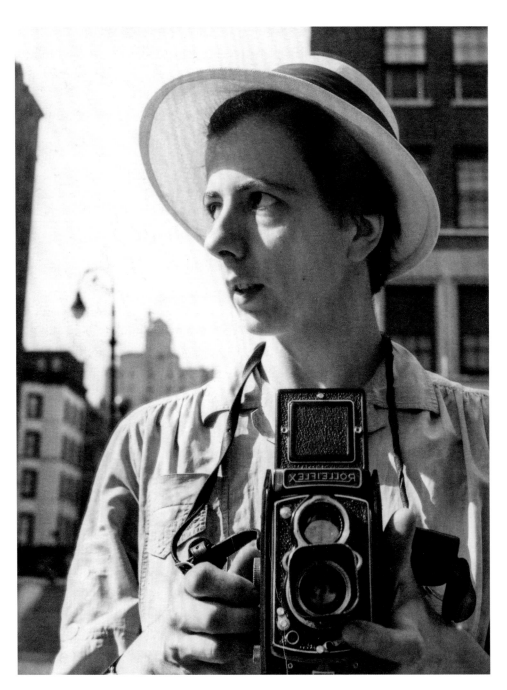

Self-portrait, New York, 1954 *(Vivian Maier vintage print)*

8

THE BEST YEAR

The best age in life is twenty-eight.

—Vivian, to an employer

Vivian's contact sheets confirm that the primary reason for her abrupt return to New York in August 1953 was a desire to advance her photographic skills and professional ambitions. Having begun such endeavors with the purchase of her Rolleiflex the previous summer, she now redoubled her efforts. For the next year, photography would be the focal point of her life, and while it was still early in her career, she would produce some of her most admired work. In fact, 1954 contributes more exhibition prints to the Howard Greenberg Gallery than any other year. Vivian would later reference this period by saying, "the best age in life is twenty-eight. You are old enough to know the ropes and stay out of trouble, you have the energy of youth, and you are unencumbered and free to explore." In a few months she would turn twenty-eight.

Before going back to work, Vivian spent about a month taking pictures, eagerly revisiting her favorite haunts. Her level of commitment is demonstrated by the considerable mileage she covered to pack as much as possible into each shooting day. Again, the level of energy and curiosity she exhibited was extraordinary, and would remain so throughout her entire life, even well into old age. After arriving back in New York from California, her first pictures were cityscapes, sharing a roll with wing shots of the airplane that flew her home. These urban scenes seemed designated for postcards, likely part of the stack she referenced in her letter to Amédée Simon.

During early September, Vivian stopped at the Museum of Modern Art and the Third Avenue studios to process her film. Increasingly, she sought to capture life's residual moments; those that typically go unnoticed. Under the el,

the youngest of a trio of children gazes upward in openmouthed wonder, the object of amazement is his alone. Vivian regularly turned to the ferry's melting pot of passengers for compelling subjects, like a couple who detaches themselves from the rest to lock together under windy skies. The short trip to Staten Island promised beaches and boardwalks, shadow and light. Despite the city's beauty, its underside continued to draw Vivian's eye with ubiquitous vagrants curled in doorways and ongoing parades of paddy wagon drop-offs.

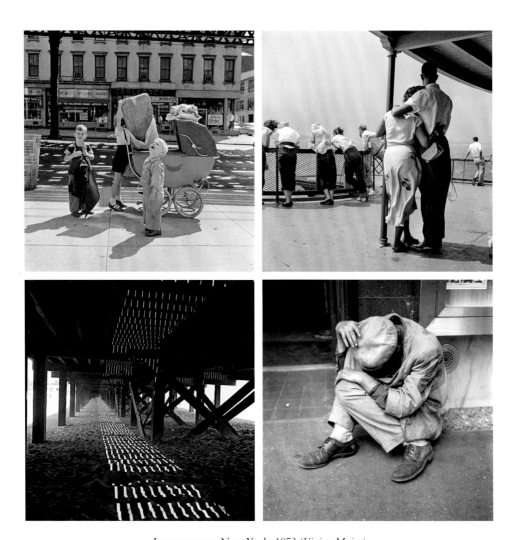

Late summer, New York, 1953 *(Vivian Maier)*

With the advent of the baby boom, governess positions were in abundant supply, and by mid-September Vivian was living with a new family at 333 Central Park West. Their children were somewhat independent teenagers, so the nanny could work fewer hours and enjoyed Thursdays and Sundays off. The fall was spent observing other photographers, composing portraits, chasing celebrities, and continuing street explorations. Vivian closed out the year with the Weegee-like pictures taken on Christmas Eve.

For the first six weeks of 1954 she kept a log detailing her day-to-day photographic activity and this rare record was recently found in an old coat pocket. These notes helped Vivian keep track of her shots and offer us intimate exposure to her practice, development, and interests.

Vivian Maier shooting record, January/February 1954 (*John Maloof Collection*)

PRACTICE PICTURES

A record of Vivian's self-proclaimed "best year" begins on the third of January 1954, a Sunday. She spent the day working with her Central Park family with whom she seemed comfortable. While she took numerous photographs of her charges and their grandmother, none were taken outside the residence, indicating she enjoyed a new freedom to pursue her own goals and pleasure. After atypically working until seven forty-five p.m., she finished off a black-and-white roll to capture the snowy night and then loaded color film to compose nightscapes, which she references in her letter to Simon: "I have many experiences since my return to the United States, photographs taken at night etc."

Vivian didn't use her camera for the next four days and then returned to night shots—it was not unusual for her to focus exclusively on a specific subject or type of picture-taking for a condensed period of time. She finally finished her color roll that weekend with shots of a doll in a bucket and crimson flowers. Sunday saw a return to black-and-white, with moody night pictures of snow and fog.

Two weeks passed before she loaded a new roll for pictures of her charges eating dinner. On the weekend she completed that and two more black-and-white rolls as she traveled to Greenwich Village to photograph Mark Twain's former home prior to its scheduled demolition. On her way downtown, Vivian photographed the new United Nations building, and when a gate or fire escape caught her eye, she fired once and kept moving. The repeating patterns of smokestacks, a step-stair building, and frosted brownstone steps all earned a frame. After successfully completing her original task, Vivian moved to lively Fourteenth Street, a prime hunting ground for both pictures and bargains.

To wrap up the month, she finished two rolls outdoors and briefly switched to her old box camera in order to use up her last pack of Kodak Tri-X film. January's contact sheets confirm the photographer's practice of rarely covering the same scene twice.

Vivian began February with a new black-and-white roll that lasted four shooting days. She held a portraiture session with the girl in her care, employing her standard procedure of three different setups. When she left the apartment, she tracked elderly ladies maneuvering around a wet Upper East Side; cats, construction, infants, dolls, and an old newspaper filled up the roll. It was completed with a self-portrait making use of the mirrors on Fifth Avenue.

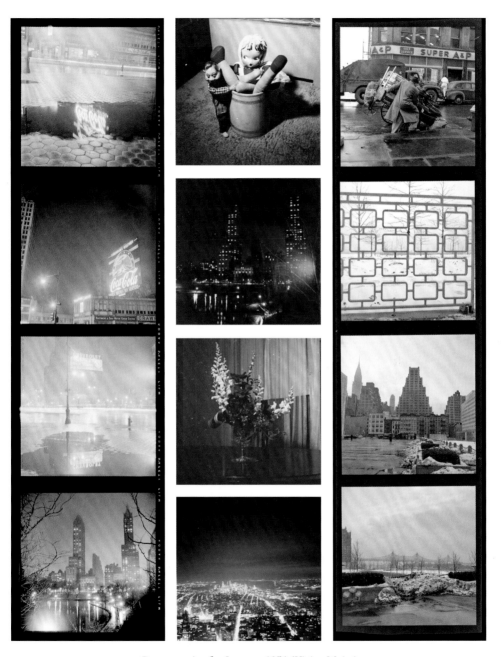

Contact strips for January 1954 *(Vivian Maier)*

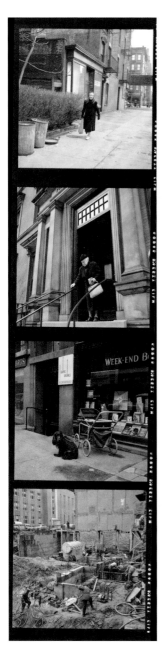
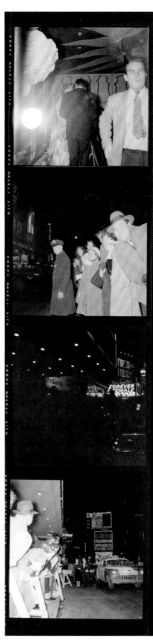

Contact strips for February 1954 *(Vivian Maier)*

As Valentine's Day approached, Vivian shifted into paparazzi mode. At the opening of *Act of Love*, starring French actress Dany Robin and the legendary Kirk Douglas, she joined the swarm waiting in Times Square but soon wriggled her way into the Astor Theatre—a type of move she consistently made with success. That same evening, Weegee would take his famous photograph of the theater's marquee. Vivian stopped at the Baronet Theatre to cover Swedish actress Elsie Albiin autographing pictures for the film *Intimate Relations*. Afterward, she walked a block south and stopped to record Geneva McKenzie examining the negatives of the elderly ladies Vivian had photographed two Sundays before.

In the space of six weeks, Vivian shot with two different cameras, three types of film, in the day and the night, indoors and out, and in snow, rain, and sunshine. She scoured the Upper East and Upper West Sides, Central Park, Fourteenth Street, and the Village. Some days she took no pictures, some days just one; and on weekends she plowed through multiple rolls. Her use of film was measured and deliberate. She explored a range of genres including cityscape, architecture, portraiture, celebrity, tabletop, self-portraiture, and street. She made no known prints of the exposures taken during this stretch of time, demonstrating how her vintage collection represents a very small sample of her overall work.

Vivian's position on Central Park West ended in the spring of 1954, but before she moved on, she drafted her postcard business proposal for Amédée Simon. In fact, one of her January color shots was of postcard samples, arranged around a map of the Hautes-Alpes. Afterward, the postcards made no further appearance in her records or portfolio.

Hautes-Alpes vignette, New York, 1954 *(Vivian Maier)*

BEST SHOTS

Vivian's took the summer off to put her new skills into practice. A richly layered image taken in front of the New York Public Library illustrates her developed skill and innate eye. The candid features a beautiful, swan-necked woman who rises from the crowd like a modern-day Venus. An out-of-focus foreground adds a sense of the ethereal, and strong horizontal and vertical lines force focus onto the subject, compelling the viewer to follow her impassive gaze. The most fascinating aspect of the picture may be that based on her eye-level positioning and the foreground ledge, Vivian likely snapped it from the window of a passing bus. Many have commented on her sky-high "hit rate," the number of "keeper" frames on a roll of film. A twelve-exposure contact sheet she produced

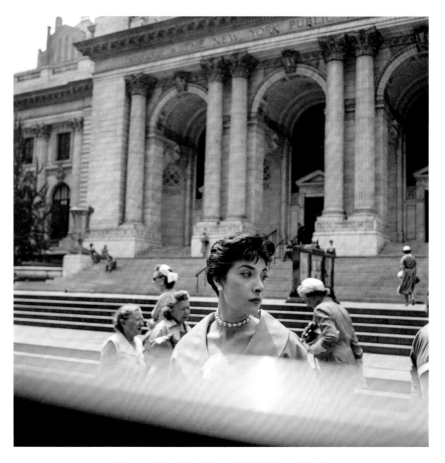

Library lady, New York, 1954 *(Vivian Maier)*

in 1954 contains three exhibition-quality images, including the library shot and the photograph used on the cover of this book.

Shortly after she purchased her Rolleiflex, Vivian began to photograph people from behind, and after just six months of using her new camera, she created a stunning portrait of a father walking his son and daughter home on a rain-drenched Riverside Drive. She fires just as the young girl turns toward the camera. The beautifully balanced composition is rich with reflections, shadows, and texture, as expressive as any forward-facing shot. Throughout 1954, Vivian approached so many subjects from the back that it became a sort of signature, along with her "less is more" captures of people's appendages, torsos, and possessions. At times she relied on a clenched hand, shoeless foot, or simple gesture to tell the whole story.

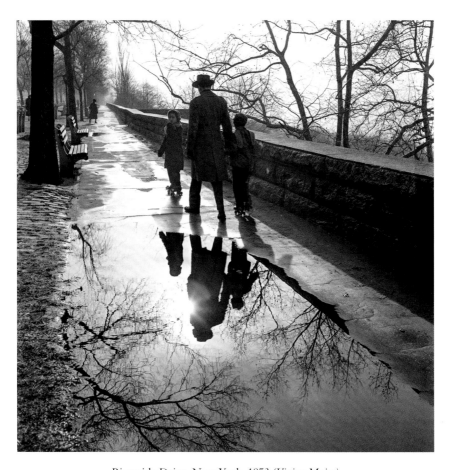

Riverside Drive, New York, 1953 *(Vivian Maier)*

Backsides, New York, 1953 *(Vivian Maier)*

In Midtown, she trailed a white-gloved threesome moving in lockstep as their shadows tagged along behind. The mirror-image women form a perfect frame to spotlight the little girl they have in tow, who charmingly breaks ranks to sneak a sideways peek. Unpredictably, even a hairstyle can evoke emotion. A woman's meticulous curls mesmerize with their rounded precision and three-dimensionality, as if ready to bounce free from their hairnet confinement. Drop earrings and a pearl choker finish off the perfection. A couple's long torsos echo each other, while their belts draw the eye to the real action, the overlapping arms and curled fingers that join them together. Wrinkled pants, popping veins, dirty fingernails, and chapped hands reinforce the authenticity of the image.

Backsides too, New York, 1953 *(Vivian Maier)*

I ♥ New York, 1954 *(Vivian Maier)*

Many of Vivian's 1950s streetscapes reflect quintessential New York. A shot taken 102 stories up showcases an Empire State Building worker precariously perched on the wrong side of safety. He leans on a railing topped with sharp metal claws that reinforce the sense of danger. At a much lower altitude, next door to the Carola Studio, a proprietor cleans his storefront amid the dirt, clutter, and cacophony of the Third Avenue el. Another man suspiciously locks eyes with Vivian, and with a cigarette dangling from his

lips, he reads like a thug straight from central casting. Before starting work in the fall of 1954, Vivian created two stills that dynamically feature the magical qualities of water. Uptown, children unleash a fire hydrant to create a geyser of joyous relief from the late summer heat. Downtown, the Financial District is refreshed from the rain and glistens with reflections. Commuters streaming toward their offices navigate the labyrinth of puddles and trails left behind.

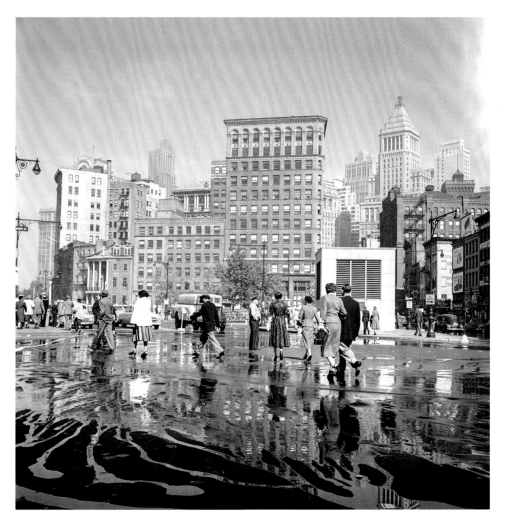

Navigating Wall Street, 1954 *(Vivian Maier)*

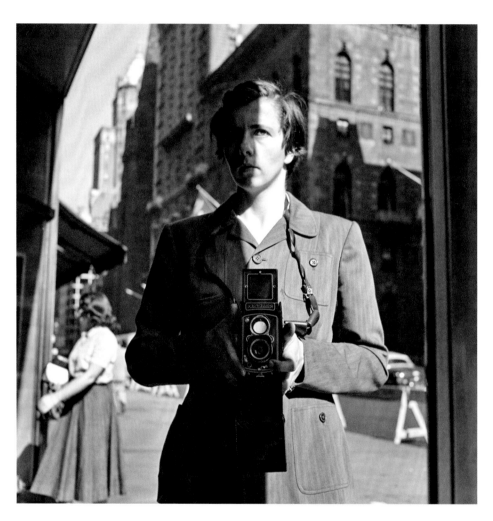

Dark and light, New York, 1954 *(Vivian Maier)*

SELF-REFLECTIONS

The twenty-five existing portraits of Vivian from her year in France consistently present her as a conservative, confident Frenchwoman. In New York, she conjured a different persona, decidedly portraying herself as a serious photographer. Almost all the self-portraits from this period showcase Vivian prominently holding her camera dressed in tailored clothing like every other businesslike practitioner. In a classic self-portrait (see page 104), she experiments with "Rembrandt lighting" while facing a Fifth Avenue mirror. She turns her head so that her face is partially in shadow and a triangle of light forms under her eye, creating a subtle chiaroscuro effect. Another version plays with shadow and light so that they divide her body in half, treatment reminiscent of the timeless theme of the duality of human nature—good and bad, light and dark.

These early renditions represent the beginning of a lifelong pursuit of self-portraiture that displays boundless experimentation and creativity. By the time Vivian left New York, she was inserting her likeness in all kinds of places, even on toasters and trays. She almost always presented herself as covered-up and unsmiling, but at the beach did let loose, donning a bathing suit and hint of a smile. Just a few years later, her self-portraits would reveal less and occur more frequently, documenting how her physical persona grew more and more extreme.

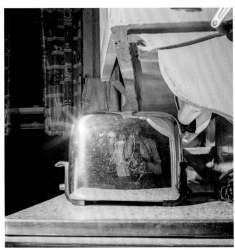 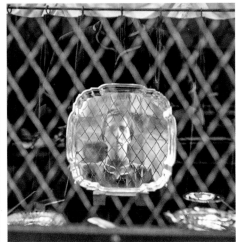

Reflections, New York, 1954 *(Vivian Maier)*

AN URBAN UTOPIA

As the summer of 1954 turned into fall, Vivian moved into the Peter Cooper Village section of Stuyvesant Town, the new "suburb within a city." Running from Fourteenth to Twenty-Third Street between First Avenue and Avenue C, the complex of cookie-cutter units on the east side of Manhattan was designed as affordable housing for World War II vets and their young families. Committed to recording the middle-class life that swirled around her, Vivian uncharacteristically ignored the counterculture movement emerging nearby in Greenwich Village. In vivid images, she chronicles birthdays with icing-smeared chins, teetering tricycles, and scraped knees. She found mothers galore, some carbon copies of one another, with almost identical coats, hairstyles, and sobbing children.

Stuyvesant Town, 1954 *(Vivian Maier)*

Vivian's first stint in the community was with the Hardy family, a divorced father and his two children, Meredith and Tom, of whom he had custody. They distinctly remember their nanny, with her unusual presence and ubiquitous camera. During the time they all lived together, Vivian showed little affection toward the pair, who were starved for maternal warmth. They recall that there was no emotional connection with the nanny and that she "was cold, unapproachable, and disengaged." She photographed them frequently and provided assorted prints, which they still possess.

One day, Meredith came home from school to find her younger brother crying. He had been severely scolded by their caregiver for refusing to undress for his bath. Meredith was shocked when Vivian slapped Tom across the face, and she promptly reported the incident to her father. Vivian was fired, yet subsequently

The Hardys, Central Park, 1954 *(Vivian Maier)*

exercised corporal punishment with most of the children she cared for, and not necessarily with the consent of their parents. In those days, and especially in Catholic rural France, corporal punishment was accepted, if not encouraged. However, rather than follow the mores of her individual employers, Vivian typically forged ahead to do what she deemed best.

Within a week, Vivian was employed next door by a family desperate for help. The match had strong potential: Mrs. McMillan wanted her daughters to speak French, and her husband was a doctor and amateur photographer. The new babysitter immediately accompanied them upstate to their "gentleman's farm" for their annual ritual of cutting down a Christmas tree. Dr. McMillan and Vivian photographed the event, developed the film in the bathroom of the family's city apartment, and created an image for their annual holiday card. But the Norman Rockwellesque overtones were soon exposed as artifice: the girls were privileged, but suffered from a significant lack of parental attention and supervision. Dr. McMillan had returned from World War II as a drinker and a womanizer, throwing his wife into recurrent cycles of depression and sedation.

Eldest daughter Mary recognizes Vivian's photos from the copies she owns. In one shot, two of the sisters sport matching coats and berets, while their nanny sits in the background, impassively crossing her arms. A meaningful picture for Mary centers on a dinner with a beautifully set table, her father carving the turkey—the last proper meal the family enjoyed in the apartment. Soon after, her father began to return from work at ten p.m., and his daughters learned to content themselves with cold cereal for supper. Dr. McMillan eventually became a full-fledged alcoholic and checked into Bellevue Hospital for "stress." After multiple rehab programs, he lost his job as a physician for Standard Oil.

An incident regarding a photo of the sisters taking a bath made a strong impression on Mary. The picture was a favorite of her mother's, and she asked Vivian for extra prints to send to friends and relatives. When the nanny refused, Mrs. McMillan was annoyed and complained, "Mademoiselle must be mentally ill. Why else would she refuse to make copies? Making copies is how you make money with photography." Mary explains that this was "the only time I ever remember my mother being critical of an adult non-family member, so this is a really strong memory. I was shocked." While her mother may have found Vivian difficult, Mary feels gratitude toward the caretaker for stepping in to fill the void in her family. She doesn't recall that they received further photographs from the nanny after the bathtub incident. This is the first of many occasions in which Vivian seemed to have trouble letting go of her pictures.

The McMillans, Hopewell Junction and Peter Cooper Village, 1954–55 *(Vivian Maier)*

1955: A PIVOTAL YEAR

Despite a period of remarkable photographic success, Vivian sought to further develop her skills and ideas. During the first half of 1955 the seminal exhibit *The Family of Man* took place at New York's Museum of Modern Art, curated by the museum's director of photography, Edward Steichen, who explained that it was "conceived as a mirror of the universal elements and emotion in the every-dayness of life—as a mirror of the essential oneness of mankind throughout the world." Steichen and his staff reviewed more than two million photographs from around the world and settled on 503 images that best reflected their theme. Fifteen percent of the featured photographers were women, including Dorothea Lange, Margaret Bourke-White, Helen Levitt, Ruth Orkin, and Gita Lenz. It was as if the show had been designed with Vivian in mind, and that winter she made two visits to see it. Given its alignment with her own themes, she must have absorbed its content with great interest. Although her previous work was surely influenced by photographic exhibits and books, there is no evidence to suggest that it was specifically derivative. Her archive contains

no attempts to duplicate pictures made by other photographers, and none are even referenced in her vast collection of materials. It is logical, however, that *The Family of Man* was inspirational—it featured techniques that Vivian had just begun to explore: use of mirrors and silhouettes, focus on body parts and gestures, and shooting subjects from behind.

Likewise, its subject matter dovetailed with her areas of interest. The working-class portraits on display, from men with tools to a lady carrying crusty bread, were reminiscent of her own images from France. The collection featured symmetrical windows and crisscrossed clotheslines with the types of patterns that frequently drew Vivian's eye. Some pictures reflected synchronized motion—American railroad workers lined up to repair tracks, Australian rowers stroking in unison, and nuns frolicking, their veils flying—reminiscent of Vivian's later travel photos. Children, largely depicted as exuberant and in constant motion, permeated the exhibition. While they are also prevalent in Vivian's work, her photographic treatment continued to be decidedly different; she was clearly unusual in her reluctance to idealize young subjects.

With its comprehensive coverage of the cycle of life, *The Family of Man* helps identify gaps in her own portfolio. A segment of the show features portraits of traditional and extended families throughout the world, but few such examples exist in Vivian's work. She almost never included fathers in family shots, and in fact, photos with men smiling, laughing, or playing with children are virtually nonexistent. These omissions are consistent with what is known about her background, and represent one way in which Vivian's childhood experience influenced her photography. A topic extensively considered in the exhibit was the bond between mother and child, depicted with images of scooping arms and tender smiles. Vivian would display a deep fascination with this inherent connection and explored it in a multitude of ways; her interest of course driven by that which she had missed.

Vivian was scheduled to remain in Stuyvesant Town through the end of the school year, and while there she devoted herself to creating a large portfolio for an attractive young caregiver who lived and worked in the complex. Their relationship seemed limited to photographer and subject, and resulted in more than a hundred portraits. Over a dozen sessions, the woman posed in a vast array of outfits and accessories, with each shot showcasing new hairdos, makeup, manicures, and props. Occasionally, two ensembles were covered at once. Many setups were stilted; some were a bit sultry. A few were purposely

fun, even silly, as when Vivian posed her subject peeping out from the shower or wrapped in pink tissue paper like a Madame Alexander doll. The pictures bear little resemblance to Vivian's other work and suggest she may have been practicing with an eye toward working as a portrait photographer. While she had previously used color sparingly due to the high cost of film and processing, she devoted multiple rolls of color film and a great deal of time to this project. At the end of one session, Vivian created two self-portraits featuring a serious, if exhausted, practitioner.

Beauty shots, Stuyvesant Town, 1954–55 *(Vivian Maier regular and vintage prints)*

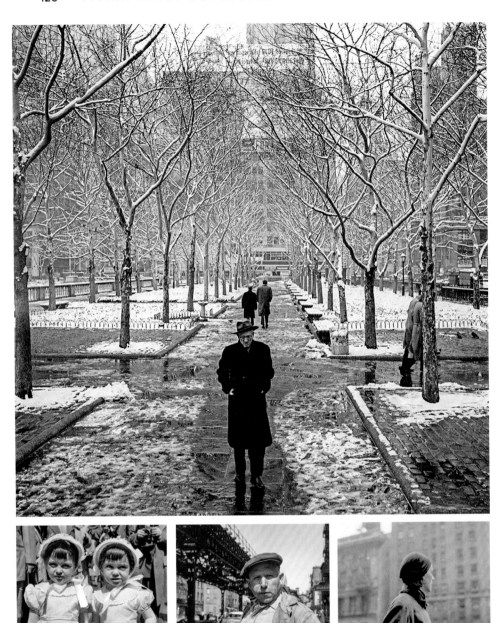

City scenes, winter and spring, 1955 *(Vivian Maier)*

While composing these beauty shots, Vivian devoted less time to other forms of photography, but nevertheless roamed the streets when she could. That winter she covered the city blanketed in snow, at perhaps its most beautiful, exuding an uncharacteristic sense of fragility and quiet. Spring brought the Easter parade and bonneted twins, creepy in their simultaneous sameness and difference, foreshadowing work Diane Arbus would create a decade later. This was the year that demolition of the el began, in favor of less intrusive transportation. Its trains had long carried Vivian on her creative explorations, and she documented a typical New Yorker seeming to offer a farewell toast. In May, she scored the most elusive celebrity of all: Greta Garbo, walking alone on Park Avenue.

Now twenty-nine years old and unflaggingly in search of new challenges and adventures, Vivian turned her attention toward her future. Her nanny stints were becoming shorter and more strained, and she had left some positions on less-than-favorable terms. She had made little progress toward establishing a photographic career. In retrospect, it is clear that her efforts were erratic and disorganized, but even had she been more tenacious, an uneducated practitioner without credentials or connections would have faced an uphill battle, irrespective of her talent. And any inroads Vivian did make were likely self-sabotaged by what could be an unwelcoming demeanor and uncompromising nature.

With her employment at the McMillans' concluding, Vivian decided to try her luck elsewhere. Virtually everyone from the Champsaur had the fantasy of California embossed on their psyche, and she was likely no different. The massive migration from long before was such a watershed event for the region that it is commemorated to this day with original plays, poems, and songs that poke fun at French and American differences. At a crossroads during the summer of 1955 and free from personal and professional obligations, Vivian sought to check out the myth. The promise of Hollywood beckoned.

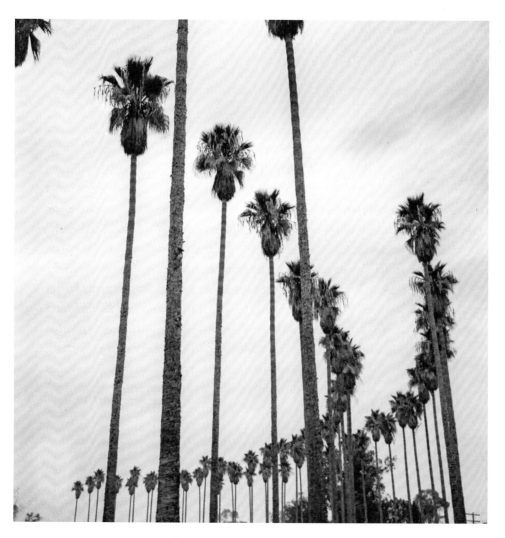

Southern California, 1955 *(Vivian Maier)*

9

CALIFORNIA BOUND

Los Angeles is a very dull place. Not a city, a hick town.

—Vivian, to a neighbor

When she left New York in July 1955, Vivian was no longer invisible. By disconnecting from her family and with the help of photography, she had managed to establish an indisputable presence, such that six decades later she would be remembered by almost everyone who had known her. Now she was on her way toward carving out an altogether new life. On her trip west, she traveled by train through Canada to visit the shrines of Quebec. Her first stop was Saint Joseph's Oratory in Montreal, where pilgrims climb ninety-nine wooden steps on their knees to show devotion. From there she set out for Quebec City to visit the basilica of Sainte-Anne-de-Beaupré, a destination that draws the desperately ill, who come seeking to be healed, hoping to leave their crutches and wheelchairs behind. Vivian documented every bronze statue from the "Way of the Cross," but only one human being, a chaste-looking boy with a milky complexion who fits in perfectly with the pious surroundings. The image is composed with sharp focus on the boy, who is framed with a foreground fence, background building, and side railing that combine for an almost three-dimensional effect. A wisp of blown hair adds life to his statue-like presence.

Catholicism was deep-seated in Vivian, and she built a large portfolio of churches and nuns, the latter visually appealing for the graphic power and symmetry of their black-and-white habits. She photographed them with a wink, in decidedly nonsecular behaviors like shopping, cruising, sunning, moviegoing, and giggling. The clustered sisters with tall cornettes look like nothing more than geese about to take flight. Later she would eschew religion, particularly Catholicism, and advocate for universal access to birth control and abortion.

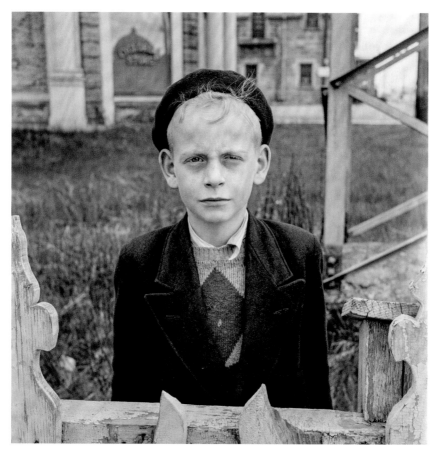

Catholic Canada, Quebec, 1955 *(Vivian Maier)*

Sisters, 1950s *(Vivian Maier)*

As she made her way through Canada, Vivian collected new scenes of intimacy. The physical affection unique to little girls is reflected in a poignant portrait of two friends who stand so close to each other that they almost touch tummies, foreheads, eyes, and noses—and whose heads appear to form a heart. The result is sweet and viscerally moving. In an abstract depiction, a pair of pine trees frame an ocean sunset in a setting so romantic that the viewer can't help but wonder what was going on in the tilted Volkswagen Bug. There are many examples of how Vivian had no problem recording the closeness and touching of others that she could not tolerate herself.

Arriving in Los Angeles in July, Vivian opened a bank account and settled into the residential Southland Hotel, frequented by "single elderly women pensioners and working men." The grand opening of Disneyland in Anaheim

Pairs, Canada, 1955 *(Vivian Maier)*

coincided with Vivian's arrival in Southern California and, perpetually drawn to the new and exciting, she was among the first to visit the attraction. For someone determined to depict reality, she was strangely taken in by the actors costumed as Native Americans, covering them as if they were the real deal. While her West Coast photographs were mostly black-and-white, Fantasyland demanded living color.

Disneyland opening, Anaheim, 1955 *(Vivian Maier)*

For two months, Vivian cared for a fair-haired toddler named Diana whose family embodied all that California promised: upward mobility, country club living, emerald-green lawns, and a bottomless supply of sunshine. Mother Charlotte Martin and the nanny had much in common, including their strong, tall physiques. Both came from humble backgrounds, were highly intelligent, and possessed a deep interest in the disenfranchised. As the photographs suggest, these were happy days. Charlotte enjoyed a successful, loving husband and the newly adopted Diana, who confirms this was the best time of her mother's life. The summer's pictures exude a glamour and family contentment that would eventually evaporate. It seems impossible, but the gilded mother and daughter that Vivian captured would be estranged before Diana reached adulthood.

During the 1960s, the family moved to Washington, DC, for Mr. Martin to work in the Kennedy administration, returning to California after the assassination. The pressures of the era's demands for female perfection plunged Charlotte into a host of addictions, destroying their family unit. This

Golden girls, California, 1955 *(Vivian Maier)*

story's unexpected ending is a reminder that photographs are just fleeting moments in time. As best articulated by Susan Sontag, "To take a photograph is to participate in another person's mortality, vulnerability, mutability. By slicing out this moment and freezing it, all photographs testify to time's relentless melt."

In her free time, Vivian squeezed in a Hollywood tour, day trips, and personal photography. With her passion for film and celebrities, it makes sense that she would seek opportunities in Los Angeles, especially after preparing practice portraits in Stuyvesant Town that were reminiscent of starlet publicity shots. Committed to photography in one form or another, while in California she purchased a second Rolleiflex, a new automatic model that conveniently locked shutter speed and aperture together. When her caregiving position with

the Martins ended in August, she had not yet established the professional connections she seemed to have hoped for. Later, she told a neighbor the motion picture industry was terribly inbred: "If you aren't in, you're just washed out."

She took the next month to tour Southern California and enjoy reunions with the Champsauran friends she had first visited in 1953. The large Eyraud family welcomed her into their fold, sharing albums, cemetery visits, and a dose of French companionship. She visited another friend, Margarite Heijjas, a Hungarian nurse whom she had originally met in Central Park and who had subsequently moved to Pasadena. Each time they were together, Vivian made a portrait of her strikingly pale friend, who became increasingly ghostlike as time progressed. On several occasions, loyal Margarite "loaned" Vivian money which she promised to return, although there is no evidence that she ever did.

Margarite Heijjas, New York, 1952; Pasadena, 1955 and 1959 *(Vivian Maier)*

ON TOUR

In October 1955, members of the famous Mary Kaye Trio improbably surfaced in Vivian's photographs. The jazz group was comprised of Frank Ross, Norman Kaye, and Mary Kaye, a guitarist so renowned that a custom Fender Stratocaster electric guitar was made in her name. The ensemble was at the height of their popularity after establishing the first Las Vegas lounge act, becoming the highest-paid entertainers of their era. They headlined on the city's strip for six months a year while producing bestselling records—and a wide range of children through multiple marriages. They needed a nanny for their upcoming tour, and Vivian ended up in that role. Undoubtedly, this would have filled her guitarist brother with envy.

Mary Kaye Trio album, 1961 *(Courtesy of John Kaye)*

Playing with the Trio, San Francisco, 1955 *(Vivian Maier)*

Kandee, one of the eldest children, recalls that Vivian taught her to count in French while she babysat for them in San Francisco, vacationed at their cabin during Thanksgiving, and toured with the Trio across the Midwest. The most striking picture from their two months together features the entire clan spontaneously lined up in formation to enjoy a whimsical spiral slide shaped like a supersize corkscrew.

During the six months she spent out west, Vivian Maier carved out a stimulating life for herself. She covered a wide swath of geography, met a diverse group of people, experienced Hollywood glamour, reconnected with old friends, participated in the opening months of Disneyland, and toured with the "first lady of rock-and-roll." With the Trio's last concert scheduled in the Windy City in December 1955, she answered a classified ad for work in Chicago's northern suburbs. According to John Maloof, when prospective employer Nancy Gensburg interviewed Vivian, she offered no references despite having worked for at least a dozen families. Taking determined steps to close the door on her New York family and life, Vivian would never again reveal her true background, even when employment was at stake.

Avron Gensburg ran a successful family gaming business that produced pinball machines. His wife, Nancy, a sculptor from Georgia, found the prospective nanny interesting and forthright, and was said to have hired her on the spot. Vivian moved into their Highland Park home in January 1956 and stayed for eleven years, the longest, most stable living situation she would ever enjoy. Here, and in almost every subsequent position, it took an employer with a creative background to see past her atypical exterior and connect with her unique attributes. She would make only three return trips to the northeast: the first to tie up loose ends, and then two stopovers when traveling elsewhere. Despite steadfastly disassociating with her bedrock of thirty years, Vivian forever championed her real hometown as the best place on earth. Her gift to New York would be a meticulous and stunning documentation of city life during the 1950s.

Vivian and her boys, Highland Park, 1966

10

CHICAGO AND THE GENSBURGS

Mary Poppins—child servant, outdated, a real fiasco!

—Vivian, in her photo notes

THE REPLACEMENTS

Vivian Maier found her improbable match made in nanny heaven in the Gensburgs, who became the family she never had. When her employment began, son John was a one-year-old and Lane was an infant; a third son, Matthew, would be born two years later. She arrived with bags and books, promptly locked her door, and took over the household. She lived in comfort in the finished basement of the family's contemporary home and with a spacious bathroom to use as she pleased, Vivian had a makeshift darkroom of her own.

The Gensburgs considered the nanny to be competent, responsible, and honest, and appreciated the creative ways in which she engaged their sons. The family never learned about her past and were even unaware that she had spent most of her life in New York, despite traveling to the city together to attend the World's Fair in 1965. Vivian kept some distance from the boys' parents, not once allowing them a hug, but her charges were another story: she loved them as her own and devoted herself to exposing them to all aspects of life. Some of their intrigues were atypical for children; Lane Gensburg describes how they tiptoed through cemeteries to absorb history from headstones and enjoyed opera, theater, and museums. Their nanny organized neighborhood plays, taught them French, and brought them to the Chinese New Year's parade. Some children thought she was strict and mean, but the well-behaved Gensburg boys fell in line and loved her back. All the while, Vivian tracked the most quotidian events

with her camera, from homework, report cards, and barbecues, to all of life's little victories and defeats.

The result is a visual record of suburban culture of the late 1950s and 1960s as it unfurled in the Gensburg family room, with its distinctive cowhide sofa and drapes. It's all there: sugary birthday cakes, jittery rehearsals, and the daily laughter, tears, and wrestling matches that make up the lives of little boys. Her notes call out "firsts" that only the most doting mother would record, from haircuts to trying corn on the cob.

In late August 1956, Vivian received word that her surrogate mother, Berthe Lindenberger, had died in Manhattan, prompting a three-week stay in New York. This conveniently dovetailed with her scheduled time off and there is no indication that her employer was aware of this significant event in her life. Functioning as Berthe's next of kin, Vivian canceled their joint savings account, photographed each page of their bank book, and emptied her Flushing PO Box of records and snapshots. She traveled to Jackson Heights to visit old neighbors and to take a picture of the home where she and Berthe had lived together. The fancy Frank E. Campbell funeral home handled Berthe's arrangements, as they had for Eugenie, including cremation at Ferncliff. Vivian photographed it all, even the shipping carton containing Berthe's ashes.

While in New York, she stopped at Manhattan's Bellevue Hospital, where Berthe had likely died, made

Fun with Vivian, Highland Park, 1950s

an exposure from the roof, and then hopped on a train to Long Island. Her destination was Pilgrim State Hospital, a psychiatric institution in Islip that Alfred Eisenstaedt had famously photographed for *Life* magazine in 1938. Vivian's excursion seems not to have been to take pictures: she returned with just a few exterior shots. There are no accessible records to confirm whom she may have been visiting.

Vivian had moved away from the city just one year before, yet her photos lacked familiar faces, suggesting that there were no former employers or friends she wished to look up. She stopped at Hemes's studio and took a shot of the bridal display, but the Carola sign had been removed; the elder photographer had left for a visit to Germany and never returned. Perhaps the most notable series from the trip is one of an Armenian woman wrestling with a cop. Like a photojournalist, Vivian spent hours covering their neighborhood squabbles and interviewed the arresting officer so as to write up the incident, presumably an example of journalistic playacting. She later made a print for herself, cropped closely to feature the adversarial pair. Before returning to the Midwest, Vivian traveled to Gate of Heaven Cemetery to bid a final farewell to Eugenie, closing the door on her New York life all the more tightly.

Pushback, New York, 1956 *(Vivian Maier)*

Wide-eyed teens, Chicago, late 1950s *(Vivian Maier)*

SETTLED IN SUBURBIA

Back in Chicago, Vivian was content to photograph the Gensburgs and their friends, and made thousands of exposures in their suburban homes and neighborhoods. She continued her street photography by wandering the towns of the city's North Shore and darting into downtown Chicago. Again and again, she returned with images coursing with life and authenticity, registering the moments that mostly fall through the cracks. She held the unflinching gazes of teenagers and fired before they could blink. The results deftly reflect the "what you see is what you get" attitude typical of the age group.

As before, Vivian included herself in the action. Without the mirrorlike storefronts that lined Fifth Avenue, she reflected her image on tire hubs, vending machines, and rearview mirrors. She fully developed the idea of presenting herself via shadow with ingeniously conceived compositions that expressed her

Self-portraits 2.0, Chicago, 1956–57 *(Vivian Maier)*

circumstances, feelings, and creativity. Many are composed with an eye toward humor: she poses with her bicycle, proffering elongated silhouettes that accurately reflect their imposing neighborhood presence. A particularly memorable rendition features the pelvic placement of a sprinkler head to comically signal what is off-limits.

A self-portrait Vivian completed when she first arrived at the Gensburgs' summarizes her skill development. Covering the composition in both black-and-white (see below) and color (see page x) she uses off-camera and soft-bounce lighting to control the outcome. Photographer Dan Wagner explains that this is a hard shot to execute: "Vivian had to look through the viewfinder, focus, compose, place her finger on the shutter button, and not move a muscle lest the camera move and ruin the composition—then she had to aim the flash at the ceiling. By lifting her head upward, it created a flat 'beauty' light that avoided harsh shadows below the nose and neck and left nice catchlights in her eyes. Her shirt remains tucked in tightly—generally this type of body posture would pull the shirt out and result in a disheveled look." Vivian could now juggle multiple factors to execute a technically flawless portrait.

Reflections, Chicago, 1956 *(Vivian Maier)*

THE EXTRATERRESTRIAL

Fully settled in Chicago, the nanny became a visible and memorable fixture in the neighborhood, moving about on her VéloSoleX moped or her bicycle. Duffy Levant, a friend of the Gensburgs, remembers her as being everywhere at once, and when she rode around with her camera flying from her neck, "she looked like the Wicked Witch of the West." Almost everyone who met Vivian agrees that she loomed larger than her five-foot-eight height would suggest. Duffy explains that "she didn't have to say a lot to make an impression. She was more a persona than a personality and was a very foreign presence in Highland Park." In fact, Vivian was described in similar terms in Saint-Bonnet. A cousin, Marius Pellegrin, remembers her from his childhood and commented that to the children of the Champsaur, she was like an "extraterrestrial." Wherever Vivian went she was always noticed, but almost never known or understood. Dichotomous elements built her complicated persona: French country sensibility, urban sophistication, immense creative and intellectual resources, and the effects of a profoundly traumatic childhood. They coalesced into a one-of-a-kind personality whose motives and actions were difficult to discern.

Vivian steadfastly stuck to the uniform of her conservative French roots. She dressed formally; her everyday attire consisted of a tailored suit or crisp Peter Pan–collared blouse paired with a calf-length skirt. She still wore old-fashioned rolled-down stockings, unable to make the transition to pantyhose. It was all

Vivian's Liberty of London blouses (*John Maloof*)

covered up with oversize men's coats in beiges and grays and topped with a
trademark floppy hat. The androgynous getup enabled Vivian to both hide
and stand out at the same time. Most believed her wardrobe originated in
thrift shops or at the Salvation Army, but nothing could have been further
from the truth. Forever a fan of the best, her clothing boasted labels from Mar-
shall Field's, Saks, and Fifth Avenue boutiques. Her trench coats were from
London Fog, her hats handmade by Parisians, and some of her woolens pure
cashmere. She was described as plain and colorless, but oftentimes silk slips
with ruffles and colorful Liberty of London blouses were tucked under her
dull exterior. Counter to all other reports, the Gensburgs say she was actually
quite feminine.

Her grooming habits also derived from her practical rural upbringing.
Vivian shampooed with vinegar and slathered Vaseline on her hair and cheeks
for everyday protection, frugally purchasing beauty aids in bulk. Suffering from
anemia and some type of hormone imbalance, she possessed linebacker arms
and dark circles under her eyes. These physical attributes, combined with her
oily visage, were off-putting to those who met her. Again and again, employers
and friends characterized her as unattractive, and her self-portraits confirm she
became progressively so.

Beauty in bulk, Chicago, 1960s (*Vivian Maier*)

When John Maloof conducted interviews for his documentary, virtually
everyone brought up Vivian's militaristic gait, describing it as a loud and
ungainly march propelled by wide-swinging arms. Many remembered her
brown size 12 men's shoes, chosen because they were built to last and which
she wore until they literally fell apart. While indelicate, she operated with
speed and purpose and the gait became part of the powerful presence she
conjured.

Footlongs *(John Maloof)*

People who met Vivian invariably commented on her stone-faced manner and lack of friendliness. An acquaintance explained that she "didn't speak with her face." Her countenance reflected a limited ability or unwillingness to express outward emotion and some found her brusque and imperious, consistent with the stereotype sometimes attributed to the French. Her use of the royal "we" implied that her opinions were in line with the majority, at least the cultured part. When asked questions that weren't to her liking, she did not hesitate to respond, "It's none of your business." Despite an overall affect that was described as intimidating and formidable, she spoke softly and almost never raised her voice. Her accented, lilting speech was pleasant and crisp, and she sprinkled conversation with *Sacré-Cœur*s, *oh là làs,* and *voilà*s. Yet as a result of her keen intelligence and strong opinions, she often came across as authoritative and overbearing when expressing her views. With underdeveloped social skills, she could be insensitive to hurt feelings and miss critical cues. Her desire to conceal her past shaded all her interactions by imparting a cool distance. Tape recordings Vivian made while talking with employers and neighbors during the 1970s confirm her mastery at guiding conversations and deflecting questions. Her aloof exterior was so deceiving that her true inner feelings almost always went unrecognized and unacknowledged.

Under the circumstances, Vivian's secretiveness regarding her background was a thoughtful and rational approach. She had been bred to hide her identity, just like her mother and grandmother, who never met a form they didn't falsify. Already hardwired to conceal, she clearly concluded that no one would want to learn their nanny had an unstable, narcissistic mother; a violent, alcoholic father; and a drug-addicted, schizophrenic brother. Even worse, a traceable trail could lead her family back to her, looking for money and blowing her cover. It made sense for her to keep quiet and compartmentalize. Naturally,

Vivian's photography was her emotional outlet. Many have noted the irony that a woman who had such difficulty expressing herself in person could produce photographs so full of openness, feeling, and humanity. In some ways, her dispassionate demeanor worked to her photographic advantage by diminishing her own presence as she sought honest and unaffected pictures of her subjects.

At the Gensburgs', Vivian was guarded, but most herself. She was wholly accepted and integrated as a family member, invited to join school events, holiday celebrations, and vacations. They describe Vivian differently than all other employers and former charges because with them, she *was* different. In photographs taken at their home, she looks happy and relaxed, and during the summertime, with her pixie-like haircut, lightweight clothes, and trace of a smile, she even managed to blend in.

PERSONAL PURSUITS

In Chicago, Vivian arrived at a fork in the road regarding her professional ambitions. While she had actively participated in the commercial community in New York, she never got anything meaningful off the ground. Now she decidedly chose the amateur path. Her engagement with the Chicago photographic community was limited, and she almost never pursued commercial opportunities. Eschewing feedback and confirmation, she was free to take pictures solely for herself.

There was another meaningful change in Chicago: unlike before, Vivian rarely shared her photographs with others, except for the Gensburgs and their close friends. Few were offered prints, not even neighbors whose children Vivian covered with thousands of frames. Duffy Levant's blond-haired sister Jennifer was a favorite subject, and their mother was eventually granted a few copies. In later years, when reviewing these photographs, Jennifer stated that Vivian could unmask people and "peek into their souls."

The Gensburgs were unaware of the extent of Vivian's street photography, although they appreciated her interest in the medium and the pictures she took of the family. They told John Maloof they had even encouraged her to pursue a professional track but believed she really didn't have the training or credentials to succeed. Nancy described a two-week period where *Life* magazine came to their home to cover a special party, noting that Vivian had refused to engage. Unknown to her employer, her archive reveals that she had discreetly taken pictures of the magazine photographers in action. She also composed an extensive

"Advertisement," Chicago, 1956 *(Vivian Maier)*

series of professional-looking photographs of a woman modeling cosmetics; while these read as advertisements, they seem to have really been prepared for a Gensburg family member or friend and served as a form of role-playing for Vivian.

Celebrity stakeouts continued in Chicago. Vivian found Gene Kelly dining with Jackie Gleason before the *Gigot* premiere, and snapped candids of Eva Marie Saint, James Mason, and Cary Grant when they were filming Alfred Hitchcock's *North by Northwest* nearby. Later, she would place a print of Eva Marie Saint front and center on her bureau.

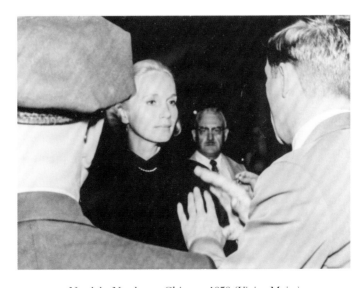

North by Northwest, Chicago, 1958 *(Vivian Maier)*

Without a pressing need to return to New York after Berthe's death, Vivian used her vacation time to travel. Having already made two visits to Canada with notable pictorial results, in 1958 she embarked on a new adventure to the country's far north. Churchill and Cranberry Portage offered an abundance of history, plus the intrigue of polar bears, Inuit tribes, and fur-trading routes. Once again, the Canadian exposures were standouts, portraying scenes so pristine

Clean-cut Canada, 1958 *(Vivian Maier)*

they look as if contrived for a film set, reflective of the clean-cut wholesomeness and whimsy that prevailed in the 1950s.

Vivian accompanied the Gensburgs when they traveled to visit relatives in Florida. One night in Miami in 1957, after a day photographing family members and palm trees, she ventured out on her own. On that balmy evening she took but one photograph, as she had on many other occasions, resulting in an exposure that is widely regarded as one of her best. This perfect picture attests to Vivian's talented eye. Out of nowhere, an ethereal woman in white floats toward the curb. A soft spotlight places the apparition center stage, as if she glows from within. Distant streetlights sparkle like stars before receding into darkness. With just this single exposure, Vivian called it a night.

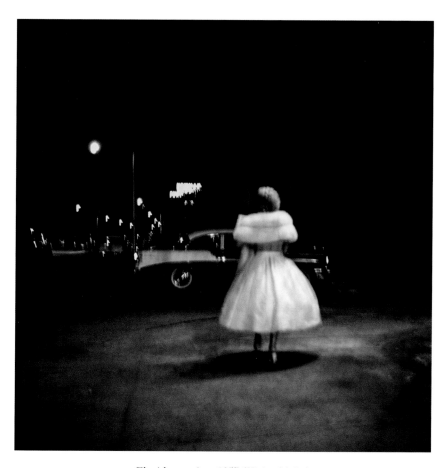

Florida evening, 1957 *(Vivian Maier)*

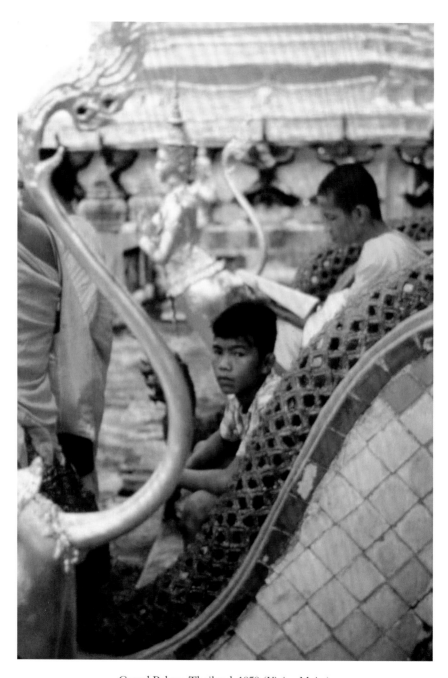

Grand Palace, Thailand, 1959 *(Vivian Maier)*

11

AROUND THE WORLD

Some people live to work. I work to live.

—Vivian, to an employer

In 1959, Vivian informed the Gensburgs that she was taking a six-month leave to fulfill her dream of seeing the world. Demonstrating her curiosity, courage, and independence, she traveled to Los Angeles and boarded the cargo ship *Pleasantville* to explore the continents of Asia, Africa, and Europe. Ports of call included the Philippines, Hong Kong, Thailand, Malaysia, Singapore, India, Yemen, Egypt, and Italy. Bookending the trip were meet-ups with friends and family in Southern California before her departure, and in her hometowns of Saint-Bonnet and New York afterward. Like an overstimulated kid in a candy store, Vivian took more than five thousand pictures during the voyage, seeming to capture every baby in China and every painting in the Louvre. She returned with reflections of reality, symmetry, and beauty from the far corners of the globe. For the remainder of her life, she would proudly state that she had traveled around the world, evidence that the accomplishment became an important part of her identity.

Vivian began her adventure that April with a train ride west; like all "civilized" Americans of the time, she dressed up to travel, wearing a tweed business suit. First stop: Pasadena, where she reconnected with old French friends and nurse Margarite Heijjas, who again lent her money. Once settled in aboard the *Pleasantville*, she mingled with passengers and photographed the crew in between stops at alluring locales. She participated in the fanfare of sail-aways, and secured unique vantage points to record arrivals in new ports and to map out her photographic plans. Her pictures were a mix of compelling portraits, standard tourist fare, repetitive ocean waves, and the activities, shapes, and patterns aboard the ship.

While she didn't miss a single cultural attraction, Vivian was particularly

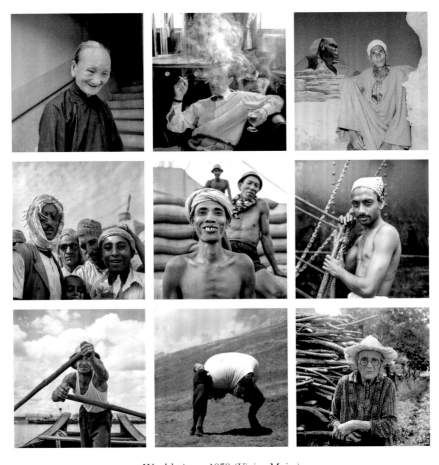

World views, 1959 *(Vivian Maier)*

interested in meeting the locals. Her visuals vary dramatically by region, but there are commonalities in their subject matter. To her portfolio of compelling hats found in America, she added an assortment of indigenous headwear: bamboo rice hats in Vietnam, painted cones in Thailand, snowy headscarves in India, straw high-hats in Yemen, and tightly wrapped turbans in Egypt.

The well-organized itinerary facilitated her exploration of country interiors via funicular, bus, ferry, river boat, and rickshaw. Every day spent in port offered a new experience, from muay Thai kickboxing matches and golden palaces in Southeast Asia, to the sweeping sands and astonishing pyramids in Giza. With her ability to find beauty and meaning in the everyday, Vivian often took note of clotheslines. Laundry can reveal a population's habits and culture—what garments are worn under and over, inside and out; how belongings are cared for;

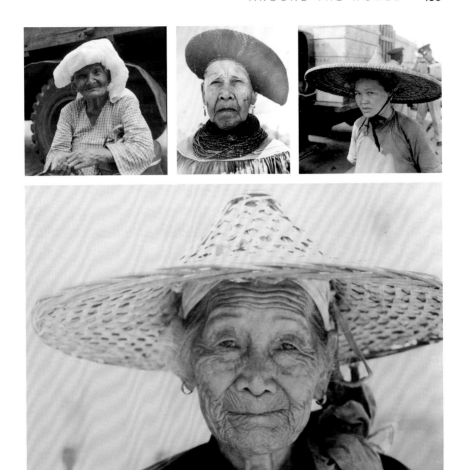

Women in hats, Asia, 1959 *(Vivian Maier)*

the composition of families, sleeping customs, even the region's sense of aesthetics.

Raised to hang clothes in the fresh air to dry, Vivian was troubled when the Gensburg boys failed to understand why garments would ever be left outdoors, assuming every house came equipped with a Maytag. In an interview with *Chicago Magazine*, Nancy Gensburg relays the story of one son spotting clotheslines from a train and telling Vivian to look because "the closets are hanging outside." Now, in both black-and-white and color, Vivian documented the world's laundry. Nowhere were the lines more pleasing than on the ship, where crisp

Hanging out onboard, 1959 *(Vivian Maier)*

Laundry lines, Hong Kong, 1959 *(Vivian Maier)*

sheets billowed and sailors' trousers were strung across decks like paper dolls.

Atypically, as she traveled, Vivian marked a portion of glassine negative sleeves with notes related to her technique, a film speed here, an f-stop there. She tried a variety of films and filters, shooting mostly in black-and-white with two different Rolleis, supplementing these efforts with 35mm color shots to capture the visual exoticism she discovered. The prior year Vivian had purchased a Robot Star camera, noting that it had good depth of field, and she brought it along as well.

Interestingly, she composed just a handful of self-portraits during her travels, although occasionally she handed her camera to others, resulting in blurry portraits that feature a relaxed and smiling Vivian. The journey's photos attest to the fact that she fraternized and went sightseeing with her fellow travelers, and there are no signs of the odd, detached woman described in Highland Park. It seems as if Vivian was just being her real self; in her element, she may have felt like she belonged.

After ending the sea voyage in Italy, Vivian made her way to Saint-Bonnet, eager for her homecoming. Soon she had reshot every mountain, stream, and tree that she had photographed before. The villagers remembered her well from her earlier visit, and their observations again paralleled those of people who knew her in New York and Chicago. Her cousin Auguste Blanchard describes that "she wasn't friendly, she was

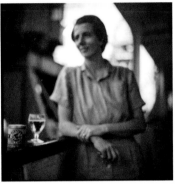

Arrivals, Egypt and Italy, 1959

silent and cold, but everyone just accepted her." According to researcher Paul Vacher, Vivian left a lasting impression as a woman on a mission, flying across the region with multiple cameras dangling from her neck, offering few pleasantries as she single-mindedly pursued her own goals. She would photograph whomever she found interesting, and if met with resistance, she simply shrugged her shoulders and kept on going. Just like in the States, she came and went without warning, and no one could figure out where she ate or slept.

Just a few months before, Prexede Jouglard had passed away in Saint-Bonnet, leaving behind a typical array of old photographs and memorabilia. Upon arrival, Vivian immediately got her hands on these materials and arranged a dozen vignettes to photograph. Some of the images reflect Prexede's siblings in America, and their houses are confirmed as existing in Saugerties, New York. Others are surley portraits of François and Prexede, but no one survives to identify them with certainty. While Vivian may not have known its significance, among the mementos she photographed was a postcard François had sent to Prexede while he was living with Eugenie in New York.

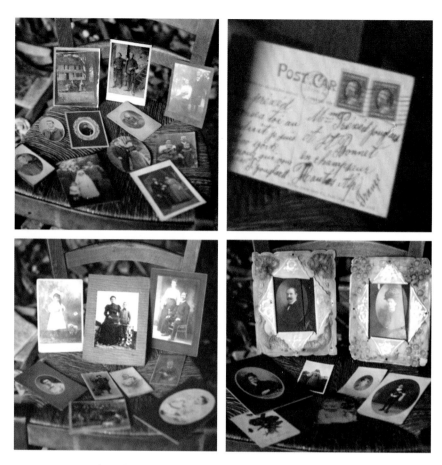

Life with the Jouglards, Saint-Bonnet, 1959 *(Vivian Maier)*

By now Vivian was estranged from all members of her direct family except for, of all people, Grandfather Baille. The old man had lived out his days on his remote farm, unmarried and isolated from the rest of his relatives. Lucien Hugues, forty years younger and living next door, befriended his curious neighbor and was amused that Baille owned only a single pan, which he used for coffee in the morning, to fry up his lunch in the afternoon, and to make soup in the evening. In his own way Baille was a fixture in the valley, harmless but known for his eccentric behavior. He became a sort of French Boo Radley character that children loved to fear and provoke. Highly paranoid, he dug holes throughout his property so intruders would stumble and fall. If this method failed, they would encounter a trapdoor in his entranceway, covert enough that his sister dropped in. He carved out peepholes in his kitchen wall to keep an eye out for trespassers and warded them off with shots from his rifle.

Once, Hugues was poking around inside and behind a curtain found a set of handcrafted oak furniture. Baille confided that it was reserved for his daughter, awaiting her return to the Alps. After all the angst and much too late, he was finally ready to embrace Marie, but in a karmic reversal, now she was the one who failed to show up. Vivian visited Baille at the Gap hospital where he now resided and found him sickly and said to be suffering from dementia. She deployed several rolls of film to photograph each patient in the ward and to take her last pictures of her grandfather who would die two years later, at age eighty-three.

After many months of travel and measureless rolls of film, Vivian was almost out of money. She wrote to soft-touch Margarite Heijjas, asking her to send more. She also sent a letter to Nancy Gensburg, whom she had corresponded with throughout the trip, mentioning her diminished funds and plans for returning to Chicago. Vivian's financial woes were compounded by a visit to the Jaussauds, who demanded she repay the loan they made for her and her mother's return passage to

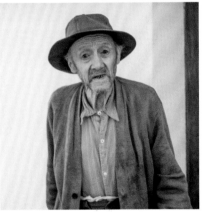

Gap hospital and Grandfather Baille,
France, 1959 (*Vivian Maier*)

America in 1938. Taken aback by this request, she offered up her Rolleiflex, but her relatives considered it of no value and rebuffed the gesture. By the end of the encounter, Vivian had turned over the last of her cash to reimburse the cost of the original ticket, but made no provision for inflation or interest, and the parties separated in a state of ill will. As a result of the dispute, she did not socialize with or photograph the Jaussauds as she might have, but did compose a portrait of Sylvain's elegantly striking father-in-law deftly cleaning a bottle.

Auguste Gras, Allard, 1959 *(Vivian Maier)*;
milkman Férréol Davin, Bénévent, 1959 *(Vivian Maier)*

During her 1959 stopover in the Champsaur, Vivian photographed many of the villagers, just as she had as a fledgling practitioner. The new images reflect her advancement, displaying artful compositions with effective interplay between light and shadow. One features an old friend, Férréol Davin, whom she had known as a child, pouring fresh milk in the partial morning light. The picture is charming enough to look staged, but is in fact wholly authentic: Davin lived in the same house, with the same bucket and dimpled chin, for sixty more years.

While in 1951 Vivian's efforts had been largely represented by landscapes, now graveyards dominated her French portfolio. During the three weeks spent in the Hautes-Alpes, she visited the cemetery in almost every town in the valley and photographed hundreds of individual graves. For drama, the Champsaur's cemeteries put their American counterparts to shame. Each family maintains a square plot they decorate with bouquets, photographs, and personal mementos. Vivian stopped in Saint-Julien, where Maria Florentine rested alone in a corner plot, and made the remainder of the rounds as if she were memorializing everyone she had once known—the Jaussauds, Pellegrins, Bailles, Lagiers, Eyrauds, Bertrands, and many, many more. With nary a stone left uncovered, Vivian departed France, never to return to her home in the Alps.

Maria Florentine grave, Saint-Julien
marker, 2018 (*Ann Marks*); tombstone, 1959 (*Vivian Maier*)

Back in New York, Vivian prematurely cashed in the Lindenberger life insurance policy from 1943, putting $145 in her pocket. During the short visit, she set out to photograph late summer in the city. While her pictures from the

City sidewalks, New York, 1959 *(Vivian Maier)*

stopover are mostly upbeat, one features a destitute man coated in grime with his hair standing on end. Vivian closed in to capture his glazed eyes, which moved in different directions, one looking up at the photographer and the other nowhere at all. The picture is particularly poignant because its subject, intentionally or not, resembles Vivian's brother, Carl.

Vivian had become especially adept at detecting opportunities, enabling her to shoot with an impeccable sense of timing. In Central Park, she freezes a rising balloon the split second it obscures a father's face, shifting all focus to his mesmerized child. Uptown, Vivian lies in wait for sidewalk action, then fires as a boy rolls a tire, so that his playmate magically appears to ride in the tube. With these New York images, she capped her voyage and headed back to Chicago, which had now become home.

City sidewalks, New York, 1959 *(Vivian Maier)*

Women's lib, Chicago, ca. 1969 *(Vivian Maier)*

12

THE SIXTIES

If men can do it, why not women?

—Vivian, on obscene phone calls

Upon Vivian's return to the Gensburgs', it was as if she had never left. Having written letters full of personal references to each of the boys while away, everyone naturally just picked up where they left off. Her maternal instincts quickly kicked back in and gangs of playmates, pumpkin carving, trick-or-treating, and winter holiday celebrations returned to her portfolio in full force. Vivian continued to record the boys' happenings and accomplishments. In a write-up of John Gensburg's school play, her notes are loving, earnest, and attentive, simultaneously provoking an eye roll and a smile. She reports that "John recited his part perfectly" and documents his line of dialogue. She includes that "one little girl forgot her lines," but sought help from the teacher who was backstage, and was able to continue.

Glassine envelopes again filled up with exposures of the boys' day-to-day activities, sporadically embellished with humorous quips: a photo of their artwork was labeled "Pictures à la Picasso," a feline play session classified as "Love affair with 2 cats," and bath time simply "Nudes."

HAPPY DAYS

From all appearances, the years Vivian spent with the family were the happiest of her life. For the first time, she had "long-term" comfort, security, control, purpose, love, and freedom. Her self-portraits continued to showcase a happy, engaged young woman. While she eschewed posing with other adults, many photographs include the boys and even other neighborhood children. Here,

Life is good, Chicago, 1960s *(Vivian Maier)*

every season was full of happiness and adventure. The kids ran home waving their homework, watched snowstorms through floor-to-ceiling windows, and snuggled on couches to view home movies. Their carefree existence was the antidote to Vivian's own childhood.

In Chicago, Vivian continued to pursue celebrities as doggedly as ever and her A-list "gets" grew ever more impressive. She had a direct line to the Playboy Club's publicity department from which she secured tips on where to find VIPs who were in town. Coups included Kirk Douglas, Audrey Hepburn, and Bob Hope.

Kirk Douglas and Audrey Hepburn, 1960s *(Vivian Maier)*

Wrangled with a wink, Chicago, 1960s *(Vivian Maier)*

In the sixties, Vivian's street pictures burst with irony, wit, and warmth as she advanced favorite themes: visual incongruence, connections between mother and child, and resistance to authority. The latter is demonstrated by a matron teasing a straitlaced cop, who tries to ignore her at all cost. Large is juxtaposed against small in a shot annotated "Saw 'giant' for the first time" that features a very tall man shopping with a much shorter companion, while overhead a frou-frou restaurant menu promoting potato puffs, sherbet, and a frothy ice cream soda looms large, dwarfing all but the "giant." Vivian incites a petite lady's glare while recording her oversize choices, from the saucerlike button that fastens her coat to the towering confection of pin curls atop her head. Another shot features a toddler who presses firmly against his mother for safety while dutifully guarding her packages, the tilt of her torso all that is needed to proffer protection. The fun continues with a tall, thin, well-coiffed dog, patiently awaiting a call at a phone booth like anyone else. Fashion and shopping are recurring motifs, and in one image a mannequin peruses the shelves, portraying the pervasiveness and robotic nature of the era's consumerism. Collectively, Vivian's street work reveals a sense of humor that went largely unrecognized in person.

Vivian rejected the notion that the elderly were uncompelling subjects and sought to record their domestic rituals and perishable moments. In one rendering, an older couple sleeps on a train as intimately as they would at home, leaning together, the wife tucked gently under her husband's hat. A comic depiction features a dressed-up pair whose dignity is blown away by a strong breeze, leaving unruly hair in its wake.

Enduring love, Florida, 1960, and Chicago, 1968 *(Vivian Maier)*

Fun in Florida, 1960 *(Vivian Maier)*

In 1960, Vivian returned to Florida with her employers, detouring to photograph the Seminole Tribe before meeting the family at the iconic Fontainebleau Hotel. In Miami, she found Frank Sinatra and Shirley MacLaine premiering in *Can-Can* and caught Jimmy Hoffa just before he entered jail. Among her pictures are those that memorialize the Fontainebleau's classic design and lively cabana action.

Inexplicably, Vivian spent a day on set with Jerry Lewis, who was filming *The Bellboy*. Her eighteen color exposures of Lewis directing a racetrack sequence reveals a closed set with only the actors and crew present. Except for Vivian.

Union Station, Chicago, 1961 *(Vivian Maier)*

Vivian was drawn to scenes of patriotism and service and often photographed uniformed men as they marched in parades and enjoyed city parks. A spectacular 1961 image in Chicago's Union Station pays homage to the country's sailors. The picture is composed so that the building's windows serve as apertures for brilliant, almost divine rays of sunshine that dramatically spotlight the servicemen.

THE ADVOCATE

As the 1960s progressed, Vivian turned more of her focus toward the condition of the world, and political figures leapfrogged movie idols as her celebrities of choice. She ardently documented the glow of the Kennedys

1960 campaigners: JFK with Daley, and Eleanor Roosevelt *(Vivian Maier vintage prints)*; Richard Nixon *(Vivian Maier)*

and the machinations of Mayor Daley's administration over the course of the decade. Chicago was a campaigning epicenter during the 1960 election, and Vivian took advantage of the opportunity to maneuver close-ups of all the key players: President Eisenhower, John F. Kennedy, Richard Daley, Eleanor Roosevelt, and Richard Nixon. The shot she grabbed by jumping in front of JFK's motorcade was identical to the one plastered on Chicago's front pages the following day. When photographing Eleanor Roosevelt, she looked to be in an intimate setting with the legend. Vivian sidestepped barricades and policemen to get close to Richard Nixon, even though she was not a fan. When he was impeached, she gleefully declared, "Nixon had the mug of a loser."

LBJ and Lady Bird campaigning, Chicago, 1960 *(Vivian Maier)*

Lyndon B. and Lady Bird Johnson also joined her collection in a double shot that exhibits the effectiveness of Vivian's occasional second exposure. After a distant capture of the LBJ campaign vehicle lacked distinction, she closed in for a dramatically improved composition. A constituent's outstretched hand leads to the dominant politician, with his diminutive wife primping behind him. Here the subjects are perfectly aligned to accurately depict their real-life positions.

For convenience and flexibility, Vivian began to use high-quality Leica cameras, which accepted interchangeable lenses with a variety of focal lengths. The 35mm-format Leica required less frequent loading and was small enough to fit in a coat pocket or purse. By pairing these instruments with her 120mm Rolleis, Vivian could choose between rectangular and square compositions.

She devoted much of her free time to social justice, whether attending lectures at Africa House, covering Chicago's race riots and workers' rights rallies, or offering support for birth control and abortion. An ardent feminist, she argued that a woman could outdo any man. Yet when sportswear was introduced to meet the needs of modern women and pants were adopted as their go-to apparel, Vivian never wavered from her below-the-knee skirts. In 1965, Vivian watched the hit movie *Mary Poppins*, which she wholeheartedly despised. Her angry notes describe it as "outdated," "a real fiasco," and portraying a servant-child type of relationship. Ironically, the Gensburg family, among others, would invoke

Nanny on nanny, Chicago, 1965
(Vivian Maier)

the fictional nanny as fully representative of Vivian, which they intended as the greatest form of flattery. But obviously, the "practically perfect" cinematic nanny was not her feminist cup of tea.

Street candids chronicled how the era's environment of agitation and transformation was reflected in everyday life. A burned man, literally missing his face, is shown placing a call. Indigents idle on Maxwell Street, grouped together yet isolated, their loneliness reinforced by a single background figure. An upscale couple's fight turns physical as the woman is pinned against a wall, her rage conjuring images of a trapped animal. While Vivian's reflections of racial strife evoked feelings of alienation and angst, she also portrayed the world as she hoped it would be, filled with interracial friends, couples, and colleagues. Ever creatively experimental, she implemented a new photographic approach capturing social opinion, inspired by the era's omnipresent graffiti. She recorded slogans that appeared throughout the city, from "Men must change or die" to "Pigs kill," work that encapsulates forms of expression unique to America in the 1960s. Politics were pervasive, validated by a poster of Robert F. Kennedy that abuts help-wanted signs to form a totem pole of mixed messages.

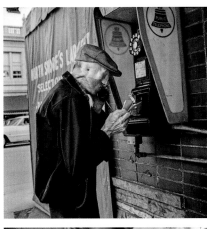
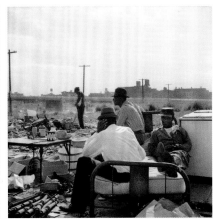
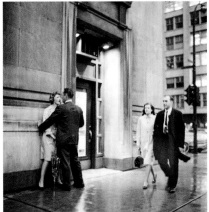

Hot topics, Chicago, 1960s *(Vivian Maier)*

Newspapers, Chicago, 1957–67 *(Vivian Maier)*

NEWSPAPERS

Outwardly, the nanny's life was better than ever. But inside, old issues were brewing. Vivian had become a serious accumulator, mostly of newspapers. Her photographs had long incorporated them in natural situations or in headline montages. But her behavior had become obsessive, as she acquired and stored large numbers of old books, magazines, and especially daily papers. Not surprisingly, the *New York Times* was Vivian's newspaper of choice, representing both her sophistication and her affection for her hometown. Her bathroom overflowed with negatives and newspapers, which eventually made their way into her employer's garage. The Gensburgs considered her a pack rat and remained unalarmed. In truth, a serious disorder, which had lurked under the radar, had begun to surface. Newspapers even showed up in ominous self-portraits, surrounding and even entrapping the photographer.

From the time she lived in New York, Vivian had playacted the role of a photojournalist, and this behavior intensified in Chicago. With a fox-like modus

operandi, she circled her targets and pounced when the moment was right. One unfortunate example of her brazenness occurred in the fall of 1966, when the daughter of soon to-be senator Charles Percy was murdered in her bedroom in a nearby suburb. Attracted to the mayhem, Vivian packed her telephoto lens to join the press in a cordoned-off area at the end of the family's driveway. Set on photographing the crime scene, Vivian discovered it was not visible from the journalists' vantage point. Fearless, determined, and frequently dismissive of the privacy of others, she snuck around the estate to a guesthouse and illegally entered the property to secure her shot.

After she was apprehended by the police and her information recorded, Vivian was escorted from the premises. Undeterred, she walked down the street to the church where the young woman's funeral was shortly to take place. Again, she was spotted by law enforcement who recognized her from earlier and was ultimately arrested for disorderly conduct; the violation was reported in the next day's *New York Daily News*. Her archive does not contain the Percy pictures; perhaps they were confiscated during her arrest. But for months afterward, Percy references appeared discreetly in her photographs in the form of headlines, television coverage of the inquisition, and campaign memorabilia. One wonders what the housewives of Highland Park would think.

Valerie's murder and Vivian's arrest, *New York Daily News*, September 20, 1966

Home movies, Highland Park, 1960s

PARADISE LOST

The inevitable came in 1967: the Gensburg brothers had grown up, and it was time for their cherished nanny to move on. It is understandable that caregivers can have trouble leaving the children they helped raise, and unquestionably, Vivian possessed deep love for the boys. This is visually apparent in home movies that were made along the way, where body language and expressions reveal true feelings. The films would evoke childhood nostalgia in anyone, watching how the nanny transforms the simplest of materials like boxes, ropes, and brooms into infinitely amusing toys. Together, she and her charges play hide-and-seek, read books aloud, examine bugs, swing on vines, and pick strawberries. Though Vivian was usually the filmmaker, one time the camera turns toward her as she helps one of the boys from a tree. She tenderly kisses the side and top of his head, enveloping him in a big bear hug. The warmth emanating from her is almost shocking, a testament that she had let down her emotional guard.

Describing Vivian's departure to John Maloof, Nancy Gensburg stated the obvious: that the nanny would have chosen to stay forever. She readily confirms that Vivian was like a real mother to the boys, but recalls that their parting was anything but dramatic. Vivian simply packed up and left, without revealing her next assignment. It is predictable that the proud, independent woman would be stoic and may not have been prepared for how she would feel. But her outward demeanor apparently did not reflect her true emotions. Vivian was not just losing daily contact with the boys she loved as

her own but was leaving the only stable living situation she had ever enjoyed, and her archive tells the real story. In late 1966, right before her departure, there was a marked change in Vivian's photographic behavior. She began to take pictures of newspapers, page by page, and frantically developed old film, even though her next employer would have a darkroom. Just as newspapers crowded her room, their images now began to clutter her rolls. Her displacement was clearly inwardly devastating and triggered intensified hoarding. The Gensburgs stayed in close touch with the nanny but, through no fault of their own, were totally unaware of her true inner struggles.

Move out, Highland Park, 1966–67 *(Vivian Maier)*

Self-portrait, Chicago, 1976 *(Vivian Maier)*

13

STARTING OVER

I come with my life and my life is in boxes.

—Vivian, to a new employer

ENTER INGER

In March 1967, Vivian began caring for five-year-old Inger Raymond, and remained with her in Wilmette, Illinois, for seven years—her last long-term position. Inger's parents were sold on the nanny from their very first drive together. When Walter Raymond sped through a curve and his car began to tip, Vivian instinctively reached out to protect Inger. Overall, the family felt the nanny was competent and reliable, although sometimes erratic and quick to anger. Mother Margery Raymond worked in a creative profession as photo editor for the local newspaper chain *Pioneer Press*, and her husband was a dentist. There were photographers around the property all the time, but Vivian chose not to engage with them or use the in-house darkroom. For about a year, her photographic momentum and creativity slowed. Her pictures from this time generally lack their usual sense of feeling and vividness. This period seemed to be among her most difficult, as she strived to regain emotional stability after leaving the Gensburgs.

In many ways Inger understood Vivian better than any of her other charges had because she was mature enough to consider her motivations. The nanny bonded with her in a different way than she had with the Gensburg boys. Inger was a chubby only child who was bullied at school and had only one real friend. Just like Vivian, she held underdog status and had loner tendencies. Thus, they moved through life together, enjoying operas, movies, baseball games, and long exploratory walks. Vivian was eager to teach, and Inger was eager to learn. As an adult, Inger remembers the caregiver with affection because of the companionship

they shared, and feels "Miss Maier's" intentions were good. Nevertheless, she acknowledges the existence of a dark side and along with her best friend, Ginger Tam, describes a very different nanny than the one who cared for the Gensburgs.

Inger's parents worked full time, so Vivian, in effect, raised her from age five to eleven, taking the responsibility to heart. She taught Inger how to cook, sew, and pick goodies from garbage cans, while imparting key life lessons. When the Kent State shootings were covered on television, Vivian brought Inger downtown to witness that protests can be peaceful. Hitchhiking to the racetrack, the nanny predicted that no rich people would care enough to pick them up, and sure enough, their ride came in the form of a run-down jalopy. When they dropped into a jewelry store, Inger learned how to discern the quality difference in diamonds. On rare occasions, she was even invited to view slides from her caregiver's travels.

Portraits from the period show the pair at arm's length. There was affection between them, but not a strong emotional bond, no tenderness or lists of accomplishments such as the ones Vivian had kept for the Gensburg boys. Nevertheless, Inger became Vivian's subject of choice, and hundreds of pictures were devoted to their day-to-day activities.

Today, Inger understands that some of their pursuits were inappropriate for a child. Her bedtime stories were authored by O. Henry and "if they ended lousy, all the better." She remembers that during the opera *Madame Butterfly*, "when the woman got betrayed and ended up cutting open her belly with a knife, that really freaked me out. I had nightmares about that for years." An animal lover, she enjoyed their trip to the stockyards, until some of the sheep were trampled and thrown onto a pile of carcasses.

During all her years of accompanying Vivian on photo adventures, Inger had an incomparable opportunity to observe her in action. Her parents respected photography and encouraged their "shooting safaris," Vivian with her Rolleiflex and Inger with a Kodak Instamatic, which was soon replaced by a better camera. The nanny taught her the basics of photography and allowed her to experiment with focus on her Rolleiflex. She emphasized the need for sharpness and contrast. Inger feels that she was referring not just to literal light and darkness, but also to the contrast within a picture's subject matter. In other words, when Vivian photographed a dead bird in the garbage, she was documenting a "dove of peace, thrown away." When she repeatedly shot the same waste can, she was noting how its contents changed each day. Mrs. Raymond offered free Canon cameras to the nanny when her staff switched to Nikons, but Vivian refused them in favor of her Rolleiflex.

Inger, Wilmette, 1967–74 *(Vivian Maier)*

Looking back on their excursions, Inger was most impressed with the speed with which Vivian identified and captured shots. "She would see a subject, open her camera, focus it, and she'd snap. It was just *bam*! It was fast. She went from walking to focus to shoot in under a second. The subject wouldn't even have time to react." Ginger often joined the photo treks and describes Vivian as intense and intrusive, disregarding all privacy concerns when she approached the impoverished or distressed: "It was imposing and rude and I'm sure they felt they were being mocked in some way." She seemed fixated only on her desire to grab the photograph. Later, in a tape-recorded conversation, Vivian told Inger's grandmother that she had recently taken a picture of a fat man in the neighborhood and he became very embarrassed. She expressed some remorse, seeming to care about her subject's feelings but unable to anticipate them in the moment.

Paradoxically, Vivian almost never let anyone take her picture, meeting all attempts with vigorous protest. When one of Mrs. Raymond's photographers grabbed a candid of her for the newspaper *Wilmette Life*, she objected so strongly that it never ran. Another time, Ginger's brother observed a man trying to take a picture of Vivian and she reacted by hitting the photographer with an umbrella. Perhaps she feared that a publicly placed picture could lead her family to her. Alternatively, she carefully curated her identity and may not have wanted to subjugate its portrayal to others.

About a year into caring for Inger, Vivian's street photography was galvanized by the political events of 1968. Following the assassination of Martin Luther King Jr., Chicago became a hotbed of activity, hosting violent protests and the year's contentious Democratic National Convention. No subject matter could be more suited to Vivian, and she settled back into regular picture-taking with less emphasis on everyday people and more on the pulse of current events.

While her street photography became increasingly distanced and abstract, trademark subjects and techniques still comprised a portion of her 1970s portfolio. Moving in tightly, she maintained her approach of using less of a subject to tell more. She was particularly drawn to people's hands. One picture deftly conveys a man's tension without a glimpse of his face just by featuring his twisted gloves. In another, all that is needed to sum up a little boy are his lower extremities. The same holds true for two well-heeled women who are locked in cross-legged symmetry, converted into a threesome when Vivian joins via shadow. An appealing stack of bakery boxes is tied up with string, its carrier merely a prop. The essence of a muscle-bound lifeguard is captured eloquently from behind, as is an ample woman's inability to squeeze onto her side of a bench.

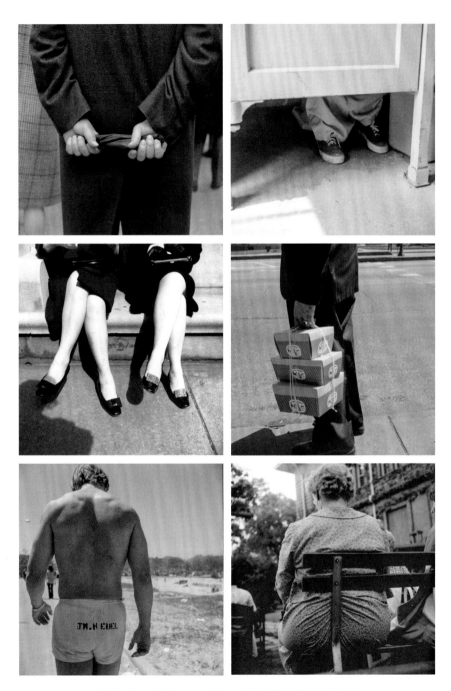

Body shots, Chicago, early to mid-1970s *(Vivian Maier)*

DARKER DAYS

Vivian lived in the Raymonds' guesthouse, in a cozy second-floor space that she decorated with her eclectic collection of artwork, which included three pencil drawings by Dutch artist Willem van den Berg, who specialized in portraits of peasants. In 1971, she invested in a self-portrait by German expressionist artist Käthe Kollwitz, who "dedicated her art to the poor and oppressed, especially women and children." One day, Inger and Ginger snuck into Vivian's room and discovered it was so stuffed with newspapers that the floor had buckled from their weight and there was nowhere to sleep. Soon the collection inched its way onto the back porch, under Inger's bed, and into the basement. To make even more room, the nanny emptied one of Inger's toy drawers and, in the process, threw out the girl's French puppet—a toy Vivian had previously derided as a prostitute because its legs appeared to be shaved. Mrs. Raymond eventually put a stop to the creeping accumulation of newspapers and even considered firing the caregiver.

While the good times far outweighed the bad, Vivian isolated herself more often and displayed periods of moodiness. When she physically disciplined Inger, she did so in anger, and occasionally appeared out of control. Her edges were sharpened; the soft, loving side she had displayed with the Gensburgs was no longer present. Pictures of children and animals diminished. She disliked the family dog, and inadvertently killed the pet parrot, which would fly into her hair, attracted to the petroleum jelly she still applied daily, learning the hard way that lubricants can be toxic to birds.

Ginger considered the situation from a distance and increasingly felt there was something wrong with Vivian. She perceived that the nanny was controlling and had a tendency to take advantage of Inger's good nature and low self-esteem. In retrospect, she thought Vivian may have done her

The late parrot, Wilmette, 1973 *(Vivian Maier)*

friend more harm than good. Inger was, by her own admission, an outcast, and the constant presence of the imposing, outspoken, greasy-looking woman with hairy legs and big hats didn't do much to bolster her social status. At the beach, when Vivian placed an oversize hat on Inger's head and slathered her nose in zinc, Inger appeared more out of place than ever.

The girls also observed Vivian's abnormal reactions to men. On several occasions, she warned Inger that men just want sex and "are out to ruin you." The nanny avoided contact with Mr. Raymond, and when he attempted to hand her objects, she sometimes required him to put them down first so they could avoid touching hands. One day he banged on the table after learning she had force-fed Inger for not cleaning her plate, and Vivian had recoiled in fear.

Another time, a photographer in Mrs. Raymond's employ reached out to prevent the nanny from falling off a tree stump. Vivian turned and "decked him," resulting in a concussion and the need to talk him out of a lawsuit. Subsequent employers would confirm Vivian's overt fear of men, suggesting she may have suffered some kind of abuse during her childhood. It was as if she possessed a form of post-traumatic stress disorder related to potentially threatening men. She wasn't frightened by all males, however, and developed sporadic friendships with younger men with whom she shared common interests. Looking back, Ginger fears that something had happened to Vivian, stating, "I would bet money that she was brutalized in some way, attacked or molested."

Vivian's self-portraits from the period mostly reflected her shadow, and their tenor suggests an internal emotional shift. Before, her depictions had varied in tone, some humorous, some negative, others upbeat. Now a disproportionate number cried out in despair and loneliness via their placement in stark and forbidding environments. In one, created shortly after departing the Gensburgs', a broken branch replaces Vivian's arm, as if she has left it behind. In others, her lone figure penetrates desolate landscapes, conjuring coldness and isolation.

One aspect of Vivian's personality that is particularly difficult to grapple with is her capacity for empathy. Most of the children she cared for noted a profound insensitivity as she made matter-of-fact comments about their appearances, including the dreaded onset of puberty. Yet many admirers find her work to be filled with sympathy and understanding, an impression that may be at least partially driven by her choice to photograph even the destitute and disenfranchised. In fact, when accuracy and authenticity were at stake, most of

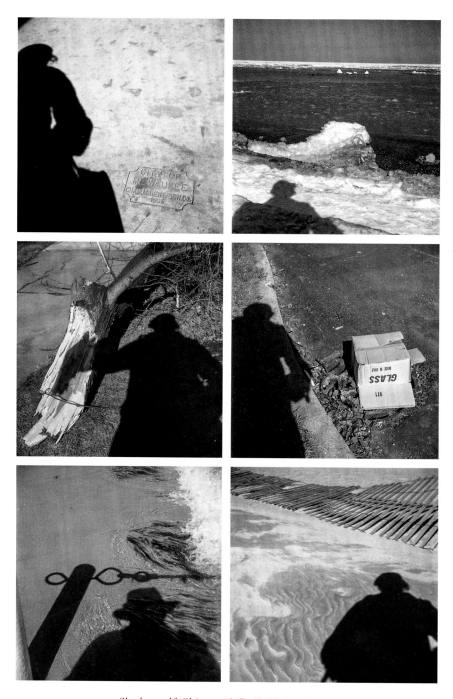

Shadow self, Chicago 1967–68 *(Vivian Maier)*

her renderings were uncompromising and unsympathetic. Lane Gensburg's friend Duffy Levant tells about the time his brother was hit by a car. He lay in the street scared but not seriously injured. Everyone ran to help, except Vivian, who repaired to the sidelines and snapped way. A flagrant lack of empathy is evidenced by a photograph that features Inger with her back turned to three laughing girls. It takes a deeply complicated woman to be willing to detach herself enough to record such a

Mean girls, Chicago, early 1970s
(Vivian Maier)

heartbreaking scene. It's a relief that Inger became a well-adjusted adult.

By the time the Raymonds relocated to South Dakota in 1974, Vivian was suffering from a serious form of hoarding disorder, which would progressively impact most aspects of her life. She continued to stockpile newspapers and photographs, almost all of which she kept for herself. Despite the thousands of images she took during her time with the Raymonds, Vivian left the family with only one, a picture of Inger's grandmother.

Newspapers, Chicago, 1973 *(Vivian Maier)*

Newspaper self-portrait, Chicago, 1977 *(Vivian Maier)*

14

CHILDHOOD: THE AFTERMATH

Never open this door.

—Vivian, to an employer

Trauma is not necessarily caused by a single event, and childhoods can be considered traumatic when abuse occurs over an extended period of time. Drivers include household disruption, divorce, abandonment, emotional or physical neglect, parental substance abuse, or violence. Vivian didn't face just one of these factors, or even several; she suffered them *all*.

She was raised almost exclusively by a woman who was emotionally damaged by her own childhood rejection and subsequent mental illness, and who was unable to even take care of herself. In "Narcissism, Parenting, Complex Trauma: The Emotional Consequences Created for Children with Narcissist Parents," Dr. Donna Mahoney discusses the implications of having a mother like Marie. She explains that while it may seem counterintuitive, such mothers "tend to repeat the negligence of their own parents as a means of trying to repair their own self-esteem." They objectify their children and require them to conform to their point of view to fulfill their craving for self-reinforcement. She ventures that Vivian may have received abundant praise when mirroring her mother and cold criticism when asserting any type of normal individuality or independence. Such mixed messages can confuse children, making them feel degraded and unloved, and inhibit the development of their own sense of self. Some mothers, like Vivian's, eventually repudiate the responsibility of raising their children altogether. Marie's erratic, inappropriate, and narcissistic behaviors are well-documented, and clearly created severe emotional and identity issues for her children.

Physical and sexual abuse can contribute to trauma, and Vivian's behavior suggests that she may have endured this type of exploitation. Almost everyone she

191

knew believed she had experienced abuse of some kind based on her acute fear
of men with periodic flashback-like reactions, her aversion to being touched, her
covered-up androgynous appearance, and her strange warnings to the children
in her care. She would caution young girls against sitting on men's laps and point
out that all crimes of sex and violence were perpetrated by men. Dr. Mahoney and
several other mental health experts were consulted on this issue and confirm that
Vivian's behaviors are consistent with physical and sexual abuse. If such violations
did occur, they could have taken place almost anytime and anywhere, because so
much of Vivian's childhood is unaccounted for. She had a violent father, a troubled
brother with dishonorable friends, and a mother who didn't protect her. She lived
with her great-aunt's abusive paramour in France. The most obvious manifestation
of Vivian's disturbing childhood is her well-documented case of hoarding disorder.

HOARDING DISORDER

In the late 1960s, a perfect storm of circumstances converged to fully expose
Vivian's debilitating hoarding disorder, which was a textbook case in virtually
all ways. Psychoanalyst Robert Raymond explains that a childhood of disrup-
tions and setbacks like Vivian experienced can lead to identity issues and low
self-esteem, with hoarding offering a much-needed sense of control. Such chil-
dren commonly develop trust and intimacy issues and can attach themselves
to possessions, rather than people, to fill a deep emotional void. It is largely
irrelevant that Vivian grew up in poverty, because hoarding is not a result of
inadequate material support, but rather of emotional deprivation. Possessions
provide comfort, and acquiring them is part of the pleasure. Ownership can be
felt as an extension of identity, which made antiques stores, flea markets, and
dumpsters favorite destinations for Vivian.

Dr. Randy Frost, a worldwide expert on hoarding disorder, explains that
hoarders can be highly intelligent, and some are so optically creative that
they may "see and appreciate features of objects that others overlook, perhaps
because of their emphasis on visual and spatial qualities." Vivian mostly accu-
mulated items in the paper category, including junk mail, books, newspapers,
and photographs, which Frost says is especially common among those with
keen visual sensibilities. Such materials offer a myriad of potential connections
and are sources of information that can be later recalled or referenced. Their
physicality—crisp pages and bold designs—provides tactile and visual pleasure.
Varying typefaces and fonts add to their appeal.

Fonts, Chicago, 1961 and 1973 *(Vivian Maier)*

Overt signs of hoarding typically present themselves by age thirty—roughly the age Vivian was when she abruptly refused to share photographs with the McMillan family. At the Gensburgs', she acquired large numbers of magazines and newspapers, and by the time she departed, her space was overflowing with materials. While in New York, Vivian readily shared her photographs, but in Chicago she rarely did, except with the Gensburgs, with whom she felt secure. Otherwise, she kept them for herself and no longer pursued commercial activity or professional relationships. Her pictures fell victim to her increasing compulsion to hoard.

Hoarding disorder is progressive, and without effective intervention it almost always worsens over time, evolving from collecting to clutter to social withdrawal and dysfunction to, in some cases, a full downward spiral. Stressful events can accelerate the progression, and on the precipice of leaving the Gensburgs' employ in 1966, Vivian demonstrated a marked change in behavior by beginning to photograph newspapers, page by page. Her displacement from the home and family environment she had enjoyed for eleven years was destabilizing enough to trigger intensified hoarding.

The Raymonds' descriptions of Vivian starkly contrasted with those of the Gensburgs. Inger and her friend Ginger reported Vivian's withdrawal, erraticism, and bouts of depression. Her room became uninhabitable, filled to the rafters with papers and only "goat-paths" for walking. Vivian slept on the floor, and locked her doors to prevent anyone from discovering her accumulation. Her hoarding was noted by every subsequent employer, as she continued to live in chaotic spaces and isolate herself to prevent inquiries and intervention. Frost indicates that serious hoarders will fill up every space available to them, and by the early 1980s Vivian was spending all her money on storage lockers, where she stashed a combined *eight tons* of newspapers, books, and photographic material.

As the years progressed, Vivian's paranoia in regard to her possessions heightened. She sternly warned her employers to keep away from her rooms and installed deadbolts on doors without fail. Naturally, that made everyone want to look all the more. Vivian confided to her friend Roger Carlson, owner of Bookman's Alley, that people were spying into her window with binoculars and that her employer's children were going through her belongings. She took him home to show how she had rigged her desk to catch perpetrators if anything was moved. This was an era when few understood hoarding disorder—much less how to help. The idea that *Hoarders* or *Buried Alive* could be fodder for television entertainment was far in the future.

Vivian was fired from multiple jobs as a direct result of her hoarding, and all her employers knew that she had some type of personality quirk or mental

illness, which created an inevitable and often uncrossable divide between them. When one employer gave away just a few copies of the *New York Times* that were stacked on the back porch, Vivian became hysterical. Hoarders can be rational and high-functioning in most ways, but are unable to recognize the irrational value they place on their collections, or acknowledge the resulting difficulties. Believing that their hoards comprise irreplaceable sources of information and satisfaction, they become increasingly protective, anxious, and paranoid in relation to their belongings.

HOARDING: PHOTOGRAPHS AND NEWSPAPERS

Frost noted that Vivian may have been vulnerable to collecting newspapers because of her keen aesthetic sensibilities, particularly in regard to pattern, shape, and texture. In a sense, the very source of her talent, her ability to see so much in the mundane, contributed to her need to accumulate. She did specifically emphasize graphic elements in her photography, from bocage—the patchy plots that made up French farmland—to the tangled materials embedded in construction sites. Her intense visual focus enabled her to elevate shots of the banal to images of geometric beauty, whether mesh trash baskets, mattress coils, or tumbling boxes. Photography design expert Elizabeth Avedon believes Vivian possessed an innate ability to "recognize patterns, to arrange and compose space, and eloquently distribute light and gesture within the frame." Vivian's visual sensitivity and quest for knowledge made the hoarding of newspapers, which provide so much pleasure at such little expense, an obvious choice.

Along with newspapers, Vivian of course hoarded photographs, which offered many of the same satisfactions. Frost explains that like newspapers, which capture events for posterity, photographs freeze objects and moments in time so they can be physically possessed: enjoyed, remembered, or just owned in a variety of forms. Just as Vivian could not part with her newspapers, she increasingly held on to her photographs.

If there is any doubt that photographic material was part of her hoard, the proof is that she treated photographs exactly like she treated newspapers. She placed prints into binders just as she filled binders with precisely clipped newspaper articles. She interspersed arrangements of cheaply framed photos and newspaper articles around her room. Entire newspapers, stacks of prints, glassine sheets with negatives, and rolls of undeveloped film were placed into cartons, to be stored away and never retrieved. Some items were packed with

Shape, pattern, and texture, 1950s *(Vivian Maier)*

Stored clippings and prints *(John Maloof)*

care, others thrown together with no order or protection. Every year, Vivian collected more newspapers and produced more photographs and, as she ran out of space, rented more storage lockers. It was imperative, whether she could afford it or not. She knew she was talented, liked her own work, and periodically toyed with restarting her career, but sharing her photographs had become impossible. The form in which she saved images was inconsequential to her: prints, negatives, and undeveloped rolls were just different ways of achieving the same goal. Vivian had the resources to process her film, had she wished to do so. But ultimately, her need to possess was greater than her need to see her pictures.

BEYOND HOARDING

Dr. Mahoney explains that Vivian may have also been susceptible to other disorders, especially with existing mental illness in her family. Her brother was definitively diagnosed with schizophrenia, and her mother almost certainly had a history of some sort of mental illness. Many felt Vivian's grandfather Nicolas Baille may have also, based on his antisocial behavior and extreme paranoia. It can be safely assumed that Vivian did not have DNA on her side, and that she too was vulnerable to mental illness. After an extensive review of material relevant to the photographer and her family, Dr. Mahoney hypothesizes that in addition to hoarding disorder, Vivian may have had her own form of a personality disorder. While posthumous diagnoses can be fraught with inaccuracies, Mahoney notes that Vivian's behavior presents as a classic case of schizoid disorder, which is prevalent in families with a history of schizophrenia but is an

entirely different condition. With schizoid disorder, there is a break from peo-
ple, and with schizophrenia, a break from reality.

Schizoid personality results in behavioral and identity issues that can stem from
factors particularly relevant to Vivian: genetic vulnerability, inadequate fulfillment
of infant needs, and narcissistic parents. The disorder is defined in the *DSM-5*, the
authoritative American psychiatric manual, as "a pervasive pattern of detachment
from social relationships and a restricted range of expression of emotions in inter-
personal settings." Diagnosis requires demonstration of four of seven criteria, and
Vivian manifested *all seven*: lack of desire to form close relationships (even as part of
a family), choice of solitary activities, little interest in sexual experiences, lack of close
friends or confidants, indifference to the praise or criticism of others, emotional cold-
ness or flattened affect, and pleasure in few activities. Regarding the latter, Vivian
did deeply enjoy solitary activities, but not those that were social.

In lectures on schizoid disorder, Dr. Mahoney indicates that individuals can
be highly functional and often develop compensatory qualities, such as authorita-
tiveness, strong opinions, self-sufficiency, and perfectionism as a means of survival,
all of which apply to Vivian. She explains some "exhibit an inability to know their
own feelings or to make sustained social contact. Deeply ambivalent, they crave
closeness yet feel the constant threat of engulfment by others; they seek distance
to reassure themselves of their safety and separateness." Those who experienced
sexual abuse are known to "purposively make themselves unattractive to conceal
the sexuality they consider dangerous. Women can posture themselves as mascu-
line and powerful to repudiate their underlying femininity."

Whether Vivian suffered schizoid disorder or another condition, the po-
tential effects explain so much: the inability to form relationships except with
elderly women and children, the emotionless veneer, and the repellant presence
conjured through oversize male clothing, aggressive movements, and a coating
of Vaseline. The *DSM-5*'s international counterpart, the *ICD-10*, adds two
additional criteria to the diagnosis of schizoid disorder that are also relevant to
Vivian: insensitivity to prevailing social norms and conventions (unintentional),
and a preoccupation with inner experience and fantasy. Many adopt a rich
fantasy life as a coping mechanism, and for Vivian this was evidenced by her
escapist interests: celebrities, film, travel, and, most predominantly, role-playing.
Clinical schizoid expert Dr. Ralph Klein explains that role-playing is a form of
relationship by proxy that "permits schizoid patients to feel connected, and yet
still free from the imprisonment in relationships." In other words, while Vivi-
an's hoarding formed an external relationship with possessions, her role-playing

existed as a form of internal relationship. Photography afforded another type of relationship: the ability to establish connections at a safe distance.

ROLE OF PHOTOGRAPHY

The dichotomy between Vivian Maier's outward presentation and the unmistakable sense of humanity embodied in her photographs can now be better understood. Photography served as an outlet to express her beliefs, feelings, and deep understanding of the human condition, resulting in a vast body of work that reflects universal truths and wide-ranging emotions. Vivian's photographic lexicon derived from a myriad of influences, but logically, a portion of her subject matter was inspired by her childhood experience. For instance, elderly women made frequent appearances in her work and were presented in a positive light, while men of all ages received more derisive treatment. Other areas of pictorial focus seem to reflect basic desires that she was unable to fulfill herself: friendship, maternal love, intimacy, and even detours into X-rated subject matter.

Dr. Jean-Yves Samacher, director of the Freudian School of Paris, and his son, Dr. Robert Samacher, coauthors of the scholarly article "Vivian Maier, ni vue ni connue" ("Vivian Maier, Neither Seen nor Heard"), postulate that the negative themes that surface in Vivian's portfolio—including death, violent crime, demolition, and garbage—represent subconscious reflections of her low

Garbage, Chicago, 1966 *(Vivian Maier)*

self-esteem. While it is impossible to definitively discern the underlying drivers of this choice of subject matter, it is interesting to consider why Vivian photographed a horse bleeding out on the street, a cat flattened by a car, and a self-portrait associating herself with trash.

ROLE OF SELF-PORTRAITS

Self-portraiture served as a nonthreatening vehicle for Vivian to create juxtapositions, explore her identity, and establish her presence in real time. Thus far, more than six hundred such portraits have been found in her archive, and each time it is examined, additional examples are spotted. The sheer quantity of these renditions demonstrates a need to communicate and participate, and collectively they provide touchstones for viewing Vivian's changing self-image and state of mind. Undoubtedly, psychoanalysts could have a field day with these self-depictions, and they may be vulnerable to overanalysis. Surely, many were composed as a means of experimentation and enjoyment. Yet a chronological review of all of Vivian's self-portraits verifies that psychological forces were at least partially in play. There is strong correlation between their content and tenor and her corresponding life events.

Vivian's presentation in her self-portraits progresses from that of a conservative Frenchwoman to one of a serious photographer. Most renditions that she printed and kept for herself came from her years in New York. Portraits at the Gensburgs' generally portray Vivian as the content nanny that she was, and she frequently posed with the boys, confirming their strong connection. During her travels, she reflected similar contentment. However, as the 1960s progressed, she adopted a contrived presentation of oversize coats and large floppy hats, rendering a distinct, unmissable silhouette, an imprimatur she left wherever she went. In reflective self-portraits she purposely appeared impassive, as if masking her real being, and by diverting her gaze, she rendered herself even more inaccessible. Some pictures show her practicing this countenance in the privacy of her bathroom mirror. For a period after departing the Gensburgs', she presented herself in stark and ominous environments, even though contact sheets reveal there were often others nearby.

Over time she reverted back to a more humorous and upbeat approach. In one example she attaches herself to JFK, and in another she goes head-to-head with a bathing beauty. Anne Morin, a researcher and curator of the photographer's

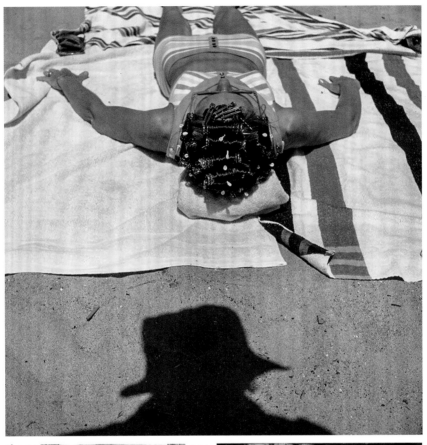

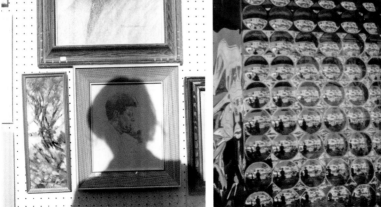

Vivians, Chicago, 1970s *(Vivian Maier)*

work, describes shadow portraits as "a doubling of oneself in the negative, creating a simultaneous presence and absence" and believes that "self-portraiture allowed Vivian to produce irrefutable proof of her presence in a world where she seemed to have no place." To this end, it is no surprise that Vivian incorporated multiple likenesses of herself into individual photographs with concoctions that are at once clever and ironic. One displays fifty-four Vivians; another uses a sequence of circular mirrors to reflect her likeness into infinity (see page 201).

As Vivian's hoarding intensified, she began to feature newspapers in self-portraits, revealing that she was at least subconsciously aware of her condition. In the mid-seventies, she composed a pair of self-portraits that approached newspapers in opposing ways: one portrayed them as a threat by smothering her distinct silhouette, and the other made light of her obsession by whimsically employing a floating newspaper and floppy hat to stand in for her physical self. In these ways Vivian acknowledged the disorder that she could not face in real life.

With immense strength of character and perseverance, Vivian developed compensatory qualities and coping mechanisms, like photography, to manage her mental health issues. Perhaps now, her off-putting qualities may be reconsidered through a more forgiving lens, as manifestations of her upbring rather than the behavior of an antisocial oddball. Buried under her protective armor were her own needs for intimacy, friendship, and acceptance. She functioned quite well under the circumstances, and when things didn't work out, as was almost always the case, she picked herself up and found a new way to secure independence and pleasure. As she aged, despite periods of melancholy or frustration, she remained vital and active, taking photographs on most days and going out many nights. In fact, the majority of the time she appeared remarkably happy. None of her employers could recall that she ever voiced dissatisfaction with her circumstances, and until her old age she was filled with enthusiasm and a desire to live each day to its fullest.

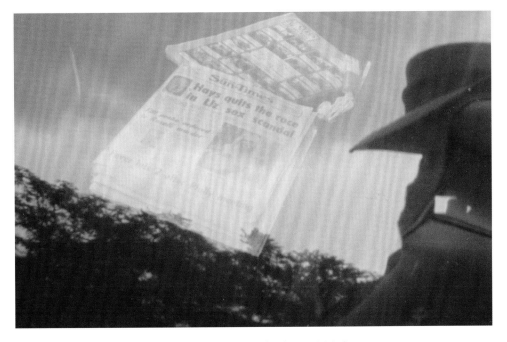

Alter ego, Chicago, 1976 *(Vivian Maier)*

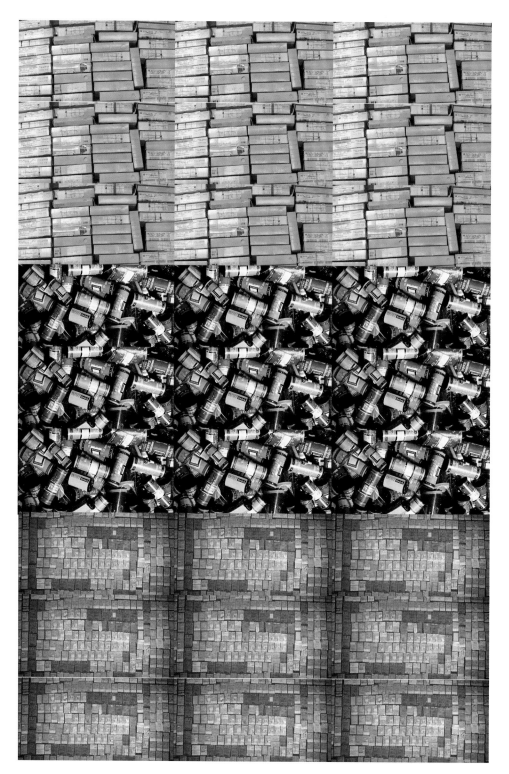

Mixed materials (*John Maloof*)

15

MIXED MEDIA REBOUND

Please do nice work. Very Important!

—Vivian, from her lab instructions

By 1974, as she approached age fifty, Vivian was ready to face a less-predictable future. Her employment would become more transitory, but her photography was reenergized when she concentrated her efforts on 35mm cameras and color film. She was always attentive to trends and sought to remain technically and intellectually contemporary. New York gallery owner Howard Greenberg is impressed that "she seems to be aware of what's happening in photography, street photography in particular, as she goes along. She is working within the confines of what she is interested in, but also of what the visual style is that is going on."

Shooting more graphic and event-based pictures, Vivian had a diminished need for clandestine photography, and began to favor Leicas. She bought them used and then battered them to such an extent that they required regular repair. Each died a slow death, after which she sought a replacement, yet as with almost everything else she owned, she saved the broken models. She also collected vintage cameras and accessories, many of which were recovered by John Maloof and donated to the University of Chicago, where they are now archived (see page 217). One is a duplicate of the instrument her mother owned in the early 1930s. Her 1970s address book contained no telephone listings from the New York area except for the *New York Times* delivery number and the New Jersey Leica dealership.

With the availability of new and improved film, Vivian increasingly shot color slides. Her work continued to reflect her intuitiveness and skill, but with the added dimension of color, she could intensify irony and juxtaposition, while unifying disparate visual elements. At their best, the color exposures would

Vivian's Rolleiflex and Leica *(John Maloof)*

be unsuccessful if rendered in black-and-white. Vivian moved forward with the times, capturing everything from the era's escalation of racial conflict to its Day-Glo hues and unfortunate fashions. With additional exposures per roll and the ability to fire off successive shots, she was less stingy with film and more frequently covered setups with multiple frames.

A news junkie, Vivian's obsession with the Watergate scandal was bottomless. While her portfolio reflects a range of political opinions, the majority of her images are decidedly leftist. She held a mix of communist, socialist, and libertarian beliefs, and she developed an intolerance for certain conservative politicians and positions, such as gun rights advocacy. If her employers received literature counter to her own dogma, she would occasionally steal their mail: a cache of unopened Republican letters and pamphlets addressed to some of them was found in her storage locker. Much of her work during the seventies reveals her fascination with slogans and signage. She readily embraced the concept that "the medium is the message" by taking thousands of pictures of Chicago's graffitied surfaces. The graphics were executed in vibrant color, and Vivian found ideas that supported her activist and ironic perspectives around every corner. Use of marijuana was pervasive enough to be promoted on a garage door in suburbia. The upbeat suggestion to "just put on a happy face" suffers from its presentation on a sad sign stained with age. The idea that "people hate truth even more then [sic] the devil" is tossed in the trash and the demand for Nixon's impeachment is rendered in bloodred. Mostly, Vivian shot what she deemed clever and humorous.

Graffiti, Chicago, 1970s *(Vivian Maier)*

Marginalized, Chicago, 1959 *(Vivian Maier)*

Naturally, racial issues can be powerfully presented in color, and as early as 1959 Vivian used color film to document tensions in the city. One poignant example centers on affluent white businessmen in front of Chicago's city hall, their presence graced by an American flag. On the other side of the street, two young African American women frame the visual, blurred and on the margins. Unlike their oblivious counterparts, they glance suspiciously into Vivian's lens. This single composition effectively encapsulates the racial dissonance brewing in downtown Chicago.

Divided together, Chicago, 1977 *(Vivian Maier)*

Vivian spent many years covering the racial divide, and in 1977 recorded what must have struck her as a troublesome tableau on a train platform. A trio of white commuters form a cluster while one, a young preppy girl, turns away from the African American woman sharing her bench. A virtual wedge separates the pair. The Black woman sits sideways, in isolation, with clasped hands and downcast eyes. The pinkish-purple colors in the three women's apparel ironically offer a touch of visual unity, while compositional diagonals connect the two women and the teen and man.

Stacked, Chicago, 1977 *(Vivian Maier)*

Old hands, Chicago, 1972 *(Vivian Maier)*

Yellow fever, Chicago, 1975 *(Vivian Maier)*

Balloon man, Chicago, 1971 *(Vivian Maier)*

Through color treatment, Vivian enhanced the visual complexity of her work. A matron serves as a kaleidoscopic foil to the repetition of black and white found at a newsstand. Vertical columns, each built from horizontal elements, draw the viewer from front to back. The lady's garment is constructed from strips of brightly hued and opposing patterns that line up to simultaneously mirror and contrast with the physical newspapers. The artful combination of sameness and difference vibrates and entertains the eye. The visual temperature of color is used to fully capture the affection of an elderly couple. Their cool-hued torsos serve as a frame to intensify the warmth of their sun-dappled, entwined flesh. The woman dominates with a sturdy arm and overhand clutch, rendering an unexpectedly sensual effect.

Incongruence was effectively heightened by color. Vivian must have been struck with laugh-out-loud amusement when she encountered a curious trio attired in smiley-face yellow, moving along in frowning formation. A grayed-out vendor appears cemented in place, wrapped in a cocoon of bright, frolicking balloons. A photograph of a candy-apple-red convertible takes the driver's perspective, the steering wheel and rearview mirror beckoning. Daisies dancing in the backseat are along for the ride. None of these evocative images would work in black-and-white.

Summertime, Chicago, 1978 *(Vivian Maier)*

PROCESS PERFECT

Vivian remained largely uninterested in film processing, and with color she completely outsourced the task, while more than closely supervising it. The scores of envelopes left behind confirm that her photographic confidence and sense of authority never waned. Comments are firm, critical, repetitive, and frank. She would rate the content of photographs on return envelopes "*asi-asi* [sic]" ("so-so" in Spanish) or "*bon*" (French for "good"), or highlight specific gets. Invariably, the number of images is noted, proof of her success in squeezing additional frames from a thirty-six exposure roll. Now and then a funny comment shows up, such as "gaga roll" or "some goodies."

Perhaps the most fascinating aspect of the processing histrionics is that in almost all cases, the only person who would see the finished product was Vivian herself. She ordered enlargements to file into her spiral-bound portfolios and to place in plastic frames to display in her room. As with her black-and-white prints, she frequently requested that color images be cropped vertically for heightened subject focus.

Vivian Maier's processing notes, 1970s and '80s *(Vivian Maier)*

Full images and cropped images, Chicago, 1970s *(Vivian Maier)*

Vivian Maier Photo Envelopes
Samples of Processing Instructions

"Silk with border print lighter full frame"

"Print regardless (out of focus)"

"Mixed surfaces: E/and Glossy"

"This is underexposed—make print as light as possible"

"Crop forward only, not top of arch"

"Please include full reflection in mirror on left side"

"Print—stop deeper"

"Please nice work"

"Print lighter. Dull surface. Matt /w borders"

"Matt not silk not glossy. Please do nice work. Very important"

"Do not cut edges, top, bottom or sides"

"All color—Most not crop"

"E/with borders clean, dust negs"

"Borderless silk"

"Best you can do"

"Vertical, cut inside of the lamp"

"Matte finishing—no silk finishing"

"Use only glossy paper but remove gloss to get matte finish"

"Don't substitute paper. Print darker"

"Remake matte not silk"

"Print lighter not silk/not glossy"

"DO NOT CROP!"

"Print light as possible. Special deal"

"Glossy without gloss—use textured"

"Silk full frame with border"

"Nice work appreciated"

"Please redo. Customer not satisfied too dark. Print lighter."

"Use glossy paper without gloss shine"

"Do not use any other paper (Y or W or E)"

"Do best job so no redo!!"

"No borders on enlargement"

"Customer is very particular!!"

Photographic Equipment Donated to University of Chicago
John Maloof Collection

Kodak, Retina IIc, camera, 1954–1958

Camera with lens and filter attached, Zorki 3-C, USSR, 1955–1956

Camera in leather case, Bell & Howell Filmo, USA, 1939–1952

Camera, Igahee Exakta VX 4.1, Dresden/East Germany, 1951–1953

Camera, Graflex 22, USA, 1951–1955

Camera, Keystone B-1, USA, mid-1930s

Lens board with Schneider Optik (lens), Bad Kreuznach/West Germany

Camera case, Leica/Leitz, leather, West Germany

Camera accessory case, leather, Switzerland

Folding viewfinder in leather case, Weiss, West Germany

Macro adapter in leatherette case, Vivitar, Japan

Lens shade and adapter ring, assembled together, Tiffen Series

Close-up lenses (3) in leather case, Kalimar, Japan

Lens, anastigmat, FR Corp., New York

Adapter, Elmar/Ernst Leitz, Wetzlar/West Germany

Plastic lens case, Franke & Heidecke/Rollei, Braunschweig/West Germany

Lens hood Kodak Series V, USA

Viewfinder, Ernst Leitz, Wetzlar/West Germany

Lens hood and adapter ring, including Kodak Series IV, USA

Camera, Bell & Howell Filmo with lens and lens hood, USA, 1939–1952

Camera, Kodak, Rainbow Hawk-Eye No. 1, Rochester, 1920s–1930s

Cameras (2), Kodak Baby Brownie Special, Rochester, 1930s–1950s

Flash, Rolleiflash, West Germany

Filters (3) in plastic case, Tiffen (case), EdnaLite (filters), USA

Filters (3) in plastic case, Tiffen, Prinz, Harrison, USA, Japan

Viewfinder in leather case, Japan, Switzerland

Photographic developing thermometer, Kodak, USA

Film canister in packaging, 8mm, Bell & Howell

Leatherette case from Rolleikin adapter, West Germany

Telephoto Leica lens in bakelite, Ernst Leitz case, West Germany

Meier Premium Sheet Protector boxes (2), USA

Kodak Mini-Poster and poster print boxes, USA

Von Lengerke & Antoine box, Chicago

MOTION PICTURES

Vivian experimented with home movies in the 1950s by filming the Gensburg boys running through sprinklers, igniting fires with mirrors, creating shadow portraits, and sucking on Popsicles. As her interest in the medium developed, she ventured out to make several hundred color 16mm and Super 8 short films, mostly taken in downtown Chicago. Her general approach was to stand in one place and allow the world to unfold around her without narration or much camera movement, and the result bears a strong resemblance to her still photography. Curator Anne Morin describes the link: "She observes, stops intuitively on a subject, and then follows it. Rather than physically moving in to focus on a detail like someone's legs in the middle of a crowd, she zooms in with her lens." Vivian frequently filmed from behind, closing in on unusual couplings, pedestrians walking arm in arm, and a wide assortment of chubby legs and oversize derrieres.

Most of Vivian's films were created during the 1970s and fully capture the era's unflattering sideburns and pervasive plaids. Like her photographs, much of the content focuses on day-to-day life on the streets. Familiar subjects abound: theater marquees, newspaper headlines, and a myriad of signs and hats. In fact, the imagery is so similar to that of her still photographs it can be argued that the medium adds minimal depth to her oeuvre. She typically carried her Leica as she filmed and occasionally duplicated images. The most compelling contribution of her film experiments may be the real-time opportunity to follow how and why subjects catch Vivian's eye.

Certain scenes did benefit from video coverage. By panning across Monroe Street, she could capture its X-rated offerings in a single clip, memorializing such gems as *Without a Stitch* and *Weekend with the Babysitter*. A procession of sheep marching to slaughter, oblivious to what is in store, provides some heart-wrenching footage, while a long sequence of briskly stepping feet effectively captures the collective rush of commuters. Shoots of local events leave the impression that Chicago hosts far too many parades; among those that Vivian covered were celebrations honoring veterans, Girl Scouts, Christmas, and space travel, to name just a few. She seemed to genuinely enjoy the fanfare, the hokier the better, but her interest was more in the spectators than the marchers. At the Apollo 15 festivities, she spent just two minutes on the astronauts and seven minutes on related preparation and cleanup.

Vivian returned to criminal coverage after a young mother who had

advertised her babysitting services was found dead. The woman secured a job interview and brought her eighteen-month-old baby along. The prospective "employer" brutally murdered her and sexually assaulted her baby, who then choked to death on her own vomit. Most would find this story so horrific they would flee from the details. Vivian, however, was drawn to the drama and dispassionately filmed the aftermath, recording newspaper headlines, the supermarket that had posted the woman's ad for employment, the young family's house, and the exterior of the funeral home as mourners arrived. Such events gave Vivian the opportunity to step into the shoes of a crime beat reporter.

Some of her films are so devoid of action that the choices are puzzling. While the cityscapes Vivian photographed from tour boats effectively showcased Chicago's spectacular architecture and bridges, her films of the same subject matter, with their long takes and absence of action, were much less engaging. Likewise, her films of theater productions, political speeches, and music solos suffer for their complete lack of sound.

Home movies (*John Maloof*)

TAPE RECORDINGS

The most enduring impressions of Vivian Maier have largely been driven by people's recollections of her physical attributes and countenance, and in that context, her tape recordings are showstopping. Conducted mostly in the 1970s, her taped conversations with children, employers, and acquaintances reveal a person wholly at odds with the physical descriptions that define her. These recordings may well provide the most accurate portrait of Vivian's personality, offering unadulterated exposure to her impressive conversational skills, vast array of knowledge, striking sense of humor, and insatiable interest in others. Particularly impressive is that these recordings were made at the same time Vivian was suffering employment displacements and escalated hoarding, yet she registers as high-functioning, enthusiastic, and happy.

In 1973, Vivian used her portable tape recorder to capture a conversation with Inger's maternal grandmother, whose family emigrated from Scandinavia to settle in Montana as pioneers. Vivian's intellect and curiosity are on full display as she probes the woman on the region's education system, teachers' salaries, the presence of Native Americans, and anti-European sentiment. She delights in the answers, intrigued that in an atypical switch, some relatives eschewed Catholicism for Quakerism. When the grandmother told her that one relative had too many children and gave one away, Vivian was taken aback, especially upon learning that the birth parents never attempted to see the child again. When the family tree becomes too confusing, she quips, "This is all too Norwegian for me." She punctuates the exchange with her own beliefs, like "Herbert Hoover may have been in the wrong place at the wrong time, but he paid for his mistakes." She sagely observes that he passed money to the rich believing "it would trickle down to the poor," adding, "Of course, it doesn't work that way."

After Inger moved away, her paternal grandmother remained in Chicago, and Vivian visited her in a nursing home and taped their long conversation. The ninety-four-year-old woman sings songs in Hebrew and German and reviews the history of her family while Vivian delves for details. When her elderly interviewee repeats stories, Vivian patiently steers her back on course each time. Though she made no effort to contact Inger herself, Vivian references her with familiarity and affection.

Likewise, in a 1976 recorded exchange with employer Jean Dillman, a frail young mother recovering from an accident, Vivian is upbeat and kind, and works hard to help the woman regain mental agility. They tease and laugh as Vivian quizzes her about the events of the day and proffers a guess regarding her height. Her estimate of five feet ten is correct, and Vivian confides that, at *only* five feet eight, she wishes she were that tall. Amusingly, the nanny, who is universally perceived as a giant, doesn't think she is tall enough. The conversation veers toward burials and Vivian explains that Italians bury loved ones aboveground because they have trouble letting them go. She sums up her fatalistic attitude with, "Nothing is meant to last forever. You have to make room for other people."

Primarily hired to care for the recovering woman's four children, Vivian casually mentions that she will be leaving the following week. When Mrs. Dillman asks why, she references another job commitment instead of burdening her with the truth: that she had been fired by Mr. Dillman for complaining that

their children were wild. Vivian doesn't seem bothered about her status in any way, and the conversation shifts to hilarious tales about responses she received to her ad seeking employment. One man who called didn't have children—he just wanted to hear the caretaker's voice. She referred him to the library to find a way to fill his time. Another respondent asked to interview her—of all people—in the nude, to make sure she didn't have hang-ups. She suggested that he advertise in a nudist magazine to target the right person. Finally, when a female caller spewed obscenities into the receiver, Vivian quipped, "Equality—if the gentlemen do it, why not the ladies?"

This particular conversation ended so that Vivian could interview a neighbor who had met screen legend Rudolph Valentino at a bank in 1925, and the recording is particularly revealing. As the host, Vivian formally introduced the session by stating her desire to get the story "right from the horse's mouth." The conversation veers from the neighbor's disappointment that the star wore brown shoes with a black suit to the worry that legends no longer look "fresh." Vivian, clearly an aficionado, rattles off obscure details about the matinee idol and clarifies that he was not a homosexual, but rather a well-known escort of lonely ladies who wanted a well-bred man, not an uncouth one like those in America. Her comments on the attractiveness of specific male movie idols expose a new side of Vivian.

During the interview, which at times becomes a monologue, Vivian alludes to her own unusual reactions and behaviors as if they were the norm. When the topic turns to Howard Hughes's death, which had occurred the day before, Vivian breathlessly exclaims that after learning the news, "I was flabbergasted," as if she knew Hughes personally. Such a dramatic reaction to the death of a sickly seventy-year-old man seems strange and misplaced. She next shares her eagerness to shoot the headline announcing his death, ideally from more than one paper, referencing her compulsion without pause. She finishes off the topic with one of her humorous quips: "For someone afraid of germs, he hadn't lasted very long."

The session ends with a string of declarations from Vivian: "There is no mental stimulus in Los Angeles" and "It's a pathetic city." Chicago is a "good happy medium, but it's still peasantlike." New York is everything, the best place in the world, but those that fail to take advantage of its offerings "lead dull lives. They have no imagination." After departing, Vivian went to a vending machine to purchase the *Chicago Daily News* and then gathered her employer's *Chicago Sun-Times* and *Chicago Tribune*, spread out all the front pages and

interior articles related to Hughes, and took multiple photographs of different arrangements.

Vivian's liberal and feminist perspectives pervade her work in all media. While most who met her assumed she was asexual because of her prudish appearance and aversion to touch, her portfolio is dotted with strip clubs, X-rated marquees, pornographic slogans, and buff-bodied construction workers. The day Nixon was impeached, she excitedly recorded her neighbors' reactions, and when one woman hesitated to answer, Vivian egged her on with, "Come on! Women should have an opinion, I hope!" If anyone offered even a hint of support for Nixon, she firmly dismissed their views and spewed counterarguments. Vivian's tape recorder afforded her the opportunity to role-play as a self-appointed Barbara Walters, except with a lilt instead of a lisp. With her first-rate interviewing skills, she could have given any newscaster a run for their money.

PERMANENT CHANGE

During the mid- to late 1970s, Vivian moved five times in six years, a marked contrast to the previous eighteen years, which she had spent with just one change in residence. Her working life now resembled the one she had in New York, with shorter-term assignments and less-than-favorable partings. Almost anyone would feel disoriented by such constant uprooting, but Vivian had been raised in a family where moves were the norm, and she readily adapted. She was enjoying a life filled with movies, plays, shopping trips, and visits with the Gensburgs, who continued to treat her like family, even flying her to Atlanta for one of the boys' college graduations.

In 1976, Vivian became the nanny for talk show host Phil Donahue, who had recently divorced. He recalls that she photographed him at the end of their

Donahue days, Chicago, 1976
(Vivian Maier)

coffee shop job interview, and the image was found in her archive, taken in both color and black-and-white. While in his employ, Vivian regularly watched and recorded him on television and kept her journalistic tools ready to take to the streets. By the time she left, she had shot page-by-page pictures of Donahue's photo albums, occasionally throwing in bananas for a splash of color. She would continue to follow his activities through the decades, photographing stacks of his biography in bookstores and framing a newspaper article featuring his proclamation that women were underestimated in television.

Vivian's final position of the 1970s was with a family that remembers her in mostly negative terms. The grown children recall that the nanny was "very greasy looking, with hair flattened on her head." They felt that Vivian was not nice and warm like caregivers should be, and that she "terrified" them. Unlike the Gensburg boys, these children rejected her ideas, like throwing a picnic in the snow. Vivian was clearly uncomfortable in this household and never carried a camera in front of the family, even though her employer was a photographer and had a darkroom. One day, she walked into Vivian's bedroom and found almost every inch filled with stacks of newspapers. She concluded that these posed a serious fire hazard and that "there is something wrong with this person." To be fair, anyone would be disconcerted to discover that their caretaker lived in such conditions. After almost three years, it was once again time for Vivian to go.

In opposition to the family's recollections are four recordings Vivian made with the primary school–age boys she cared for. The children in no way sound terrified, although they do try the nanny's patience with uncooperative and obnoxious behavior, typical of young boys. She goes to great lengths to entertain and develop them, listening closely as they read books, practice plays, sing, and quiz each other on scientific facts. Together they learn that snakes are deaf and all mammals have hair, while Vivian rattles off silly quips at breakneck speed, calling them "tough guy" and "hambone" and referencing herself as the "mystery woman." When they become distracted, she feigns exasperation with: "Give us the answer before we all die of anxiety." In a poignant moment, Vivian replays the tape because she had been told her pronunciation of *k*'s and *w*'s was incorrect and she wanted to improve.

One day she conducted a serious interview with the older boy to extract his opinions on various matters, including who he liked best, his mother or his father, his parents or his grandparents, absorbing his responses with great interest and a lack of judgment. Here, as in other situations, Vivian's caretaking

skills and commitment seem to be undermined by her shortfalls in likability and her employers' discomfort with her hoarding. One wonders if those who fired her—the mother whose little boys she helped learn to read or the husband whose injured wife she devotedly coaxed back to health—would have made the same decisions if they'd been privy to these recordings.

The social issues that had long served as a backdrop to Vivian's photography dominated much of her personal attention. Photographic expert Allan Sekula, one of the first to purchase Vivian's work from Maloof, felt that "she had an open and inclusive and very fundamental idea of what constituted 'America' that was missed by a lot of photographers in the 1950s and '60s." First among her causes was the fight for the advancement of Native American rights, and by the seventies she had photographed members of more than a dozen Indigenous groups, including the Seminole, Iroquois, Cree, Inuit, Métis, and Arawak. She was an active member of the American Indian Center of Chicago and became very involved with Operation PUSH, Jessie Jackson's platform promoting self-help and social justice for African Americans. Straying far from her Catholic roots, she supported the organization's educational efforts regarding birth control.

Responsible reproduction, Chicago, 1979 *(Vivian Maier)*

When describing Vivian to John Maloof, Lane Gensburg characterized her as committed "to standing up for those who couldn't stand up for themselves"—and in this regard she was unmistakably empathetic. It is striking that someone raised by people so lacking in consideration for others could be found on the forefront of broad social change. Positive values related to acceptance and justice must have been seeded by her grandmother Eugenie and then activated by Vivian's deep intelligence and rigorous thinking so that she formed her own firm and progressive perspectives.

SELF-PORTRAITURE REVISITED

During the mid- to late 1970s when Vivian enjoyed a creative resurgence, her focus on newspapers slightly diminished and her self-portraits displayed a newfound visual vitality. In one clever exposure, she precisely positions herself so that she radiates in an electric A-line skirt. Consistent with her self-presentation, she often photographed herself as a spy, presumably tongue in cheek. Shadow portraits could also be lighthearted, as when she places her silhouette on a workman's muddy behind. In a highly textured composition from the spring of 1975, Vivian's shadow hovers over rich green grass sprinkled with cheerful buttercups, as if to signal life and regrowth. Or is she envisioning herself underground, metaphorically "pushing up daisies"? Perhaps both. The image has become so popular that its design was incorporated into a dress that was featured in a Bergdorf Goodman window on Fifth Avenue, incredibly in the very same pane that reflected her image in the 1953 self-portrait John Maloof placed on Flickr.

As the decade wound down, Vivian's pictures increasingly comprised her daily pursuits. A theater production or lecture would earn thirty-six exposures, almost too dark to see. When watching television, she shot sequenced pictures of newscasts, shows, and films of interest. She continued a long habit of incorporating items relating to her history into pictures, insignificant to anyone but her: the new Madame Alexander dolls at Marshall Field's; biographies of David Sarnoff and Fulton Sheen; signage relating to parts of her name, or anything French. Newspapers and magazines returned in full force, now cropping up in one form or another on almost every roll.

Color self-portraits, Chicago, mid- to late 1970s *(Vivian Maier)*

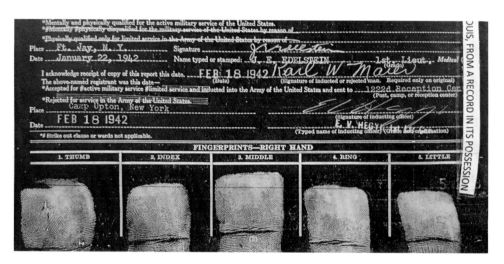

Carl Maier, military fingerprints, 1942 *(NPRC)*

16

FAMILY: THE END

People get what they deserve.

—Vivian, to an employer

fter Carl and Vivian parted ways at the Sixty-Fourth Street apartment, the trajectories of their lives moved in opposite directions. While very different in character, the siblings possessed noted similarities: both were tall, big-boned, and hardy, liked to talk and wander, and required a means of creative expression, Carl through music and Vivian through photography. Emotionally, they both seemed frozen in adolescence, a time when they were happily free to poke around the footpaths of Saint-Bonnet and the alleys of the Bronx. Carl failed to find enduring, one-on-one intimacy, and his grandmother Maria once wrote that at sixteen her grandson thought like a twelve-year-old.

Carl's whereabouts were unknown for a few years after his grandmother Eugenie's death, but according to him, he was at one point confined to a state hospital in Chicago from which he subsequently escaped. In 1952, at thirty-two years old, he sought help at a New Jersey veterans hospital and listed Lankenau Hospital in Philadelphia as his residence. On the veterans hospital's admission form, Carl claimed honorable discharge status to qualify for medical benefits. He was admitted to the psychiatric ward in good physical condition but exhibiting signs of psychosis, and received treatment pending a check of his military discharge records. His father was contacted for information and wrote back that he knew nothing about his son and, most appalling, he didn't even inquire about his offspring's whereabouts or condition. Carl's request for benefits triggered a paperwork tsunami between Washington, New York, and New Jersey. Finally, fingerprints exposed Carl as the recipient of a drug-related dishonorable discharge, and medical coverage was denied.

He didn't surface again until the spring of 1955, exactly when Vivian was preparing to leave New York. Experiencing drug withdrawal, he checked himself into Ancora Psychiatric Hospital in New Jersey. He sought pension benefits, asserting that his dishonorable discharge had been favorably reversed, but he was again found out and denied coverage. His admittance record revealed that he was calling himself "John William Henry Jaussaud (Karl Maier)" and exposed definitive delusions. His diagnosis was "Schizophrenia, Paranoid Type."

Throughout the 1960s and '70s, the remaining Maiers passed away. Aunt Alma died in 1965, planning to leave her money to the government rather than enriching relatives; she despised her brother, had apparently given up on Carl, and barely knew Vivian. Since she had predeceased her husband, Joseph Corsan, the family assets were left in his hands. He subsequently willed his large estate of $300,000 to his Philadelphia relatives, most of whom he disliked. Had Vivian's mother allowed her to have a relationship with the Maiers, Vivian might have been the only relative in good stead and possibly the lucky beneficiary of the valuable estate.

On her 1959 passport application, Vivian reported that her parents were long deceased—her father in 1932 and her mother in 1943. Although this was a fabrication, these dates are deeply symbolic. Vivian left for France with her mother in 1932, which was possibly the last year she saw her father. It was in 1943 that she was abandoned by her mother and moved to Jackson Heights in the care of Berthe Lindenberger. Charles, meanwhile, continued to reside in Queens with his second wife, Berta. He transitioned from manufacturing to the entertainment field, working as an air-conditioning engineer at Madison Square Garden and then for Broadway's Alvin Theatre. His wife was employed as a housekeeping supervisor at the Pierre hotel, and later as a dresser at the Metropolitan Opera. Charles reportedly thrived in the theater world, enjoying daily brushes with top celebrities and backstage visits with musicians. An article in the *New York Times* describes how he escorted Ingrid Bergman through a frenzy of fans when she starred in *Joan of Arc*. As an avid reader of the newspaper, Vivian may have even seen the write-up.

After the war, two of Berta's nephews traveled from Europe to live with her and Charles. The first, Manfred Michel, stayed for a year but was so uncomfortable with his uncle's coarseness, drinking, and abusive personality that he returned to Germany even as others were fleeing from its postwar devastation.

A second nephew, Leon Teuscher, arrived soon after, and Berta confided to him that Charles had breached her bank account and gambled away her money. Her husband's cycle of drinking and tirades continued, followed by apologies and outings in his brand-new Mercury. According to Leon, the apartment revealed no signs of offspring; no photographs, letters, or telephone calls. Charles would merely say that his children had each gone their own way. He saved his affection for his Doberman pinschers and was once arrested for walking them without leashes and muzzles, causing a neighbor to faint.

Leon describes Charles as about five feet ten and heavyset, with white hair that was balding. Although he spent the first decade of his life speaking only German, he had no accent and would go out of his way to say that he hated the French. He was a loathsome man who shoplifted fruit and boasted of watching dancers change their clothes in the Alvin Theatre's orchestra pit. One day Leon came home to find Charles holding a knife to Berta's throat. He had had enough, and promptly left to join the American army.

Charles Maier passed away in Queens in 1968 at age seventy-six, a month after the sudden death of his wife. He was so ravaged by alcohol and shaken with grief that he could barely sign for her ashes. With no Maier friends or relatives

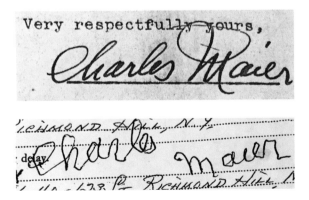

Charles Maier standard signature and signing for Berta's ashes

in sight, Berta's sister came from South America and arranged for both funerals. She buried Berta's urn in a cemetery alongside a friend and then, most tellingly, threw Charles's ashes into the air to blow away in the wind. Charles's in-laws had come to intensely dislike him, angry that he had failed to take proper care of Berta and had gambled away her money. Charles specifically disinherited

Carl and Vivian in his will, claiming he had not "seen them in many years," and "they have not been close to me." He further stated that Marie had divorced him in France, and that they had not met in over thirty years. Berta's siblings petitioned for and won his $10,000 estate.

> **THIRD**: I have made no provision for my children,
> **CARL** and **VIVIAN**, for the reason that I have not seen them
> in many years, and that they have not been close to me.
> **FOURTH**: I make this Will with the understanding
> that my first wife, **MARY**, whom I have not seen in over thirty
> years divorced me in France, many years ago.

Charles Maier's will, New York, 1968 *(QCA)*

In 1975, Marie Jaussaud Baille Maier died in New York City at age seventy-eight, destitute and alone. She had been living in a welfare hotel riddled with prostitutes and drug dealers, but the Jeanne d'Arc Home still appeared as her contact. She had seen neither of her children in almost twenty-five years, and there wasn't a single reference to them among her belongings. After four years of searching for heirs to her $360 estate, the public administrator closed the case. She is assumed to be buried in an unmarked mass grave on Hart Island in the Bronx.

Surrogate's Court: **County of New York**

ACCOUNTING OF

the Public Administrator of the County of New York,
as Administrator of the

ESTATE OF

MARIE JAUSSAUD, also known as
MARIE JAUSSAUD MAIER,

Deceased.

Account of Proceedings

File No. 5706-1975

 Nothing was found among decedent's effects
which would assist your petitioner in ascertaining who
the distributees of the decedent are or where they might
be located.

 The decedent herein died on June 28, 1975, and
to date no proofs of kinship have been submitted to your
petitioner nor have any claims of alleged kinship been
made.

Marie Jaussaud Maier estate closed, 1979 *(NYCA)*

Vivian's brother applied for his first Social Security number in 1967 at the age of forty-seven. He was well enough to participate in an outpatient Family Care program at the L & S Rest Home in Atco, New Jersey, owned by the Pliner family. After all these years, the owners haven't forgotten Carl. Ilene Pliner writes: "I remember him to be tall with a full head of hair. He was a medium built man with a gentle heart. Always respectful and kind. Carl got along with other residents, and seemed to be content during his stay with us. Please know that he was well taken care of." Another Pliner family member recalls he had salt-and-pepper hair and was polite, almost formal, and he stood out for always wearing a sports jacket. He no longer played the guitar and there was nothing about his outward appearance that revealed his inner issues.

Arguably doomed to a life of adversity from birth, Carl never seemed to catch a break. He quietly spent his final decade at the rest home. Like his grandmother Eugenie, he suffered from congestive heart failure and died suddenly in 1977 at age fifty-seven from a rare and fatal aortic thrombosis. Ancora Psychiatric Hospital performed an autopsy and buried him in their cemetery among the other patients who had no one else. Carl's death certificate states that he never married and includes no mention of next of kin. There is no indication that Vivian was ever aware of the deaths of her father, mother, or brother.

Carl Maier's death certificate, New Jersey, 1977 *(Hammonton Public Records)*

Last picture, Rogers Park, 2008 *(Kellee Gary)*

17

LATE LIFE

If you want to take care of someone,
why don't you take care of me?

—Vivian, on fostering to an employer

WORK

In the early 1980s, Vivian was hired by Curt and Linda Matthews, publishers with three children, Joe, Sarah, and baby Clark, for a three-year stint. She was again embraced as family, joining them for meals and trips to their Michigan cabin. She developed a connection with Linda, an intellectual and feminist, who coauthored a 1976 book entitled *The Balancing Act* that considered motherhood from a career woman's perspective. Linda took an interest in Vivian's daily excursions, opinions, and original ideas. On occasion, the nanny would open the door to her inner life and grant a quick peek. Linda noted Vivian had "an eye for the bizarre, grotesque, incongruence," and an interest in people's "follies and foibles." Once the pair discussed the question Vivian liked to ask children: "Who do you love the most?" Invariably, the child would respond, "My mother." Fascinated by the sanctity of the mother-child relationship, she relayed these anecdotes to Linda.

In this comfortable, nonthreatening setting, Vivian appeared less severe and guarded. She always carried a camera and occasionally shared her pictures with the Matthewses. In some ways, she had loosened up with the times, donning bright scarves and handcrafted jewelry, and practicing yoga, although she still refused to wear pants. The family fondly mimicked her expressions, "God oh God" and "ta, ta, ta," and noted her offbeat behaviors, such as her morning

cold shower. Like other families, the Matthewses had favorite tales related to Vivian's meals, including her oft-mentioned "specialty": beef tongue, served as if just pulled from the mouth of a cow. She did make lovely desserts from scratch, whipping up crème caramel and soufflés without recipes. Food was important to Vivian; she had a large appetite and was concerned with nutrition. She was known to pour the juices from a roast pan or vegetable boil into a glass and drink them down.

The Matthewses felt Vivian was competent and honest, and she was especially devoted to their young toddler, chatting with him incessantly and addressing him as Monsieur Count. Amusingly, his first words were in French. The nanny's most successful relationships were with those too young to develop biases. She worked hard to make life fun; once Linda came home to find everyone—even the family cat—wearing 3-D glasses.

At first Vivian's relationships with the two older children were satisfactory, although unlike the ones she had enjoyed with the Gensburg boys or even Inger. Ten-year-old Sarah was open-minded about her nanny's differences but became uncomfortable when Vivian slapped her little brother for spilling his milk or indulged in other acts of aggression. Seven-year-old brother Joe became more skeptical once he realized that the real purpose of their outings was for his nanny to take pictures. He didn't understand why she photographed nude mannequins and garbage cans, or why she was angry at men. He was baffled when she warned that little girls should not sit on men's laps. She reminded him of the "Wicked Witch," and his opinion of her "craziness" was confirmed by her room, which was so stuffed with newspapers they overflowed into the hall and backyard. Father Curt Matthews observed that Vivian was becoming increasingly paranoid in regard to her photographs. Her escalating obsessiveness and instability finally convinced Curt and Linda that it was time for the family and their nanny to part ways.

Vivian's subsequent positions were variations on the same theme. When she didn't feel a personal connection to her employers, she didn't reveal herself or her photography. Some employers never saw her with a camera, although under the best of circumstances she was only willing to share a few photos. During the 1980s, she moved from job to job, alternately taking care of children and the elderly. Some positions ended because of her hoarding, others due to a change in family circumstances. These employers tended to remember her as dedicated, confident, intelligent, secretive, and *very* opinionated. A few commented on her wry sense of humor. By this point, Vivian seemed to take all events in stride,

functioning well and at least outwardly immune to rejection. Her main concern was the physical inconvenience of moving after she had comfortably settled in.

Toward the latter part of the decade, Vivian was employed by three different suburban families whose basements could accommodate a large number of boxes. She dragged two hundred cartons along with her to each of the positions, and having her possessions safely nearby seemed to afford her a new kind of freedom. While these employers observed that she filled up her room and their basements, her pictures reveal that, at least for a time, her own space was less cluttered than before. One employer was the Baylaenders, where Vivian cared for their disabled daughter. The family was immensely grateful for her hard work, and she stayed with them for five years, once again settling into a stable living situation and making herself at home. After placing her boxes in the basement, she warned them, "Don't ever open this door." She routinely, and somewhat humorously, answered the phone with "Not here," and would then abruptly hang up. The family was vaguely aware of her photography, and asked for copies of some family pictures she'd taken. At Vivian's request, they agreed to pay for the processing, yet as was typical, she was unable to follow through.

FRIENDS

While living in Chicago, Vivian enjoyed a few long-term acquaintances, most of whom were young men associated with the arts. She left behind distinct impressions on these friends, and while each described her off-putting presence and her need to control conversations so as to reveal little about herself, they enjoyed their interactions with Vivian and spoke about her in favorable terms. She was a "character" in the very best sense, interesting, well-informed, and opinionated.

Bill Sacco was a college-age filmmaker when Vivian approached him in the lobby of a nonprofit film organization during the early 1980s and said he looked "artsy." She asked if he would help her move boxes from one storage facility to another, which he was happy to do. He remembers, "It was a lot of stuff, it probably took all day, the whole weekend," and that her heavy boxes broke the springs in his car. Sacco was categorically unaware that the heft was from old newspapers. In appreciation, Vivian gave him a few Smith-Victor Photoflood lights, and they remained friendly.

Sacco had no way of getting in touch with Vivian, but she periodically dropped by his house of her own accord. She gave him a few enlargements of pictures she took at his wedding in Daley Plaza, but his wife didn't care for

them because he received most of the focus. While Sacco described Vivian as ungainly, curt, and shut down, both he and his wife found her smart and entertaining and accepted her for who she was. When they asked her if she was married, Vivian indicated that she was "still pure" and cut off the conversation. She got to know the couple well enough to invite them into her room and share some travel and celebrity photographs. But after about five years, just as abruptly as she had entered their lives, she left them behind, by now a familiar story.

At this juncture, in the mid-1980s, she met Jim Dempsey, a painting student who worked at the movie theater behind the Art Institute of Chicago where Vivian was a regular. They chitchatted about film once every week or two for more than a decade, but he never knew her name. Dempsey found her fascinating and an intense, close talker. He remembered, "There was something very visceral about her. When we were talking, she would come very close to me, occasionally some spit might hit my face . . . You had to be up for conversation, because it encompassed everything, sights, smells." When he was busy, he avoided getting "sucked into her talking vortex." He particularly noted the dichotomy between her appearance and demeanor, indicating there was a slight aggressiveness to her physically, but when you spoke to her she was a bit shy and eager to talk about shared interests. "A lot of the staff seemed to be afraid of her, they thought she was mean. I think there was just something about her body language and her approach, which could be a little off-putting." He told them just to talk to her and she would be fine.

Dempsey eventually became an art gallery owner, and when the "mysterious" nanny photographer was discovered, he followed her work and was inspired to launch his first photography show. It was not until a late self-portrait of Vivian was released that he realized that the photographer who had piqued his interest was his old friend. She had always carried a camera but he had assumed it was just for show, part of her curated persona. When he learned about all the undeveloped rolls, he commented, "It made me imagine that she was almost like an image hoarder. It was almost as if she captured each image at the moment, stashed it, and didn't have a chance to revisit probably like she would have wanted to."

Vivian's longest affiliation was with Roger Carlson, owner of the bookstore Bookman's Alley. As an avid reader and collector, she patronized his shop regularly from the early 1980s until about 2005. He said, "She looked like the

warden of an Eastern European women's prison, and wore clumpy shoes . . . which forced her to walk in a certain way, which she sort of liked." Vivian stuck out in his mind because he thought she was a real original: strong, confident, savvy, intellectually curious, and "as opinionated as can be." She bought a lot of magazines and books and had a great sense of humor. He believed "she was a woman essentially content with the way life was treating her." He added that "physically and from the standpoint of personality, she held together pretty good. She could defend herself and was seemingly not afraid of much of anything."

PLAY

In 1986, Vivian turned sixty and remained functional and engaged for many more years. She still took advantage of all that Chicago had to offer, accomplishing more in a day than most would in a week, and when off work she would be out from morning to night. She hardly missed an opening at the Wilmette Theatre and came to know its owner, Richard Stern, over a twenty-year period. He remembers she was the rare customer who could discuss movies with expertise equal to his own: "She was like a walking encyclopedia about the motion picture business." He was aware of her passion for photography, and on occasion she would pull out a bundle of prints to share, explaining that she didn't sell pictures, just kept them. Those who knew Vivian reported that she religiously attended retrospectives like those on Michelangelo Antonioni, Federico Fellini, Ingmar Bergman, and Andy Warhol, and loved all types of foreign offerings, from low-budget British B movies to the comedic work of Frenchman Jacques Tati.

Ever eager to photograph new celebrities, her pursuits resulted in a collection that included a staggering list of conquests, from Marcel Marceau to Muhammad Ali. These pictures provide visual proof of the relentlessness that propelled her to maneuver past fans and other photographers to secure unobstructed views of her targets. Presumably operating without a press pass, she waited with the pack and then usually managed to jockey to the front. At autograph and book signings, she cut lines, earning plenty of scorn. She fearlessly insinuated herself into intimate settings, dressing rooms, hallways, and waiting areas, and jumped in front of motorcades. In addition to Jerry Lewis, she appeared on set with a number of celebrities, including Tony Curtis. And of course, she had lived with Phil Donahue and the Mary Kaye Trio.

Celebrities Photographed by Vivian Maier

Elsie Albiin	Lillian Gish	Patricia Nixon
Nelson Algren	Jackie Gleason	Richard Nixon
Muhammad Ali	Barry Goldwater	Kim Novak
Apollo 15 Astronauts	Cary Grant	Rudolf Nureyev
Josephine Baker	Julie Harris	Pope John Paul II
Anne Baxter	Audrey Hepburn	Otto Preminger
Richard Boone	Jimmy Hoffa	Anthony Quinn
Jimmy Carter	Bob Hope	Lynn Redgrave
Rosalynn Carter	Lena Horne	Dany Robin
Pablo Casals	Ladybird Johnson	Nelson Rockefeller
Prince Charles	Lyndon Johnson	Eleanor Roosevelt
Tony Curtis	Mary Kaye Trio	Eva Marie Saint
Dan Daley	John F. Kennedy	Reverend Sheen
Richard Daley	Dorothy Lamour	Simone Signoret
Sandra Dee	Jerry Lewis	Frank Sinatra
Phil Donahue	Harold Lloyd	Constance Smith
Kirk Douglas	Gene Kelly	King of Sweden
Roger Ebert	Ted Kennedy	Father Tisserant
Dwight Eisenhower	Shirley MacLaine	John Wayne
Zsa Zsa Gabor	Marcel Marceau	Richard Widmark
Greta Garbo	Ann-Margret	Shelley Winters
Ava Gardner	James Mason	

Reading material was essential to Vivian, and she maintained a comprehensive library of titles on history, politics, architecture, and photography. She also enjoyed escaping into movie star tell-alls and books of cartoons. Most of her editions were bought at a discount, either for herself or to generously gift to the Gensburg boys and casual friends. In her room, she surrounded her bed with books and habitually shelved them with their spines inward, to shield her interests from others. Most of the volumes she owned were disposed of with her other belongings, but a sampling of titles from her bookshelves and lockers chronicle her broad interests. Notably, all those relating to photography were published post-1975, too late to influence her work. Presumably she possessed similar reading material at the start of her career, but earlier examples have never been found.

Vivian Maier's Bookshelf

American Edge by Steve Schapiro

American Ground Zero, The Secret Nuclear War by Carole Gallagher

André Malraux by Guy Suarès

Berenice Abbott, American Photographer by Hank O'Neal

Best Editorial Cartoons by Charles Brooks

La Camargue by Karl Weber

The Cardinal's Mistress by Benito Mussolini

Cecil Beaton: A Retrospective by David Mellor

Century by Bruce Bernard

Cesar Chavez by Jacques E. Levy

Chicago: A Photographic Journey by Bill Harris

Children of the Arbat by Anatoli Rybakov

Dali by Luis Romero

Eddie: My Life, My Loves by Eddie Fisher

Errol Flynn: The Untold Story by Charles Higham

Frank Harris by Philippa Pullar

Giving Up the Ghost: A Writer's Life Among the Stars by Sandford Dody

Harry Benson on Photojournalism by Harry Benson

Herblock on All Fronts by Herbert Block

Ike and Mamie by Lester David and Irene David

I Saw France Fall, Will She Rise Again? by Rene De Chambrun

John Barrymore: Shakespearean Actor by Michael A. Morrison

Meyer Lansky: Mogul of the Mob by Dennis Eisenberg

My Truth by Edda Mussolini Ciano

Nijinsky, the Film by Roland Gelatt

The Orwell Reader: Fiction, Essays, and Reportage by George Orwell

Pablo Picasso: A Retrospective edited by William Rubin

Robert Redford: The Superstar Nobody Knows by David Hanna

Sahtaki and I by James Willard Schultz

Self-Portrait: USA by David Douglas Duncan

The Shoemaker: Anatomy of a Psychotic by Flora Rheta Schreiber

Show People: Profiles in Entertainment by Kenneth Tynan

Strangers and Friends by Thomas Struth

Swanson on Swanson by Gloria Swanson

Tony's Scrapbook by Anthony Wons

Wheeling and Dealing by Bobby Baker

Vivian was an avid and discerning shopper, fueled by her need to acquire as well as her appreciation of quality materials and workmanship. Her cameras were specimens of mechanical beauty and her accessories top of the line. There were telephone numbers in her address book for favorite thrift and antiques shops and direct lines to Marshall Field's lingerie and blouse departments with the dates they held sales. She treated shopping excursions like treasure hunts, and afterward kept price tags attached, even on items she wore, as if they were a way to keep score. If a tempting item was deeply discounted, occasionally she bought it no matter the size and then found the appropriate person to enjoy it. While no one would begrudge Vivian her material gratification, some of her shopping decisions seem ill-advised. While owing money to storage companies, retail stores, and personal friends, she bought a 14-carat opal ring for $397, a silk "La Vie en Rose" scarf for $245, and a Liberty of London blouse for $165. She purchased less-expensive items at flea markets and junk stores to augment her diverse collections of costume jewelry, political buttons, African artifacts, and crystals.

FINANCES

Vivian's financial behavior was paradoxical. She was unable to balance spending decisions, properly pay bills, or reimburse loans, and was invariably past due everywhere from Central Camera to the *Chicago Tribune*, and most significantly her storage facilities. She even maintained a regular correspondence with the IRS regarding her tax bill, writing breezy updates as if they were friends. Scrupulously honest, her delinquencies were not attempts to dodge obligations, but the result of poor planning and progressive disorganization.

Yet she had a keen interest in and some success with investing. Back in the 1950s, she purchased a few shares of stocks and subsequently made additional picks after devouring the *Chicago Tribune* and the *New York Times*. Her account was managed by Bach and Company and, unsurprisingly, she saved every financial statement, dividend notice, press release, and annual report sent her way. The mass of paperwork associated with just a few shares is breathtaking, and likely of interest to few other than Vivian. Later in life, as her personal effects became increasingly disordered, she misplaced certificates and ceased cashing dividend checks. Nonetheless, she left a small, impressive portfolio that included investments in Canadian Pacific Railway, General Motors, and Warner Bros.

From the early 1950s onward, Vivian managed her affairs by photographing important papers as a form of recordkeeping: stock dividend checks, tax

For the record, 1950s–'80s *(Vivian Maier)*

returns, vital records, letters, and receipts. This behavior is now universal—she just figured it out fifty years before everyone else. Each tabletop vignette was carefully composed and styled with props, illustrating Vivian's inherent need for creative expression and beauty. Sometimes she prepared tabletop compositions with the contents of refrigerators and cupboards, enhancing her tableaux

with flowers, fruits, or other items on hand, as if they were make-believe ads. During the 1970s, her photographs began to include the personal property of others. When her employers weren't looking, in an almost certain violation of trust, Vivian often took pictures of their private files and memorabilia—address books, letters, photo albums, and diaries, as if compulsively co-opting their histories for herself. When an elderly man in her care died, she arranged the contents of his wallet alongside his death notice, military records, and a favorite sweater to form a pictorial memorial.

PERSONAL SPACE

During this period, Vivian began to display her own work in her rooms. She had long made black-and-white enlargements for the Gensburg family, archiving copies for herself in spiral notebooks. Beginning in the 1970s, 8 × 10 and 11 × 14 color enlargements dominated these portfolios, prepared as if for professional submission. The majority of her material remained in rental facilities, but with access to her employers' basements for additional storage, Vivian's living spaces were less cluttered and she finally took the trouble to decorate them with her photographs. Wall space was largely reserved for the artwork of others, but she jam-packed shelves with collections, memorabilia, and her own images. Favorites were placed on display in cheap frames, with a reserve stacked in corners as proof of possession or in line for exhibition. One day in 1987, she ventured downstairs and laid out framed color enlargements end to end to select those that would earn a spot in her room.

The color prints Vivian placed on display and filed into her portfolios, selections made solely for herself, afford the best opportunity to examine her color photography preferences. The subject matter is a potpourri of celebrities, travel, humorous depictions, and street scenes. Almost all were taken in the mid- to late seventies. Some of the most prominent images reflect unflinching eye contact with the photographer. There were few visible pictures of her former charges, even the Gensburg boys, and none of family or friends from New York or France.

The specific subjects of the smaller pictures on display, most 5 × 7, include Eva Marie Saint, Marcel Marceau, a sad clown, a Tudor home with symmetrical timbers, a theater production, graffiti, travel in Africa and Asia, a poor man on a bench, and a man with a thick rope. Those taken from the back feature a lady in a fur coat, a young woman in a mauve bathing cap, a traveler lugging suitcases in the rain, a well-to-do man bidding Mayor Daley farewell, and a man bending over with a newspaper in his rear pocket. Larger prints also showcased

Framed, Chicago, 1988 *(Vivian Maier)*

Vivian's room, Chicago, mid- to late 1980s *(Vivian Maier)*

celebrities as well as a man carrying a painting of the pope, a bum with and without a "colleague," the backs of three well-heeled elderly women, a creepy guy with a bandaged head, members of the working class, and a Union Jack poster for The Who.

While crowded, the rooms were a cacophony of color and texture, and likely gave Vivian great pleasure. She left behind two large poster-size photographs—one of the little blond girl from California and the other of an older woman with crossed arms and a yellow scarf, locked in an eye-to-eye standoff with the photographer.

Poster girl, Chicago, 1977 *(Vivian Maier vintage prints)*

Men on bench, 1975; Man with bandage, 1976 *(Vivian Maier vintage prints)*

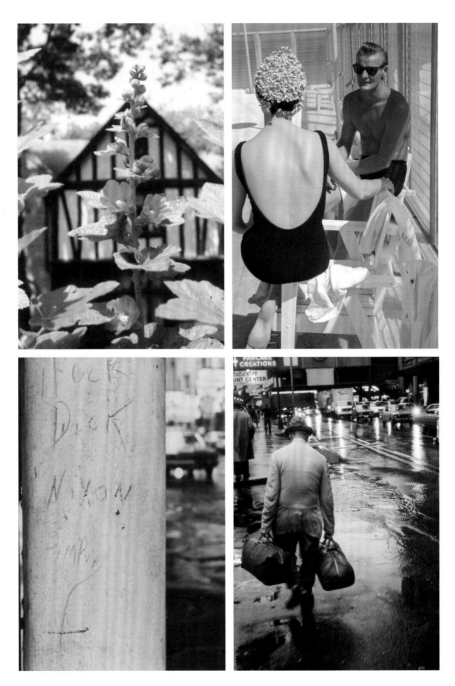

Tudor house, 1960; Florida bathers, 1963; Graffiti, 1974; Man with luggage, 1977
(Vivian Maier vintage prints)

THE END OF THE ROLL

During the eighties and nineties, Vivian's subjects were those who were out and about, whether policemen, shoppers, construction workers, or commuters. Linda Matthews thought Vivian had joined a camera club, and there were telltale signs that she periodically considered a restart of her photographic career. One acquaintance sent her a packet of articles on how to break into freelance photography, with titles like "Focusing on Freelancing," "Profit from Picture Libraries," and "How to Choose a Stock Photo Agency." A former employer wrote a note hoping Vivian "would find an audience for her photography and collections." Pamphlets from the Chicago Camera Club Evening School of Photography and other venues offering lectures on portrait photography and seminars for managing color slides were also found among her belongings. She did occasionally photograph parties, weddings, and other events for friends, although there is no proof that she was paid for the work. Her coverage of graffiti became compulsive, and she filled rolls of film with messages found on bumper stickers, windows, labels, signs, and in garbage receptacles. While somewhat tedious as a whole, this work does demonstrate the deluge of words that bombard city dwellers each day.

During this period, self-portraiture gradually faded away. Virtually all of Vivian's depictions were upbeat; there was little use of shadow or sense of darkness. As a self-described mystery woman, she occasionally depicted herself as a spy, conjured with pulled-down hats, a camera blocking her face, and a bit of a wink. Notably, the only self-portrait she displayed in her room was one of her "Vivian the Spy" renditions. In a series of six portraits, she playfully mugs for the camera in an atypical presentation of herself. And when it seems impossible that Vivian could invent a new means of self-portrayal, she used her trademark clothing to fill in for her physical presence. As with newspapers, at a distance, she could poke a little fun at herself.

No longer considered young enough to watch over children, Vivian's last position was caring for an elderly woman who would soon be placed in a rest home. Afterward, the understanding family allowed her to stay in the house until the end of the year, giving her an extra six months of stability. When the property was placed on the market, the real estate agent found Vivian unhelpful, and feared she would sabotage the sale and never leave. On the very last day of the year, her employer firmly directed her to pack up, and had the impression, as many had before her, that Vivian had hoped to stay forever. When clearing out the house, they offered Vivian her pick of its contents, but she only chose

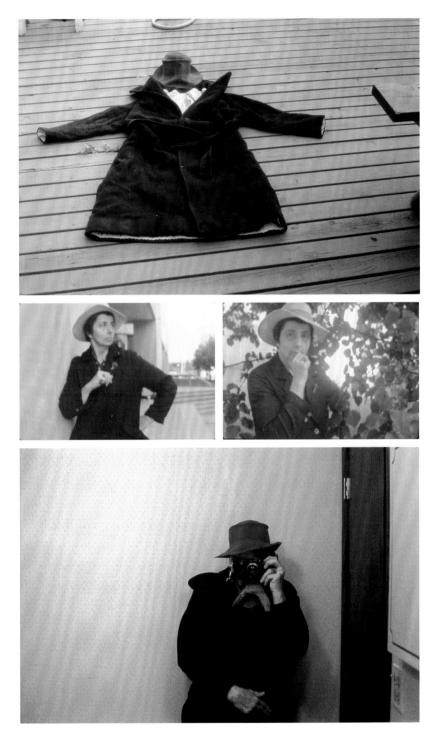

I Spy Vivian, Chicago, 1980s–'90s *(Vivian Maier)*

a military jacket and a set of Madame Alexander dolls, without mentioning her association with their creator. The family suspected that she had been going through their mother's possessions, a hunch confirmed by archive photographs of the elderly woman's wallet contents, pictures, artwork, personal letters, and paraphernalia.

Vivian's 1980s address book showed that she had severed relationships outside Chicago—there were no entries for relatives, friends, or employers from New York, California, or France. From the time she arrived in the Windy City, she never revealed her real background to anyone, maintaining secretiveness until the very end, convinced there was no upside to sharing her painful life history. In 1996, at age seventy, she could no longer find work and reluctantly retired. She sent away for a birth certificate so she could file for Social Security, the only document found in her possession that tied Vivian to her original family. With an inability to maintain friendships, her social interactions consisted of chats with shopkeepers and theater workers. Employment had always been central to Vivian's life, and her desire to work was driven by much more than financial need. Without the structure, casual relationships, and sense of accomplishment work provided, she was a bit rudderless.

During the 1990s, Vivian shot five hundred color rolls, which she never developed. Her last photographs hearken back to her early days in New York, where she instinctively gravitated toward urban patterns and textures. Just as in the beginning, her final shots include building demolitions, wire trash cans, garbage, and rows of windows. The impression is not dreary or negative, but there are few images of people and fewer close-ups. There is a sense that the photographer was less a part of the rhythm of city life. Still, she remained out and about pursuing her cultural and celebrity interests. As her photographic efforts decreased, she focused on preparing newspaper clippings for her plastic frames and three-ring binders, eventually placing hundreds of the latter in storage. Articles she chose to frame included Roxanne Pulitzer posing for *Playboy*, Dale Carnegie's tips for making conversation, recommendations for thrillers, the death of a longtime White House operator, Ann Landers on the origin of the phrase "pardon my French," and "Dear Abby" advice to adoptees on inviting birth parents to your wedding. In fact, references to adoption are threaded through Vivian's materials.

A preponderance of Vivian's late pictures featured newspapers: in the trash, crumpled on the ground, in dispensing machines, blaring headlines, stacked in newsstands, and in page-by-page coverage. As with everything else, they were shot with added interest, especially with attention to lighting.

Newspapers, Chicago, 1993 *(Vivian Maier)*

Last self-portrait, Chicago, 1996 *(Vivian Maier)*

Collectively, the final pictures impart a diminished sense of self. There is a glaring lack of self-portraits, with fewer than a dozen composed during the 1990s. After her retirement in 1996, she took almost no pictures, and in 1999, a decade before her death, she put down her camera for good. Certainly the expense of equipment, film, and processing would have been a consideration, but she had always found the money before. If photography was still an imperative, almost certainly the Gensburgs would have happily funded her efforts. While it seems impossible that Vivian would ever stop taking pictures, her pace had steadily declined. At age seventy, after a forty-year photographic career, she just seemed to have lost steam, as most anyone would.

Facing the late-life plight typical of those without relatives to provide company or care, she lived alone in a run-down rental apartment, but ultimately lost the lease due to hazards related to hoarding. She finally turned to the Gensburgs for help, and they cosigned for an apartment in Rogers Park, which would be Vivian's last address. Everywhere she lived in Chicago, Vivian became the perennial neighborhood fixture who was inevitably awarded a nickname: Army Boots, Bird Lady, Frau Blücher, Maria von Trapp, Mary Poppins, or the Wicked Witch. Her Rogers Park neighbors were very aware of her presence, and she was simply referenced as "the French lady" or "the old lady on the bench." Whether she liked it or not, the close-knit community noticed and watched out for her. Vivian was reluctant to engage, yet sat on a very public bench every day where everyone could find her. No matter the weather, she went to the same place to read and look out over the lake. She always dressed formally, in a skirt, rolled-down stockings, sensible shoes, a jacket, and a hat, even in the summer.

———

In 2005, Sarah Matthews bumped into her former nanny in Evanston, the same town where they had lived together twenty-five years before, and they instantly recognized each other. Vivian was almost eighty, and Sarah thought she appeared frail and a little depressed. They had lunch together regularly until Sarah moved away a few months later.

When her neighbors attempted conversation, Vivian's answers were curt, unless someone spoke to her in French. She was strong-willed and proudly self-sufficient and almost always refused offers of food and clothing. In 2006, writer Sally Reed stopped to chat, and Vivian told her she had an interesting face, still viewing those she met as subjects. Various neighbors observed that she

perused the local dumpsters each day, mostly to salvage the *New York Times*, and she kept up with current events, asking Sally if she thought young people really cared about what was going on in the world. The writer felt that Vivian was more than private, that she "seemed to want to hold people at arm's length as a sense of safety or protection." Neighbor Bob Kasara frequently observed Vivian walking in the area, stooped, head down with hands behind her back, a stance she had frequently captured in her photographic subjects. Like many elderly people, she became cranky and increasingly disengaged, spending the remainder of her life residing in her small apartment, surrounded by her possessions.

One late November afternoon in 2008, she fell on the sidewalk, either fainting or slipping, and bumped her head. An ambulance was called, and while being placed inside, she reached out to neighbor Patrick Kennedy and said, "Don't let them take me, I don't want to go." Vivian had only been known to have ever undergone one medical examination, in 1956, and it had not gone well. The doctor was treating her for a stomachache, but as he began to examine her, she became acutely agitated. Now, despite her protests, medics insisted on a visit to the emergency room due to the potential of a serious head injury. Vivian was expected to recover, but developed complications from a subdural hematoma and never did. She was placed in Manorcare of Highland Park, a long-term care facility, and her condition was dutifully supervised by the Gensburg brothers. Her health progressively declined, and she died on April 21, 2009, at age eighty-three.

Vivian was cremated and memorialized by the boys she had loved, who spread their cherished nanny's ashes in the forest preserve where they had picked wild strawberries together.

First picking
of strawberries
~ 1st July 66

Heaven Can Wait, Chicago, 1978 *(Vivian Maier)*

18

THE DISCOVERY

Nothing is meant to last forever. You have to make room for other people. It's a wheel. You get on, you have to go to the end, and then someone else has the same opportunity.

—Vivian, on death to a neighbor

Just like her pictures, the story of the discovery of Vivian's work is filled with colorful characters whose skills, tenacity, and scrappiness revealed her talent to the world. It's a one-in-a-million ending—another beginning, really—to an already remarkable life. If she had read the account in a newspaper, Vivian would have loved the particulars—the triumph of the working-class men, the controversies between the haves and have-nots, the story's twists and turns. She would have absorbed every juicy detail and stood on the sidelines with her camera, intent on capturing it all.

During her life in Chicago, Vivian's acquisition of storage space steadily increased to accommodate her ever-growing stockpile of possessions, and in almost all cases she failed to meet her financial obligations. She left behind a cache of past-due notices, dunning letters, and frustrated pleas for payment. As far back as 1979, she had accrued a meaningful debt at Iredale Storage, owing $2,476 on one account and $994 on another, and received a certified letter threatening to auction off her belongings within a month if the debt wasn't settled, a precursor to future events. Vivian's photographic material represented a relatively small proportion of the *eight tons* of possessions found in these storage lockers. The bulk was in the form of boxed books, magazines, and newspapers, the manifestations of her debilitating hoarding disorder.

Vivian resolved her 1979 debt with the help of the Gensburgs, but shortly

afterward, Iredale became embroiled in a tax evasion scandal. The contents of the entire facility were seized and scheduled to be auctioned off by the IRS. Justifiably alarmed, Vivian transferred her trove to Hebard Storage, and sparked another legal tangle when she ignored their tab for moving expenses. The financial shenanigans continued for almost three decades, until 2007, when new owners purchased Hebard and, after warnings, auctioned off accounts in arrears.

Storage locker default warning, 1979 *(John Maloof Collection)*

When she finally lost her belongings, Vivian is estimated to have owed $2,400 in annual charges, and while money was tight, she could have found it. Eighteen months later, when she passed away, she still had $3,884 in the bank, more than $1,000 in uncashed Social Security checks, an additional $6,000 of uncashed tax refunds, a stack of undeposited stock dividends, and the ability to borrow more from the Gensburgs. But she did not address the debt, and her possessions went to auction in the fall of 2007.

Why would Vivian Maier let the belongings she had ardently fought to keep for so long go into forfeiture? Most plausibly she was aware of the default notice but wasn't concerned; she habitually ignored warnings while rustling up payments, without dire consequences. Even if Vivian had not received the notice, she was well aware that this storage charge would come due—she had been paying it for more than twenty-five years. This time, however, she did not attempt to make restitution or check on her belongings. Adept at compartmentalizing problems, at eighty-one, Vivian may have been unable to wrestle with her multiple storage facilities and massive accumulations. She may have even stopped caring, freeing herself from the albatross that had controlled much of her adult life. Her world had gotten much smaller; she no longer took pictures, visited her stored possessions, or socialized. She spent her days on her bench in Rogers Park and her nights in an apartment already stuffed with collections.

THE AUCTION

When Vivian's containers were offered for sale, Chicago liquidator Roger Gunderson from RPN Sales salvaged their contents and resold them in lots to about a dozen bidders. One buyer was Ron Slattery, a local photo dealer with a good eye who ran the website Bighappyfunhouse.com, encapsulating his quirky personality in one word. The box he purchased was filled with rolls of undeveloped film, which he cautiously began to process. He placed several of the resulting images online—making him the first person to introduce Vivian's work to the public, but they failed to garner the traction necessary to warrant his investment in developing more of the film. Facing urgent personal matters, Slattery had borrowed money from fine arts painter, woodworker, and collector Jeffrey Goldstein. He eventually paid his friend back with fifty-seven Vivian Maier prints, thus placing Goldstein in the owners' circle.

Most of the buyers knew each other from area flea markets, and Slattery advised photographer Randy Prow to resell his lots, saying, "Why hold on to this?

You could walk out the door and get hit by a car. Just take the money." In a terrible case of fact being stranger than fiction, the next day Prow *was* hit by a car, and subsequently was out of commission for a year. Slattery was also acquainted with another buyer, John Maloof, a young man who had dropped out of art school for financial reasons. After a successful four-year run in real estate before the 2007 market crash, Maloof embarked on a new project: a book about his neighborhood, Portage Park. He bid at the auction in hopes of securing local photos to supplement his text. The images ultimately did not suit his needs, and he stored the boxes away. Remembering them a few months later, he rummaged through the contents and began scanning negatives just for fun. Reviewing the material with zero expectations, he was surprised by how much he liked what he saw.

THE IMAGES

Lacking a background in photography, Maloof sought to validate his positive impression with others. He and Slattery began an email correspondence, discussing their common interest in the work. Maloof's childhood had been as difficult as Vivian's—he was the second child from his mother's third marriage and grew up in a violent section of Chicago; his father was murdered in the neighborhood when he was only five years old. He was raised in a household of women, and the family survived on food stamps and his mother's hourly pay as a lunch lady. Temporarily postponing his plans to support himself as a painter, he embarked on a career in real estate and was able to afford an apartment so that his family would always have a place to live. Now Maloof found himself uncharacteristically free from school and employment, with time to work on a book.

Vivian's pictures inspired Maloof to take a photography class and set up a darkroom to process film and prepare contact sheets. In 2008, after living with the images for a year, he decided to devote all his savings to purchasing the artist's entire portfolio. He acquired the names of the other buyers from the auctioneer, and most were eager to sell. Slattery hesitated, sensing the photographer's talent, but he needed the money and respected his friend's devotion enough to make a deal for a few hundred prints, a thousand rolls of undeveloped film, and several thousand negatives, keeping a small collection for himself. To fund further processing, the inexperienced Maloof began offering low-quality prints and negatives on eBay, and even considered selling his undeveloped film. Renowned photographer Allan Sekula purchased a few of the eBay images and, recognizing the caliber of the work, advised Maloof to curtail internet sales. Ultimately he did, after selling a

few hundred pictures in total, insignificant in the context of the more than one hundred thousand images he owned.

While early admirers jostled for her work, Vivian spent her last days on her park bench, reading, enjoying the fresh air, and gazing at Lake Michigan. During the year and a half that she was still alive, the various buyers had searched for her on the internet, but found no reference—not even an address or phone number—a consequence of her secretive life. When Vivian's death notice appeared and John Maloof realized the photographer had been a nanny, he tracked down the Gensburg brothers, who had placed the obituary. They told him about even more storage lockers that held Vivian's belongings. Planning to dispose of most of the contents, they agreed that if Maloof carted away the material, he could keep what he wanted, gratis. With this initiative, he rescued additional prints and the ephemera of Vivian's life: notebooks, periodicals, records, clothing, and a wide assortment of offbeat collections, from political buttons to mineral specimens.

By fall of 2009, Maloof planned to share Vivian's pictures more broadly and sought advice on how to publicly display her work. He had already started a blog showcasing a small number of her photographs and now linked it to the Hardcore Street Photography group on Flickr. His post soon went viral, igniting global interest in Vivian's pictures and street photography in general. The original Flickr chronicle provides a fascinating, real-time narrative of how a serious group of enthusiasts evaluated, debated, and launched an unknown artist in the digital age. (The post and responses are still accessible at http://vivianmaier.blogspot.com.)

flickr HCSP (Hardcore Street Photography)

johnmaloof 2:26am, 10 October 2009

I purchased a giant lot of negatives from a small auction house here in Chicago. It is the work of Vivian Maier, a French born photographer who recently past away in April of 2009 in Chicago, where she resided. I opened a blogspot blog with her work here; www.vivianmaier.com.

I have a ton of her work (about 30-40,000 negatives) which ranges in dates from the 1950's-1970's. I guess my question is, what do I do with this stuff? Check out the blog. Is this type of work worthy of exhibitions, a book? Or do bodies of work like this come up often?

Any direction would be great.

Flickr posting, 2009

As Vivian's images flew through cyberspace, the last lots of her photographs came up for sale. By 2010, the only major collection of Vivian's work not owned by John Maloof was in the hands of Randy Prow, who had recently recovered from his accident. With the photographer's fame and the value of her pictures building, Prow was now ready to sell. His first buyer was Jeffrey Goldstein, who made two purchases that established his own sizable collection. Prow then agreed to terms that allowed Goldstein and Maloof to split his remaining lots fifty-fifty for $140,000, rendering the price per exposure roughly 100 times that of their original auction price. For the collectors, big money was at stake, and they carefully choreographed the transaction to ensure they received every last piece Prow owned. A rendezvous took place on neutral ground, a gas station in Mattoon, Illinois, midway between the parties' residences. From there they spotted a small-town hotel that provided a meeting space. The atmosphere was so tense that each side brought an armed bodyguard in case of a conference-room showdown. Thankfully, no one was harmed during the overwrought transaction.

After all the deal-making was done, the archive amounted to a total of 143,000 images. Maloof owned 84 percent, Goldstein 14 percent, and Slattery and all others just 2 percent. Maloof initially felt that the photographs should be introduced by a public institution, and he diligently contacted a list of the country's most important museums. But no one was interested in the work of an unknown artist with a limited number of existing prints and, regardless of their enthusiasm, could not devote the time and expense necessary to catalog, prepare, and display the archive. Switching course, Maloof partnered with the Chicago Cultural Center for the debut and worked with curator Lanny Silverman to select, digitally print, and mat seventy photographs for a January 2011 exhibit. The reaction was explosive, attracting the greatest attendance in the center's history. *Chicago Tonight*

Top, John Maloof (*Drew Maloof*); *bottom*, Jeffrey Goldstein (*Ron Gordon*)

and *Chicago Magazine* chronicled the event, kicking off an international frenzy in broadcast, print, and digital media. Everyone wanted to cover the story of the mysterious nanny who happened to be a world-class photographer.

THE ARCHIVE

The owners were exhilarated by the unexpected response, which confirmed their instincts and the validity of their investments. But now the real work would begin—properly preparing the outsize archive. Vivian provided no instructions; thus, posthumous finishing decisions were left largely in the hands of the two collectors who felt an enormous obligation to understand and emulate her choices. Fortunately, both possessed artistic experience and sensibility, as well as an unwavering commitment to authenticity, and turned to highly regarded specialists to develop a protocol using methods available during Vivian's lifetime. They organized themselves into separate operations but continued to work together on challenging issues, such as hiring skilled technicians to develop decades-old film. Maloof partnered with the preeminent Howard Greenberg Gallery in New York to represent Vivian Maier's photographs, and brought the renowned Steve Rifkin (who printed famed street photographer Lisette Model's works) on board. Goldstein chose to manage his own exhibitions, hiring Chicago-based master printing team Ron Gordon and Sandra Steinbrecher.

The enormity of readying an archive of 140,000 images cannot be overestimated; the photographic material required a long and costly sequence of preparation. In addition to developing and printing, each image needed to be scanned, dated, identified, cataloged, and digitally archived. While it would be logical to assume that Vivian would carefully pack her work for storage to ensure its preservation, that was in no way the case. The negatives were filed in glassine sleeves, but most of the remaining material arrived in a mixed-up tangle of prints, undeveloped film, tape recordings, movies, and assorted ephemera. She had shown the least care for her prints, which she haphazardly threw into boxes unprotected.

Archiving the collection was impeded by a dearth of notations indicating dates, locations, and subject matter. Maloof and Goldstein set out to identify each image's content and were excited when a church steeple led them to Vivian's French hometown of Saint-Bonnet. But the task of pinpointing thousands of buildings and bridges from all over the world could only be accomplished at a snail's pace, and felt daunting and impossible. With no professional organization

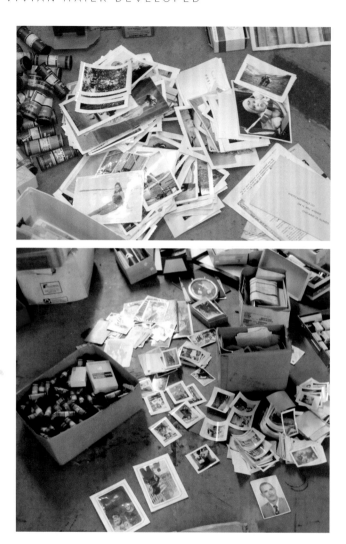

Raw material, 2011 *(Jeffrey Goldstein)*

offering to undertake the massive effort, all the work and financial risk fell to the nascent collectors, who could not afford to pay themselves a salary. Placing their lives on hold, they dug in.

THE ROLLOUT

Following the blockbuster show at the Chicago Cultural Center, Maloof and Goldstein booked separate New York premieres, followed by exhibits everywhere from Munich to Moscow. Over and over again the popular and

professional press told the Cinderella story of Vivian Maier. As exhibits opened and accolades poured in, the collectors began to receive offers to collaborate on books, films, and other projects.

Maloof had a clear vision for a documentary and spent the next year scouring his materials for clues that would lead to people who knew Vivian, sorting through thousands of scrawled notes, purchase receipts, and photo envelopes. While the majority of leads were red herrings, he ultimately connected with almost every one of Vivian's former Chicago employers, as well as a handful of her friends and acquaintances. When he was ready to find a producer, Maloof met with a team from Milwaukee and shared all his contacts and research in good faith. Initially naive, he soon realized that the group had really just sought his information and photographs and was planning to shut him out of an integral role in the production. With the same confidence that drove him to purchase Vivian's work, he walked away. Subsequently, the producers received funding from the BBC to produce their own documentary and, after realizing their mistake in letting Maloof's pictures slip through their fingers, unsuccessfully tried to lure him back.

Instead, Maloof joined forces with Charlie Siskel, nephew of late film reviewer Gene Siskel, to produce, direct, and star in *Finding Vivian Maier*. Later, unaware of the cutthroat nature of the movie business, he was shocked to learn that the BBC had moved ahead without him and was using his proprietary information. Making matters infinitely worse, Jeffrey Goldstein, never apprised of the team's prior negotiations with Maloof, was contracted to appear in the BBC film and supply them with his photographs. Ultimately, Goldstein, unhappy with his own portrayal and his betrayal of his colleague, regretted participating in the documentary. But the damage was done, and Maloof and Goldstein's relationship was never fully repaired.

The cinematic divide even propelled the proud residents of Vivian's ancestral town to split into factions to support and participate in the films: the Association Vivian Maier et le Champsaur aligned with Maloof; Les Amis de Vivian Maier with Goldstein. The British film was shown in the United Kingdom as *Vivian Maier: Who Took Nanny's Pictures?* and in the United States as *The Vivian Maier Mystery*, which debuted shortly after Maloof's *Finding Vivian Maier*. The dueling documentaries drove intense public interest, causing exhibit demand and attendance to soar. Both of the films were favorably received and when *Finding Vivian Maier* earned a 2015 Academy Award nomination for Best Documentary, Vivian Maier became a full-blown media sensation.

Dueling documentaries, 2014

THE FAME

By 2014, Vivian Maier, really the "photographer nanny," was a household name. The high profile of the discovery led to passionate public debates and spurious accusations on a host of matters. Complex estate issues ultimately compelled Jeffrey Goldstein to fold his tent and sell most of his collection, leaving John Maloof as the last man standing.

Vivian's underdog tale of achievement and talent has continued to ricochet around the world, making her one of the most talked-about photographers of the twentieth century. Today, exhibits take place across the globe, and a dozen museums have acquired her pictures. Elegant art books featuring her photographs have been released, and John Maloof's film has been subtitled in nine different languages. Vivian Maier–inspired projects, tributes, and forums are threaded throughout the internet. The inspirational story and relatable images have even drawn new people to the art form. Cortney Norman from the Howard Greenberg Gallery confirms that "Vivian's work has attracted a fresh audience to the medium, including folks who had never been to a photography exhibition or acquired works from a gallery before." As an art lover, collector, and advocate for culture, Vivian may have noted this with a firm nod of approval.

The late Mary Ellen Mark believed Vivian would have been famous in her lifetime if others had seen her images, and succinctly summed up her talent with

"Her work is great, no question about it. She is a fantastic street photographer and a fantastic portrait photographer. Great eye, everything's perfect. Beautiful framing, beautiful point of view, real point of view. She's fantastic." Some continue to mention Vivian Maier in the same breath as the masters of street photography. The conversations about Vivian Maier's legacy are just beginning, and more than a decade after the discovery of her work, admirers still avidly seek to know her story.

WHO *WAS* VIVIAN MAIER?

Like everyone, Vivian was the manifestation of genetics, her childhood experiences, and the twists and turns of chance meetings, found relationships, and random decisions, and she was undoubtedly dealt a difficult hand. Her destiny was cemented by the actions of her grandfather Nicolas Baille on May 11, 1897, when his rejection of Eugenie and Marie spawned three generations of family dysfunction. While Vivian suffered from the lasting effects of a traumatic childhood and a corresponding hoarding disorder, her talent and sense of humanity were all her own. If there is a tragedy, it is that her interpersonal issues prevented others from discovering her real genius and her from sharing it.

Despite enormous obstacles, Vivian summoned the strength and courage necessary to rise above childhood constraints to forge an independent life. She possessed deep feelings and a need to be loved and accepted, just like everyone else. Her photography was the outlet she used to express these emotions, and she created pictures teeming with humanity, humor, and beauty. We can now understand that the qualities so evident in her work resided in her authentic self, reconciling the contradictory words used to describe her. Self-portraits gave her a way to convey personal feelings in real time and establish an indisputable presence.

One of Vivian's images in particular stands out as a metaphor for the photographer herself: a portrait of a child who appears as part little girl and part grown man. The oversize man's watch, defiant stare, crossed arms, and confident demeanor conjure the stance of an adult. Yet the girl displays a head of soft curls, a dirty face, tear-filled eyes, and the too-small T-shirt of a child. The conflicting signals are hypnotic, provoking the viewer to stare back, unable to look away. In a similar way, Vivian transmitted mixed messages. Her complicated personality, formed by a challenging and bifurcated childhood and later burdened by identity issues, mental illness, and shifting compensatory characteristics, rendered her unable to expose her very real talents and emotions. The resulting tension simultaneously confuses and engages us.

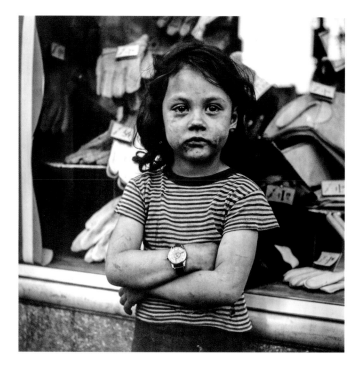

Mixed messages, Canada, 1955 *(Vivian Maier)*

Vivian's mental illness is a crucial part of her story, but it plays only a supporting role. While its existence almost certainly influenced the subject matter of her work and self-portraiture, its primary significance is to explain the reason she did not share her images. Even if Vivian wanted to disseminate her photographs, she was unable to let them go, just like her newspapers. It is with this awareness that her true hopes and feelings should be considered. Her extant work, whatever the route toward its creation, stands alone as a reflection of her artistic mastery and profound ability to understand and portray the human condition in all its diversity. As a crucial outlet for her own expression, it's no wonder she sought to capture authenticity and a wide a range of emotions.

Over time, as her disorder progressed, Vivian transformed from a conservative, clean-cut, pretty woman to an unattractive version of herself, with a distinctive, off-putting presence that caused her to be noticed even as she drove people away. Though disguised and distanced, underneath was a five-foot-eight-inch woman with a willowy figure, perfect posture, and enviable cheekbones.

Vivian's fear of intimacy and rejection prevented her from maintaining relationships, and she ultimately contented herself with living alone, surrounded

only by her possessions. In a sense, her impenetrable facade and lack of connections freed her to push forward on her own terms, traveling the world, enjoying the arts, and practicing photography. She would surely reject any notions of pity or unhappiness; she saw others as victims, never herself, and frequently reached out to help. Her extraordinary personal qualities enabled her to turn every obstacle on its head and craft a life that made her feel secure and satisfied. Happiness is relative, and considering her origins and the fate of her family, Vivian lived an inspired life.

For Vivian, photography was more than a vehicle for self-expression; it was the facilitator that enabled her to engage. Her camera opened doors and allowed the socially awkward photographer to connect with thousands of diverse and interesting people from around the globe. As she entered new households and neighborhoods, the instrument that hung from her neck helped to define her, imparting a sense of purpose and authority and allowing her to elicit emotion at a safe distance.

It was through photography that Vivian Maier established an essential link to the world and, when she wanted to, inserted herself in the action, claiming her rightful place.

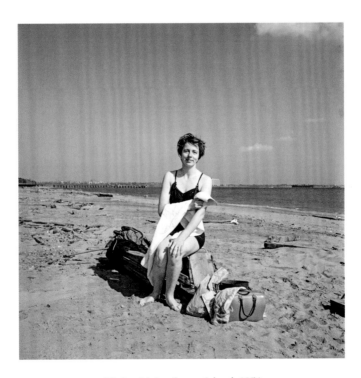

Vivian Maier, Staten Island, 1954

APPENDIX A:
THE CONTROVERSIES

Vivian Maier's high-profile and uncertain circumstances spurred public discussions on every aspect of her discovery, from her presumed desires to posthumous preparation methodologies to the rights and capabilities of the owners of her work. But nothing generates interest, incites jealousy, and escalates emotion like money, and as greater numbers of people joined the arguments, they filled with inaccuracies, innuendo, and guesswork. Unsubstantiated aspersions were picked up by the controversy-hungry press and repeated so many times that they began to solidify as fact. Today, many of the claims have been tempered or disproved by the course of events, but they still exist in the archives of thousands of media outlets and, most significantly, in the minds of many photography fans. This review of the key controversies surrounding the discovery of Vivian Maier, summarized with verified facts, is intended to set matters straight.

ESTATE MATTERS

Not surprisingly, with few assets and fewer relatives, Vivian left behind no will when she died, spawning a host of estate issues that took time to unfold. While observers had difficulty differentiating rights of ownership from those of copyright, it is actually very simple, and the law is quite clear: the auction purchasers had legal ownership of the pictures, negatives, and film in their possession because the materials were bought outright while Vivian was still alive, fair and square. While the prints have inherent worth, negatives and undeveloped film only derive value when reproduced. This right to reproduce images for sale or use in exhibits, films, and books is called copyright, and it is held by Vivian Maier's estate until assigned to her living heirs. Before they sold posthumous prints, Maloof and Goldstein joined forces to secure copyright control, splitting expenses for genealogists and lawyers to perform due diligence. The information on Vivian's death certificate, provided by the Gensburgs, was that she was born in France and had no siblings. Logically, Maloof and Goldstein assumed that a French relative would inherit her copyright.

Sylvain and Rosette Jaussaud, Saint-Laurent-de-Cros,
France, 2018 *(Ann Marks)*

Their international genealogical expert identified Vivian's closest heir as her cousin Sylvain Jaussaud, who resided in Saint-Laurent-de-Cros, France, with his wife, Rosette. Almost all of Vivian's direct maternal ancestors had lived in this commune, and many of her photographs depict its scenery, homes, and residents. Sylvain had known Vivian since his birth, confirmed by photographs from 1933. Other relatives still lived in the Champsaur, but no one came forward to dispute Sylvain's right of heirship. Thrilled to hear of his cousin's success, he offered to sign over copyright to Maloof for free. They ultimately reached an agreement for a relatively small fee, officially consummated the deal with a handshake, and a local judge informally told Maloof that the rights were his. As majority owner, he assigned the copyright to include Goldstein. Incorrectly believing that they had met their legal obligations, the pair confidently began to share and sell Vivian's images in books, exhibits, and galleries around the world.

Unfortunately, the French judge was wrong, and copyright laws required that the collectors also obtain rights in the United States. For five years, Maloof and Goldstein operated under the assumption that the matter was closed, and from their point of view their actions made sense: they had rescued unwanted photographs, devoted significant resources toward preparing and promoting them, and made an agreement with Vivian's closest identified living heir, which had garnered no dissent and had been blessed by a judge. Out of naivete, they did not explore copyright in the courts of America and were unknowingly vulnerable to the actions of an intellectual property lawyer from Virginia.

David Deal's name is tailor-made for parody, puns, and the press. After practicing photography for twenty years, he became a lawyer specializing in photographic copyright. Understanding that US law dictates that the closest living relative should inherit an estate, he traveled to Europe to construct Vivian's comprehensive family tree. Technically, Sylvain was Vivian's distant cousin, and in the line of succession, relatives that Vivian had little to do with, mostly for very good reason, jumped ahead of those she knew.

In 2014, Deal filed a petition on behalf of Francis Baille, a cousin who had never met Vivian, a category of relative sometimes referred to as a "laughing heir," as in, "laughing all the way to the bank." He was descended from Vivian's grandfather Nicolas Baille, who had impregnated her grandmother and set off three generations of emotional turmoil. When Deal had his day in US court, the judge ruled that there was insufficient evidence to declare Francis Baille as Vivian's heir, but the lawyer's actions triggered the opening of a proper probate case in Chicago. When a definitive heir was not named, by law the estate was turned over to Chicago's Cook County public administrator to manage, which is where it resides today.

The Vivian Maier case represents an anomaly for Cook County: the stakes are high, information has been difficult to find, and the potential living heirs are distant relatives most likely residing outside of the country. While the public administrator is responsible for managing and closing the case, substantial resources are required to identify a definitive heir, and under these circumstances no one wants to make a mistake. The issue of Vivian's brother casts a long shadow over these proceedings. If he fathered a child, even out of wedlock, that offspring would step far in front of all others to inherit the entire estate. Cook County may be hesitant to close the case if there is potential for such a relative to surface, and they have every right to keep it open in perpetuity.

With Deal's actions, estate matters moved center stage in the Vivian Maier drama. Maloof and Goldstein were required to enter into operational and revenue-sharing arrangements with the administrators in order to legally continue their reproduction activities. The press and public had difficulty following the complex proceedings, and accusations began to fly: that the owners had purchased the materials illegally (the purchases were legal) and tried to skirt copyright (they thought they had secured proper copyright in France). While Maloof and Goldstein could be accused of lack of legal thoroughness, the charges themselves were spurious and senseless. It defies credulity that they were trying to duck the issue of copyright altogether as some concluded;

their activities were being featured in media outlets across the world. As estate matters rose to the forefront, the owners temporarily placed operations on hold, and Deal became the target of criticism for paralyzing the progress that had already been made. Fans feared that as quickly as Vivian Maier had entered the scene, she would now evaporate in a puff of legal smoke, and they choked the internet with protest.

This is when Goldstein threw up his hands and sold all of his black-and-white negatives to Toronto gallery owner Stephen Bulger, who subsequently sold them to a Swiss fine art consortium. Goldstein did keep his beloved vintage prints. The years of working to promote Vivian with no salary had taken a marked toll: he had used up his daughter's college fund and simply could not afford to move forward. Selling his Chicago home and studio, he moved to North Carolina for what he described as a "do-over." Goldstein still had legal matters to settle with the estate related to his previous activity, but like Vivian herself, he possessed a negative knee-jerk reaction to authority, and it took him five more years to resolve outstanding issues with the administrators.

Maloof, who had similarly invested all his time, savings, and passion in Vivian's work, had just begun to turn a profit when the estate issues arose. He was able to negotiate an amicable agreement with Cook County, and in May 2016, he and the public administrator's office signed and sealed a working contract, leaving him as the focal point for matters associated with Vivian Maier. In the meantime, David Deal is still shaking the family tree for heirs. Even if they are named, their reproduction rights have no value without access to the physical negatives now largely owned by Maloof.

OWNER CAPABILITIES

Shortly after Vivian's work was discovered, the art community began to raise questions about the owners themselves—specifically if the two men who purchased the bulk of her pictures had the qualifications and experience to manage her archive. As arguments turned heated, detractors made assertions of profiteering, exploitation, and incompetence, providing the media with new fodder. Goldstein and Maloof were publicly maligned, claiming that few outlets contacted them for fact-checking or comment, easily evidenced by the absence of their voices in the critical media coverage. Regardless of how Vivian would have felt about her posthumous exposure, as a fervent advocate for the "average joe," she would surely have bristled at the manner in which portions of the art

and press establishments steamrolled the entrepreneurial collectors. Critiques lobbed from afar, devoid of practical alternatives, were the antithesis of her pragmatic orientation. As the main collector, Maloof was the primary target of the vitriol, although Goldstein periodically shared the hot seat.

The owners were accused of being unqualified to manage the work (they were artists themselves and hired world-class experts for every task); of dispersing photographs in such a manner that Vivian's body of work couldn't be studied (they prepared a digitized archive of 140,000 images); and of preventing public management of the photographs (a dozen overtures were made to museums and all were rejected). A few original auction buyers joined the criticism, complaining that they didn't receive credit for discovering the photographer. The squabbles shrouded Vivian's triumphant story with confusion, suspicion, and negativity.

Most galling to Maloof and Goldstein were claims that they had exploited the photographer for riches. In many forums, Vivian was construed as a defenseless elderly woman who had been taken advantage of by men solely motivated by money. Arbitrary calculations of profit were carelessly thrown around, ignoring the years of hard work and expenses for research, materials, staffing, storage, shipping, lawyers, developing, printing, and framing that Maloof and Goldstein had invested to prepare the massive archive. In reality, from the outset expected costs well outweighed any projection of monetary reward. The owners had followed their passion, never anticipating the once-in-a-century traction achieved by Vivian's photographs. Shocked by the attempts to undermine their integrity, they were unprepared to defend themselves. While they had certainly stumbled along the way—Maloof characterizes his cropping and selling of images on eBay as an amateur mistake—they were blindsided by the fabrications and viciousness. Now they had to acquire public speaking, social media, and press management skills on top of everything else.

In a 2014 interview, Maloof said, "Every time I get in front of people, I'm getting 'How do you feel about exploiting the work of a poor woman? You're making all this money after she's gone,'" at a time when he was still in the red and plowing revenue back into archive development. So frustrated by accusations of outsize profits, Goldstein released tax returns that showed that after five years of full-time dedication to Vivian's work, his cumulative earnings amounted to less than $100,000 of pre-tax profit, without paying himself a cent in salary. While these were official returns, the media showed little interest in revisiting the issue.

With legal proceedings and most of the malignment in his rearview mirror, Maloof returned to business as usual, methodically developing and cataloging the remaining rolls of unseen film and sharing Vivian's work through exhibits and sales. In 2019, he spent $35,000 to develop her last five hundred rolls of color film, exposing her final images from the 1980s and '90s, including her final self-portrait, which is shared here for the first time. Seeking to refocus on his own art and with an ongoing desire to grant public access to his Vivian Maier materials, he donated a large collection of artifacts and most of his valuable vintage prints to the University of Chicago.

POSTHUMOUS CHOICES

In the world of fine art, image selection, cropping, and printing are considered intrinsic parts of a photograph, almost as important as the exposure itself. As Ansel Adams eloquently explained, "The negative is the equivalent of the composer's score, and the print the performance." That Vivian Maier printed only 5 percent of her images has significant implications. Fine art institutions are hesitant to embrace her work because most of the exhibit-worthy photographs were not selected or printed by her. In a brief conversation, Jeff Rosenheim, head curator of photography for the Metropolitan Museum of Art, expressed interest in Maier's work but sought to know which pictures she herself selected to print and crop, echoing the art community's belief that when these functions are performed by others, the work does not represent the artist's true vision.

With this backdrop, the manner in which the new owners chose to select, crop, and print Vivian's photographs was a real concern. They had an unwavering commitment to stay true to the artist and turned to highly regarded specialists to develop a protocol using methods available during Vivian's lifetime. Most artists leave instructions for the posthumous handling of their work, which is obviously not relevant in this case. While every effort was made to understand and reflect Vivian's preferences, there is no getting around the fact that she did not edit or print the bulk of her pictures; not because she viewed them as unworthy, but because she had no need to do so. An early decision was made to produce prints made by hand on 16" × 20" gelatin silver paper, in editions of fifteen. To identify preparation methodologies they could adopt, the teams studied Vivian's vintage prints, those she made herself and those over which she saw preparation.

Of the approximately 7,000 extant vintage prints, 6,000 are from the Maloof

and Goldstein collections and have been digitized for examination. (This number does not include duplicate prints given to the Gensburgs and other families.) Many of the vintage photographs are in color and were produced by outside processors; the remaining 3,500 black-and-white hardcopies best serve as a proxy for Vivian's subject choices, printing preferences, and cropping style.

From a content perspective, about 50 percent of the black-and-white images Vivian made over her lifetime are landscapes and portraits appropriate for her postcard venture. Another 30 percent are city and street photographs taken in New York and during her travels. The remaining 20 percent are shots from Chicago, and the subjects of many are her employers' families and friends. Vivian composed more than six hundred self-portraits, but printed about fifty, mostly in the 1950s. During forty years of inserting herself into the action, she showed little desire to view the documentation. This breakdown demonstrates that many of Vivian's print selections were influenced by factors other than artistry. In France and New York, they were often driven by commercial concerns, and in Chicago by caretaking and family connections. Not surprisingly, the remaining black-and-white prints comprise textured streetscapes, character-driven portraits, and celebrities, consistent with the subject matter of the color enlargements she chose for her room. These prints are so few in number, it cannot be assumed that they represent images Vivian would have chosen from her entire archive if she were pursuing a career in fine art photography.

In regard to printing, Vivian displayed no consistent preferences beyond the avoidance of high-contrast and glossy paper, opting for a more realistic outcome. Master printer Steve Rifkin, whose studio produces the majority of her work, describes that his goal when printing Vivian's photographs is to make a "full tonal range print so as not to lose any shadow or highlight detail. This full tonal rather than high-contrast approach allows the eye to see into the image rather than bounce off its surface. Vivian's photographs are printed to be open and seductive, to be looked at deeply rather than absorbed almost instantly."

Cropping was perhaps the thorniest issue that the owners had to tackle because of the inconsistency of the photographer's approach. Other than to crop many shots vertically, her decisions varied from picture to picture and she frequently treated the same exposure in different ways. The team concluded that it was impossible to predict how she would crop her unprinted work and made the decision to produce them full frame, just as Vivian would have seen them in her viewfinder.

While there has been much consternation about the posthumous

preparation of Vivian's work, short of forgoing public exposure, the only solution was for Maloof and Goldstein to partner with top experts and make the best decisions they could. Howard Greenberg was asked how he thought Vivian would feel about the posthumous preparation. After serious consideration, he opined that the current pictures show "good choices, beautiful prints, and I cannot imagine Vivian Maier or any other photographer disapproving. So, I feel good about the posthumous print project, but that is a legitimate issue that people speak about."

MENTAL ILLNESS

The topic of mental illness in relation to Vivian Maier is controversial not because of the debate it sparked, but because its existence and ramifications were largely ignored even after a debilitating hoarding disorder was documented in a hundred different ways, and indisputably impacted every aspect of Vivian's life—relationships, employment, finances, and state of mind. If addressed, it would have been apparent from the start that Vivian didn't share her photographs because she was hoarding them, and had no choice in the matter. Even without the elucidation of her family background and changing photographic behavior, Vivian's hoarding of newspapers should have prompted serious consideration of the existence of photograph hoarding: pictures offer the same qualities as newspapers, thousands of contact sheets comprised page-by-page shots of newspapers, the vast majority of her images were left in unfinished form, and most were stored away without ever being revisited or ever seen. But prejudices and stigmas prevented discussion of mental illness as the reason Vivian progressively held on to her work, inspiring narratives that significantly mischaracterized her behavior and motivations.

The well-intended art and feminist communities drove matters offtrack early on by voicing long-standing biases against the attribution of mental illness to explain artists' talent or women's decision-making. In the *New Yorker*, a review of *Finding Vivian Maier* conveys this stance by asking why "the unconventional choices of women are explained in the language of mental illness, trauma, or sexual repression, as symptoms of pathology rather than as an active response to structural challenges or mere preference." The problem is that in the case of Vivian Maier, it *was* trauma and mental illness that drove many of her critical choices.

Even with some acknowledgment of her hoarding disorder, critics had

trouble separating its effects on her behavior from her talent. According to scholar Hsiaojane Chen, hoarder Andy Warhol suffered from similar confusion because historians and curators were more comfortable "seeing hoarder and artist as mutually exclusive identities. Several critics expressed indignation at the idea that Warhol could have been a hoarder, as though, if true it would have detracted in some way from his art." If Vivian had battled cancer, or even lesser physical afflictions like tremors, arthritis, or lazy eye, these conditions would not have been dismissed as irrelevant to her photography. She would likely have been lauded for her fortitude in moving forward in the face of disability. Yet even among the enlightened, the bias against mental illness prevails. Many in the Champsaur bristle at the suggestion that Vivian or her family had any type of mental disorder, even in the face of incontrovertible evidence. Experts who swept the issue under the rug only reinforced these misconceptions.

The interpretations of Vivian's actions that were publicly proffered never made complete sense and cast her as a victim in her own discovery. Some said she must have lacked the confidence to show her work or didn't have the money to properly process it, both untrue. Others thought she kept her pictures secret so she could enjoy and care for them herself, even though the vast majority were unfinished and thrown into boxes that were never reopened. It was said that she guarded her pictures because she eschewed feedback and criticism, but did that risk really exist by sharing them with employers, neighbors, and friends? The loss of Vivian's belongings was framed as the abuse of a confused and helpless elderly woman, the printing and sale of her photographs as outright exploitation, sensational claims rooted in fiction. With no intervening attempts to explain or place her behaviors into context, in many minds Vivian Maier lives as a talented oddball with a sad life story, a perception she would inarguably despise.

WHAT WOULD VIVIAN DO?

The question that propelled the most proselytizing was one that can never be definitively answered: whether Vivian would have wanted her photographs to be exhibited after her death. She left no will, made no arrangements for her belongings, and expressed no posthumous wishes regarding her work. Initially, because she was universally described to be private, a vocal constituency composed of historians, self-described protectors, and the professional press jumped headfirst to the conclusion that she would have objected to public display of her

work, and that her privacy should be respected. The fallout from this rush to judgment was twofold: first, the archive owners were accused of unethically exploiting the photographer; and second, fans were dissuaded from fully embracing Vivian's photography. But as details of her life emerged, many who first spoke for the nanny realized that they knew very little about her, and expressed support for a more informed analysis.

We now know that while Vivian *was* extremely private, the reasons for this are complex and have little direct bearing one way or another on her desires for the posthumous treatment of her work. The discovery of those who knew Vivian in New York sheds new light on matters, because they also described her as private and unforthcoming, and at the time she *did* share her pictures. She also fraternized with other photographers, tried to start a business and sell prints, and gave copies of almost all relevant pictures to her employers and friends.

When she moved to Chicago, Vivian maintained her much-described secretiveness, coolly deflecting inquiries and fabricating whenever necessary. She took the opportunity to begin anew by overtly shielding her identity and disconnecting from her painful childhood and unsavory family. While she established sporadic relationships with those interested in photography and employees of local camera stores, she shifted away from professional involvement. As time progressed and her hoarding disorder escalated, she began to collect newspapers and hold on to her pictures; both became part of her identity, and she couldn't let them go. These actions, driven by inescapable forces, do not necessarily reflect Vivian's true wishes. Andy Warhol again provides an analogous example: he wrote in his diary that he desperately wished to get rid of his accumulation and live in a clean, uncluttered space, but it was impossible for him to follow through. His actual behavior was the opposite of his real wishes.

In a story full of irony, the fight to protect Vivian's privacy is perhaps the most ironic twist of all. She was the last person in need of protection. While private in regard to her background, Vivian espoused her opinions and impressions boldly, to the point of oversharing. She became offended when anyone tried to help or protect her, brushing off assistance right up until her death, declaring that she could take care of herself. Moreover, Vivian had minimal respect for the privacy of others. Her pictures depicted people at their very worst: the vulnerable, distressed, and passed-out subjects would have undoubtedly objected to her intrusion if given the chance. Colin Westerbeck, coauthor of *Bystander*, calls a portion of her work "predatory street photography" because she takes advantage of those "who cannot defend themselves from the camera's humiliating stare."

Equally invasive was the manner in which Vivian pried into her employers' personal effects, recording their letters, albums, address books, and diaries, a complete violation of trust. While perhaps uncontrollable, Vivian's own needs trumped all other privacy considerations.

By the 1980s, Vivian had become so paranoid that she was convinced she was being watched and her possessions rifled through. She was undeniably seriously ill, and her statements and actions must be viewed in this context. One comment that she made to employer Curt Matthews has been inaccurately portrayed as evidence that she chose not to exhibit her work: she said that if she had "not kept her images secret, people would have stolen or misused them." But, according to Matthews, he did not relay this story to demonstrate her true wishes about exhibiting her work. Rather, he wanted to convey the opposite: that Vivian "could not get past her deep paranoia" to make a choice. Matthews firmly believes that she "would have been delighted that her work was shown." His wife, Linda, adds that coverage of the issues in the press initially led her to fear that the photographer was being exploited, but that she "no longer feels that the discovery of Viv's work was a betrayal to her" and is happy for the reception her art has received.

Vivian was practical and proud of her talent and may have embraced the benefits of becoming one of the world's most popular photographers, particularly after death. Would she really have abhorred the lauding of her capabilities in the *New York Times*, her lifelong bible for news? Would she have been dissatisfied to have her work finished by the same master printer as Lisette Model's, when she held little interest in processing herself? Would the establishment of a Vivian Maier archive at the esteemed University of Chicago really be that objectionable, when she had long studied the collections of scholars and artists she admired? With a fantasy life filled with celebrities, perhaps Vivian would enjoy a brush with fame at a distance.

As John Maloof moved to promote her work, he gave serious consideration to what her prospective desires might have been and the most ethical course of action. He sought input from all her employers and friends, who almost unanimously agreed that her work should be shown. They were more divided on how she would have felt about it. Most believed Vivian would have dreaded the exposure while alive, but would have come to terms with and been honored by the discovery after her death. The knowledge that it was mental illness, not desire, that drove her behavior, further clouds the issue.

A Highland Park neighbor, Carole Pohn, summed up Maloof's actions: "I

bet ninety-nine out of one hundred people wouldn't have given a damn about what was in that locker. . . . Luck finally smiled down on Vivian." From an artist's point of view, Vivian is, indeed, one of the lucky ones. Against all odds, she was discovered and revered by the public without undergoing artistic criticism or compromise, or the need to market one's work. In all likelihood she would have been gratified that it was not the establishment but regular people who had selected her as one of the most gifted street photographers, because her work spoke directly to them. While Vivian may have taken pride in this reaction, there is no doubt that she would have found it painful for her personal secrets to surface, especially after guarding them for so long. Perhaps in the name of advocacy, she would have understood that her story could help other survivors of traumatic childhoods. She stands as a stellar example of persisting through adversity and, with her enlightened mind and social consciousness, serves as a true inspiration to others.

What did Vivian expect to happen to her work once she was gone? Some hoarders believe they should leave a legacy, and some build their collections only for themselves. Vivian falls firmly into the latter group, and likely failed to even consider what would happen to her photographs after her death. They functioned as a very real part of her identity, and the thought may have been unbearable. Most likely she had no need to think about it because she was fatalistic: once you are gone, you are really gone, and decisions are for others to make. Inger Raymond remembers a prophetic conversation in which Vivian referred to Van Gogh and lamented that artists are never recognized in their own lifetime, acknowledging that it is typical to be discovered posthumously.

What do we really know for sure? Vivian made no plans for her images. As a young woman, she tried to launch a career in photography and sought to sell and share her work. She developed a progressive mental illness that manifested in the escalating collection of newspapers and a need to hold on to her images, whatever the form. She was confident in her talent, admired celebrity, believed art trumped privacy, and was ultimately fatalistic. By neglecting to pay her storage bills and never throwing away a print, negative, or undeveloped roll, she was, unwittingly or not, the one who triggered the unlikely chain of events that led to her discovery. While a full picture of her life helps clarify matters, no one will ever know her ultimate wishes with certainty, and she may have been unable to grapple with them herself.

We can only hope that Vivian Maier's real dreams and desires have in some way come true.

APPENDIX B:
THE LEGACY

Even though she is one of the most talked-about photographers of the twentieth century, major institutions have yet to bring Vivian Maier's work into their permanent collections, and her oeuvre has not been formally considered in the context of the masters of street photography. No one knows if she will ultimately participate in the canons of photographic history. Alternatively, her enduring value could be as a documentarian whose broad range of images serves as a cultural chronicle of the time in which she worked. She may even persevere as an inspirational figure who overcame formidable obstacles to create a life in which she could pursue her passions and advocate for society's underdogs. The conversation about Vivian Maier's legacy is just beginning.

HISTORIC PHOTOGRAPHER

There is broad agreement among experts that Vivian was a highly skilled photographer, yet inclusion in the annals of history is an elusive achievement that can require categorization and advancement of the medium. Arthur Lubow of the *New York Times* wrote that it is nearly impossible to apply these criteria to Vivian because she "photographed in so many styles, her sensibility is indistinct, and a signature viewpoint is absent. Depending on which picture you are looking at, she could be Weegee, Helen Levitt, Saul Leiter, Bruce Davidson, André Kertész—even Garry Winogrand." Others dispute this conclusion, including the *New York Times'* Roberta Smith, who claims that Maier's photographs "may add to the history of 20th-century street photography by summing it up with an almost encyclopedic thoroughness, veering close to just about every well-known photographer you can think of, including Weegee, Robert Frank and Richard Avedon, and then sliding off in another direction. Yet they maintain a distinctive element of calm, a clarity of composition, and a gentleness characterized by a lack of sudden movement or extreme emotion."

To date, no one has characterized and placed Vivian's work into context better than master street photographer Joel Meyerowitz, who was one of the

first experts to examine her pictures: "It looks like there is an authentic eye, real savvy about human nature, photography and the street, and that kind of thing doesn't happen that often. Vivian's work instantly has those qualities of human understanding and warmth and playfulness." He further describes the photographs as authoritative and made in the moment and that Vivian "has got it all, a sense of humor, of poignancy, a sense of the tragic, and a sense of timing." Meyerowitz explains that a canon is established with photographers like Robert Frank, Lisette Model, and Walker Evans and then "someone comes in and there is always the sense that they are a secondary figure, but I don't feel her as secondary. When I look at Vivian's pictures I always feel a genuine intelligence at work there, something primary, not secondary." He does not view the work as derivative, and any similarities to that of others can be attributed to the common subject matter and overriding humanism of the 1950s and '60s: "You can make photos without any influence, except the influence of your culture at that time."

The fact that Vivian's best work was printed posthumously remains an ongoing stumbling block. Her hoarding disorder kept her from processing the vast majority of her portfolio, and may have long-term repercussions for her legacy. Experts must consider if posthumous full-frame printing of the images as she saw them in her viewfinder is enough. Ironically, the authenticity of her posthumous prints is discounted because Vivian didn't supervise finishing tasks such as cropping, yet her images are so well-composed there is no need for cropping. A similar debate swirls around other photographers, including Garry Winogrand, who left one hundred thousand undeveloped images behind when he passed away. In 2014, fully thirty years after his death, the Metropolitan Museum of Art exhibited his pictures, edited and printed posthumously by curators. As Erin O'Toole from the San Francisco Museum of Modern Art explained, "He didn't care about print quality so much. For him it was all about getting the shot. . . . It was better to bring out the work and let it live and die on its own merit than to let it lie in a box." Such commentary seems particularly relevant to Vivian Maier.

DOCUMENTARIAN

Vivian documented a large swath of mid-twentieth century American culture, and it can be argued that the depth and breadth of her portfolio in this regard propels her into a league of her own. While individual pictures course with nostalgic detail, it is the work as a whole that can add new insight through its comprehensive coverage. Merry Karnowsky of the Contemporary Art Gallery

in Los Angeles describes the portfolio as "extraordinary and encyclopedic. Culturally it covers every gamut of a certain period of time."

Vivian's pictures from the early 1950s capture the decade's imperative for conformity during a time when veterans and their young families aspired to participate in middle-class life and its cookie-cutter trappings. With insider access and an outsider point of view, the nanny shot hundreds of photographs of a single family living on Manhattan's Upper West Side. Collectively, the photos reveal an immaculate, middle-class lifestyle so generic that there is no discernible clue to the family's identity. Their apartment is decorated with damask curtains, Asian-influenced armoires, tasteful paintings, and tchotchkes appropriate for the milieu. There are no telltale signs of ethnicity or profession apparent from their food, dress, or appearance. Papers, books, and satchels, a source for surnames and interests, are hidden from view. The residences of friends and relatives are so homogenous that the same all-American frosted bakery cakes and card store decorations appear at every party. The fancy frocks, anklets, and Mary Janes that the girls wear could have been bought in bulk. When Vivian traveled with the family, she captured classic highway motels and popular souvenirs of the era. This appealing family conveys absolutely no sense of their own identity via the frames.

Other portions of Vivian's 1950s portfolio shine a far-reaching light on the period's formality, dress code, and manners, especially as they relate to women. When hosting other children, mothers don heels, hose, and seasonally appropriate suits or dresses, even when there is no peer in attendance. These put-together women look more like today's female executives than stay-at-home moms. Proper outfitting and full makeup were a given, even for school pickups and park visits, a far cry from modern-day workout attire and dashes of lipstick. Details abound: the updos, pinched-at-the-waist dresses, and hats that could trump those worn at royal weddings. Vivian showcases them all, from cloches with mysterious veils to broad-rimmed specimens risking a tip-over on a windy afternoon.

Acutely attuned to the minutiae of everyday life, Vivian provides a historical record that crosses time frames, geographies, and categories. Take meat markets: her work recalls everything from the ubiquitous presence of pork-only stores to kosher butchers promoting "beef-fry": fake bacon designed for assimilating Jews. Transit system billboards advertise defunct products, and the el itself takes center stage with its intrusive cast-iron pillars and incongruous chalet-style stations crowding New York's avenues. Vivian proffers a rare perspective by poking her lens into tenement windows as she whizzes along the upper tracks, memorializing those at the mercy of the trains that roared past their living rooms.

Pictures from the sixties in Chicago testify to the conflict inherent in the emergence of feminism. When women finally "had it all," suburban housewives didn't necessarily transform so quickly. Instead, they tried to square new freedoms with the lives and responsibilities to which they were already committed. Portraits of their daily existence contrast sharply with parallel graffiti shots, showcasing messages such as "men must change or die." While everyone knows that diapers weren't always disposable, their inclusion in pictures conjures the drudgery of the actual changing, washing, and repeating that our tireless and not-so-distant ancestors endured.

Vivian thoroughly documented cultural conventions that have since been rendered extinct; longhand correspondence, the format of choice for contact with distant friends, relatives, and lovers, is apparent throughout the archive. Another habit gone missing that pervades the work is the regular reading of physical newspapers. It is striking to watch those from all walks of life devour exactly the same headlines at exactly the same time, every single day. These photos show how dailies threaded communities together in a way disparate digital sound bites never will.

Other documented aspects of life ring bells of alarm and reflect our changing mores. Infants ride in laps, not car seats. Children wait alone in automobiles and sit up front, beltless. Unattended strollers are parked on the sidewalk as caretakers dash around to complete errands. Babies rest on tables and sofas without protective barriers to prevent them from falling off. Carefree kids climb up trees and across rooftops without pre-concussion records on file.

Among the subjects that receive unique attention in Vivian's portfolio are photographers themselves. Images capture the rise of postwar professionals: the freelancers roaming uptown streets and the all-male packs converging on premieres. Likewise, she caught amateur shutterbugs practicing their hobby with shiny new cameras and the latest accessories. Memorializing her own medium is just one more way in which Vivian Maier's comprehensive archive preserves themes and nuances that may otherwise be missed.

INSPIRATIONAL ACTIVIST

Wherever her legacy lands in the world of photography, the case can and should be made that Vivian Maier is deserving of an entirely different distinction. She stands as an inspirational figure, a woman who knocked down obstacles to push through life on her own terms while remaining firmly committed to improving the greater good.

As a young adult, Vivian espoused a deep-seated belief in the equality, if not superiority, of women. During the fifties, she made her feminist views well-known to the Gensburgs, in advance of the next decade's explosion of activity. Despite her Catholic background, she advocated for birth control and supported abortion rights. Perpetually placing herself among the working class, she promoted leftist causes and organized labor. In 1950, she attended a rally for French Communist leader Maurice Thorez, and in 1954 photographed the funeral mob honoring Israel Amter, founder of the US Communist Party. While residing in Chicago, she supported Socialist Workers' campaigns and kept literature like the "Bill of Rights for Working People" and a critique of *Washington Post* union busting in storage. Her earliest pictures treated all races as equal and important. She was committed to desegregation and minority rights, featuring the mixing of races well before the height of the civil rights movement. She was also an active member of Chicago's Africa House and Jesse Jackson's Operation PUSH.

Vivian was a true maverick in the area of Native American rights. In her twenties, she traded a day at the beach for a visit to the Shinnecock population in Southampton. Her interest was scholarly and intense, such that she designed most of her personal vacations around meeting Native Americans and championing their cause. Her archive showcases more than a dozen Indigenous groups and active involvement in the American Indian Center of Chicago. The photos reveal few other Anglo-Saxon women participating in such activities, and it was not until 1968 that Native Americans even secured meaningful legislation establishing comprehensive rights.

The photographer's openness and independence of spirit played out in other ways. Enthralled with the new and exciting, she visited Disneyland during its first months of operation, among the first 1 percent of those who eventually made the trip. Before 1960, less than 1 percent of the world's population traveled internationally, and only a fraction of that comprised women vacationing alone. Yet when Vivian returned to Saint-Bonnet as a young woman to sell Beauregard, she casually swept through France, Spain, and Switzerland by herself. Her greatest adventure of all was also undertaken as a single traveler: her around-the-world cruise, a base from which to visit exotic ports where few other women ventured alone.

What will Vivian Maier's legacy be—historic photographer, documentarian, inspirational activist? Only time will tell.

APPENDIX C:
THE BACKSTORIES

While writing and speaking about Vivian Maier, I have frequently been asked about my methods for tracking down those who once knew the photographer and her family. Luck and persistence played prominent roles, and most quests took multiple years. I was driven by a passion for Vivian's journey and pictures, as well as a desire to challenge myself. The majority of my sources were free—purchasing the information would have eliminated most of the fun.

BACKSTORY #1: THE ROOFTOP RANDAZZOS

The Randazzos, subjects of two dozen 1951 prints, topped my interview wish list because the family appeared to know Vivian both as a friend and a nascent photographer. No one had been found who knew her in New York, and the anonymous subjects in the photos had the potential of filling critical biographical gaps. The images themselves were the only available clues, comprising an elderly couple, three young women, and a tenement rooftop. A few of the prints were dated and one was labeled "Madame Randazzo," providing a rare head start in the form of a surname. With this in hand, I anticipated meeting them within a week. The search would take a full year.

A quick online perusal revealed the surname as Sicilian, its crest similar to a charm worn by one of the girls in the photos. Surprisingly, the 1940 census surfaced almost seven hundred Randazzos in New York City alone. Only 1 percent were listed in Manhattan, and none of those residences fit the visual location or family composition displayed in the archive images.

Madame Randazzo, New York, 1951 *(Vivian Maier)*

The photograph of the rooftop contained many neighboring and distant buildings, including a large white apartment complex to the south. The Bronx and Queens were filled with such high-rises, and over the next six months I methodically examined old pictures and censes for these boroughs, looking for Randazzo households with three daughters. I contacted many families that seemed like good prospects, but they were never the right ones. Over and over, I returned to the photograph of the rooftop and its visible surroundings. The white tower's window and balcony configuration became embossed on my brain, and one day while driving on Third Avenue, I glanced up, and it was right before my eyes—except backward.

I hurried home to flip the original image, and it all made sense. Now the white apartment complex was northwest of the tenement, and I could identify Hunter College's familiar turret. The photograph showed a gabled building next door, but Google Earth did not. Determined to pinpoint the exact location of Vivian's camera, I referenced the uniquely useful site OldNYC.com, which maps every Manhattan street with old photographs. There was the missing landmark, the Lexington School for the Deaf, in its tri-gabled glory, demolished after the photo was taken.

Flipped rooftops and Randazzos, 1951 *(Vivian Maier)*;
Lexington School for the Deaf and Hunter College *(OldNYC)*

Having definitively positioned the image's north side, I found the Hospital for Special Surgery to the far south, over the shoulder of the women in one of the photos. By triangulating these locations, I traced Vivian's camera to 403 East Sixty-Third Street, the site of a demolished building also visible on OldNYC. Facades of still-standing tenements across the courtyard were identical to those in the picture, confirming the discovery. A reverse search of the address yielded hard evidence: a 1948 telephone directory entry for "Miss S. Randazza." In order to secure the names and ages of the family members, I consulted the 1940 census for the surname ending with both an o and a, but no entry for or near the address surfaced.

Assuming that the family had moved to the Sixty-Third Street location after 1940, I began the near impossible task of tracking every "S. Randazzo/a" in New York in the 1940 census. When stuck, it can be fruitful to switch databases, and I did so by turning to the 1930 census. Sure enough, I found the family living on East Sixty-Third Street and could ascertain their first names. Not only had their last name been misspelled in 1940 as "Randzzo," but the telephone directory spelling as "Randazza" was also incorrect, preventing each record from surfacing. (Misspellings would become the bane of my genealogical existence.) The rooftop that had long eluded me was only one block from Vivian's Sixty-Fourth Street apartment. I cringed when, on close examination, it was partially visible in a photo behind the eldest daughter, Sophie, all along.

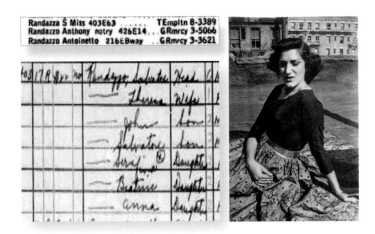

1948 NYC Directory; 1940 Census; Sophie Randazzo, 1951 *(Vivian Maier)*

Anna Randazzo, 2017
(Ann Marks)

A search of obituaries identified the married name and residence of the one sister who was still alive and well. I found eighty-year-old Anna Randazzo Cronin in Queens, and within days was in her living room. After more than half a century, she remembered Vivian vividly.

Following long, intense searches, it seems as if subjects are my friends, even before setting eyes on them. That's how I felt about Anna, who couldn't have supplied a better interview. She described Vivian's personality and physical appearance in remarkable detail. For me, it is particularly satisfying to share images with families and to learn about their lives after the photographs. In this case, there were many experimental prints of Sophie, and Anna explained she was the oddball sister and the real friend of Vivian's. They were the same age and met in the neighborhood. Each of the sisters married shortly after their friendship with Vivian. Middle sister Beatrice, a beauty, was wed several times and suffered from ill health. Sophie stayed in the neighborhood until she was struck and killed by a bus later in life. Anna raised a lovely family in Queens and, while reminiscing about the old days, began to tear up. Of course, so did I.

BACKSTORY #2: JOAN FROM RIVERSIDE DRIVE

While I traced numerous New Yorkers that Vivian had cared for, I pledged to continue my work until locating the charming young girl from Riverside Drive. She was Vivian's first long-term charge, and the start of Vivian's employment with the family coincided with the purchase of her Rolleiflex. The six-year-old served as a transitional subject whose image was captured with different cameras and processed through cropping and printing experimentation. Vivian took almost five hundred frames of Joan's family, far more than any other in New York, and joined them on a long Western vacation.

Despite an abundance of pictures, I was unable to glean clues to this employer's identity, as there were no notes, visible names, or unusual locations. The pictures simply revealed Catholic, middle-aged parents and their daughter in an apartment building I easily identified as 340 Riverside Drive. With no

census prepared after 1940, the telephone directory was my best resource and I reverse-searched the address for 1952 building residents. I superficially traced the history of every family in the large apartment complex to determine their composition, but none fit the profile. For years, I reexamined the photographs for leads, even asking master printer Steve Rifkin to blow up photos for readable details. As a last resort, I landed on the idea of contacting other children that lived in the building in the early 1950s in case they remembered the little girl with the French nanny. That was the trick!

In the absence of a census, obituaries can be the most expedient source for determining the composition of families. And through this means I found Sydney Charlat, who had lived at the Riverside Drive address and had had four children. A search of their names revealed a book written by daughter Joan Charlat Murray entitled *Confessions of a Curator*. The opening featured an old picture of her mother, Lucia Charlat, who looked very familiar. I recalled a similar woman from a photo Vivian took at a 1953 Valentine's Day party, standing behind the little girl that I sought. If she was Lucia, then the families were friends.

Sidney A Charlat

13 Dec 1909

340 Riverside Dr Apt 14a, New York, NY, 10025-3440

Charlats, 1952 NYC Directory; Lucia Charlat holding baby;
Lucia and unknown girl, 1953 *(Vivian Maier)*

The book also contained a picture of Joan Charlat, who resembled a girl in a second party photo. I searched Ancestry.com for Carol Charlat, a daughter also named in the father's obituary, and the high school photo that surfaced resembled the other girl in the party photo, thus I knew I had found the Charlat sisters.

Lucia, Sydney, and Joan Charlat; Carol Charlat, 1959; the Charlat sisters, 1953 *(Vivian Maier)*

Before I contacted them, I wanted to be sure. A full internet search clinched it: a picture of Carol Charlat in a 2014 Texas newsletter featured her dining room table, and on it was the same distinct candlestick as was on the family table in Vivian's photos.

The candlestick, 1953 (Vivian Maier); Carol Charlat's table, 2014.

Now I only had to hope that someone in the family would remember their young friend from long ago. I called Joan Charlat in Canada and, after conferring with Carol she reported that there was an only child with a French nanny from their Riverside Drive building who they had heard was deceased. Her name was also Joan, and her mother, Marie, and the family had owned a famous steak house. This name led me to a picture of Marie in a Hawaiian newspaper, taken while she was on vacation. My heart leaped when I immediately recognized her as the mother reflected in many of Vivian's photos, a face that I had

Marie, Waikiki Press; Joan and Marie, 1952 *(Vivian Maier)*

stared at for years. The subjects of my search were definitively identified at last.

Contact information was available through public records, and within twenty-four hours I was interviewing "little" Joan, who was alive and well. Coincidentally, she was an admirer of Vivian's work and had even seen the documentary *Finding Vivian Maier*, but didn't realize that it was her nanny, primarily because she never knew her caregiver's name—everyone just called her Mademoiselle! I subsequently reviewed all the family's old photographs and discovered that they unknowingly possessed a large number of original Vivian Maier prints. For biographical purposes, I gleaned new details from both of the Joans. As relayed, they, along with their siblings and cousins, found the nanny cold, strict, and lacking in empathy, although she had generously shared her pictures.

BACKSTORY #3: THE FEMALE PHOTOGRAPHERS

Vivian made studio portraits of only two photographers during her lifetime, both at the beginning of her career. There was a dearth of information regarding her early photography and intense interest in these elderly colleagues. But other than their images and the adjacent negatives, there were no hints to help identify the subjects. While my search for them would take two years, it yielded important new perspectives about Vivian's photographic history. Two of the pictures, shot within a six-month time frame, looked to be of the same subject. The third was of a somewhat younger woman. None of the three photos offered a sense of exterior location, and there were no accompanying notes other than dates.

Carola Hemes and Geneva
McKenzie, 1953–1954 *(Vivian Maier)*

I confirmed that the first two pictures were of the same elderly woman by enlarging and lightening them to uncover the same distinct stool in the back of the darkroom photo and in a picture hanging on the wall in the office photo. This woman must have been significant to Vivian, as she not only posed her twice but made a print of the second portrait for herself. Based on the Karlsruhe catalog, foreign-language newspapers on her desk, and the nature of images on her walls, the subject could be identified as a German bridal photographer. A step forward, but still scant information to go on.

With no other leads, I turned the search inside out by examining the neighborhoods Vivian frequented in the early 1950s. A sequence of shots covering the 1953 filming of the movie *Taxi* displayed a photo studio in the background. While it looked to be part of the set, it was the only obvious studio found in the New York pictures, prompting further exploration. I learned that things important to Vivian were often included but not highlighted in her pictures, so that only she would understand their significance.

The studio's sign advertised "Carola Studio," with samples of celebrity, passport, and bridal photos on display, suggesting that the photographer could be the woman in Vivian's pictures. Finding the establishment in public records proved to be surprisingly difficult. To me, "Carola" sounded Italian, but only two such surnames were listed in the 1953 Manhattan telephone directory and none were photographers.

Reverse searches for "987 Third Avenue" bore no fruit. It eventually dawned on me that Carola was a first name, and I discovered it was the German equivalent of Carol. Having learned the hard way to search multiple spellings and time frames, I uncovered a 1933 listing for Carola Hemes, a photographer living near the 987 Third Avenue address. Old census records indicated that

Carola Studio, New York, 1953 *(Vivian Maier)*

she worked with her husband, and a directory posted his place of work as the Third Avenue building. A newspaper article from the period divulged a bitter divorce, with Mr. Hemes jailed for not providing support. The couple had no children and Carola went on to take over the studio.

Carola's immigration and passenger records brought the news that she was in fact from Karlsruhe, but definitive proof required a corroborating photograph. For this I turned to her extended family and found a relative in New Jersey, who confirmed the existence of a great-aunt who was a photographer. He agreed that the woman in Vivian's shots resembled his grandmother Elise Loeffel Mehls, the photographer's sister, but there were no surviving photos for comparison. Seeking an alternative

source, I correctly assumed that his unnaturalized grandmother had registered as an Enemy Alien, as was required of Germans during the war years. Elise Mehls's record included a picture of a woman almost identical to the one in the photos, confirming that Carola Hemes was indeed her sister and Vivian's mentor. Much later, I deciphered a very blurry envelope on the office desk as sent to "M. Hemes, 3rd Avenue," further confirming the result.

Elise Mehls, 1940
(NARA)

When Vivian revisited New York in 1956, she photographed a display of bridal pictures out of context. I was able to determine she was in fact at Hemes's old studio because reflected on the glass was the chiropractor sign that long sat above the now missing Carola Studio sign. Vivian had returned to visit her mentor, but Carola had retired and was traveling in Germany, and passed away on the trip.

While researching Hemes, I came upon newspaper advertisements

promoting classes, processing, and darkroom rentals on the very same block. During the 1940s and '50s, the building two doors down at 983 Third Avenue was a mecca for photographers. It also appeared in many of Vivian's pictures, establishing her apparent go-to spot for photography-related activities. Much later, this knowledge helped me identify the other photographer.

Robert W. Cottrol announces an eight-week informal course in photography for beginners at his studio, 983 Third Avenue. The course fee of $7.50 for each session of four hours includes the use of equipped darkrooms for class assignments.

NEW! NEW! NEW! NEW!
Darkrooms and Studios for Rent
HOUR — DAY — WEEK
COMPLETELY EQUIPPED
SIMMONS OMEGA ENLARGERS
ERRY HOWARD'S STUDIOS
ird Ave. (at 59th St.) N. Y. C.

Ads for lessons and darkrooms 1940s–'50s (NYT and NYH)

The portrait of the second female photographer seemed to be equally significant because, after enlarging her portrait, it was apparent that she was posed examining Vivian's negatives. A year after finding Carola, I was working in the Hautes-Alpes and perusing the digitized 1953 New York City Directory for unrelated reasons. Amid the dense page of surnames beginning with "Mc," a familiar address jumped out: "983 3Av." My pulse quickened as I focused on the listing and saw that it was for photographer Geneva McKenzie. I immediately sensed that she was the unidentified subject of Vivian's 1954 picture. Verification came from a 1908 high school yearbook accessed on Ancestry.com, which shared the same lovely oval face and "up-do" as those in Vivian's photo.

McKenzie Geneva E photo studio
983 3Av. PLaza 3-0074

McKenzie yearbook, 1908; NYC Directory, 1953;
McKenzie darkroom, 1954 (Vivian Maier)

BACKSTORY #4: THE McMILLAN SISTERS

Of all my pursuits, the McMillan search was the most far-fetched—a true stab in the dark. I had hoped to find the family because Vivian and the family's father processed film together. In this case, there were scores of pictures, but only one note, "Upstate New York," on a glassine envelope. The associated photos showcased a day trip to a grandmother's estate to cut down a Christmas tree. The father and caretaker recorded the bucolic events and later turned them into a holiday card.

Other images were taken in and around the family's city residence. Surrounding buildings and Google Earth helped me pinpoint their address as either 360 or 390 First Avenue. With no census to consult, I again needed to use much less informative telephone directories to trace the residents. Frustratingly, the hundreds of listings for the First Avenue addressees proved useless without additional clues. Careful scrutiny of the apartment interior yielded no insights.

Ultimately, I put aside the search and returned to it almost a year later to devote one last afternoon toward locating the family. I magnified Vivian's pictures and painstakingly scoured them for clues. In the process, I closed in on a toy telephone and noticed writing in the center dial. Rather than a pretend number, as I had long assumed, there appeared to be a name. Hours of manipulating that tiny, blurred label led me to conclude that it might read "Sarah." And so I performed a search of Sarahs born in the late 1940s who had lived in Manhattan. Options were of course plentiful.

My expectations were low as I casually perused the results, seeking connections. On the PeopleSearch.com engine, I encountered Sarah R. McMillan, whose residences included downtown Manhattan and Hopewell Junction, New York. The latter is a popular country house location, just an hour and a half up the Taconic Parkway. I vaguely recalled a McMillan from the First Avenue directory search, Jas R McMillan at 390 First Avenue.

Sarah R McMillan

San Bernardino, California 92405
San Luis Obispo, California 93401
Llano, California 93544
Arroyo Grande, California 93420
Nashville, Tennessee, in zip codes 37212 and 37214.
Knoxville, Tennessee, in zip codes 37923 and 37920.
Hopewell Junction, New York 12533
Millbrook, New York 12545
New York, New York 10012

McMillan Jas E 359W126MOnumnt 2-4871
McMillan Jas R MD 390 1Av .,...ALgnqn 4-8323
McMillan Jean 30EEndAvREgnt 4-6095

Sarah and the telephone dial, 1955 *(Vivian Maier);* addresses
(PeopleSearch and NYC Directory)

McMillan homes *(Google Earth)*

McMillan estate, 1954 *(Vivian Maier)*

In truth, the findings were so dubious that I didn't take them seriously. The unreadable dial probably didn't say "Sarah" to begin with. Still, I needed to see my hunch through. Hopewell Junction is now an incongruent area of town houses, housing developments, and weekend escapes. On Google Earth, Sarah's address at 112 Phillips Road showed a house nestled in the woods down a long driveway, but it wasn't the large white estate from Vivian's picture. Yet there was something about the landscape—the winding creek and types of trees—that propelled me to continue a virtual stroll up the country lane. Soon wooden fences lined the road, ones identical to those in Vivian's images! Less than a mile away, I came upon Duchess Farm, once owned by prominent lawyer Banton Moore. It was all there: the stone walls, fenced fields, and large white main house.

As it turned out, the Moore family owned both houses, and Sarah's was the smaller residence down the road from the estate. Margaret Moore had married James McMillan, a union which resulted in three daughters: Mary, Lucia, and, yes, Sarah.

Public information revealed that she had, sadly, passed away. Lucia would have been too young to remember the nanny from 1954, so I set my sights on Mary and found her in New Mexico. At first she could recall little about Vivian, but the images themselves provoked important memories and stories about her family. Her famous grandfather had died during the 1953 holiday season, impaled

by a beam while reconstructing the farm's large barn. That set the stage for a visit to their widowed grandmother the following year. In early December 1954, their new caretaker, Vivian, accompanied the girls and their parents for the pre-Christmas excursion.

Mary went on to explain that the warm holiday pictures were largely a charade—taken while her parents suffered through substance abuse, infidelity, and depression. Her father stayed with both his wife and mistress for the remainder of his life. This demonstrated to me how photographs can mislead, reflecting brief moments that are not necessarily authentic or emblematic. Here photographic togetherness was nothing of the sort. Coincidentally, Vivian's pictures of the families who preceded and

Mary, Lucia, and Sarah McMillan, 1954 *(Vivian Maier)*; 2000 *(Mary Cavett)*

followed the McMillans also masked underlying struggles. The interview with Mary was full of anecdotes, most tellingly that Vivian had become unwilling to share her photographs—perhaps the first sign of her hoarding of images.

BACKSTORY #5: MAIER FAMILY MEMBERS

The elusive Carl Maier ironically turned out to be the genealogical gift that kept on giving. The discovery of his Coxsackie reformatory file provided more background than any biographer could hope for, and his military record filled out the family history, including documentation of genetic mental illness. These records cracked open Vivian Maier's life story, but I sought firsthand information for validation and more nuanced understanding. I set a goal to interview someone who personally knew each of Vivian's direct family members. This was easily accomplished for Marie Jaussaud and Nicolas Baille, because several people who had known them (all were more than ninety years old) still lived in the Champsaur Valley. Vivian's brother, father, and grandmother, however, presented major challenges.

Carl Maier

Because Carl had dropped out of society, there were few places to turn to locate anyone he knew. Friends who had written him letters during his teenage years were long gone, some went to prison and others faced premature deaths. In the military, the drug addict had rendered himself invisible, and his go-to treatment center, Ancora Psychiatric Hospital, would only confirm his burial. The last remaining source was the outpatient home where Carl spent his final decade, the name of which was revealed on his original Social Security application.

L & S Rest Home in Atco, New Jersey, was included in an in-depth study on elderly care abuse, which is available in the state archives. The facility received relatively high marks, and the study imparted much information relevant to Carl's experience as well as the names of the longtime owners, who I tracked to Florida. Two members of the Pliner family immediately remembered Carl and could provide credible details. I found some aspects of their descriptions surprising, having assumed they would recall a troubled, disruptive soul. Instead, their words could have applied to Vivian: he was well-spoken, formal in dress and demeanor, with a large yet quiet presence.

Charles Maier Sr.

I devoted an inordinate amount of time seeking an individual who had first-hand experience with Vivian's father, but it ultimately paid off in spades. My approach was to work through his second wife's family tree—a large clan who I assumed, correctly, stayed in touch with their sister, Berta Ruther Maier. As an unnaturalized German, she had registered as an Enemy Alien during World War II, filling out an informative five-page questionnaire. From that document, I gleaned clues to help me track her relatives.

Records of the Ruther family—who were spread across the United States, Europe, and South America—contained more than their fair share of genealogical variations and misspellings, testing even my patience. The components of Berta Ruther Maier's name alone were spelled sixteen different ways (Berta, Bertha, Herta, Ruther, Rutter, Rother, Keither, Reuter, Maier, Mair, Meier, Mayer, Mayers, Meyer, Meyers, Myer), with combinations driving infinite possibilities. The couple's probate records, available only in hard copy in Queens, provided the springboard for locating Berta's relatives.

Berta Ruther Maier, 1942 *(NARA)*

In New York, probate records are available to the public and can be invaluable for revealing private family dynamics. Berta died intestate and her public administrative file detailed five lines of descendants. In nearby Rochester, I found a nephew who not only remembered Berta, but had actually lived with her and Charles in Queens. He had quite a story to tell. I was primed for bad news, based on dismal descriptions of Charles by his own mother, but this story was so sordid, my contact hesitated to reveal it. After two vivid telephone discussions, he finally spilled that Charles was not only a liar, a gambler, and a drunk, but a violent abuser. The description of him holding a knife to Berta's throat is one I'll never forget. It can only be hoped that, unlike her brother, Vivian had very little interaction with her father.

Eugenie Jaussaud

Eugenie Jaussaud had departed France more than one hundred years ago and passed away in 1948, rendering chances of finding someone who knew her fairly remote. Still, from her extraordinary success as a cook and the impression she gave in letters, I felt she was ethical, warm, and wise, and appeared to be the most significant person in Vivian's life. After all, Vivian possessed deeply held values and she must have been influenced by someone, it was important to confirm this characterization. The children of Eugenie's past employers represented the only shot, and I logically began with the final family posted in the census, the Gibson/Clarks from Bedford. Their son was an elderly man living in Fort

Pierce, Florida, when I found him, and has since passed away. He had strong memories of his childhood cook, and the description was just as I had imagined.

Despite the importance of Eugenie to the family, a photo of her had never been found, not in Vivian's belongings, not in the Hautes-Alpes archives, and not among friends and family in France. Desperate to find just one, I began to look for images in the archives of her wealthy employers, but came up empty-handed. Finally, I fell back on my overriding belief that many government records have yet to be unearthed. I reexamined Eugenie's journey to America, hoping that I had missed a step, and a new online index included a Eugini [sic] Jaussaud who was naturalized in Nassau County in 1932. Unlike New York City and Suffolk County, Nassau keeps their own records, which only became searchable after I had finished studying Vivian's family. I retraced Eugenie's steps to citizenship and found new information.

Eugenie arrived in America in 1901, but atypically did not immediately file a Declaration of Intent for Naturalization form. Perhaps she had planned to return to France, or simply had not been advised to do so. She ultimately filed her declaration in the Southern District of New York in 1925, just as Marie had become pregnant with Vivian. After waiting the prerequisite seven years, she submitted her naturalization petition in 1931, but unexpectedly did so in Nassau County, while working for the Dickinsons in Oyster Bay.

By that time, arrival records from 1901 were no longer available, and a Certificate of Arrival validation was required. Once this was accomplished, witnesses needed to be collected. By the time Eugenie completed the process, it was already 1932 and that was the year under which her records were filed, in a rarely accessed book in Nassau County. When I ordered a copy of her records, the archivist tried to open the book but some of the pages were stuck together. Without trying to extract Eugenie's information, he sent the entire volume out for repair and notified me to call back in two months—one of the more frustrating moments of my search. I convinced him to give me contact information for the repairer, who kindly searched the book and provided me with copies of Eugenie's documents. I soon figured out that her actual Certificate of Citizenship wasn't filed at the county level, but had to be ordered from US Citizenship and Immigration Services. As luck would have it, by postponing the process, Eugenie had paid me a genealogical favor. Early naturalizations, like that of the Maier family, contained no photographs, but by the 1930s they were required. As I had long hoped, when the certificate arrived in my inbox, the treasured photo was there—the only known picture of Eugenie Jaussaud.

Eugenie Jaussaud, certificate of citizenship, 1932 *(USCIS)*

APPENDIX D: GENEALOGICAL TIPS

A head start for amateur genealogists to help you work less to find more.

GENEALOGICAL SITES

Genealogical records are fraught with errors that significantly restrict searches. *Example:* Carl Maier's surname was misspelled as "Mair" in the 1920 birth index, a tiny mistake that prevented the record from ever surfacing in internet searches of "Maier." By accessing the primary record at the library, I identified the error and reconfirmed Carl's date of birth.

Genealogical sites offer stand-alone databases that can be reviewed page by page. *Example:* I found Carl Maier's baptism record in an unsearchable, stand-alone Saint Peter's church database on FamilySearch.com. It took a page-by-page review, but I finally came across his entry.

Expanding search geographies can yield unexpected findings. *Example:* After limiting my searches to New York City, I expanded them to include all nearby areas for no particular reason. Lo and behold, up popped the New Jersey death record of a Karl Maier.

Collective examination of records can identify gaps to be addressed. *Example:* I knew Eugenie Jaussaud lived in the United States but couldn't find her in the 1910 census. I changed my search to French Eugenies with no last name. Many entries surfaced, including one in upstate New York for a "Eugenie Jouglard." I thought her last name was a mistake, until I found her marriage certificate.

Subjects should be re-researched because genealogical sites regularly add data. *Example:* I couldn't find Eugenie's naturalization documents, but I knew they existed. The problem turned out to be that she had unexpectedly filed her petition in Nassau County, which manages their database separately from all others and was late in placing it online. When I retried years later, the index to the records surfaced and I quickly found the records.

Genealogical sites have built-in peculiarities that dramatically impact searches. *Example:* On Ancestry.com, a search for someone in "Manhattan" yields results from the 1930 census but not the 1940 census, which is only keyed to the term "New York City." Residential searches require inputs that exactly match the format and abbreviations of the directory listings. The only way Vivian's or Joan's residences can be searched is by precisely entering "421E64" or "340RivDr."

Genealogical sites can offer the same records but provide different details. *Example:* On Ancestry.com, John Lindenberger's death record contained merely the basics. The FamilySearch version offered many more details including his wife's maiden name, which opened up a new avenue of exploration for Berthe Walperswyler, Vivian's "second mother."

Searches using similar rather than exact terms yield very different results by site. *Example:* I searched for François Jouglard with the surname I initially thought correct: "Jougland." Ancestry.com offered no results for "François Jougland" but FamilySearch surfaced several records, including the bigamous marriage certificate.

INTERNET SEARCHES

The bulk of genealogical information can't be accessed via search engines. *Example:* Carl Maier's reformatory records are not indexed and cannot be found through a Google search. Locating them required a search of prison records from a direct source, in this case the New York State Archives. Even entering his name into their search engine didn't work. It took sifting through layers of the archives' database to find it.

An effective way to begin searches is with birth and death records. *Example:* A quick roundup of broadly available vital records revealed that Vivian's ten New York relatives were buried in nine different places. This set the stage to search for a broken family.

Obituaries are important for what they include and what they don't. *Example:* Obituaries are one of the few post-1940 resources that include the names and compositions of families. Conversely, William Maier's initial obituary didn't include his granddaughter Vivian, revealing her distance from the Maier side of her family.

Newspapers contain content that can't be found anywhere else. *Example:* Searches of New York newspapers on FultonHistory.com revealed everything from the classified ads placed by Marie to Vivian's Chicago arrest. Telephone numbers from other records can be matched with those in classified ads.

With a first and last name, almost anyone can be found on the internet. *Example:* By using multiple online directories and collecting tidbits of information from each—age, addresses, maiden names, middle initials, and affiliations—I found *every* person associated with Vivian Maier whom I sought.

PHOTOGRAPHS

Photographs should be examined from all angles and for reflections. *Example:* As simple as it seems, by reversing the Randazzo rooftop print, I gleaned the new perspective I needed to locate their tenement.

Photographs should be examined over and over. *Example:* Success in genealogical research entails making connections from findings that evolve over time. Despite looking at Vivian's 1959 pictures repeatedly, a benign postcard took on entirely different meaning once I learned about François Jouglard.

Minor adjustments can yield new findings from photographs. *Example:* After a dozen examinations, I reviewed the McMillan pictures one last time and altered size and exposure until I saw that the toy telephone was labeled "Sarah," the crucial clue to finding the family.

There are free resources for identifying historical buildings and locations. *Example:* I made extensive use of heritage sites including OldNYC Mapping, which contains photographs of every street in New York City. These collections enabled me to locate where and how Vivian took many of her early pictures, which included buildings that were long gone.

Pictures paint a thousand words. *Example:* The candlestick!

INTERPRETATION

Avoid the temptation to fill gaps with hypothesis instead of evidence. *Example:* Early on, I discovered Vivian's parents practiced different religions and that

Carl was atypically baptized in both the Protestant and Catholic churches. My working hypothesis was that these differences pulled the family apart, but soon learned that religion was the least of their problems.

Just because it's in a record doesn't mean it's true. *Example:* Going in I assumed that records were generally accurate. Much later I realized that Vivian's family were largely fabrications and should be viewed in the context of hiding family secrets.

If a record is puzzling or doesn't make sense, don't immediately dismiss it. *Example:* When I discovered Eugenie and François living together under the name Jouglard, I assumed the census entry was faulty and dismissed the notion that the two were really married. Then I came across the last thing I expected: their marriage certificate.

GENERAL SLEUTHING

Probate records provide incomparable details and are typically public. *Example:* Eugenie's will alone exposed that Marie lived separately from her children, that she was no longer Vivian's contact or guardian, and that she was not trusted with a direct inheritance. Plus, Carl Maier signed his name "William Jaussaud."

Legal transcript searches yield rich information. *Example:* The transcript of a business trial involving Fred Lavanburg not only paints a picture of Eugenie's and Marie's day-to-day life, but describes the evolution of events that brought Marie to America in 1914. The Vanderbilt trial transcription was eye-opening in a myriad of ways. Some trial transcripts surface when searched under Google Books.

If a person can't be found, look for someone who may have known them. *Example:* I failed to find Joan, Vivian's charge from the Upper West Side, until I first found other children from the building who knew her growing up. It was time-consuming but worth it.

A host of valuable federal records are available for public consumption. *Example:* The Freedom of Information Act grants extensive public access to historical records, like original Social Security applications. Vivian's 1943 application disclosed that she had moved in with Berthe and was working at the Madame

Alexander factory. Marie's application confirmed she wasn't living with Vivian. Eugenie's confirmed Margaret Emerson was her employer. Carl's named his rest home, the only source that offered this information.

International archives can offer deeper, easier access to records than the US. *Example:* I initially assumed it would be impossible to navigate French resources, but the opposite was true. The Hautes-Alpes archive offers comprehensive online records that are easy to identify and acquire. With the assistance of Frédéric Robert, the extraordinarily helpful archive manager, I secured over two hundred pages of French primary source material including coverage of Nicolas Baille's recognition of Marie, François Jouglard's abuse, Jean Roussel's military troubles and arrests, and a century of family successions.

Unrelated resources can contain otherwise unattainable information. *Example:* Most records contain dates, addresses, and alternate names. I ordered land sale records from France for no other reason than to learn where Eugenie lived and worked in the US at various points in time.

Be ready to waste time. *Example:* Ultimately, 95 percent of the leads I followed and information I reviewed were irrelevant to my search. It wasn't really time wasted, however, as I learned about a wide array of people, places, and things that I previously knew nothing about.

ACKNOWLEDGMENTS

It didn't take a village, but it did take an exceptional group of people with whom I would never have crossed paths save for a midwestern nanny and her storage lockers. Topping my thank-you list are the administrators of Vivian Maier's estate, particularly General Counsel Leah Jakubowski; and outside legal team Gregory Chinlund, James Griffith, and Coleen Chinlund. With unwavering support, they granted me worldwide rights to use any photograph I wished in order to tell Vivian's story. I imagine I shall never be so lucky again.

My six-year journey began after John Maloof and Jeff Goldstein offered me access to their archives. When I first met them I laughed, because they in no way resembled their public portrayals as greedy, exploitative philistines. It is karma that John became the discovery's key player since he is almost an extension of Vivian, sharing traumatic childhoods, working-class orientations, artistic sensibilities, obsessive personalities, can-do attitudes, and commitment to social causes. John has my gratitude, but also my infinite admiration: This twenty-six-year-old kid with no background in photography recognized and devoted himself to Vivian's talent, introduced her work to the world, and made an Academy Award–nominated film to tell the story. Need I say more? Jeff, thank you for being the first to bring me into the inner circle and for sharing your essential vintage prints. I appreciated the time we worked together, especially sharing moments of incredulity as my findings unfolded.

Many others generously lent photographic support, particularly the Howard Greenberg Gallery family: David Peckman, Karen Marks, Zach Ritter, Alicia Colen, and Cortney Norman, the focal point for all things Vivian. Howard, I owe you buckets of thanks for guiding me through unfamiliar terrain from beginning to end. Anne and Francoise Morin, international curators who represent Vivian's work, bent over backward to propel this book forward, and I'm eager to continue our collaboration. I never expected to know a master printer, but I'm sure glad he turned out to be Steve Rifkin, with his incomparable expertise and eagerness to help. Much thanks to Dan Wagner, my photography consultant; Colin Westerbeck, who reviewed an early manuscript; and Joel Meyerowitz, for his expertise and kindness.

I pregamed with my Aevitas literary agent extraordinaire, Jon Michael Darga. The interval between our first conversation and book auction was a mere ninety days. Afterward, he was there for every step—and it wouldn't have been nearly as fun with anyone else. Aevitas also supplied my foreign rights agent, Erin Files, who secured Italian, Spanish, German, French, Polish, and Chinese contracts before we got to first pass. I don't know what I was expecting, but by the time Poland rolled in, my global dreams had come true.

In regard to publishers, I am especially indebted to those who didn't work out, landing me happily in the competent hands of Simon & Schuster. I have boundless appreciation for each member of my team. In fact, I am grateful to even have a team. First and foremost, much gratitude to editor Trish Todd, whose narrative suggestions were right every single time; Dana Sloan, who devotedly designed a book that could accommodate over five hundred images; and Emma A. Van Deun, creator of our stunning cover. Putting my grammar and punctuation skills to shame were manager Tamara Arellano, copy editor Ivy McFadden, and proofreader Kristen Strange. Thanks to Fiora Elbers-Tibbitts, whose eagle eye caught all my mistakes, and counsel Carolyn Levin, who meticulously policed my permissions. From production, thank you to Vanessa Silverio and Jim Thiel, and Ray Chokov in prepress. For me, the more the merrier, and I am happy that Navorn Johnson, director of copyediting; Jaime Putorti, head of interior design; and Paige Lytle, managing editor, each sprinkled a little of their magic on this project. Now, on the cusp of making it all come true in real life, are deputy publicity director Joanna Pinsker and associate marketing manager Isabel DaSilva.

I eagerly await my return to the Champsaur, with its welcoming residents, still-charming villages, and country cuisine. I love every bit of the valley and this biography would not have been possible without the dedication of the locals. I challenge anyone to find a more knowledgeable and responsive archivist than Frederic Robert of the Haute-Alpes. On-the-spot translation help from Agnes Clark was much appreciated. From day one, I liaised with the Association Vivian Maier et le Champsaur, initially joining forces with president François Perron for years of transatlantic collaboration. François, a special thanks for your research on Jeanne Bertrand. Her replacement was president Marie Hugues, who has been a tireless partner, fielding questions, funneling information, and tracking down interviewees. Marie even confirmed that a snowstorm occurred at the end of April 1950, helping identify Vivian's first photo. She introduced me to Vivian's family and friends and, poignantly, our conversations were conducted just in time, as many have subsequently passed away: Sylvain Jaussaud a month after our interview and

milkman Férréol Davin, Baille neighbor Lucien Hugues, and playmate Marie Daumark soon after. I continue to receive invaluable assistance from both sides of Vivian's French family via cousins Auguste Blanchard and Rosette Jaussaud.

An equal debt is owed to those who knew Vivian in Chicago and sat for extensive interviews with John Maloof and follow-ups with me. The unique details and insights supplied by Inger Raymond and Linda Matthews made the narrative really come alive. The Gensburgs chose not to participate in this venture but they inarguably afforded Vivian a long period of happiness and I sincerely hope they will be satisfied with my work. Conversations with employers and acquaintances discovered in New York and California added new dimension to Vivian's story. Special thanks to interviewees Gwen Akin, Mary Cavett, Joan and Carol Charlat, Charles Gibson, Tom and Meredith Hardy, John Kaye, Diana Martin, the Pliners, Anna Randazzo, Leon Teuscher, and little Joan.

Why don't people like lawyers? I have the deepest affection for my personal attorney, Steven Pokotilow, and know Mark Merriman will continue to keep me out of trouble. Many specialists nationwide supported my research, including dozens of archivists and mental health professionals, especially psychoanalyst Robert Raymond and hoarding experts Randy Frost and Jenny Coffey. I am particularly beholden to Donna Mahoney, who waded through rafts of information to provide a well-considered assessment of Vivian's entire family.

During the years that I worked on this book, all of my children graduated from high school and college. Thank you to Jack for lending me your U of C library password, to Jake for a bit of French translation, and to Jessie for unflagging pep talks. I love each of you for just being you. I love my husband, John, especially for allowing me to write in solitude on the daybed of my screened porch. Thank you to friends and relatives for encouragement and cocktails. My deeply missed parents, Harriet and Jack, would have loved to place this book among their collection of accomplishments from my overachieving siblings and in-laws: Bruce, Irene, Jon, Joan, Jane, and Bruce.

My kids weren't the only ones to receive an education. My far-fetched and serendipitous intersection with Vivian brought me greater enrichment than my years in the Ivy League. I learned about immigration waves and ethnic neighborhoods, children's services and public housing. For the first time, I made my way to the Bowery, First Avenue Estates, NYC Archives, StuyTown, Fresh Pond Crematory, and multiple neighborhoods in Queens. Improbably, through Eugenie and Jeanne, I vicariously experienced the life of high society. Of course, my learning transcended New York—I enjoyed exposure to Chicago, rural France,

and bits of the rest of the world. A most cherished outcome was the opportunity to learn about photography from the very best. Finally, if I didn't know it already, it became crystal clear that the least likely people can be the most inspiring. Thank you, Vivian, for this unintentional detour into adult education.

To Vivian's fans: Without your widespread embrace of Vivian's work, this remarkable woman would have faded into obscurity. My hope is that her biography will compel you to advocate for destigmatization of mental illness and to view and collect Vivian's photographs with even deeper enjoyment and understanding.

SOURCES

Information in *Vivian Maier Developed* that is not sourced below is derived from Vivian Maier's photographs, notes, and possessions, courtesy of the Estate of Vivian Maier, the John Maloof Collection, and Jeffrey Goldstein.

INTRODUCTION

Susan Sontag, *On Photography* (New York: Farrar, Straus and Giroux, 1977).

Vivian Maier descriptors from John Maloof recorded and transcribed interviews of employers and friends, 2011–2013: Maren Bayleander; Bindy Bitterman; Terry Callas; Roger Carlson; Jim Dempsey; Phil Donahue; Karen Frank; Bob Kasara; Patrick Kennedy; Duffy and Jennifer Levant; Linda, Joe, and Sarah Matthews (Luddington); Cathy Bruni Norris; Anne O'Brien; Carole Pohn; Inger Raymond; Sally Reed; Bill Sacco; Richard Stern; Judy and Chuck Swisher; Ginger Tam; Karen and Zalman Usiskin; Barry Wallis; as well as personal interviews with Meredith and Tom Hardy, Mary McMillan, and Anna Randazzo.

Mary Ellen Mark, recorded and transcribed interview by John Maloof, 2011–2013.

Vivian Maier image counts and composition, John Maloof and Jeffrey Goldstein.

Vivian Maier obituary, *Chicago Tribune*, April 23, 2009, main edition, pp. 1–23, http://chicagotribune.newspapers.com/image/233157476.

John Maloof, original blog on Flickr, *Hardcore Street Photography*, October 10, 2009, https://www.flickr.com/groups/onthestreet/discuss/72157622552378986.

David W. Dunlop, *New York Times Lensblog*, January 7, 2011, https://lens.blogs.nytimes.com/2011/01/07/new-street-photography-60-years-old.

Leah Ollman, "Art Review: Vivian Maier at Stephen Cohen," *Los Angeles Times*, October 13, 2011, http://latimesblogs.latimes.com/culturemonster/2011/10/art-review-vivian-maier-at-stephen-cohen.html.

Sarah Cohen, "Celebrating Vivian Maier's Genius: Undiscovered Photographer Finally Acknowledged," Associated Press/*Huffington Post*, March 12, 2011, updated May 25, 2011, http://www.huffington post.com/2011/03/12/celebrating-vivianmaiers_n_834905.html.

Roberta Smith, "Vivian Maier: Photographs from the Maloof Collection," *New York Times*, January 19, 2012, http://www.nytimes.com/2012/01/20/arts/design/vivian-maier.html.

Finding Vivian Maier, John Maloof and Charlie Siskel, producers, Ravine Pictures, 2013.

Karl William Maier Jr., Baptism 2, July 30, 1920, Saint Peter's Lutheran Church, New York City.

Karl Maier, Beneficiary Identification Records Locator Subsystem (BIRLS) Death File, Washington, DC: U.S. Department of Veterans Affairs.

Jason Meisner, "Hunt for Acclaimed Photographer Vivian Maier's Long-Lost Brother Heats Up," *Chicago Tribune*, August 17, 2015, http://www.chicagotribune.com/ news/ct-vivian-maier-estate-fight-met-20150814-story.html.

Karl Maier, #395, Prison and Parole Records: NYSVI; Coxsackie Correctional Facility; NYSA; Albany 14610-88C, inmate case files, 1930–1965.

Karl Maier, 1942 National Archives at Saint Louis, Saint Louis, Missouri; Record Group Title: Records of the Selective Service System, 1926–1975; Record Group Number: 14.

CHAPTER 1: FAMILY: THE BEGINNING

Vivian Maier quote, to the Frank children on tape in late 1970s, Tape 10, John Maloof Collection.

Maier Family Background

Von Maier family history in Modor, Slovakia, research by genealogist Peter Nagy, Slovakia.

Robert Maier, ancestor in Slovakia, email exchange regarding family history, 2017.

Alma Maier baptism, October 2, 1887, Slovakia Church and Synagogue Books, FamilySearch.

Wilhelmine Hedvig Alma Maier baptism, 1887; citing p. 9, Baptism, Modra, Pezinok, Slovakia, Odbor Archivnictva, Slovakia; Family History Library microfilm 2,406,626.

Charles Maier baptism, July 26, 1892, Slovakia Church and Synagogue Books, FamilySearch.

Gusztáv Vilmos Károly Maier baptism, 1892; citing p. 4, Baptism, Modra, Pezinok, Slovakia, Odbor Archivnictva, Slovakia; Family History Library microfilm 2,406,626.

Maier family immigration, New York Passenger Arrival Lists (Ellis Island), 1892–1924, Wilhelm Maier, October 17, 1905; citing departure port Bremen, arrival port New York, ship name *Kronprinz Wilhelm*; NARA Microfilm Publication T715 and M237.

Meyer [sic] family residence, 1910 Census: Manhattan Ward 19, New York, New York; Roll: T624_1040; Page: 9B; Enumeration District: 1052; Family History Library microfilm 1375053.

Wilmos Maier naturalization, New York City Archives, November 12, 1912, Volume 8, p. 128, #3089921.

Alma Maier marriage, 1911 New York City Municipal Archives, New York, New York; Microfilm: 1375053, indexed #M11.

Alma and Joseph Corsan residence, 1915 New York State Archives, Albany, New York; Election District: 02; Assembly District: 20; New York; County: New York; Page: 18.

Alma and Joseph Corsan residence, 1920 Census, Manhattan Assembly District 10, New York, New York; Roll: T625_1203; Page: 3A; Enumeration District: 735.

Alma and Joseph Corsan residence, 1925, Election District: 49; Assembly District: 09;

City: New York County, New York; Page: 12; New York State Archives; Albany, New York; State Population Census Schedule.

Alma and Joseph Corsan residence, 1930 Census: Manhattan, New York, New York; Roll: 1567; Page: 22B; Enumeration District: 0566; Image: 647.0; Family History Library microfilm 2341302.

Alma and Joseph Corsan residence, 1940 Census: New York, New York; Roll: T627_2656; Page: 4A; Enumeration District: 31-1368.

Joseph Corsan military registration, U.S. Selective Service System, World War I Selective Service System Draft Registration Cards, 1917–1918, Washington, DC: National Archives and Records Administration, M1509, 4,582 rolls.

Joseph Corsan naturalization, Petitions for Naturalization from the U.S. District Court for the Southern District of New York, 1897–1944, NARA Microfilm Publication M1972, 1457 rolls, Records of District Courts of the United States, Record Group 21, National Archives at Washington, DC.

Jaussaud Family Background

"*Les Jaussaud de Saint-Laurent-Du-Cros*," family history from seventeenth century to present, courtesy of the Jaussauds.

Vivian Maier family tree, 1700s to present, prepared by Mrs. E. Denante, president of the Genealogical Association of the Hautes-Alps.

Jean-Pierre Eyraud and Marie Hugues, *The Emigration of the Champsaur People to America* (Imprimerie H. Clavel, Gap, 1987).

Agnes Clark and Marie Hugues, in-person interviews in France about the lifestyle of the Champsaur, 2018.

Paul Vacher, *Ceux de Beauregard* (Gap, France, June 2019).

Robert Faure, *Anthologie des Bonheurs Paysons* (Emprunt Abonnement Kindle, July 13, 2017).

Maria Eugenie Jaussaud birth, No. 4, January 30, 1881, 2 E 154/8/2, Saint-Laurent-du-Cros, France, Archives departementales de Hautes-Alpes.

Maria Florentine Jaussaud birth, No. 29, December 18, 1882, 2 E 154/8/3, Saint-Laurent-du-Cros, France, Archives departementales de Hautes-Alpes.

Joseph Albert Jaussaud birth, No. 22, November 8, 1884, 2 E 154/9/1, Saint-Laurent-du-Cros, France, Archives departementales de Hautes-Alpes.

Joseph Albert Jaussaud death, Age 4, February 28, 1889, 2 E 208/6/9, Saint-Laurent-du-Cros, France, Dates 1883–1922, *Contexte: Tables cantonales*, Archives departementales de Hautes-Alpes.

Joseph Marcellin Jaussaud birth, No. 17, June 16, 1887, 2 E 154/10/1, Saint-Laurent-du-Cros, France, Archives departementales de Hautes-Alpes.

Jaussaud family residence, 1891 Census, House 43, 6 M 308/18, Les Cros, Saint-Laurent-du-Cros, France, Archives departementales de Hautes-Alpes.

Jaussaud family residence, 1896 Census, House 1, 6 M 315/18, Les Cros, Saint-Laurent-du-Cros, France, Archives departementales de Hautes-Alpes.

Jaussaud family residence, 1896 Census, House 37, 6 M 315/17, Saint-Julien-en-Champsaur, France, Archives departementales de Hautes-Alpes.

Nicolas Baille residence, 1896 Census, House 37, 6 M 315/17, Saint-Julien-en-Champsaur, France, Archives departementales de Hautes-Alpes.

Marie Jaussaud birth, No. 10, May 11, 1897, 2 E 153/18, Saint-Julien-en-Champsaur, France, Archives departementales de Hautes-Alpes.

Germain Andre Jaussaud succession, 4 Q 2880-Transcription registers, August 30, 1899–October 10, 1899, Volume 723, Gap Mortgage Conservation Office, 1899, Archives departementales de Hautes-Alpes.

Homestead Act of 1862, National Archives and Records Administration, https://www.ourdocuments.gov.

Jaussaud 1901 land sale, 4 Q 2896, Transcription registers 08 March 1901–28 March 1901, Volume 739, Gap Mortgage Conservation Office, 1901, Archives departementales de Hautes-Alpes.

Jaussaud family residence, 1901 Census, House 53, 6M 322/17, Saint-Julien-en-Champsaur, France, Archives departementales de Hautes-Alpes.

Cyprien Lagier residence, 1861, House 43, 6 M 263/17, Saint-Julien-en-Champsaur, France, Archives departementales de Hautes-Alpes.

Anais Lagier Dusserre (Cyprien's sister) residence, 1901, House 44, 6 M 322/17, Saint-Julien-en-Champsaur, France, Archives departementales de Hautes-Alpes.

High-Low Life

Eugenie Jaussaud immigration, May 20, 1901, SS *La Gascogne*; Arrival: New York, NY; Microfilm Serial: T715, 1897–1957; Microfilm Roll: Roll 0197; Line: 22; Page: 92.

Eugeni Joussaud [sic] certificate of arrival, SS *La Gascogne*, May 20, 1901, U.S. Department of Labor, Naturalization Service, No. 2-1180178.

Nicolas Baille, 1901, New York Passenger Arrival List (Castle Garden and Ellis Island), 1820–1957, departure port Le Havre, June 15, 1901, arrival port New York, final destination, Walla Walla, Washington, ship name *La Bretagne*, NARA, T715, Roll 0208.

Cyprien Lagier family residence, Year: 1900; Census Place: Norfolk, Litchfield, Connecticut; Page: 10; Enumeration District: 0246; Family History Library microfilm: 1240140.

French families, Litchfield County, Connecticut, United States of America, Bureau of the Census, Washington, DC, National Archives and Records Administration, 1900, T623, 1854 rolls.

Bertrand family residence 1891, Rue de Lageron, House 198, 6 M 308/15, Saint-Bonnet-en-Champsaur, France, Archives departementales de Hautes-Alpes.

Bertrum [sic] family residence, Year: 1900; Census Place: Litchfield, Connecticut; Page: 2; Enumeration District: 0240; Family History Library microfilm: 1240140.

"From Factory to High Places as Artist, Jeanne J. Bertrand, a Girl of 21, Has Become One of the Eminent Photographers of Connecticut," *Boston Globe*, August 23, 1902.

Jennie Bertrand, 45 Water Street, Title: Torrington, Connecticut, City Directory, 1900–1905, U.S. City Directories, 1822–1995 [database online], Ancestry.com, 2011.

Jeanne Bertrand, descriptions of her life and relationships by researchers Françoise Perron, Gary V. Smith, and Jim Leonhirth via email, 2015–2016.

Jaussaud land sale, 1904, signed by Eugenie in Litchfield, Connecticut, 4 Q 2932, Transcription Registers, October 8, 1904–November 12, 1904, Volume 775, Gap Mortgage Conservation Office, 1904, Archives departementales de Hautes-Alpes.

Jouglard family residence, 1901 Census, House 192, 6 M 322/15, Saint-Bonnet-en-Champsaur, France, Archives departementales de Hautes-Alpes.

Jouglard emigration, Year: 1901; Arrival: New York, New York; Microfilm Serial: T715, 1897–1957; Line: 1; Page: 77.

François Jouglard residence 1903–1904, Cleghorn, Fitchburg, Massachusetts, City Directory.

Jouglard family residence, 1906 Census, House 235, 6 M 329/15, Saint-Bonnet-en-Champsaur, France, Archives departementales de Hautes-Alpes.

Marie-Therese Jouglard death, March 12, 1906, 2 E 137/17, Civil Status Register, Saint-Bonnet-en-Champsaur.

Jouglard/Jaussaud marriage, March 9, 1907, New York, New York, Marriage Records, 1829–1940, Certificate 7069.

Jouglard family residence, 1911 Census, House 57, 6 M 336/15, Saint-Bonnet-en-Champsaur, France, Archives departementales de Hautes-Alpes.

Dyani Mae Bryant, "History of the Walter C Witherbee Mansion," Historic Port Henry, Moriah, New York, https://www.porthenrymoriah.com.

New York Department of Education, 1909, doi: 10.2307/community.28479474, *The Champlain Tercentenary: Final Report of the New York Lake Champlain Tercentenary Commission* (J. B. Lyon Co. State printers, Albany, New York, 1913).

Eugene and François Fauillard [sic] residence, Year: 1910; Census Place: Port Henry Ward 1, Essex, New York; Roll: T624_934; Page: 9B; Enumeration District: 0051; Family History Library microfilm: 1374947.

Joseph Jaussaud travel to Port Henry, New York, Year: 1910; Arrival: New York, New York; Microfilm Serial: T715, 1897–1957; Line: 27; Page: 12.

Joseph and Eugenie Jaussaud in America, 1 E 11041, Aubert, Jules (notary), Saint-Julien-en-Champsaur, Archives departementales de Hautes-Alpes, April 19, 1911.

Joseph Jaussaud return to Saint-Julien, 1 E 11044, Aubert, Jules notary, Saint-Julien-en-Champsaur, Archives departementales de Hautes-Alpes, August 13, 1912.

François Jouglard return to Saint-Bonnet, February 28, 1912, Military Record FRAD005_1R_00957_0453, Archives departementales de Hautes-Alpes.

Joseph Jaussaud death, 2 E 153/28/1, Register des Acts de Deces, Dates: 1916–1920 Contexte: Saint-Julien-en-Champsaur, No. 1, January 18, 1917, Archives departementales de Hautes-Alpes.

Emilie Pellegrin Jaussaud death, 2 E 153/28/1, Register de Deces, Dates: 1916–1920 Contexte: Saint-Julien-en-Champsaur, No. 2, February 30, 1919, Archives departementales de Hautes-Alpes.

Emilie Pellegrin Jaussaud succession, 3Q 5992, June 9, 1917–April 7, 1919, Hautes-Alpes Recording, Declaration of transfers by death, Volume 22, Archives departementales de Hautes-Alpes.

Prexede Roux Jouglard, "Opposition of François Jouglard," 18 December 1913; Inventory Jouglard-Roux, 19 December 1913, 1 E 10855, Guilhaumon, Albert, November

1–December 31, 1913, Saint-Bonnet-en-Champsaur, Archives departementales de Hautes-Alpes.

Jouglard-Roux reconciliation, January 17, 1914, 4 U 1063-1913, Civil act and judgments, Saint-Bonnet-en-Champsaur, Archives departementales de Hautes-Alpes.

Charles Dana Gibson, telephone interview about Eugenie Jaussaud as his childhood cook in Bedford, 2016.

Eugenie Jaussaud, 1940 Census: Bedford, Westchester, New York; Roll: T627_2802; Page: 14A; Enumeration District: 60-10.

Gibson Girl, Wikipedia, 2020, https://en.wikipedia.org/wiki/Gibson_Girl.

"House of the Week. Horse Country Estate: Ensign Farm," *Wall Street Journal*, October 4, 1996, https://www.wsj.com/articles/SB844360798600498500.

Fred L. Lavanburg, Hecla Company lawsuit, S. C. Posner, Inc. vs. Emanuel Jack and E. A. Jackson, Inc, February 17, 1914, appeal, Supreme Court New York County, January 13, 1922.

Fred L. Lavanburg passport application, National Archives and Records Administration (NARA), Washington, DC; Roll: 105; Volume: Roll 0105; Certificates: 23575-24474, 05 Apr 1910–13.

Maria Jaussard [sic], Year: 1914; Arrival: New York, New York; Microfilm Serial: T715, 1897–1957; Line: 26; Page: 154.

Louise Heckler passport application, National Archives and Records Administration (NARA); Washington DC; Roll: 1575; Volume: Roll 1575, Certificates: 22126-22499, 20 Apr 1921–21 Apr 1921.

Louise Hecher [sic], Year: 1914; Arrival: New York, New York; Microfilm Serial: T715, 1897–1957; Line: 11; Page: 149.

Eugenie and Marie Jaussaud residence, 1915 Census: New York State Archives; Albany, New York; State Population Census Schedules, Manhattan Ward 22, New York, NY; Roll: T624_1046; Page: 5B; Enumeration District: 1319.

George Seligman residence, Year: 1920; Census Place: Manhattan Assembly District 7, New York, New York; Roll: T625_1197; Page: 4B; Enumeration District: 559.

Meyer [sic] family residence, 1915 New York State Archives; Albany, New York; State Population Census Schedules, 1915; Election District: 02; Assembly District: 20; City: New York; County: New York; Page: 18.

Charles Maier employment, National Biscuit Company, 11th Avenue, New York City, Draft Registration Cards, 1917–1918, Washington, DC: National Archives and Record Administration, M1509, 4,582 rolls, imaged from Family History Library microfilm.

Classified Advertisements, 220 East Seventy-Sixth Street, 1900–1930, classifieds referencing first-floor commercial space and ads placed by the Maier family selling horse and buggy accessories.

The Parents

Charles Maier and Marie Margaret Jaussaud, Certificate and Record of Marriage, No. 13505, City of New York Department of Health, May 11, 1919.

Maier family residence, Year: 1920; Census Place: Manhattan Assembly District 15,

New York, New York; Roll: T625_1212; Page: 2A; Enumeration District: 1064, 162 East Fifty-Sixth Street.

Eugenie Jaussaud residence (Henry Gayley), Year: 1920, Census: Manhattan Assembly District 15, New York, New York; Roll: T625_1213; Page: 2B; Enumeration District: 1087.

Maier family dynamics from reports, interviews, and letters from Karl Maier reformatory file, #395, Prison and Parole Records: NYSVI; Coxsackie Correctional Facility; NYSA; Albany, 14610-88C, inmate case files, 1930–1965.

Charles Mair [sic], birth record, March 3, 1920, 11181, NYCA.

Charles Maurice Maier, Baptism 1, May 11, 1920, Saint Jean de Baptiste Church, New York.

Karl William Maier Jr., Baptism 2, July 30, 1920, Saint Peter's Lutheran Church, New York City.

Nicolas Baille return to France, 1 R 998—Service register, class 1898 (Hautes-Alpes), Volume 2, #916, Archives departementales de Hautes-Alpes, July 7, 1920.

Eugenie Jaussaud letter and addendum to sister Maria Florentine, New York, December 20, 1920, Archives departementales de Hautes-Alpes.

Eugenie Jaussaud inheritance transfer, 4 Q 3068, Transcription Register, February 12, 1921–March 21, 1921, Volume 911, Gap Mortgage Conservation Office, 1921, Archives departementales de Hautes-Alpes.

Eugenie Jaussaud transactions regarding transfer of Beauregard inheritance: 1E 10944, Beaume, Alphonse (notary), July 1–July 31, 1921, Saint-Bonnet-en-Champsaur, Archives departementales de Hautes-Alpes.

Eugenie Jaussaud final documentation of transference of inheritance rights to Maria Florentine Jaussaud, 1 E 11079—Aubert, Jules (notary), September 1–December 1924, Saint-Julien-en-Champsaur, Archives departementales de Hautes-Alpes.

"Heckshers Give $3,000,000 to Aid Children," *New York Tribune*, November 9, 1920, pg. 1.

"Children's Home Occupying Fifth Avenue Block Rapidly Nearing Competition," *New York Times*, October 16, 1921, page 102.

"August Heckscher Lost His Fortune at 42 but He Quickly Accumulated a Larger One," *Brooklyn Daily Eagle*, October 4, 1925, page 103.

"The Heckscher Foundation for Children," *Brooklyn Life and Activities of Long Island Society*, September 24, 1924.

Fifty-Eighth Annual Report of the State Board of Charities, State of New York, for the year 1924, Legislative Document 1925, No. 13.

Charles and Marie Maier residence, 1925 Census, New York State Archives; Albany, New York; State Population Census Schedules, 1925; Election District: 27; Assembly District: 16; City: New York; County: New York; Page: 1.

Maier grandparents residence, 1925 Census, New York State Archives; Albany, New York; State Population Census Schedules, 1925; Election District: 14; Assembly District: 15; City: New York; County: New York; Page: 12.

Eugenie Jaussaud residence (Charles E. Lord), 1925 Census, New York State Archives; Albany, New York; State Population Census Schedules, 1925; Election District: 06; Assembly District: 01; City: Mount Vernon; County: Westchester; Page: 7.

Eugenie Jaussaud petition, May 27, 1925, National Archives and Records Administration; Washington, DC; NAI Title: Index to Petitions for Naturalizations Filed in Federal, State, and Local Courts in New York City, 1792–1906; NAI Number: 5700802; Record Group Title: Records of District Courts of the United States, 1685–2009; Record Group Number: RG 21.

CHAPTER 2: EARLY CHILDHOOD

Vivian Maier quote to a Chicago employer in the 1960s, John Maloof recorded and transcribed interviews, 2011–2013.

New York Childhood (1926–1932)

Vivian Maier, Birth Certificate, Department of Vital Records #04473, February 1, 1926, NYSA.

Viviane Therese Dorothee Maier, Baptism Record, Saint Jean de Baptiste Church, New York, residence 345 East Fifty-Eighth Street, March 3, 1926.

Victorine Benedetti witness to Vivian Maier Baptism, Saint Jean de Baptiste Church Record, 1926.

Eugenie Jaussaud residence (Hunt Dickinson), 1930 Census: Oyster Bay, Nassau, New York; Roll: 1462; Page: 9B; Enumeration District: 0194; Image: 576.0; Family History Library microfilm: 2341197.

Carl Maier and grandparents residence, Year: 1930; Census Place: Bronx, Bronx, New York; Page: 7A; Enumeration District: 0254; Family History Library microfilm: 234120.6.

Eugeni [sic] Jaussaud naturalization, Petition 035 9649, witnessed September 30, 1931, filed 1932, Nassau County Clerk's Office, Mineola, New York.

Eugenie Jaussaud, Certificate of Citizenship, #3536421, Supreme Court of Nassau County, March 18, 1932, C-file, https://www.uscis.gov.

Social Service Exchange records, 1925–1930, Karl Maier case file, #395, Prison and Parole Records: NYSVI; Coxsackie Correctional Facility; NYSA; Albany, 4610-88C.

Marie Jaussaud classified ad, *New York Times*, March 13, 1932.

Jeanne's and Eugenie's Remarkable Careers

Jeanne Bertrand, Marie and Vivian Maier residence, Census Year: 1930; Census Place: Bronx, Bronx, New York; Page: 1A; Enumeration District: 0733; Family History Library microfilm: 2341204.

Jeanne Bertrand, ". . . severe attack of nervous prostration," *Torrington Register*, January 22, 1904.

Jeanne Bertrand, ". . . a sudden mental breakdown due to overwork at her studio in Boston," *Torrington Register*, February 3, 1910.

Meagan Barke, "Nervous Breakdown in 20th Century American Culture," *Journal of Social History*, March 22, 2000.

Letter from C. S. Pietro to Mrs. Harry Payne Whitney (Gertrude Vanderbilt Whitney),

January 18, 1917, Whitney Museum Library, Whitney Studio Club and Galleries, 1907–1930.

C. S. Pietro and Gertrude Vanderbilt Whitney, James Bone, *The Curse of Beauty* (New York: Regan Arts, April 18, 2017).

Pietro Michael Cartaino birth, May 28, 1917, U.S. Social Security Applications and Claims Index, 1936–2007 (database online), Ancestry.com, 2015.

"'Friends' Gertrude Vanderbilt Whitney, C. S. Pietro Provide Aid to Young Artists," *New York Sun*, October 28, 1917.

"Sculptress Goes Insane," *Bridgeport, Connecticut, Evening Farmer*, June 14, 1917.

"Sculptress Tries to Kill Her Two Nieces," *Register Citizen*, June 14, 1917.

C. S. Pietro biography, 1886–1918, Arc Art Renewal Centre, https://www.artrenewal.org/artists/c-s-pietro/26444.

Cartaino Di Sciarrino Pietro (C. S. Pietro) death, 1886–1918, *Who Was Who in American Art: 400 years of artists in America*, second edition, three volumes, edited by Peter Hastings Falk (Madison, Connecticut: Sound View Press, 1999).

C. S. Pietro widow and children residence, Year: 1920; Census Place: Pelham, Westchester, New York; Roll: T625_1281; Page: 16A; Enumeration District: 16.

Jeanne Bertrand residence, Year: 1920; Census Place: Manhattan Assembly District 10, New York, New York; Roll: T625_1203; Page: 2A; Enumeration District: 721.

Estate of Pietro Cartaino Sciarrino vs. Margaret Baker, New York Supreme Court, Case on Appeal, No. 362, June 20, 1924.

Janne Bertrand [sic] residence, New York State Archives; Albany, New York; State Population Census Schedules, *1925*; Election District: *25*; Assembly District: *03*; City: New York; County: New York.

Associated Press, "Vanderbilt Left Above $50,000,000," *Fort Worth Star-Telegram*, May 29, 1915.

Bob Luke, *Bromo-Seltzer King: The Opulent Life of Captain Issac "Ike"* (Jefferson, North Carolina: McFarland Incorporated, 2020).

"Boy Now Has $4,969,789," *New York Times*, February 2, 1915.

"Hunt Dickinson Financier, Dead," *New York Times*, March 11, 1967.

Jeanne Bertrand residence, April, Year: 1940; Census Place: Weehawken, Hudson, New Jersey; Roll: m-t0627-02353; Page: 6A; Enumeration District: 9-345.

Jeanne Bertrand residence, May, New Jersey State Hospital, Year: 1940; Census Place: Parsippany-Troy Hills, Morris, New Jersey; Roll: m-t0627-02373; Page: 75B; Enumeration District: 14-89.

French Childhood (1932-1938)

Maria Florentine Jaussaud residence, 1931 Census, House 91, 6 M 357/17, Saint-Julien-en-Champsaur, France, Archives departementales de Hautes-Alpes.

Nicolas Baille residence, 1931 Census, House 44, 6 M 356/3 Le Ricous, Saint-Jean-Saint-Nicolas, France, Archives departementales de Hautes-Alpes.

Jouglard family residence, 1931 Census, House 191, 6 M 357/15, Saint-Bonnet-en-Champsaur, France, Archives departementales de Hautes-Alpes.

Reconnaissance d'Enfant Naturel par Baille, 12 Aout 1932, Marie Jaussaud Maier, 1
E 11098, Aubert, Jules (notary), June 1–September 31, 1932, August 12, 1932, St.-
Julien, Archives departementales de Hautes-Alpes. (Review of ten thousand notary
entries in the Champsaur failed to surface a similar record.)

Route of Napoleon establishment in 1932, Portoferraio, https://route-napoleon.com.

Sylvain Jaussaud, 1933 photographs of Jaussaud family, Saint-Bonnet, France.

Auguste Blanchard, in-person interview in Saint-Bonnet, France, regarding his mother's
(Josepha's) relationship with Marie Jaussaud and impressions of Vivian Maier
during various stages of her life, 2018.

Vivian Maier confirmation, Convent du J'Cours de Marie, May 31, 1934, recorded on
Vivian Maier's baptism record in Saint Jean de Baptiste Church, New York.

Férréol Davin, in-person interview in Bénévent-et-Charbillac, France, regarding
Vivian Maier friendship, 2018.

Sylvain and Rosette Jaussaud, in-person interview in Saint-Laurent-de-Cros regarding
cousin Vivian Maier, 2018.

Jean Pierre Roussel military record, 1 R 980—Service register, class of 1893 (Hautes-
Alpes), Volume 1, #394, Archives departementales de Hautes-Alpes, July 7, 1920.

Zoe Magnan succession to Jean Pierre Roussel, March 10, 1930, 1 E 11001, Beaume,
Alphonse (notary), March 1–April 31, 1920, Saint-Bonnet-en-Champsaur, Archives
departementales de Hautes-Alpes.

Eugenie Jaussaud substitution of power of attorney, 23 Mai 1933, 720 Park Avenue,
Jack Straus, 1 E 11101, Aubert, Jules (notary), May 1–August 31, 1933, Saint-
Julien-en-Champsaur (Hautes-Alpes, France), Archives departementales de
Hautes-Alpes.

Eugenie Jaussaud land sale, 28 Aout 1933, signed by Maria Baille of Saint-Julien-en-
Champsaur, 1 E 11101, Saint-Julien-en-Champsaur (Hautes-Alpes, France), Ar-
chives departementales de Hautes-Alpes.

Maria Florentine designation of Vivian Maier *légataire universelle*; will dated January
18, 1934, Archives departementales de Hautes-Alpes.

Verta Ruther [sic], 1927 Arrival: New York, New York; Microfilm Serial: T715,
1897–1957; Microfilm Roll: Roll 4021; Line: 30; Page: 160.

Berta Maier, 1934 Arrival: New York, New York; Microfilm Serial: T715, 1897–1957;
Microfilm Roll: Roll 5538; Line: 11; Page: 48.

Berta Maier, Enemy Alien Registration, 1940–1943, #3073121, USDJ; Probate Intestate,
134084, Surrogate Court, QCNY, 1943.

Berta Maier naturalization, National Archives and Records Administration (NARA);
Washington, DC; Index to Naturalization Petitions of the U.S. District Court for
the Eastern District of New York, 1865–1957; Microfilm Serial: M1164; Microfilm
Roll: 89, 1949.

François Jouglard succession, January 17, 1936, 3 Q 6009-1936, Hautes-Alpes Record-
ing, Saint-Bonnet-en-Champsaur, Volume 39. (Death July 11, 1935.)

Nicolas Baille residence, 1936 Census, house 154, 6 M 362/18 Le Ricous, Saint-Jean-
Saint-Nicolas, France, Archives departementales de Hautes-Alpes.

Maria Florentine Jaussaud residence, 1936 Census, house 88, 6 M 364/17, Saint-Julien-
 en Champsaur, France, Archives departementales de Hautes-Alpes.
Jean Roussel residence, 1936 Census, servant, house 88, 6 M 364/17, Saint-Julien-en
 Champsaur, France, Archives departementales de Hautes-Alpes.
Jouglard family residence, 1936 Census, house 193, 6 M 364/15, Saint Bonnet-en
 Champsaur, France, Archives departementales de Hautes-Alpes.
Pellegrin and Davin families' residences, 1936 Census, houses 1 & 5, 6 M 364/2,
 Bénévent-et-Charbillac, France, Archives departementales de Hautes-Alpes.
Blanchard family residence, 1936 Census, house 257, 6 M 364/14, Le Domaine, Saint-
 Bonnet-en-Champsaur, France, Archives departementales de Hautes-Alpes.
Sylvain Jaussaud residence, 1936 Census, house 49, 6 M 364/17, Saint-Laurent-du-Cros,
 France, Archives departementales de Hautes-Alpes.
William Maier death record, January 29, 1936, NYCDR, CN2664, GS Film #2079190.
William Maier cremation, #48960, ashes returned to Maria Maier, February 28, 1936.
William Maier obituaries, *New York Times*, January 30–31, 1936.

The Trouble with Carl

Karl Maier (Carl), events, records, and letters related to his incarceration, #395, Prison
 and Parole Records: NYSVI; Coxsackie Correctional Facility; NYSA; Albany;
 14610-88C; Inmate case files, 1930–1965.
Joseph F. Spillane, *Coxsackie: The Life and Death of Prison Reform* (Johns Hopkins
 University Press, 2014).
Eugenie Jaussaud residence 1933–1936, Jack Straus, 720 Park Avenue, New York,
 records from France, Archives departementales de Hautes-Alpes.
Michael Gross, *740 Park: The World's Richest Apartment Building* (New York: Crown,
 2006).
Eugenie Jaussaud residence 1936–1937, Consuela Vanderbilt Balsan, Casa Alva, Palm
 Beach, Florida, letters to Carl in Coxsackie.
Barbara Marshall, "A Rare Glimpse Inside a Vanderbilt Mansion: It Could Be Yours
 for $13.5 Million," *Palm Beach Post*, March 31, 2012.
Straus and Vanderbilt family histories, Ancestry.com.
Marie letter to the "President" asking for information about Carl, August 3, 1936.
Marie letter to Superintendent indicating consulate in Marseilles told her to write
 directly, March 29, 1937.
Alphonse Beaume letter in French to Coxsackie superintendent on behalf of Marie,
 October 29, 1937.
Letter from Carl to Coxsackie superintendent relaying his family story and placement
 in the Heckscher Home at age 5, October 19, 1937.
Letter to Carl from Grandmother Maria Maier, Bronx, New York, December 3, 1937.
Eugenie Jaussaud, employer Margaret Emerson (Vanderbilt), Social Security Appli-
 cation, July 30, 1937.
Associated Press, "Vanderbilt Inherits Huge Fortune Today," *Wilkes-Barre Times
 Leader*, September 24, 1935.

"Vanderbilt 'Most Eligible Bachelor' Weds," *The Pantagraph*, Bloomington, Illinois, June 8, 1938.

Eugenie Jaussaud summer residence 1937, Burrill, Jericho Farms, Jericho, New York, letter dated September 23, 1937.

Jericho Farm, *Old Long Island*, http://www.oldlongisland.com/search/label/Jericho%20 Farm.

Letter from Carl to friend Gene Fabian asking to take him in to avoid living with his mother, July 30, 1938.

Marie Armande, interview via telephone in Saint-Bonnet, France, (translated by Agnes Clark) regarding her childhood friendship with Vivian Maier, 2018.

Marie and Vivian Maier 1938 Arrival, New York, New York; Microfilm Serial: T715, 1897–1957; Microfilm Roll: 6190; Line: 21; Page: 34, 1940; Census: New York, New York, NY; Roll: T627_2653; Page: 8B; Enumeration District: 31-124.2.

CHAPTER 3: NEW YORK TEENAGER

Vivian Maier quote to an employer in the late 1980s, recorded and transcribed interview by John Maloof, 2011–2013.

Mommy Dearest

Karl Maier (Carl) parole, all events, records, and letters from file #395, Prison and Parole Records: NYSVI; Coxsackie Correctional Facility; NYSA; Albany; 14610-88C; Inmate case files, 1930–1965.

Marie and Vivian Maier residence in August 1938, 421 East Sixty-Fourth Street, apartment 44, September 23, 1937, Sixty-Fourth Street Apartments, Landmarks Preservation Commission, November 21, 2006, Designation List 383 LP-1692A, Amendment to City and Suburban Homes Company, First Avenue Estate; Landmark Site: Borough of Manhattan Tax Map Block 1459, Lot 22.

Marie Maier meeting with parole officer to arrange for Carl's parole in her custody, August 4, 1938.

Letter from Marie to Albany Department of Corrections asking if Carl can ever be paroled, September 8, 1938.

Letter from Coxsackie superintendent to Marie stating she had already been informed of Carl's parole, September 10, 1938.

Letter to Carl at Coxsackie from Marie complaining about the parole officer and her health, October 1, 1938.

Internal approval from Coxsackie superintendent to permit Carl to move to YMCA, December 2, 1938.

Marie Jaussaud letter to parole officer Joseph Pinto complaining about Italians, January 10, 1939.

Letter from Marie to parole officer claiming everyone is plotting against her and requesting that Carl move out, March 22, 1939.

Scheduled meeting for parole officer and Marie to discuss her letter, March 29, 1939.

Carl Maier release from parole, April 20, 1939.

Vivian Maier on return to New York at the end of her childhood, to Linda Matthews, employer 1980–1983.

Marie Maier family residence, 1940 Census: New York, New York, NY; Roll: T627_2653; Page: 8B; Enumeration District: 31-1242.

Charles and Berta Maier residence, 1940 Census: New York, Queens, New York; Roll: T627_2750; Page: 5B; Enumeration District: 41-1663A.

Grandmother Maria Mair [sic] residence, 1940 Census: New York, Bronx, New York; Roll: m-t0627-02460; Page: 61A; Enumeration District: 3-5.

Dr. Donna Mahoney, interviews via telephone and email in regard to Marie Maier mental illness.

Narcissistic Personality Disorder, *Diagnostic and Statistical Manual of Mental Disorders* (DSM-5), 5th edition (Washington, DC: American Psychiatric Publishing, 2013), p. 301.81 (F60.81), Diagnostic Criteria and Features.

Elsa Ronningstam, PhD, *NPD Basic, A Brief Overview Of Identifying, Diagnosing and Treating Narcisstic Personality Disorder* (McLean Hospital, Harvard Medical School, 2016).

The Final Dissolution

Emilie Haugmard, *1929 Passenger Lists of Vessels Arriving at New York, NY, 1820–1897*, Microfilm Publication M237, 675 rolls, NAI: 6256867; Records of the U.S. Customs Service, Record Group 36; National Archives at Washington, DC; Microfilm Serial: T715, 1897–1957; Microfilm Roll: 4636; Line: 3; Page: 218.

Emilie Haugmard residence, 1930 Census: Manhattan, New York, New York; Roll: 1562; Page: 3A; Enumeration District: 0627; Image: 413.0; Family History Library microfilm: 234129.7.

Emilie Haugmard residence, 1939, 242 East Fifty-First Street, (Roll 551) Declarations of Intention for Citizenship, 1842–1959 (No. 429301-430300), U.S. District Court for the Southern District of New York.

Emilie Haugmard residence, 419 East Sixty-Fourth Street, 1942 National Archives and Records Administration, Washington, DC; Petitions for Naturalization from the US District Court for the Southern District of New York, 1897–1944; Series: M1972; Roll: 138.2.

Maria Florentine death, January 5, 1943, Domaine, commune de St-Bonnet-en-Champsaur, Archives departementales de Hautes-Alpes.

Maria Florentine Jaussaud succession, will dated January 18, 1934, registered April 9, 1943, Viviane Maier *legataire universelle* in guardianship of Marie Maier, September 17, 1943, 1255 W 218-1950, Volume 51, Archives departementales de Hautes-Alpes.

Maria Florentine transfer of rights of succession and inheritance tax of 8,000 francs, 1255 W 1946–1947 (Volume 48), Declarations of transfer by death, Saint-Bonnet, November 18, 1947, Archives departementales de Hautes-Alpes.

Jean Pierre Roussel death, 2 E 109/6/1, Civil Status Register, November 18, 1949, Poligny, France, Archives departementales de Hautes-Alpes.

Lindenberger arrival 1913, New York, New York, Microfilm Serial: T715, 1897–1957; Microfilm Roll: 2217; Line: 23; Page: 61.

Lindenberger residence, 1915, New York State Archives, Albany, New York; State Population Census Schedules, 1915; Election District: 34; Assembly District: 01; City: Hempstead; County: Nassau; Page: 13.

Lindenberger residence, 1920 Census: Manhattan Assembly District 7, New York, New York; Roll: T625_1198; Page: 11A; Enumeration District: 581.

Lindenberger residence, 1925 New York State Archives; Albany, New York; State Population Census Schedules, 1925; Election District: 27; Assembly District: 03; City: New York; County: Queens; Page: 38.

Lindinberg [sic] residence, Year: 1930; Census Place: Queens, New York; Page: 12A; Enumeration District: 0800; Family History Library microfilm: 2341326.

Lindenberger residence, 1940 Census: New York, Queens, New York; Roll: T627 _2730; Page: 13A; Enumeration District: 41-542.

John Lindenberger, 1942, U.S. Selective Service System; Selective Service Registration; Cards, World War II: Fourth Registration; Record Group Number 147; National Archives and Records Administration.

John Lindenberger death record, January 22, 1943, Death Certificate #734, Bureau of Vital Records, Queens County, New York; Municipal Archives, New York; Family History Library microfilm 2,188,921, FamilySearch.

John Lindenberger probate, Surrogate Court, Queens County, New York, File #4010-1944, September 7, 1944.

Berthe Lindenberger, Alien Registration Record, December 4, 1940, A-4384331, USCIS.

Berthe Lindenberger naturalization, Certificate Assembly District: 03; City: New York; County: Queens; Page: 38 Certificate, 5896549, April 17, 1944, USCIS.

Frederic Walperswyler, interview via email regarding Berthe Lindenberger's family in Switzerland, 2017.

Marie Maier residence 1943, 14 W 102nd Street, Employment Hotel Dorset, November 25, 1943, Social Security Application, Social Security Administration.

Vivian Maier residence 1943, 2622 Ninety-Fourth Street, Jackson Heights, Queens, New York, Social Security Application, February 22, 1943, Social Security Administration.

Beatrice Alexander, "Women of Valor," Jewish Women's Archive, https://jwa.org /encyclopedia/ article/ Alexander-Beatrice.

Marjorie Ingall, "The Woman Behind the Dolls," *Tablet*, May 7, 2013.

Madame Alexander Doll Company, https://www.madamealexander.com.

Alfonso A. Narvaez, "Beatrice Behrman, 95, Doll Maker Known as Madame Alexander," *New York Times*, October 5, 1990.

Karl Maier military enrollment attempt, July 9, 1941, Local Board No. 24, Sherman Square Hotel, 200 West Seventy-First Street, prior address 229 West Sixty-Ninth Street, c/o Charles Maier, 117-14 85th Avenue, Richmond Hill, New York.

Karl Maier military enrollment, February 18, 1942, National Archives and Records Administration; Electronic Army Serial Number Merged File, 1938–1946

[Archival Database]; ARC: 1263923; World War II Army Enlistment Records; Archives and Records Record Group 64; National Archives at College Park.

Karl Maier life, service, and medical records 1942–1977, military file 1942–1977, National Archives at Saint Louis, Missouri; Record Group Title: Records of the Selective Service System, 1926–1975; Record Group Number: 14.

Karl Maier medical records, Station Hospital Langley Field, June 22–August 12, 1942.

Private Karl W. Maier discharge hearing, 322217512, 416 Ordinance Company, Avn. (Bomb), July 18, 1942, Langley Field, Virginia; National Archives at Saint Louis, Missouri; Record Group Title: Records of the Selective Service System, 1926–1975; Record Group Number: 14.

Karl Maier admission to State Hospital of Trenton; Diagnosis: Mental Illness, Schizophrenic reaction, March 25, 1953.

Karl Maier Application for transfer to Veterans Hospital, Lyons, New Jersey, April 9, 1953; letter from Charles Maier to Veterans Hospital disavowing information related to Carl, April 23, 1953.

Carl William Maier admission to New Jersey State Hospital at Ancora, April 11, 1956, diagnosis schizophrenic, paranoid type, May 11, 1956.

Maria Hauser Maier death record, NYCDR July 20, 1947, 27 East Ninety-Fourth Street, New York, NY.

Maria Hauser Maier cremation, July 23, 1947. Interment: September 24, 1947; Ferncliff urn placement: Main Mausoleum Colombian Room 2, Alcove B Column 4, Column F.

Ferncliff Cemetery attendant, in-person interview regarding Maria Maier's interment, 2015.

Marie Jaussaud classified advertisement, *New York Times*, August 22, 1948.

Berthe Lindenberger residence, Maple Avenue 132-32, Flushing, New York, PO Box 287, employment, David Sarnoff, 44 East Seventy-First Street, Social Security Application, October 1, 1948, SSA.

Eugenie Jaussaud, Death Certificate, #23162, 960 Park Avenue, Municipal Records, Borough of Manhattan, October 19, 1948.

Eugenie Jaussaud, 1948 Social Security Applications and Claims, 1936–2007; New York City Municipal Deaths, October 19, 1948, cn23162, Film 2166838.

Eugenie Jaussaud mass, Saint Jean de Baptiste, attending priest from St. Ignatius Loyola Church, 980 Park Avenue, funeral home Frank E. Campbell, October 22, 1978.

Eugenie Jaussaud obituary, *New York Times*, October 22, 1948.

Eugenie Jaussaud burial, Gate of Heaven Cemetery, Hawthorne, New York, Sec. 47/ plot 217/stone 9, October 22, 1948.

Eugenie Jaussaud will, May 13, 1948, executed by William Jaussaud aka Charles Maier, October 25, 1948, P2970, Surrogate's Court, New York County.

CHAPTER 4: FIRST PHOTOGRAPHS: FRANCE

Vivian Maier quote from a letter draft to Amédée Simon, Saint-Bonnet photographer, ca. 1954, John Maloof Collection.

Vivian Maier departure to France, New York, New York, March 29, 1950; National

Archives at Washington, DC; Series Title: "Passenger and Crew Lists of Vessels and Airplanes Departing from New York"; NAI Number: 3335533; Record Group Title: Records of the Immigration and Naturalization Service, 1787–2004; Record Group Number: 85; Series Number: A4169; NARA Roll Number: 69.

Susan Sontag, *On Photography* (New York: Farrar, Straus and Giroux, 1977).

Vivian Maier sale of Beauregard property by auction on October 6 and October 25, 1950, registered November 7, 1950, Case 470, Volume 1380, Articles 36 and 42–47, Alphonse Beaume (notary), Saint-Bonnet-en-Champsaur, Archives departementales de Hautes-Alpes.

Escallier law suit, 4 U 1073-1945-1951, civil acts and judgments, Saint-Bonnet, filed April 10, 1951, residence defendant Vivian Maier, Saint-Bonnet, with Madame Jouglard; decision for defense, August 25, 1951; reaffirmed August 5, 1961, Archives departementales de Hautes-Alpes.

Vivian Tank (née Cherry) arrival, New York, New York, April 16, 1951, Microfilm Serial: T715, 1897–1957; SS *De Grasse*; Microfilm Roll: Roll 7973; Line: 9; Page: 20.0.

Vivian Maier departure Le Havre, France, April 16, 1951, SS *De Grasse*, Microfilm Serial: T715, 1897–1957; Microfilm Roll: Roll 7973; Line: 9; Page: 20.0.

CHAPTER 5: FIRST PHOTOGRAPHS: NEW YORK

Vivian Maier quote about New York from tape-recorded interview with Evanston neighbor, 1976, Tape 9, Track 1, John Maloof Collection.

Pamela Walker, family employed Vivian Maier in Southampton, New York, in 1951, recorded and transcribed interview with John Maloof, 2011–2013.

Sylvain and Rosette Jaussaud, in-person interview regarding identification of Vivian Maier's mother, 2018.

Gwen Akin, personal interview via telephone and email regarding Vivian Maier's 1952 nanny position with her family in Brookville, Long Island, 2015.

Architectural drawings for construction of First Avenue Estate, Stahl CA44, Submission to Sixty-Fourth Street Landmarks Preservation Commission, 2014, Designation List 383 LP-1692A, Amendment to City and Suburban Homes Company, First Avenue Estate; Landmark Site: Borough of Manhattan Tax Map Block 1459, Lot 22.

Randazzo residence, 1920 Census: Manhattan, New York, New York; Roll: 1564; Page: 12B; Enumeration District: 0653; Image: 794.0; Family History Library Microfilm: 2341299.

Randazzo residence, 1930 Census: Manhattan, New York, New York; District 0653. Page: 12B; Enumeration District: 0653; Family History Library microfilm: 2341299.

Miss S. Randazza [sic] directory listing, 1949 Manhattan City Directory, New York City; U.S. City Directories, 1822–1995, Ancestry.com.

Randzzo [sic], residence, Year: 1940; Census Place: Manhattan, New York, New York; Roll: m-t0627-02654; Page: 61A; Enumeration District: 31-1258.

Salvatore A. Randazzo obituary, Advance Funeral Home, Hamilton, Ohio, July 13, 2004.

Buildings in Manhattan, OldNYC, Irma and Paul Milstein Division of United States History, Local History and Genealogy, New York Public Library Digital Collections.

Anna Randazzo, in-person interview about her 1950s friendship with Vivian Maier in New York, 2016.

Emilie Haugmard residence, 1942–1965, 419 East Sixty-Fourth Street, Manhattan, New York, City Directory.

Emilie Haugmard death, New York City Department of Health, October 8, 1964.

Emilie Haugmard, Intestate Petition, February 9, 1965, New York, #926/1965.

Emilie Haugmard, great niece telephone interview by Françoise Perron, 2015.

CHAPTER 6: PROFESSIONAL AMBITIONS

Vivian Maier quote from her written instructions on a photo lab, John Maloof Collection.

Dan Wagner, *Explora*, 2016, https://www.bhphotovideo.com/*explora*/Photography/buying-guide/wonderful-world-rolleiflex-tlr-photography-buying-used-rolleiflex-tlr.

Photography classes and darkrooms, Classified Ads, *New York Times*, 1940s–1950s.

Photography classes and darkrooms, Classified Ads, *New York Herald Tribune*, 1940s–1950s.

Carola Loeffel birth, 1882, *Namensregister, Geburtsregister*, 1870–1904, Stadtarchiv Karlsruhe, Karlsruhe, Deutschland.

Carola Loeffel immigration, 1896, Arrival: New York, New York; Microfilm Serial: M237, 1820–1897; Microfilm Roll: Roll 662; Line: 21.

Carola Loeffel residence, 1910 Census: Manhattan Ward 19, New York, New York; Roll: T624_1042; Page: 14A; Enumeration District: 1136; Family History Library microfilm:1375055.

Carola Loeffel Hemes marriage, 1912, New York City Municipal Archives; New York, New York; Borough: Manhattan; Indexed Number: M-12.

Emile Hemes residence, 1918 New York City Directory, U.S. City Directories, 1822–1995 (database online), Ancestry.com, 2011.

Carola Hemes residence, 1920 Census: Manhattan Assembly District 15, New York, New York; Roll: T625_1213; Page: 4B; Enumeration District: 1067.

Carola Hemes immigration records, 1921, Records of the Immigration and Naturalization Service, 1787–2004; Record Group Number: 85; Series Number: A4169; NARA Roll Number: 389.

Carola Hemes residence, 1933, New York City Directory, U.S. City Directories, 1822–1995, Ancestry.com, 2011.

Hemes divorce, "Court Sees 'Inhumanity' to Alimony Prisoner," *New York Herald Tribune*, July 19, 1931.

Carola Hemes, telephone interview with great-nephew regarding identification of the photographer, 2016.

Geneva McKenzie, "Members, Guests Win Photo Prizes," *Long Island Daily Press*, October 27, 1942.

Geneva McKenzie studio, Manhattan, New York City Directory, 1953, p. 1102.

Photographers working at 39 West Forty-Sixth Street, Manhattan, New York City Directory, 1957, U.S. City Directories, 1822–1995, Ancestry.com.

John Wrinn, "Resident of Stamford Found Dead in Studio," *Hartford Courant*, October 28, 1961.

The School of Modern Photography, 136 East Fifty-Seventh Street, New York City, Director: H. P. Sidel.

Weegee biography, International Center of Photography, New York, 2019, https://www.icp.org/browse/archive/constituents /weegee?all/all/all/all/0.

Thomas Mallon, "Weegee the Famous, the Voyeur and Exhibitionist," *New Yorker,* May 28, 2018.

Dan Wagner, New York photographer and author of *Never Seeing Nothing* and *Schmendrick*, analysis of photographs and description of characteristics of the Rolleiflex camera.

Taxi, 20th Century Fox Exhibitor's Campaign Book, 1952.

Taxi, "Pawnshop Goes to Movies," *New York Herald Tribune*, August 2, 1952.

Weegee photograph, *Act of Love*, Astor Theatre, Times Square, New York, 1954.

It Should Happen to You, directed by George Cukor, July 1953, Columbus Circle, Manhattan, New York.

Bishop Fulton Sheen, *Time* magazine cover, August 14, 1952.

Archbishop Fulton J. Sheen, https://www.fultonsheen.com.

Draft of letter to Amédée Simon, Saint-Bonnet photographer, regarding a business collaboration, ca. 1954, John Maloof Collection.

Charlat sisters, personal interview via telephone and emails regarding Vivian Maier and Joan, 2018.

Joan, in-person, telephone, and email interviews regarding Vivian Maier as her nanny 1952–1953, 2018.

Postcards printed for Vivian Maier by Amédée Simon in 1950–1951, John Maloof Collection.

Ansel Adams quote, Marie Street Alinder, *Ansel Adams: A Biography* (New York: Bloomsbury USA).

CHAPTER 7: STREET PHOTOGRAPHY

Vivian Maier quote told to Linda Matthews, employer 1980–1983.

Joel Meyerowitz, master photographer and coauthor of *Bystander: A History of Street Photography*, recorded and transcribed interview by John Maloof, 2011–2013, and personal interview via email, 2020.

Churches of Vancouver, Vancouver Public Library, Special Collections Historical Photographs, https://www3.vpl.ca/dbtw-wpd/exec/dbtwpub.dll.

CHAPTER 8: THE BEST YEAR

Vivian Maier quote from tape-recorded interview with Evanston neighbor, 1976, Tape 9, Track 1, John Maloof Collection.

Howard Greenberg Gallery, review of Vivian Maier exhibition prints, 2019.

Julie Besonen, "Stuyvesant Town: An Oasis Near the East River," *New York Times*, 2016, https://www.nytimes.com/2016/08/14/realestate/stuyvesant-town-an-oasis-near-the-eastriver.html.

Vivian Maier photo log for January–February 1954, found in a coat pocket, John Maloof Collection.

Dan Wagner, technical analysis of Vivian Maier self-portraits, 2020.

Rembrandt lighting, Wikipedia, 2020.

Stuyvesant Town–Peter Cooper Village Tenants Association, http://www.stpcvta.org.

Hardy family, personal interviews with Meredith and Thomas Hardy via telephone and email regarding their 1954 experience with Vivian Maier as their nanny, 2017.

Mary McMillan Cavett, personal interviews via telephone and email regarding her family and their experience with Vivian Maier as their nanny in 1954–1955, 2017.

Edward Steichen, *The Family of Man: The Greatest Photographic Exhibit of All Time* (New York: Museum of Modern Art, 1955).

Diane Arbus photograph, *Identical Twins*, Roselle, New Jersey, 1967.

CHAPTER 9: CALIFORNIA BOUND

Vivian Maier quote from a tape-recorded conversation with Evanston neighbor, 1976, Tape 9, Track 1, John Maloof Collection.

"Five Quebec National Shrines," *Religious Travel Planning Guide*, Willowbrook, Illinois, https://religioustravelplanningguide.com/five-quebec-national-shrines.

Ray Herbert, "$12 Million Building to Replace Dowdy Hotel on 6th Street," *Los Angeles Times*, March 2, 1971.

Disneyland attendance, Disneyland Linkage, http//:www.scotware.com.au/theme/feature/atend_disparks.htm.

Diana Martin, family employed Vivian Maier in Los Angeles during the summer of 1955, personal interviews via telephone and email, 2018.

Susan Sontag, *On Photography* (New York: Farrar, Straus and Giroux, 1977).

Vivian Maier purchase of second Rolleiflex, photo notes, August 1955, Los Angeles, California.

Margarite Heijjas arrival, 1951, New York, New York; Microfilm Serial: T715, 1897–1957; Microfilm Roll: Roll 7946; Line: 3; Page: 122.

Margarite Heijjas residence, mid-1950s and 1960s, Pasadena, California, City Directories.

Margite Hejjas [sic] naturalization, 1958, National Archives at Riverside, California; NAI Number: 594890; Record Group Title: 21; Record Group Number: Records of District Courts of the United States, 1685–2009.

William J. McBurney and Mary Rice Milhollanda, *Greater French Valley, Images of America* (Mount Pleasant, South Carolina: Arcadia Publishing, 2009).

Photographed check from Norman and Shirlee Kaye, 1955, Vivian Maier Estate.

Kandee and John Kaye, personal interview via telephone and email about their 1955 experience with Vivian Maier as their nanny, 2017.

Mary Kaye obituary, *Los Angeles Times*, February 20, 2007.

Norman Kaye obituary, *Las Vegas Review-Journal*, September 17, 2012.

Mary Kaye Trio website, http://marykayetrio.com.

Gensburg family interviews were conducted by John Maloof. For privacy reasons they chose not to participate in his film and gave no further comment after initial interviews. Family members did not respond to inquiries for this book. Information regarding the Gensburgs was sourced from verbal discussions with Maloof about the interviews he conducted with their friends and neighbors; the Nora O'Donnell interview in *Chicago* magazine; public records; and Vivian Maier photographs, tapes, films, and belongings.

CHAPTER 10: CHICAGO AND THE GENSBURGS

Vivian Maier quote from photo notes, 1965, John Maloof Collection.

Berthe Lindenberger, photographs of Queens County Savings Bank passbook 140874, safety deposit contents, and cremation shipping container, by Vivian Maier, September 1956, John Maloof Collection.

Berthe Lindenberger death, New York City Death Index, Ber Lindenberger, August 16, 1956, No. 8374.

Berthe Lindenberger, Social Security Death Claim, April 1, 1957, SSA.

Carola Hemes return to Germany, 1956, Passenger and Crew Lists of Vessels and Airplanes Departing from New York, New York, 07/01/1948–12/31/1956; NAI Number: 3335533; Record Group Title: Records of the Immigration and Naturalization Service, 1787–2004; Record Group Number: 85; Series Number: A4169; NARA Roll: 389.

Duffy Levant, friend of the Gensburg boys, recorded and transcribed interview by John Maloof, 2011–2013.

Marius Pellegrin, description of Vivian Maier as an extraterrestrial to John Maloof, Saint-Bonnet, France, 2011.

Barry Wallis, acquaintance from Northwestern Language Lab, on Vivian Maier's expressionless face, recorded and transcribed interview by John Maloof, 2011–2013.

Vivian Maier quips and expressions, personal interviews with Linda Matthews, 2017.

Jennifer Levant, friend of the Gensburg boys, recorded and transcribed interview with John Maloof, 2011–2013.

"Pump Room Will Be Closed . . . for Gallivantin Gleason's Gay Private Shindig," *Chicago Sunday Tribune*, May 27, 1962, Newspapers.com.

North by Northwest filming, Ambassador East Hotel, Chicago, with Eva Marie Saint, Cary Grant, and James Mason, 1958, https://the.hitchcock.zone/wiki/Main_Page.

CHAPTER 11: AROUND THE WORLD

Vivian Maier quote to Linda Matthews, employer 1980–83.

Vivian Maier purchase of Robot camera in 1958, photo notes, John Maloof Collection.

"Shipping in the Port of Baltimore," Sailing of *Pleasantville Norwegian*, *Baltimore Sun*, April 5, 1959.

Photographed letters to Margarite Heijjas to borrow money, June and August 1959, Vivian Maier Estate.

Gensburg boy's description of a laundry line, Nora O'Donnell, "The Life and Work of Street Photographer Vivian Maier," *Chicago*, December 14, 2010, http://www.chicagomag.com/Chicago-Magazine/January-2011/Vivian-Maier-Street-Photographer.

Auguste Blanchard, in-person interview in France regarding impressions of Vivian Maier during her 1950 and 1959 visits, 2018.

Paul Vacher, Vivian Maier researcher and author of *Ceux De Beauregard*, June 2019 exchanges via email.

Phillipe Simon, exchange via email about family interactions with Vivian Maier in Saint-Bonnet, France, 2020.

Lucien Hugues, in-person interview in France regarding neighbor Nicolas Baille, including his personality, behavior, and relationships, 2018.

Nicolas Baille death, 2 E 155/9, Civil Status Register, 1878, Saint-Léger-les-Mélèzes, June 13, 1961, Gap, Archives departementales de Hautes-Alpes.

Rosette Jaussaud, interview with Marie Hughes on details regarding 1959 Jaussaud family interactions with Vivian Maier, 2020.

Photograph by Vivian Maier of letter to Nancy Gensburg about finances and plans for returning to Chicago, September 1959, Vivian Maier Estate.

Photograph by Vivian Maier of the 1943 Metropolitan Life Insurance Policy bought by the Lindenbergers, September 1959, John Maloof Collection.

CHAPTER 12: THE SIXTIES

Vivian Maier's quote on tape recording with Jean Dillman, employer 1976, Tape 2, Track 2.

Playboy club publicity department contact, Vivian Maier notes, John Maloof Collection.

Vivian Maier tape-recorded interviews on Nixon's impeachment, Tape 13, Track 2, John Maloof Collection.

The Bellboy, director Jerry Lewis, filmed at greyhound race track and Fontainebleau Hotel, Miami, Florida, 1960.

Alton Slagle, "Amid Grief, Curious Abound," *New York Daily News*, September 1966 (courtesy of Johnny de Palma).

Film of Vivian Maier helping a Gensburg boy from a tree, John Maloof Collection.

CHAPTER 13: STARTING OVER

Vivian Maier quote to Zalamin and Laura Usiskin, employers 1987–1988, recorded and transcribed interview by John Maloof, 2011–2013.

Inger Raymond, experience with Vivian Maier as her nanny from 1967 to 1974, recorded and transcribed interview by John Maloof, 2011–2013; personal interviews via telephone and email, 2018 and 2020.

Ginger Tam, impressions of Vivian Maier by Inger's friend, recorded and transcribed interview with John Maloof, 2011–2013.

Duffy Levant, experiences with Vivian Maier in Highland Park, recorded and transcribed interview by John Maloof, 2011–2013.

Käthe Kallwitz, *German Expression: Works from the Collection*, MOMA, 2020, https://www.moma.org/s/ge/curated_ge/index.html.

Willem van den Berg, Kilgore Gallery, New York, New York, 2020, https://www.kilgoregallery.com/usr/library/documents/main/berg-willem-van-den.

CHAPTER 14: CHILDHOOD: THE AFTERMATH

Vivian Maier quote to Bayleanders, employers 1990–1994, recorded and transcribed interview with John Maloof, 2011–2013.

Dr. Donna Mahoney, personal interviews via telephone and email regarding the implications of Marie Maier's mental condition on daughter Vivian, 2020–21.

"Definition of Childhood Trauma," National Institute of Mental Health, Bethesda, Maryland, https://www.nimh.nih.gov/health.

Dr. Donna Mahoney, Lucy Riskspoone, and Jennifer Hull, "Narcissism, Parenting, Complex Trauma: The Emotional Consequences Created for Children by Narcissistic Parents," *Practitioner Scholar: Journal of Counseling and Professional Psychology* 45, Number 5 (2016).

Dr. Donna Mahoney, "Narcissism and the Used Child," lecture, Illinois School of Professional Psychology, Chicago, Illinois, 2020.

Dr. Robert Raymond, in-person interview with clinical psychologist and psychoanalyst, regarding Vivian Maier's overall emotional and psychological condition.

Dr. Joel Hoffman, in-person interview regarding the potential implications of Vivian Maier's childhood on her adult behavior.

Mental health experts consulted regarding Vivian Maier's possible physical or sexual abuse: Dr. Donna Mahoney, Illinois; Dr. Robert Raymond, New Jersey; Dr. Joel Hoffman, New York, Dr. Jean-Yves Samacher, Director of the Freudian School, Paris, and Robert Samacher, Doctor of Philosophy, Paris.

Dr. Randy Frost, personal interview with hoarding expert via telephone and email regarding hoarding disorder and Vivian Maier, 2017.

Hoarding Disorder, *Diagnostic and Statistical Manual of Mental Disorders* (DSM-5) (Washington, DC: American Psychiatric Publishing, 2013), 300.3, Diagnostic Criteria and Features.

Drs. Randy Frost and Gail Steketee, *Stuff: Compulsive Hoarding and the Meaning of Things* (Boston and New York: Houghton Mifflin Harcourt Publishing, 2010).

Drs. David Tolin, Randy Frost, and Gail Sketekee, *Buried in Treasures: Help for Compulsive Acquiring, Saving and Hoarding* (Oxford University Press, 2013).

Jenny Coffey, LMSW, in-person interview with expert who has visited the homes of over two hundred hoarders on causes, symptoms, and effects of hoarding disorder, 2017.

Matt Paxton and Phaendra Hise, *The Secret Lives of Hoarders: True Stories of Tackling Extreme Hoarding* (New York: TarcherPerigee, 2011).

Claudia Kalb, *Andy Warhol Was a Hoarder: Inside the Minds of History's Great Personalities* (Washington DC: National Geographic Society, 2016).

Olivia Laing, *The Lonely City: Adventures in the Art of Being Alone* (Edinburgh, UK: Canongate Books, 2016).

Hsiaojane Chen, "Disorder: Rethinking Hoarding Inside and Outside the Museum," lecture, University of Texas at Austin, 2011.

Linda Matthews, employer from 1980 to 1983, description of Vivian's reaction to her giving away newspapers, recorded and transcribed interview with John Maloof, 2011–2013.

Roger Carlson, owner of Bookman's Alley, on Vivian's paranoid behavior, recorded and transcribed interview with John Maloof, 2011–2013.

Schizoid Personality Disorder, *Diagnostic and Statistical Manual of Mental Disorders* (DSM-5) (Washington, DC: American Psychiatric Publishing, 2013), 301.2, Diagnostic Criteria and Features.

Schizoid Personality Disorder, *International Classifications of Disease* (ICD-10) (Geneva, Switzerland: World Health Organization, 2021), F60.1.

Drs. Larry J. Seiver and Kenneth L. David, MD, "The Pathophysiology of Schizophrenia Disorders: Perspectives from the Spectrum," *American Journal of Psychiatry* 161, Number 3 (March 2004).

Osamu Muramoto, "Retrospective Diagnosis of a Famous Historical Figure: Ontological, Epistemic, and Ethical Considerations," *Philosophy, Ethics, and Humanities in Medicine*, May 28, 2014.

Dr. Ralph Klein, Masterson Institute for Treatment of Trauma and Personality Disorders, "The Self-in-Exile: A Developmental, Self, and Object Relations Approach to the Schizoid Disorder of the Self," in *Disorders of the Self: New Therapeutic Horizons: The Masterson Approach* (New York: Brunner/Mazel, 1995), pp. 1–178.

Dr. Jean-Yves Samacher, Director of Freudian School, Paris, and Dr. Robert Samacher, "Vivian Maier Neither Seen nor Known," *Psychologie Clinique*, Number 48 (2019), https://doi.org/10.1051/psyc/201948110.

Danille Knafo, "Egon Schiele and Frida Kahlo: The Self-Portrait as Mirror," *Journal of the Academy of Psychoanalysis*, February 1991.

Paula Elkisch, "The Psychological Significance of the Mirror," American Psychoanalysis Association, April 5, 1957.

Elizabeth Avedon, "Vivian Maier: Self Portraits," essay (Brooklyn: powerHouse books, 2013).

Anne Morin, "The Self-Portrait and Its Double," essay, December 2020.

CHAPTER 15: MIXED MEDIA REBOUND

Vivian Maier quote, from her written processing directions, John Maloof Collection.

Howard Greenberg, gallery owner representing Vivian Maier and many other notable street photographers, in-person interviews regarding his characterization and opinion of Vivian's work, 2016–2017.

Vivian Maier 1978 address book entries for *New York Times* delivery and Leica dealership, John Maloof Collection.

Photographic equipment inventory of material donated by John Maloof, prepared by the University of Chicago Library, Chicago, Illinois, 2020.

16mm and Super-8 short films, John Maloof Collection.

Vivian Maier films, scholarly analysis by curator Anne Morin, 2020.

Phillip Wattley, "Missing Mom, Infant Are Sought by Police," *Chicago Tribune*, September 11, 1972.

John O'Brien, "Mother, Baby Found Slain," *Chicago Tribune*, September 12, 1972.

"Services for Murder Victims Today," *Chicago Tribune*, September 14, 1972.

Vivian Maier tape-recorded interview with Inger's maternal grandmother about her pioneering life in Montana, Tape 3, John Maloof Collection.

Vivian Maier tape-recorded interview with Inger's paternal grandmother, Tape 4, John Maloof Collection.

Vivian Maier tape-recorded interview with the Dillmans' neighbor in Evanston regarding Rudolph Valentino and Howard Hughes, Tape 9, Track 1, John Maloof Collection.

Vivian Maier tape-recorded interview with children, Tape 10, Track 7, employer late 1970s.

Karen Frank, employer in late 1970s, recorded and transcribed interview, 2011–2013.

Phil Donahue, employer in 1976, recorded and transcribed interview with John Maloof, 2011–2013.

Terry Callas, employer 1984–1985, recorded and transcribed interview conducted by John Maloof, 2011–2013.

Alan Sekula quote: Sharon Cohen, "Celebrating Genius of an Undiscovered Photography," Associated Press, March 13, 2011.

CHAPTER 16: FAMILY: THE END

Vivian Maier quote to Linda Matthews, employer 1980–1983.

Karl W. Maier fingerprints, medical examination, Camp Upton, February 18, 1942, Military Records, National Personnel Records Center, Military Personnel (NPRC), VA-RMC Saint Louis.

James Gerber (Joseph Corsan great-nephew) personal interview via telephone and email regarding Joseph and Alma Corsan, 2015.

Alma Maier death, January 21, 1965, New York, New York, Death Index, 1949–1965, Ancestry.com, 2017.

Alma Maier probate, New York County Surrogate Court, Petition No. 497–1965, January 29, 1965.

Joseph Corsan, Social Security Administration Death Index, June 12, 1970, Master File.

Joseph Corsan probate, New York County Surrogate Court, Index No. 4010-1970.

Ferncliff Cemetery attendants in-person interview in 2015 regarding interment of Alma Maier and Joseph Corsan, Shrine of Memories, Unit 2, Tier H, End Companion Crypt 107, Entombed.

Photograph of passport application by Vivian Maier, Vivian Maier Estate.

Leon Teuscher (Berta Maier nephew) personal interviews via telephone regarding his experiences in the early 1950s living with Charles Maier, 2015.

Murray Schumach, "Alvin Comes of Age," *New York Times*, November 21, 1948.

Charles Maier's unleashed dogs attacked woman, causing her to faint, "Woman Injured in Fall," *Leader Observer* (Richmond Hill, New York), September 6, 1956.

Berta Maier death record, January 13, 1968, Queens General Hospital, Richmond Hill, Simonson Funeral Home.

Berta Maier probate intestate, 1968, 134084, Surrogate Court, QCNY, 453–76.

Charles Maier signature, Beta [sic] Maier Urn Receipt #130484, U.S. Cremation Company, January 1968.

Charles Maier death record, February 28, 1968, Number: 096-09-1928; Issue State: New York.

Charles Maier will, August 11, 1964, probate, Surrogate Court, Queens County, New York, March 11, 1968.

Charles Maier urn delivery to Emily Metz, #784457, U.S. Cremation Company, February 1968.

Marie Jaussaud Maier death record, 440 Columbus Avenue, June 28, 1975, Public Administrator File 5706.

Marie Jaussaud Maier, probate intestate, 1975–1979, Surrogate Court, County of New York, File 5706-1975.

Karl Maier residence, L.C. Boarding Home [sic], 4026 Jackson Avenue, Atco, New Jersey, April 21, 1967, Social Security Application, New Jersey, SSA.

Judy and Gerald Pliner, owners L&S Rest Home, personal interviews via telephone and email regarding Carl Maier's 1967–1977 residence at their facility, 2015–2017.

Karl Maier death, Beneficiary Identification Records Locator Subsystem (BIRLS) Death File, Washington, DC, US Department of Veterans Affairs.

Carl Maier death certificate, Ancora Psychiatric Hospital, 201 Jackson Rd., Winslow Township, Camden, New Jersey, #04251977, 4:30 a.m. April 11, 1977.

Carl Maier burial, April 21, 1977, Ancora Psychiatric Hospital Cemetery, Hammonton, New Jersey, personal interview with Ancora Cemetery attendant via telephone, 2015.

CHAPTER 17: LATE LIFE

Vivian Maier quote to Linda Matthews, employer 1980–1983, recorded and transcribed interview by John Maloof, 2011–2013.

Curt Matthews, employer from 1980 to 1983, on Vivian's fear of having her work stolen and escalating paranoia, personal telephone interview, 2018.

Sarah and Joe Matthews, children of employers 1980–83, about Vivian Maier as their nanny, recorded and transcribed interviews conducted by John Maloof, 2011–2013.

Linda Matthews, employer from 1980 to 1983, personal interviews via telephone and email, 2018.

Cathy Bruni Norris, sister of employer from 1986 to 1987, recorded and transcribed interview conducted by John Maloof, 2011–2013.

Zalman and Laura Usiskin, employers from 1987 to 1988, recorded and transcribed interview conducted by John Maloof, 2011–2013.

Maren Bayleander, employer from 1990 to 1994, recorded and transcribed interview conducted by John Maloof, 2011–2013.

Judy Swisher, employer 1995 to 1996, recorded and transcribed interview conducted by John Maloof, 2011–2013.

Richard Stern, owner of theater Vivian frequented from 1986 to 2006, recorded and transcribed interview conducted by John Maloof, 2011–2013.

Anne O'Brien, manager of an African import store Vivian Maier frequented in the 1980s, recorded and transcribed interview conducted by John Maloof, 2011–2013.

Bill Sacco, friend from 1982 to 1988, recorded and transcribed interview conducted by John Maloof, 2011–2013.

Jim Dempsey, manager of an art film theater Vivian Maier frequented from 1988 to 2001, recorded and transcribed interview conducted by John Maloof, 2011–2013.

Bindy Bitterman, owner of Eureka Antiques, which Vivian frequented in the late 1980s, recorded and transcribed interview conducted by John Maloof.

Roger Carlson, owner of Bookman's Alley, who knew Vivian from 1983 to 2005, recorded and transcribed interview conducted by John Maloof, 2011–2013.

Celebrity photographs by Vivian Maier, John Maloof Collection and Estate of Vivian Maier.

Book list compiled from Vivian Maier notes, storage lockers, and room photographs, John Maloof Collection.

Portfolios of photographs and artwork from pictures Vivian Maier took of her rooms, John Maloof Collection.

Freelance photographer articles sent to Vivian by friend Suzanne McVicker from the early 1970s, John Maloof Collection (Neville Ash, "Agencies Explained," *What Camera Weekly*, October 10, 1981; Dave Saunders, "Assignments," *Amateur Photographer*, September 5, 1981; Henry Scanlon, "How to Choose a Stock Photo Agency," *Popular Photography Book Bonus*, 1980; Betty Morris, "Words Sell Pictures," *Practical Photography*, June 1981; Neville Ash, "Profit from Picture Libraries!," *Practical Photography*, June 1981; Raymond Lea, "Focus on Freelancing," *Amateur Photographer*, September 5, 1951).

Photographs of IRS, SSA, and investment materials taken by Vivian Maier, John Maloof Collection.

Newspaper articles cut out and placed in plastic frames, John Maloof Collection.

Sarah Matthews Luddington, description of interaction with Vivian Maier in early 2000, via email, 2018.

Bob Kasira, Rogers Park neighbor, recorded and transcribed interview conducted by John Maloof, 2011–2013.

Sally Reed, Rogers Park neighbor, recorded and transcribed interview conducted by John Maloof, 2011–2013.

Patrick Kennedy, Rogers Park neighbor, recorded and transcribed interview with John Maloof, 2011–2013 and personal in-person conversation, 2018.

Photographs of 1956 medical records by Vivian Maier, John Maloof Collection.

Vivian Maier death certificate, April 21, 2009, Highland Park, Illinois, #090587, Probate Div. Cook County.

CHAPTER 18: THE DISCOVERY

Vivian Maier quote from tape-recorded conversation with a neighbor, 1976, Tape 2, Track 2, John Maloof Collection.

Records relating to storage facilities and finances, John Maloof Collection.

John Maloof, personal interviews regarding background, discovery, and estate, 2015–2017.

Jeff Goldstein, personal interviews regarding background, discovery, and estate, 2015–2017.

BigHappyFunHouse (Ron Slattery), "Vivian Maier Follow-Up," MetaFilter, December 26, 2010, http://www.metafilter.com/98950/Vivian-Maier-follow-up.

Jay Shefsky, "Vivian Maier," *Chicago Tonight*, WTTW News, July 31, 2012, https://news.wttw.com/2012/07/31/vivian-maier.

Nora O'Donnell, "The Life and Work of Street Photographer Vivian Maier," *Chicago*, December 14, 2010, http://www.chicagomag.com/Chicago-Magazine/January-2011/Vivian-Maier-Street-Photographer.

Correspondence with Minneapolis documentary producers provided by John Maloof.

Jeff Goldstein's account of documentary production, personal telephone interview, 2017.

Finding Vivian Maier, produced by John Maloof and Charlie Siskel, Ravine Pictures, LLC, 2013.

Vivian Maier: Who Took Nanny's Pictures? and *The Vivian Maier Mystery*, producer/director Jill Nicholls, British Broadcasting Corporation (BBC), 2013.

Mary Ellen Mark on Vivian Maier's work, recorded and transcribed interview by John Maloof, 2011–2013.

Ansel Adams quote, Marie Street Alinder, *Ansel Adams: A Biography* (New York: Bloomsbury USA).

APPENDIX A: THE CONTROVERSIES

Estate Matters

Vivian Maier estate, in-person interviews and emails with Cook County administrators, 2018.

Sylvain and Rosette Jaussaud, in-person interview in France regarding copyright events, 2018.

Randy Kennedy, "The Heir's Not Apparent," *New York Times*, September 5, 2014,

https://www.nytimes.com/2014/09/06/arts/design /a-legal-battle-over-vivian -maiers-work.html?mcubz=0.

Deanna Issacs, "Losing Vivian Maier," *Chicago Reader*, February 4, 2014.

Cook County Probate Division, Case #:2014P003434, Petition filed by John M. Ferraro, June 9, 2014.

Cook County Probate Division, Case #:2014P003434, Petition filed by Levenfeld Pearlstein, LLC, June 22, 2018.

Owner Capabilities

Caroline Miranda, "Untangling the Complicated Legacy of Nanny-Photographer Vivian Maier," *Los Angeles Times*, August 11, 2014.

Jeff Goldstein tax returns, Vivian Maier Prints, Inc., U.S. Corporation Income Tax Returns, Internal Revenue Service, Form 1120, 2010–2014.

Andrew Baul, "University of Chicago Library Receives Gift of Vintage Vivian Maier Prints," *uchicago news*, July 19, 2017.

Rachel Rosenberg, "Gift Creates Largest Institutional Collection of Acclaimed Photographer's Prints," *uchicago news*, August 22, 2019.

Posthumous Choices

Andrea G. Stillman, et al., *Ansel Adams Letters 1916–1984* (New York: Little, Brown and Company, 2017).

Jeff Rosenheim, head curator of photography for the Metropolitan Museum of Art, brief in-person conversation, 2018.

Steve Rifkin, master printer, personal interview via email regarding his approach to preparing Vivian Maier's work, 2020.

Howard Greenberg, gallery owner, on the posthumous printing of Vivian Maier's work, recorded and transcribed interviews by John Maloof, 2011–2013.

Mental Illness

Rose Lichter-Marck, "Vivian Maier and the Problem of Difficult Women," *New Yorker*, May 9, 2014.

Claudia Kalb, *Andy Warhol Was a Hoarder: Inside the Minds of History's Great Personalities* (Washington DC: National Geographic Society, 2016).

Olivia Laing, *The Lonely City: Adventures in the Art of Being Alone* (Edinburgh, UK: Canongate Books, 2016).

Hsiaojane Chen, "Disorder: Rethinking Hoarding Inside and Outside the Museum," lecture, University of Texas at Austin, 2011.

What Would Vivian Do?

Colin Westerbeck, "Photographer Unknown," *Art in America*, June/ July 2018.

Roger Carlson, owner of Bookman's Alley, on Vivian Maier's growing paranoia, recorded and transcribed interview with John Maloof, 2011–2013.

Curt Matthews, former employer, personal interview via telephone clarifying his state-
ment on Vivian Maier's behavior and prospective wishes, 2018.

Linda Matthews, personal interview regarding Vivian Maier's prospective wishes, 2018.

Carole Pohn, Gensburg neighbor, on the discovery of Vivian Maier's work, recorded
and transcribed interview by John Maloof, 2011–2013.

Opinions regarding display of Vivian Maier's photographs in recorded and transcribed
interviews, John Maloof, 2011–2013: Cathy Bruni Norris, Duffy Levant, Inger Ray-
mond, Jennifer Levant, Joe Matthews, Judy Swisher, Chuck Swisher, Karen Frank,
Linda Matthews, Maren Bayleander, Phil Donahue, Sarah Matthews Luddington,
Terry Callas, Karen and Zalman Usiskin, Anne O'Brien, Barry Wallis, Bill Sacco,
Bindy Bitterman, Bob Kasara, Carole Pohn, Ginger Tam, Jim Dempsey, Patrick
Kennedy, Richard Stern, Roger Carlson, Mary Ellen Mark, Howard Greenberg,
Joel Meyerowitz, Merry Karnowsky.

Inger Raymond quote on Van Gogh, recorded and transcribed interview with John
Maloof, 2011–2013.

APPENDIX B: THE LEGACY

Cortney Norman, Howard Greenberg Gallery, personal interviews via email,
1918–2020.

Arthur Lubow, "Looking at Photos the Master Never Saw," *New York Times,* July 3,
2014, https://www.nytimes.com/2014/07/06/arts/design/when-images-come-to-life
-after-death.html.

Roberta Smith, "Vivian Maier: Photographs from the Maloof Collection," *New
York Times*, January 19, 2012, http://www.nytimes.com/2012/01/20/arts/design
/vivian-maier.html.

Joel Meyerowitz regarding Vivian Maier's legacy, personal interview via email, 2020.

Howard Greenberg, in-person interview with gallery owner regarding Maier's legacy,
2016–2017.

Joel Meyerowitz, Mary Ellen Mark, Howard Greenberg, and Merry Karnowsky,
quotes from recorded and transcribed interviews by John Maloof, 2011–2013.

Erin O'Toole on Gary Winogrand, Arthur Lubow, "Looking at Photos the Master
Never Saw," *New York Times*, July 3, 2014.

Anne Morin interview by Jim Casper, "Vivian Maier: Street Photographer, Reve-
lation," *Lensculture*, https://www.lensculture com/articles/vivian-maiervivian
-maier-street-photographer-revelation.

"Chicago Woman Discovered as a Photographer," *Daily Tribune/AP*, March 1, 2011,
http://www.dailyherald.com/article/20110313/news/ 703139924/.

APPENDIX C: THE BACKSTORIES

Backstory #1: The Rooftop Randazzos

Manhattan House, 200 East Sixty-Sixth Street, white tower in Randazzo photographs.

Surrounding buildings in Randazzo photographs, OldNYC.org, Irma and Paul Milstein Division of United States History, Local History and Genealogy, New York Public Library.

Miss S. Randazza [sic], 1949 Manhattan City Directory, U.S. City Directories, 1822–1995, Ancestry.com.

Randazzo family residence, 1930 Census: Manhattan, New York, New York; District: 0653. Page: 12B; Enumeration District: 0653; Family History Library microfilm: 2341299.

Randzzo [sic] family residence, 1940, Sheet 61A, Year: 1940; Census Place: New York, New York; Roll: m-t0627-02654; Page: 61A; Enumeration District: 31-1258.

Salvatore A. Randazzo obituary, Advance Funeral Home, Hamilton, Ohio, July 13, 2004.

Backstory #2: Joan from Riverside Drive

340 Riverside Drive residence, 1952 Manhattan City Directory, New York City, U.S. City Directories, 1822–1995, Ancestry.com.

Sidney Charlat residence, Year: 1940; Census Place: New York, New York; Roll: m-t0627-02647; Page: 65B; Enumeration District: 31-972.

Sidney Charlat residences, U.S. Public Records Index, 1950–1993, Volume 2 (database online), Ancestry.com, 2010.

Joan Murray, *Confessions of a Curator* (Toronto: Dundurn Press, 1996).

Carol Charlat, U.S. School Yearbooks, 1880–2012, School Name: High School of Music and Art; Year: 1959.

Carol Charlat's *Candlestick, The English Speaking Union, Dallas Branch Newsletter*, May 19, 2013.

"New York Restaurant Owner on Isle Holiday," *Waikiki Beach Press, Sunday Advertiser*, 1958.

Backstory #3: The Female Photographers

Photographs by Vivian Maier covering the production of the movie *Taxi*, 1953.

Carola Loeffel Hemes marriage, 1912, New York City Municipal Archives; Borough: Manhattan; Indexed Number: M-12.

Carola Hemes residence, 1915, 1918, New York City Directory, U.S. City Directories, 1822–1995 (database online), Ancestry.com, 2011.

Emile Hemes residence, 1918, New York City Directory, U.S. City Directories, 1822–1995 (database online), Ancestry.com, 2011.

Carola Hemes divorce, "Court Sees 'Inhumanity' to Alimony Prisoner," *New York Herald Tribune*, July 19, 1931.

Carola Hemes, 1933, New York City Directory, U.S. City Directories, 1822–1995, Ancestry.com, 2011.

Elise Mehls, Alien Enemy Record, A-3868101, Hudson County, New Jersey State Archives, 1951.

Elise Mehls obituary, *Kingston Daily Freeman*, April 23, 1965.

Carola Hemes great-nephew, telephone interview regarding identification of the photographer, 2016.

Photography classes and darkrooms, Classified Ads, *New York Times,* 1940s–1950s.

Photography classes and darkrooms, Classified Ads, *New York Herald Tribune*, 1940s–1950s.

Geneva McKenzie studio, Manhattan, New York*, City Directory*, 1953, p. 1102.

Geneva Ehler, East High School, Cleveland, Ohio, 1908, U.S. School Yearbooks, 1880–2012, Yearbook Title: *Ehs*; Year: 1908.

Backstory #4: The McMillan Story

Vivian Maier photograph note "Upstate New York."

James R. McMillan, MD, Manhattan, New York, City Directory 1953, U.S. City Directories, 1822–1995 (database online), Ancestry.com, 2011.

Sarah R. McMillan, addresses in New York City and Hopewell Junction, People Search and Intelius.

"Miss Moore Becomes Bride," *Poughkeepsie New Yorker*, June 28, 1941.

"Sarah Reeder McMillan Bride of Steven Dunn," *Poughkeepsie Journal*, September 26, 1971.

"Banton Moore Services Set," *Waco News-Tribune*, January 5, 1954.

Dr. James Reeder McMillan, obituary, *Jackson Sun*, October 15, 1990.

Sharon J. Doliante, McMillan Family Tree, *Maryland and Virginia Colonials* (Baltimore: Clearfield Company, 1991).

Carl Maier Backstory

Karl Maier, Beneficiary Identification Records Locator Subsystem (BIRLS) Death File, Washington, DC: US Department of Veterans Affairs.

Karl Maier, LC Boarding Home [sic] Rest Home, Atco, New Jersey, Social Security Application, 1967.

New Jersey State Nursing Home Study Committee, *New Jersey Report on Long-Term Care* (Trenton, New Jersey: New Jersey State Government, 1978).

Judy and Gerald Pliner, personal interview with the owners of L&S Rest Home, via telephone and email, regarding Carl Maier, 2015–2017.

Charles Maier Sr. Backstory

Berta Maier, 1943 Enemy Alien Registration, 1940–1943, #3073121, USDJ; Probate Intestate, 134084, Surrogate Court, QCNY.

Berta Maier, 1968 Probate Intestate, 134084, Surrogate Court, QCNY 453–76.

Berta Maier's nephew, Leon Teuscher, personal interviews via telephone regarding his and his cousin's experience living with Charles Maier, 2015.

Eugenie Jaussaud Backstory

Eugenie Jaussaud, 1940 Census: Bedford, Westchester, New York; Roll: T627_2802; Page: 14A; Enumeration District: 60-10.

Charles Dana Gibson, telephone interview about Eugenie Jaussaud, his childhood cook in Bedford, New York, 2016.

Eugenie Jaussaud immigration, May 20, 1901, SS *La Gascogne*, Arrival: New York, New York; Microfilm Serial: T715, 1897–1957; Microfilm Roll: 0197; Line: 22; Page: 92.

Eugeni Joussaud [sic] certificate of arrival, SS *La Gascogne*, May 20, 1901, U.S. Department of Labor, Naturalization Service, No. 2-1180178.

Eugenie Jaussaud Declaration of Intent, May 27, 1925, #173882, Southern District of New York, New York State Naturalization Records, NARA.

Eugenie Jaussaud residence Hunt Dickinson, 1930 Census: Oyster Bay, Nassau, New York; Roll: 1462; Page: 9B; Enumeration District: 0194; Image: 576.0; Family History Library microfilm: 2341197.

Eugenie Jaussaud Naturalization Petition, 035 9649, witnessed September 30, 1931, filed under Euginie [sic] Jaussaud, 1932, Nassau County Clerk's Office, Mineola, New York.

Eugenie Jaussaud Certificate of Citizenship, #3536421, Supreme Court of Nassau County, March 18, 1932, New York State Archives, NARA.

VIVIAN MAIER PHOTOGRAPHY ART BOOKS

John Maloof, *Vivian Maier: Street Photographer* (Brooklyn: powerHouse Books, 2011).

Richard Cahan and Michael Williams, *Vivian Maier: Out of the Shadows* (Chicago: CityFiles Press, 2012).

John Maloof, *Vivian Maier: Self Portraits* (Brooklyn: powerHouse Books, 2013).

John Maloof, *Vivian Maier: A Photographer Found* (New York: Harper Design, 2014).

Richard Cahan and Michael Williams, *Eye to Eye: Photographs by Vivian Maier* (Chicago: CityFiles Press, 2014).

Colin Westerbeck, *Vivian Maier: The Color Work* (New York: Harper Design, 2018).

GENEALOGIST-CONTRIBUTED RECORDS

Susan Kay Johnson, New York
Jim Leonhirth, Tennessee
Peter Nagy, Slovakia
Michael Strauss, Utah

MAJOR REPOSITORIES AND DATABASES

Ancestry.com
Archive departementales de Hautes Alpes (ADHA)
BeenVerified
Curbed
Ephemeral New York
Facebook
FamilySearch
Forgotten New York
Google Earth
Intelius
Library of Congress (LOC)
National Archives and Records Administration (NARA)
National Personnel Records Center (NPRC)
Newspapers.com
New York City Archives (NYCA)
New York City Department of Municipal Records (NYCMR)
New York Public Library (NYPA)
New York State Archives (NYSA)
Old Fulton New York Postcards Newspaper Website
OldNYC: Mapping Historical Photographs from the NYPL
PeopleFinders
People Search
Public Records Directory
Queens County Archive (QCA)
Queens Surrogate Court (QSC)
Radaris
Spokeo
United States Citizenship and Immigration Services (USCIS)
United States National Archives (USNA)
Untapped Cities
White Pages

INDEX

Page numbers in *italics* refer to photographs.

ABOUT THE AUTHOR

Ann Marks spent thirty years as a senior executive in large corporations and served as chief marketing officer of *Dow Jones/The Wall Street Journal*. After retirement, she put her research and analytical skills to use as an amateur genealogist and became inspired to unlock the mysterious life of photographer Vivian Maier. She has dedicated years to studying Maier's archive of 140,000 images and is an internationally renowned resource on Vivian Maier's life and work. Her research has been featured in major media outlets, including the *Chicago Tribune*, the *New York Times*, and the Associated Press. Marks lives in Manhattan with her husband and three children.